MUSEUM MATERIALITIES

This is an innovative interdisciplinary book about objects and people within museums and galleries. It addresses fundamental issues of human sensory, emotional and aesthetic experience of objects. The chapters explore ways and contexts in which things and people mutually interact, and raise questions about how objects carry meaning and feeling, the distinctions between objects and persons, particular qualities of the museum as context for person-object engagements, and the active and embodied role of the museum visitor.

Museum Materialities is divided into three sections – Objects, Engagements and Interpretations – and includes a foreword by Susan M. Pearce and an afterword by Howard Morphy. It examines materiality and other perceptual and ontological qualities of objects themselves; embodied sensory and cognitive engagements – both personal and across a wider audience spread – with particular objects or object types in a museum or gallery setting; notions of aesthetics, affect and wellbeing in museum contexts; and creative and innovative artistic and museum practices that seek to illuminate or critique museum objects and interpretations.

Phenomenological and other approaches to embodied experience in an emphatically material world are current in a number of academic areas, most particularly strands of material culture studies within anthropology and cognate disciplines. Thus far, however, there has been no concerted application of this kind of approach to museum collections and interactions with them by museum visitors, curators, artists and researchers. Bringing together essays by scholars and practitioners from a wide disciplinary and international base, *Museum Materialities* seeks to make just such a contribution. In so doing it makes a valuable and original addition to the literature of both material culture studies and museum studies alike.

Sandra H. Dudley came to the University of Leicester's Department of Museum Studies in 2003, from the University of Oxford's Pitt Rivers Museum. She is a social anthropologist, and author of publications on material culture, museums, exile and Southeast Asia, including the forthcoming *Materialising Exile*.

MUSEUM MATERIALITIES

Objects, Engagements, Interpretations

Edited by Sandra H. Dudley

LONDON AND NEW YORK

First published 2010
by Routledge
2 Park Square, Milton Park, Abingdon, Oxon OX14 4RN

Simultaneously published in the USA and Canada
by Routledge
270 Madison Avenue, New York, NY 10016

Routledge is an imprint of the Taylor & Francis Group, an informa business

Typeset in Garamond by
HWA Text and Data Management, London
Printed and bound in Great Britain by
TJ International Ltd, Padstow, Cornwall

British Library Cataloguing in Publication Data
A catalogue record for this book is available from the British Library

Library of Congress Cataloging in Publication Data
Museum materialities : objects, engagements, interpretations / edited by Sandra H. Dudley.
p. cm.
Includes bibliographical references and index.
1. Museums – Social aspects. 2. Museums–Psychological aspects. 3. Museum visitors.
4. Museum exhibits–Social aspects. 5. Museum exhibits–Psychological aspects.
6. Material culture – Social aspects. 7. Material culture – Psychological aspects. 8. Senses
and sensation – Social aspects. 9. Emotions – Social aspects. 10. Aesthetics – Social aspects.
I. Dudley, Sandra H.
AM7.M8723 2009
069.01–dc22 2009018951

ISBN 10: 0–415–49217–3 (hbk)
ISBN 10: 0–415–49218–1 (pbk)

ISBN 13: 978–0–415–49217–1 (hbk)
ISBN 13: 978–0–415–49218–8 (pbk)

FOR GRANDMA

IN MEMORY OF MY VALIANT MOTHER
SALLY MARGARET DUDLEY
1942–2008

CONTENTS

CONTENTS

FIGURES

CONTRIBUTORS

Alice Cruickshank is a postdoctoral research fellow in the Department of Psychology at the University of York. She has a background in vision science, particularly eye-movement research, and is interested in the integration of vision with other sensory cues.

Chris Dorsett is a long-established artist-curator with public outputs ranging from published essays to solo exhibitions. He is presently reader in art school practices in the School of Arts and Social Sciences, Northumbria University. He has published, presented and exhibited widely in the UK and abroad, with a particular focus on installations in museums and a special interest in the practices, objects and interpretations of museums.

Sandra H. Dudley directs the MA in Interpretation, Representation and Heritage in the University of Leicester's Department of Museum Studies, and formerly worked at the University of Oxford's Pitt Rivers Museum. She is a social anthropologist with interests reflected in wide-ranging publications on material culture, museums, exile and southeast Asia.

Elizabeth Edwards is professor in cultural history of photography and senior research fellow at the University of the Arts in London, and former head of Photograph and Manuscript Collections at the Pitt Rivers Museum and lecturer in visual anthropology, University of Oxford. She is the author of numerous books and articles on the visual anthropology of historical photographs.

Viv Golding is director of research students in the Department of Museum Studies, University of Leicester. She is a former education officer at the Horniman Museum and has worked on a number of arts education projects in London. The research interests explored in her publications include tangibles, intangibles and sensory experience in learning in the museum, and racism and inclusion.

Nuala Hancock is a writer/researcher, whose interests embrace the inter-related fields of architecture, design, art and literature. Her AHRC-funded doctoral project is a collaboration between the English Literature Department of the University of Sussex and The Charleston Trust.

Eugene McSorley is a lecturer in Department of Psychology at the University of Reading. He has published widely on the understanding of vision, visual cognition and eye movements.

Howard Morphy is professor, and director of the Research School for Humanities at the Australian National University, honorary curator of Pitt Rivers Museum, University of Oxford and adjunct curator of the Kluge-Ruhe Research Centre, University of Virginia. His research interests include amongst others material culture and the anthropology of art and aesthetics, visual anthropology, and museums.

Lydia Nakashima Degarrod PhD is both a cultural anthropologist and a visual artist who creates interdisciplinary artworks. Her latest work as artist-in-residence at the California College of the Arts is a multimedia installation depicting the internal images of migration of Chilean political exiles.

Susan M. Pearce is professor emerita in the Department of Museum Studies and former pro-vice-chancellor at the University of Leicester and a former president of the Museums Association. She has published extensively in the fields of museum objects and collections, collecting, material culture, the archaeology of southwest Britain, history of museums, ethnography and curatorship.

Helen Pheby is deputy curator at Yorkshire Sculpture Park. She manages on-site and public art projects and exhibitions. Helen's particular area of research and interest is in developing cultural strategies that have the power to improve lives locally, nationally and internationally.

Helen Rees Leahy is director of the Centre for Museology at the University of Manchester. She formerly worked as a curator and museum director, and has organised numerous exhibitions of fine art and design. Helen has published on topics relating to heritage, art collecting, the art market and art criticism, and the visitor's embodied encounter with the museum or exhibition.

Helen Saunderson is studying for a PhD within the University of Leicester's School of Psychology. She is interested in cross-disciplinary research into how contemporary art is experienced and in the influence of art expertise.

Klare Scarborough is an exhibition project manager and consultant at the University of Pennsylvania Museum of Archaeology and Anthropology, and has a PhD in history of art from Bryn Mawr College. Her research interests include contemporary performance and ritual studies, autobiographical expression, and visual communication theories.

Martha Sear is a senior curator at the National Museum of Australia, working on the new *Australian Journeys* gallery. Her research interests include the history of international exhibitions, health and medicine collections, performing arts heritage, rural and regional museums, and outreach and community collaboration.

Alexander Stevenson is a practising visual artist and artist-curator. He has exhibited in a range of UK venues, and has been artist-in-residence at the Goldfactory Research Space in Nottingham, UK. He is currently interested in artistic (re-)interpretations of archaeological artefacts in museums.

Bradley L. Taylor is the associate director of the Museum Studies Program at the University of Michigan. His degrees include advanced work in both museum studies and information and library studies. Dr Taylor is currently researching the innovative application of technology in museum settings at the Maisons Satie in Honfleur, France.

Wing Yan Vivian Ting completed her PhD at the University of Leicester and is visiting lecturer in the General Education Centre, Hong Kong Polytechnic University. Her research focuses on how object–people communication operates through display and interpretation of material culture to construct knowledge and attribute value in cross-cultural contexts.

Sheila Watson is programme director for the MA in Museum Learning, Education and Visitor Studies in the Department of Museum Studies, University of Leicester, and formerly area museums officer at Great Yarmouth Museum in Norfolk. Her interests and publications focus on museum history and space in relation to national identity and iconic figures such as Nelson and Churchill.

Kirsten Wehner is a senior curator at the National Museum of Australia, working on the new *Australian Journeys* gallery. She is co-editor, with Darryl McIntyre, of *National Museums: Negotiating Histories* (2001) and the author of a number of articles and book chapters in the field of museums.

Christopher Wingfield was a curator at Birmingham Museum & Art Gallery. He has worked on the ESRC-funded project *The Other Within: An Anthropology of Englishness*, at the Pitt Rivers Museum, Oxford, and is now working exclusively on his doctorate, *The Moving Objects of the London Missionary Society*.

Andrea Witcomb is currently associate professor at the Research Institute for Citizenship and Globalisation, Deakin University, Melbourne, Australia. She is author of *Re-Imagining the Museum: beyond the mausoleum* (2003), co-editor with Chris Healy of *New World Museums* (2006), and author of a number of chapters and articles on museums and heritage.

FOREWORD

Susan M. Pearce

Like the more fortunate of us, the study of the material world and of museums had a long, peaceful childhood with clear boundaries, rules and mealtimes, which allowed for the steady accumulation of understanding that was simple as it arrived but substantial in aggregate; it had a turbulent adolescence with dramas and departures in which complexities emerged and innocence was abandoned; and now it emerges into the maturity represented by the contributions in this book and in its editorship. The first section of the volume is devoted to objects, their qualities, and their relationships to human experience. A significant aspect of this is the way in which the scope and character of materiality has come to be understood, in large part through contemporary work on the brain, which has focused up much earlier thinking. It is as well if this is put as bluntly as possible.

In essence, materiality is all we are and all we have. We human beings exist only in our bodies, which are themselves objects, albeit of a rather particular kind. We are fundamentally the same as all other life on earth (and elsewhere, perhaps, if there is any), differing only in our considerably greater degree of self-consciousness and cognition, embodied in language and other forms of self-expression; these differences in degree can be accounted for historically by the various challenges which the animals who developed into mammals, and then those who became early humans, had to face. Contemporary neuroscientists, who are beginning to unravel the complexities through which the human brain operates, tell us that our brains have one hundred billion neurons, each of which can have one hundred thousand connections, changing from nanosecond to nanosecond as the stream of experiences come in from the world by way of our physical senses. These can all be compared to memories of past experiences, of how we reacted to these, and of what the outcomes were, which are stored in neuro-banks and which enable us to make decisions from moment to moment. A crucial aspect of all this is the enormous role that what is usefully called emotion plays in the processes of memory making and what passes for thinking. Feelings are emerging not as the lens through which we view a thought, but as part of the thought itself. From these networks of neural firings emerge meaning, belief, and consciousness.

Neuroscience is also beginning to show why we are all different, utilizing the idea of 'neural plasticity'. This means that the connections between the various parts of the brain, down to the tiniest operating level, are always linking up, creating and changing networks, and falling away in response to changing experience. We all have a different gene base, the implications of which are also being unravelled, and different experiences, which produce different abilities and inclinations. We may be in a material world, but it is not a determinist one.

This has a number of fundamental implications. The first is that, once such thoughts have been thought they cannot be unthought: science may take a very long time to deliver the detail

of how and why these things actually happen, and there may well be shifts and changes along the way, but it is very improbable that we shall ever again seriously contemplate a 'soul' or a 'spirit' which is somehow in us but separate from our physicality. Further, ancient notions of duality must be abandoned as principles of explanation, although of course they remain of enormous interest as the basis of much past understanding of the human condition, which in its turn has fed into the ways in which our minds work. The line that runs from the ancient world through Plato and the medieval church to Descartes and the Enlightenment into the contemporary world, turns out to be inaccurate. There is not an opposition between mind and body, reason and emotion, spirit and matter, order and chaos, and so on, and still less is there a privileging of the first in each pair in comparison with its poor, dark twin; instead there is only complex, lumpy, ever-present materiality, which informs ourselves and every thing we know. All of our apprehensions are part and parcel of the body of materiality, and this includes our moral and aesthetic understandings, which belong within our sensuous presence in a world known through our senses.

Materiality is essentially physical and we know it is everywhere, inside and outside our bodies, because we apprehend it through our senses. The ways in which these senses are described and understood differs from one community to another, but at the level on which understanding is built, we, like other mammals, are equipped with skins which can feel, eyes which can see, ears which can hear, and mouths and noses which can taste and smell. Although Western tradition values its musical traditions very highly, and also gives a high place to its cuisine, especially that of France and Italy, by and large it has paid most attention to the sensation of sight, and continuing developments in information technology suggest that the primacy of the vision is unlikely to be seriously challenged. The culture of modernism depended upon the notion of evidence, selected elements of the physical world, which could be assembled in a chosen order so that the viewer could see, laid out before his (as it usually was) very eyes the vision of the truth which the objects embodied. The prime location for this activity was, of course, the museum display, and museums like the Pitt Rivers in Oxford and the Sedgwick in Cambridge still preserve the style. From the material evidence were distilled the illustration, which could draw out similarities and comparisons, the map, which could fix spatial relationships, and the diagram, which could set out temporal and causal links. We should add to these the painted picture, which could demonstrate the power relationships, supported by and adding to, these hierarchies.

Vision has become the prime engagement with the world for many, probably most, people, so that their broader sensational capacities are correspondingly impoverished. Saunderson and her colleagues are engaged in work which is beginning to clarify what our eyes do when we look at images, and what this can mean. However, as Edwards points out in her paper on photographs, images are objects both representational and material, and like all objects, encircled by questions about the nature of memory, history and cognition. Probably this is equally true of virtual images, in their own ways. Images are things which are actually used by people, and are part of how sensory apprehension is impacted by, and impacts upon, objects. Images, like all other objects, although probably more than many, have a physical presence in a social world and are 'caressed, stroked, kissed'; they are part of a performative social dynamic. And, like any other object, they carry the marks of their history on their faces.

It is clear that language, long regarded as the great expression of thought and reason and a major dividing line between us and the lower creation, can no longer be seen as the single, supreme expression of our understanding of our place in the scheme of things. In fact, the relation between language and materiality is much more complex, and interdependent, than might appear. Language is remembered and produced in our brains by the firing of material

neurons, like every other activity. Its implication in the bounded circuitry of our brains may help to explain why, when we use linguistic constructs to describe the world, we do so in a series of circles, in which each individual description is conceived as a metaphor of another, so that defeats are sour, winter is hard, prospects are rosy. All of these, of course, relate to materiality, which is used as a series of referents to enable language to remain rooted in the material world, through which alone we are able to come to understanding. One of the ways in which poetry works is by suggesting, anticipating, or reversing these metaphorical images, creating pleasures of recognition or of shock. Similarly, language as uttered, like every other noise, is never pure sound (whatever that might mean). Language is produced by the manipulation of mouth, tongue and vocal chords, and it reaches listeners' ears through vibrations in the air. It always comes to us with an accent, with multiple tones, and with varying degrees of volume, all of which convey much more than the bare words. The speaker may reinforce her meaning by adding extra adjectives to make sure that the beat of the syllables arrives at the rhythm needed to accompany the sense, or interrupting an established cadence by a jarring hesitation in order stress an important point. If the speaker can be seen, then bodily movement, 'body language', is added, and is of crucial importance in the making of meaning. If the spoken word is written or recorded, the resulting object will, of course, have all the usual physical and biographical attributes. For some of our mammal cousins, this can mean more than it does to us: dogs are especially interested in library books because they relish the dense olfactory character imparted by their passage through many hands.

For humans, one of the principle ways in which objects acquire special powers is the strength of feeling, which has been poured into them. This can happen to any kind of thing, and at every level of social action. For a single individual, it may be a pencil or a shirt, which was part of a formative event and henceforward carries the freight of that event, and so we call it a souvenir. For groups – families, villages, regiments – the same kind of piece has a wider frame of reference and might be called an heirloom. For whole societies, an object like the Stone of Scone or George Washington's sword has come to embody the force of a nation, and acquire the standing of sacred relics or icons. Of course, the mash of fact and historical mythology surrounding such pieces must be known to those participating in its story, at whatever level it is operating, but once the sequence of meaning is set going, the object itself appears to gather a power of its own that is usually called charismatic. As Wingfield shows us, this has happened to the Sultanganj Buddha, now a 'star object' in the collections of Birmingham City Museum, and the focus for an annual Buddhist festival at the museum, when chants and worship are offered before it. Similar, but spontaneous, acts of devotion are recorded from the museums of Korea, where flowers are left in front of images. Witcomb, similarly, discusses a miniature model of Treblinka, made by a survivor of the camp, asking how the Holocaust can be embodied in an object like this, and answering that the model is not just a trace of past events, but memory itself given material form.

The implication of what has been said is that the distinction between culture and nature must, like the other dualities with which it belongs, be abandoned. The notion of nature as the world of matter awaiting human process through the application of culture arrived at from somewhere else, will no longer serve. There is not a world of raw material opposed to constructed material goods, but rather a complex continuity of material relationships running from our bodies across the world, which are variously constructed into meanings of different kinds, of which 'nature' is one. Culture is not a parallel universe somewhere in our minds, which can be used to calibrate our experience of the material world. We, our world, and everything in it including sound, light, and weather are, in every sense of the phrase, material culture, and, as Pheby reminds us, the fabric of contemporary art practice. Culture is created continually as

we material beings engage with our material surroundings to produce the individual and social habits that add up to ongoing life.

The nature of this practice involves some profound engagements, which are explored in the central section of the volume, particularly those involving museum and gallery users. One mode of such engagement is that which faces the viewer with the stuff of other people's lives – never, of course, as simple as it might appear. Hancock takes us to Monk's House and to Charleston in Sussex, the literary and artistic home-museums respectively of Virginia Woolf and her sister Vanessa Bell – in itself and interesting juxtaposition, because the relationship between the two sisters was not always an easy one. The houses take us into a direct encounter with the materiality of other lives, now over. As Hancock rightly says, Woolf's writing connects sight with the solar plexus, the visual with the visceral. She could convey how an impact with the materiality of the world outside the body was not just a matter of observation, but also of feeling, obliterating any demarcation between the two. This makes a visual and tactile engagement with the things that embodied her own life – her glasses, a dressing table mirror – particularly full of vivid meanings, which have accumulated on the surfaces of the material remains of life. Degarrod also takes us to the stuff of other people's lives, the shrines which grow up in the streets Santiago in Chile, and in other towns there, to commemorate the souls of those who have died unjust deaths. These shrines are the sites of the popular *animitas* cult, and they are decorated with intimate belongings of the soul in life – often, since the person was frequently a child, baby clothes and toys. As is usual with such commemorations, the dead is present in the here-and-now. The commemorated soul is able to help the living, and the commemoration itself can make a range of political points, which might be difficult to articulate in other ways. As with the homes of Virginia and Vanessa, we see objects used as bridges to the dead, as ways of making contact with individuals who still have presence in the present. This kind of engagement through objects with those who are out of our reach in other tangible ways, is one of the most powerful ways in which materiality arouses our emotions.

Two contributors, Stevenson and Leahy, concentrate upon the particular insights into the nature of the material world, which can come to us through engagement with contemporary art, whose business is to question the nature of our responses and upset what we thought we were comfortable with. Rees Leahy takes a series of eight artist's installations in the Turbine Hall at the Tate Modern, concentrating especially on Doris Salcedo's *Shibboleth*, a 167m long crack in the floor. Whether or not the Tate curators had any ideas about what the public's reception of the installation might be is not clear, but we know that Salcedo intended the piece to be a comment on the fractured nature of human relations and, in particular, to represent the faultline between rich and poor. This understanding would, presumably, have been worked out in the space by walking down beside the crack and brooding quietly over it. But the public's response was very different; the Turbine Hall was appropriated and become a street, where people could wander back and forth, drink from cans, leap over the crack, kiss across it, dandle babies over it, and capture the moments with digital cameras and mobile phones. Their performances produced an atmosphere rather like that of a holiday beach which turns out to have a particularly intriguing natural feature that inspires play. Stevenson illuminated the nature of material perceptions by drawing images of archaeological objects on a distressed hide, which was further degraded by the handling of those asked to comment on it. Here, the actual materiality of the piece changed, reflecting the changes in the longer term, which every object passes through. These papers show us how intention is only a small part of any story, and that objects and humans will always engage in a mutual dance in which meanings emerge as the experience goes forward.

The same notion of dialectical, inter-personal and inter-material relationships arises in Wehner and Sear's consideration of *Australian Journeys*, a new object-rich exhibition at the National Museum of Australia. The writers discuss how visitors make meaning by linking objects, and by imaginatively exploring various materialities in form and structure. Visitors think about and feel their own bodily interactions with objects and compare their experiences with those of the original makers and users, in ways involving tactile and emotional perceptions, as much, or more, than cognitive ones.

Many of these papers, in their different ways, bear on the question on authenticity, and suggest that, since every object, inside and outside museums, must have multiple meanings none of which can be regarded as superior or primary, no object can have an inherent meaning or a character of its own. Some lines of enquiry suggest that this is not quite true: Virginia Woolf's glasses are fundamentally *her* glasses, just as the Sultanganj Buddha is an ancient, symbolic image, but of course the viewer has to know these things in order to appreciate them. Our sensuous engagement with the material world is a different matter. Some objects feel rough or heavy or smell unpleasant, and the sensations they are capable of stimulating in us do seem to be an authentic part of their being, and ours. In the same kind of way, we may be hard-wired to admire and desire shiny things. Gold objects have a soft, dense, deep glow, which is easy to recognise, and silk frequently feels smooth yet strong, and can take a unique bright, clear colouring: we value objects made from these materials for their genuine, inherent material qualities and if we are deceived, we are correspondingly disappointed. This has a bearing on Taylor's chapter, which addresses the thorny issue of original objects as opposed to copies and reproductions, especially those that are digitally generated. He explores the limitations of Benjamin's idea of the aura of the original, placing emphasis instead on the viewer's state of mind and the context in which she finds herself, and focusing especially on the importance of affect in optimal engagement with digitised objects.

All these considerations lead naturally to issues of interpretation. Ting describes a way of interpreting Chinese ceramics, which contrasts with the traditional scholarly approaches that stresses a visual narration of object typology. A community-led project in Bristol, UK, fostered a sensory human–object communication, which turned museum visitors into co-creators of the artworks they were exploring. Similarly, Golding shows how young children's creativity can be tapped by encouraging them to explore physically the sub-Saharan material on display in the exhibition *African Worlds* at the Horniman Museum, London.

All interpretation is inevitably political, and Watson renders this particularly clear in her examination of how the style of display at the Churchill Museum, London, draws the visitor into emotional engagement which helps to create a national narrative, linked to what seems to be a sensation of collective remembering but may in fact be the constructing of a collective mythology. Correspondingly, Scarborough examines the work of contemporary performance artists, who use the display of objects in their performances. This turns objects into story-laden souvenirs, which look back to past performances. This raises questions about the scope for authenticity of a rather different kind in object-person relations, given the scope it offers for narrative manipulation, and the exploitation of power relationships through the operation of memory and speech. Finally, Dorsett explores in depth what happens (and what has happened) when an artist is invited to create a piece from the contents of a museum. Here, as Peter Reading's poem *Erosive* makes clear, a 'semiotic uncertainty', a state of subversive uneasiness, runs through such an enterprise, as Salcedo's crack ran across the floor of the Tate Modern Turbine Hall. It invites the viewer to live with dislocations, and see them as opportunities for new and different material encounters.

Some pointers, perhaps, emerge from this short tour. We are material bodies in a material world, and our engagement in the flow of things can only be through our sensory perceptions. The western tradition has privileged sight over the other senses, and has tended to employ language primarily to communicate what we see; it is on this basis that the modernist world, with its characteristic episteme, has been built. Within this world, objects behaved themselves. They did not shift their intellectual shapes, or change their places in the received scheme of things, or mean different things to different people, or different things to the same person at different times. But we have always felt that these things were not true; they did not match what happens to us and how we feel about it as we live our lives experiencing our material world. We have become free to recognise how dislocated and uncomfortable our material perceptions are, and how ambiguous, but potentially enriching, our relationships are going to be in a touchy-feely world. The chapters in this volume discuss these, and other, issues with a wealth of insight and well-considered detail. The reader is invited to enjoy.

1

MUSEUM MATERIALITIES

Objects, sense and feeling

Sandra H. Dudley

The more I looked at them, the more I studied them, the more I appreciated their beauty over and above the information about their context. They were beautiful! The more I described them and handled them, the more emotionally attached to them I became … My eyes opened.

Dr Ekpo Eyo, quoted in Vogel 1991: 195

This book is about objects, people and the engagements between them. It deals with the fundamentals of human experience of objects, specifically in the context of public display such as museum and gallery spaces. The volume aims simultaneously to return a material culture focus to studies of museums, and a museum focus to studies of human–object engagements. It heralds the re-emergence of the object as a focus point for understanding museums and what they do, and a concurrent renewal of the museum as a research site of great potential in wider explorations of interactions between people and the rest of the material world.

The book seeks to contribute to both museum studies and material culture studies. Each of these fields of enquiry has a long history of multidisciplinarity and interdisciplinarity – in keeping with which, the chapters here explore understandings of objects, sensory experience, embodiment and affect developed through work informed by such diverse disciplines as cultural studies, social anthropology, sociology, philosophy, media studies, literary theory, psychology and neuroscience. The book's case studies are also rooted in contemporary museum practice, including exhibitions, education, outreach and artistic interventions, with authors variously focusing on displayed museum objects or art installations and interactions with them by museum visitors, curators, artists and researchers. Topics encountered include materiality and other perceptual and ontological qualities of objects themselves; embodied sensory and cognitive engagements with particular objects or object types in a museum or gallery setting; notions of aesthetics, affect and wellbeing in museum contexts; and creative and innovative artistic and museum practices that seek to illuminate or critique museum objects and interpretations. The book's authors include not only academic specialists in an extensive range of disciplines, but practising artists, curators and former curators and education officers too.

The attempt to focus on the material characteristics of objects and the ways in which those characteristics are sensorially experienced in museums, is an important part of the volume's rationale and a key focus of this first chapter. The 'material turn' (Edwards and Hart 2004: 3) in

anthropology and related disciplines over the past twenty years has, rightly, led to concentration on the embeddedness of material objects in human social life and the meanings and values objects thereby acquire; yet arguably much of that 'materialist' analysis has simultaneously led us away from the reality, significance and very tangibility of material surfaces, encouraging us instead to leap straight into analysing the role of objects in social and cultural worlds, in the process missing out an examination of the physical actuality of objects and the sensory modalities through which we experience them. Despite, in other words, the renewed emphasis in much scholarship on the material – and indeed on the ultimately unbreakable, Janus-faced, definitive links that exist between it and the social – a great deal of material culture studies actually pay surprising little attention to the 'irreducible materiality of things' per se (Pietz 1985, cited in Spyer 2006). Exceptions include work on sensory culture – the 'sensual revolution' (Howes 2005) – part of a move away from the structuralist and poststructuralist dominance of language and discourse and the later pre-eminence of vision and ocularity, in both method and critical analysis. Another important area has comprised anthropological studies of art and aesthetics, wherein 'aesthetics' is broadly conceived 'as a field of discourse that operates generally in human cultural systems, since like cognitive processes it can be applied to all aspects of human action', not only art per se (Morphy 1994: 9). These sensory and aesthetic foci inform the rationale for this volume. Chapters here explore some of the ways and contexts in which things and people mutually interact; in the process, the book raises questions about how objects carry meaning and feeling, the distinctions between objects and persons, particular qualities of the museum as a context for person-object engagements, and the active and embodied role of the museum visitor. Each author addresses aspects of engagements with and experiences of objects in museum or gallery spaces. Indeed, the exploration of subjective experience – physical, multisensory, aesthetic, emotional, immersive – of publicly displayed objects, albeit from different perspectives, is the primary motif for the volume.

This book is not, however, simply an examination of strategies and technologies through which museums can seek to (i) maximize the sensory modalities visitors use to experience exhibitions and (ii) better enable audiences to interact with historical or other representations in the gallery space. Museums, and museum studies, to an extent are already substantively and constructively engaged with such issues. As will become clearer below, these engagements are generally not, however, of the 'materialist' kind called for and represented here, focused primarily or initially at least on physical, material and bodily experience rather than leaping immediately beyond into the important worlds of social context, social effect and the social and economic aspects of production and consumption.

A truly materialist approach necessitates a subtle, but important, re-jigging of emphasis in many areas of study, especially museums, influenced in part by phenomenology. Such a shift is already established in material culture studies – especially those areas influenced by sensory culture studies (e.g. Csordas 1994, Howes 1991 and 2003, Edwards & Hart 2004, Jackson 1996, Stoller 1989) – and indeed the possibilities of such a truly material emphasis were highlighted some time ago (e.g. Miller 1998). Yet this is an approach has not yet significantly influenced contemporary studies of museum collections and practices, with a few exceptions (e.g. the anthropologically focused Ames 1992 and Clifford's discussion of museums – and objects – as contact zones [1997], the more recent Edwards, Gosden and Phillips 2006a, and the more applied and less cross-cultural Pye 2007 and Chatterjee 2008). It is, as we shall see, a change of focus in which 'the frame of museum contact' (between cultures, periods, objects and persons) potentially 'is recalibrated from museum space to museum object' (Feldman 2006: 255; see especially Witcomb, and Wehner and Sear, this volume).

The museum object and materiality

There is a current, indeed dominant, view within museum studies and practice that the museum is about information and that the object is just a part – and indeed not always an essential part – of that informational culture. This approach has a long pedigree and has become an implicit part of discussions of the purpose and character of museums, be they characterized in relation to the by now extensive territory of *learning* in museums (c.f. Hooper-Greenhill 2007), social action (e.g. Gurian 2005, Sandell 2002), curation (e.g. Gathercole 1989) or to explorations of museums' historical development (e.g. in the context of exploring museum shifts from being 'object-centred' to 'experience-centred' [Parry 2007: 81]). It is a view in which objects have value and import only because of the cultural meanings which immediately overlie them and as a result of the real or imagined stories which they can be used to construct (e.g. Kavanagh 1989). The material object thus becomes part of an object-information package: indeed, in such a framework the museum object properly conceived is not the physical thing alone at all, but comprises the whole package – a composite in which the thing is but one element in 'a molecule of interconnecting [equally important] pieces of information' (Parry 2007: 80). In turn, from this perspective the package only has value as a tool in institutional practices which seek to create meanings with wider educational, social or political significance.

Museums' long-held aura as authoritative temples of enlightenment and culture rests upon the socially widespread belief that they hold in perpetuity, for the benefit of society, historically established data-sets comprised of objects and their documentation. Such repositories are available not only for repeated re-interpretation by scientists and art historians in different historical periods, but also as places of edification available to the ordinary visitor. If we are lucky, the museum-goer may come away informed, provoked, moved or inspired by the objects they see – but how? Is this simply a result of contextual information or at least object-information packages, and/or of exhibition design and interpretation? Or is it also something to do with physical, real-time, sensory engagements – even those which may be imagined – with material things, and the emotional and other personal responses such interaction can produce (e.g. variously Edwards, Witcomb, Rees Leahy, Ting, Watson and Golding, this volume)? If so, in what ways do those engagements come about, and how (if at all) do they differ in museums from those in the everyday material world which museum visitors and the originating communities of museum objects ordinarily inhabit(ed) (c.f. Taylor, Watson, Golding and Scarborough, this volume)?

Too often the possibilities for physical and emotional interaction with objects in museums are assumed to be non-existent or restricted to an elitist, 'pure, detached, aesthetic response' (O'Neill 2006: 104), unless they are enabled or underpinned by (largely textual) information provided by the museum. But might this dichotomous pair of response-types in reality be a little more complex? And while information is vital, might the conventional *emphasis* on it rather than on object, occasionally actually inhibit the varied possibilities of engagement across a socially extensive range of visitors, including those who lack prior knowledge of the objects they are looking at? To ask these questions at all, risks accusations of elitism or essentialism – but my objective is to explore the nature of objects and engagements with them, as a contributory part of contemporary investigations into how museums can effectively and inclusively enable people to reflect creatively, sometimes transformatively, on themselves and others, and to experience 'beauty and knowledge as ends in themselves' (O'Neill 2006: 111).

In the standard emphasis on meaning, important though it is and integral to it as the object may be, the object *per se* often seems lost: 'Things dissolve into meanings' (Hein 2006: 2). To

say so does not imply support for a traditional, 'essentialist' model of the museum in which museums exist only to preserve, document and display *objects*, over a socially inclusive, 'adaptive' one in which museums exist primarily to serve *society* (O'Neill 2006: 97). Rather, I am seeking to shift the focus back to physical objects, but with a strong emphasis on their impacts – actual and potential – on real people (c.f. Edwards and Ting, this volume). There are, as we shall see throughout this book, so many possibilities in human–object engagements – yet such possibilities are, I suggest, sometimes severely curtailed by much of what a museum actually does. In particular, the museum's preoccupation with information and the way it is juxtaposed with objects – the biographies of historical objects and the persons associated with them, the classification and scientific significance of natural history specimens, the demonstration by ethnographic artefacts of aspects of particular ways of life – immediately takes the museum visitor one step beyond the material, physical *thing* they see displayed before them, away from the emotional and other possibilities that may lie in their sensory interaction with it. Of course, up to a point this is only as it should be: precisely because of the manner in which institutions have selected, categorized and preserved not only objects but also information pertaining to them, museums have indeed developed as 'storehouses of knowledge as well as storehouses of objects' (Cannon-Brookes 1984: 116, quoted in Parry 2007: 80). These epistemological functions and their political and moral ramifications are a central part of museums' historical and cultural rationale, and it is clear how important objects are in these processes (Bennett 1995, Knell 2007). But what are the experiential limitations of construing material objects as simply or principally elements in broader datasets and disciplinary paradigms? What are the implications of this conventional, informational approach for how things in museums are perceived and interacted with by curators and visitors? What opportunities might it foreclose? What might a different, material, even emotional, approach to museum objects contribute to the potential of socially inclusive museums to enable rich, physical and emotional, personal experiences for all their visitors? What would it be like for visitors more often than not to be able not only to read a text panel that explains an historical story associated with an object, but also to experience an embodied engagement with that object and thus form their own ideas and/or a tangible, physical connection with those who made and used it in the past?

There are two separate points wrapped up together here, both of which are key messages. The first, ontological point is that through our sensory experience of them objects have some potential for value and significance in their own right, whether or not we are privy to any information concerning their purpose or past. The second, more practical point is that creative, materialist thinking about embodied and emotional engagements with objects can provide more powerful alternatives or additions to textual interpretation in enabling visitors to understand and empathize with the stories objects may represent. From both perspectives, engagements with material things should be the fundamental building block of the museum visitor's experience – yet so often, so unsatisfyingly, they are not (c.f. Wehner and Sear, this volume). A major reason for this, is the view that the museum object is an object-information composite. Conceiving and presenting objects as always incomplete, even useless, without the (textual) provision of associated data and interpretations, excludes the possibilities inherent in objects' material, sensorially perceptible characteristics – possibilities which appear *a posteriori* in conventional museum approaches to objects but which are in fact *a priori*, insofar as they are dependent primarily upon objects' pre-existing and inherent, real and physical properties rather than their social and epistemological associations (c.f. Saunderson *et al.*, this volume, for a psychological view). Others too have argued that museum conventions somehow demean the objects they contain. O'Neill, for example, claims that 'the origin of museums as temples to

reason means that a key aim has been to tame objects and diminish their power' (O'Neill 2006: 101). However, he still regards the real properties of objects as 'obvious' and 'trivial', considering objects' power as invariably inseparable from their wider associations and meanings. The latter are, of course, crucial to the significance and possibilities of particular objects, but they are not all that may be so. It is not the purpose of this book to argue against the value of exploring, presenting and interpreting information and meanings – clearly, the very resonance and power of material objects in and outside museums is often, if not usually, inextricable from their history and links, as poignant examples such as the physical fragments of domestic life left behind in bombsites (Moshenska 2009), the dilapidated traces of the past evident in the hospitals for new immigrants on Ellis Island (Baker 2008), old articles of clothing deliberately concealed in buildings (Eastop 2006), and a number of the chapters in this book, movingly demonstrate (e.g. Wingfield, Hancock, Witcomb). However, in varying ways the chapters which follow also pay some long overdue attention to objects themselves, *qua* objects (though they may not articulate it in this way – e.g. Taylor): to aspects of their apparently obvious and trivial material qualities and to the possibilities of people's direct, embodied, emotional engagements with them.

Reconfiguring the museum object

It is through re-examining engagements with material things in museums, and through connecting museum studies with contemporary directions in material culture studies, that we can begin to reconfigure current notions of the museum object. Even if it were possible to disentangle objects from information and from the classificatory processes embedded in the museum enterprise, it could still be argued that museum objects never stand alone. The physical things in museums and galleries continue to comprise one element in a composite, but rather than being part of an object-information package they exist within an object–subject interaction. This is the interaction between inanimate, physical thing and conscious person, and constitutes the moments in which a material thing is perceived and sensorially experienced. It is only through this interaction that the thing becomes properly manifest to the viewer – in effect, it is only through the object–subject engagement that the material artefact or specimen becomes real at all. As Tilley has argued for non-museum contexts, the object's materiality neither exists nor is perceived in isolation, but lies in the sum of a relationship between both the object's qualities *and* the embodied way in which we experience them (2004; c.f. Strathern's demonstration that persons and things alike are defined – indeed actualized – by relationships, or meaningful and active engagements, between them [1988, 1999]). At the same time, of course, the way in which we experience objects is shaped significantly, even if not exclusively, by the physical properties of the objects themselves. As Gosden puts it, '[a] building, a pot or a metal ornament has certain characteristics of form which channel human action, provide a range of sensory experiences (but exclude others) and place obligations on us in the ways we relate to objects and other people through these objects' (2005: 196). It is in this sense that objects have effects and agency – a notion which, as Gosden also points out, allows us appropriately to attribute 'power or capacity to objects' but which does not equate with alloting them 'will or intention' too (ibid.). Furthermore, we are not just acted upon by the visually apparent material qualities of an individual object upon which we gaze in the museum on a rainy Sunday afternoon; long before that Sunday, we have existed in a world constructed of and around material things – a world which has, through our prolonged, enculturated exposure to it, shaped our perspectives and sensory responses. It is in that context that '[p]eople crystallize out in the interstices between objects, taking up the space allowed them by the object world, with [their] senses and emotions

educated by the object world' (ibid.). Aspects of such object-person engagements can then be exploited by artists, curators and others in order to enhance the experience of objects in the museum or gallery (e.g. Pheby and Dorsett, this volume).

In sum, then, the museum object can be said to have two forms, both of which are composites rather than solely the physical thing itself. In the first form, as we have seen, the substantive object is simply one element in an informational fusion of data – some of which happen to be material and some ideational. In the second, the museum object consists of an enmeshing of the physical thing and human, sensory perceptions of it. The first of these denotations of 'museum object' is conventional in much of the extant museum studies literature, and in it the thing's material properties may or may not be of particular significance; indeed, even if they are significant, they are frequently missed in the rush to identify and explicate the wider social and/or disciplinary meanings that the thing might be said to represent or connote. In my second definition of the museum object, however, physical and sensible properties are fundamental to its nature. And surely it is here, not in the object-information package, that we can find the museum object's uniqueness: many cultural institutions and practices derive from and incorporate important, intersecting, informational composites, but what is special about museums and related settings is the very *physicality* of their core building blocks. Quite what that physicality may imply, not only for and beyond objects as sets of information and meanings but also for the possibilities of the museum experience, has been surprisingly little explored.

Engaging with objects in museums

Indeed, much of what is interesting in the very materiality of objects is often ignored altogether. Even in non-museum-based writings which appear explicitly to call for a focus on materiality, real *stuff* and its three-dimensionality, weight, texture, surface temperature, smell, taste and spatio-temporal presence, is often, tantalizingly, almost entirely absent (e.g. Straw 1999). Usually missing too are the intimate details of people's physical, sensory – visual, haptic, aural, oral, gustatory, kinaesthetic – engagements with the physical things in question. Sometimes it is visuality rather than materiality which is privileged in existing analyses; at other times, rather than the thing itself its meanings, values and contexts predominate, despite being at least one layer removed from the material nature of the object *per se* (even if they are essential to overall understanding and interpretation of it). As Glenn Willumson puts it in relation to one kind of object, photographs:

> Too often this socio-cultural inscription [of the shifting meanings of the photo-object] suppresses the materiality of photographs as they are squeezed within the rhetorics of canonical histories of photography and their concomitant spaces of collection and exhibition. Historically, even when attention *is* paid to the materiality of photographs, as is the case with the fine art print by the master photographer, it is submerged beneath the discourse of aesthetics.
>
> (Willumson 2004: 62)

In short, it is about time we paid more attention to the very materiality of the material, beyond narrow (though still important) discussions of aesthetic and formal qualities of artworks or technical analyses of archaeological artefacts and natural history specimens (c.f. Pheby's chapter on art, this volume). This means not treating the material as 'merely something upon which meaning is inscribed – a world of surfaces on to which we project significance', a world where

'meaning is only ever "read into" things' (Graves-Brown 2000: 4). It means enriching an existing 'interpretive preoccupation with the symbolic, representational and communicative dimension' which has 'left some other more basic and direct links between cognition' – and, I would add, emotion and physical sensation – 'and material culture unexplored' (Malafouris 2008: 401). To make such a shift will inform not only a greater understanding of the ways in which people engage with the material world, but also the aesthetic and technical explorations and wider social and disciplinary meanings from which the physical object cannot really, of course, ultimately be disentangled. Thus, for example, to pay proper attention to the materialized 'performance of thumbing through the photographs, selecting and sequencing, and gluing them' (Willumson 2004: 63) that is constituted by the construction and indeed later usage of a photograph album, is to investigate not only issues of photographic techniques and aesthetics, and matters of personal and social history (as museums may always have explored), but also to explore physical and emotional, intimate and tactile, object-subject engagements in the past and present (e.g., in this volume, the different layers of feeling represented in Nakashima Degarrod's paintings and audience engagements with them; the material deteriorations and accompanying shifts in Stevenson's palimpsests; and the changing physical, cognitive and affective interactions with the Sultanganj Buddha, described by Wingfield). Thinking in this way has been remarkably subordinate to wider questions of meaning and value not only in most of the resurgent studies of material culture (outside those influenced by sensory culture studies) that have flourished within anthropology and other disciplines over the past twenty years, but also in studies of and practices in, the museum – supposedly the material institution *par excellence*.

Self-evident materiality?

What, though, precisely is this 'materiality'? In part at least it connotes the form and the materials of which an object consists, together with the techniques by which it may have been made or formed, any additions or presentational conventions (such as a frame) which may have been added to it, and all and any traces of the passage of time and, especially, physical human interaction. Materiality implies too, though, engagement – be it cognitive, emotional or imaginative alone (e.g. Hancock, Nakashima Degarrod, this volume) or physically, bodily participative as well (e.g. Wingfield, Pheby, Stevenson, Rees Leahy, Wehner and Sear, this volume). I have already suggested refiguring the museum object as an object–subject interaction, in which the object's physical characteristics will be among the most important factors, and I said that in a sense it is only as a result of the object–subject engagement that the material thing becomes real at all. To an extent, this echoes Pearce's argument that the

> meaning of the object lies not wholly in the piece itself, nor wholly in its realization [by the viewer], but somewhere between the two. The object only takes on life or significance when the viewer carries out his realization, and this is dependent partly upon his disposition and experience, and partly upon the content of the object which works upon him.
>
> (1994b: 25)

Where Pearce uses 'meaning', we could substitute 'materiality'; where she describes an object taking 'on life or significance', we could use 'is materialized' instead. In other words, the sensible, physical characteristics of the thing trigger and thus contribute to the viewer's sensory perceptions, which in turn trigger emotional and cognitive associations, which *together* with the physical characteristics could be said to constitute the object's materiality. Materiality, then, is

about not solely meaning nor simply physical form, but the dynamic interaction of both with our sensory experience. It is in this, that perhaps we can locate that which Pearce describes as 'the power of "the actual object"' (1994b: 25). Conceptualizing materiality as a summation of physical characteristics, sensory experience and meaning in this way, firmly shifts attention back towards the object, the thing before us. This is no mere theoretical re-emphasis or slight shift in academic terminology. Rather, it reminds us of the basic truth that the material properties of the thing itself are *essential* to how our bodily senses detect it and thus to how we experience and formulate ideas about it. This is the 'argument that a deep mutuality exists between our sensory apparatus and material things' (Edwards, Gosden and Phillips 2006b: 5). Is the self-evidence of this perhaps one reason why so many studies of material culture, and especially of museums, seem to ignore it? Self-evidence, of course, does not equate to simplicity and an absence of a need for explanation. Neither, as several chapters in this volume indicate, does it imply that materiality is straightforward or static (e.g. Pheby, Stevenson, Scarborough).

Museum processes and sensory and emotional experience

This notion of materiality reminds us that before we formulate any ideas at all we can, if permitted to do so, consciously experience more fundamental sensory and emotional responses to objects. These responses can sometimes be powerful, even transformative, as Greenblatt's notion of wonder implies (1991; see also De Bolla 2005). The physical senses and the emotions are two different kinds of 'feelings' which are intrinsically linked – particularly so in the notion of 'affect', which some writers have distinguished from 'emotion' on the grounds of the intertwined physiological basis and social shaping of affect, thus its inextricability from the materiality of socially constructed body (Tomkins 1962–1992, Gibbs 2002). Emotion, affect and sensation all form a significant part of the experiences of objects discussed in this book. They do not have the prerequisite of information and are responses which are arguably possible for all. Yet museums' preference for the informational over the material, and for learning over personal experience more broadly and fundamentally conceived, may risk the production of displays which inhibit and even preclude such affective responses. Inevitably, the object-information package can still have the power to move us, but most often it does so almost entirely through textually-provided meaning, and threatens to foreclose a more basic, but no less potent, bodily and emotional response to the material itself (c.f. Greenblatt's view of what museums have lost in evolving from temples of wonder to temples of resonance, 1991).

Of course, however museums choose to present objects and object-information packages, it is inherent in the very nature of the museal process that the material things museums display are almost always distanced from the viewer in ways that do not replicate human relationships with things in the real world outside (though different forms of interpretation, especially artistic interventions, can problematise this – e.g. Nakashima Degarrod and Dorsett, this volume). The issue of *selection* is also key to what museums do – even a lump of moon rock can be turned 'into an object and a museum piece' by the crucial idea … of selection' (Pearce 1994a: 10). In addition, museums are ocularcentric, a way of seeing in their own right (c.f. Alpers 1991, Crimp 1993), an extreme version of the broader dominance of the visual in the world – especially the modern Western world (c.f. Levin 1993, Crary 2000). It has not always been so, as a number of scholars have pointed out (see especially Classen 2005, Classen and Howes 2006). Museums as 'odd and inaccessible places … that neither partake in life, nor in which life partakes' (Zimmer and Jeffries 2007: 3) are products of Western modernity that postdate earlier *Wunderkammern* and cabinets of curiosities that enabled a sense of wonder

through a full, active, sensory engagement with objects. Nonetheless, and initiatives to enable, for example, handling of museum objects notwithstanding (c.f. Pye 2007, Chatterjee 2008), the processes and impacts of today's display practices are overwhelmingly ocularcentric. Museum displays are an element of visual culture, and by default the museum is, for the visiting public, primarily a visual, rather than a material, technology. Indeed, this visual emphasis can be extended into the idea of museums as spectacle, peddling 'illusion and the suspension of disbelief' (Parry 2007: 76).

Museums' privileging of the visual does not allow the viewer to replicate their real-life, synchronous and direct use of several senses in engagements with the physical world of which they are a part (though cf. Rees Leahy, this volume). Looking at an object in a gallery, one is, for example, usually prevented from also touching, smelling, hearing or tasting it (though of course there may also be social prohibitions against such actions in other spheres of life, too – I would not, for example, lick an oil painting hanging in a friend's house any more than I would one in a gallery). Our ability to form an impression of the item's material characteristics beyond gross form, size, colour, reflectiveness and so on, is significantly compromised in the museum. It would only be by holding the bronze sculpture in my hands, maybe raising it to touch my cheek, and perhaps hearing the sound of my fingernails against the metal, that I could fully appreciate its coldness, heaviness, density, musicality and smoothness of surface. Equally, it would only be by holding a hand-woven textile, turning it around, feeling the extra thickness of the supplementary weft patterning in a different fibre, that I could properly experience not only the tangible remains of the performative act by which a decorative technique was materialized, but also the warmth it would lend to the wearer.[1] Yet I can do none of these things in the exhibition space: I cannot feel the undulations and grooves of hand-adzed wood, or the smoothness of the cowrie shells sewn in regular lines onto a piece of cloth and the way they make the whole object ripple rhythmically as you move it. My contacts with conventionally displayed objects are devoid of the familiarity with which others may have engaged with those things in the past. The dominant visual paradigm, in other words, brings about increased distance and reduced intimacy (Zimmer and Jeffries 2007: 5).[2]

I can, though, imagine some of these things. That is, I may add other sensory elements to the visual even if they have to be imagined, intuited or remembered. An object's properties, such as its colour and its texture, are internally related, cannot ultimately be separated, and together make the object what it is, just as intersecting stimuli and responses across the sensory range together make my experience what it is (c.f. Deleuze and Guattari 1988; Merleau-Ponty 1992, Tilley 2004, Paterson 2007). Equally related and ultimately inseparable, are the senses that each observer's body utilizes in experiencing the object (for an experimental psychologist's overview of scientific research into the integration of sensory modalities, see Spence 2007; see also Saunderson et al., this volume). In the museum, I might involuntarily add some sensory dimensions further to the visual, automatically suffusing my sight experience of an oil painting with an intuited and probably subconscious sense of the roughness of its visually evident three-dimensional surface, for example.[3] I might also use imagination and indeed empathy (cf. Prown 1994: 136; Edwards, Witcomb, Hancock, Nakshima Degarrod, Wehner and Sear, this volume) deliberately, in order actively and consciously to increase my sensory engagement with both the object and, in the case of a painting or photograph perhaps, the scene it may depict (I may too imagine 'ghosts' of people associated with objects – e.g. Hancock, Nakashima Degarrod and Dorsett, this volume). But, prevented from using those other sensory modalities directly, I might also get things 'wrong' – as Celia Fiennes noted in 1702, recording her surprise that a cane in the Ashmolean collections which looked heavy, was actually so much lighter than expected when,

as was permitted in those days, she picked it up (1949: 33, quoted in Classen and Howes 2006: 201).

The nature of the museum does not contradict the phenomenologically-informed notion that 'we work from within the world, not upon it' (Ingold 2000: 68, see also Heidegger 1962; c.f. Bourdieu's notion of 'body hexis', 1977), although it does restrict us more than does the world outside. We encounter ourselves, our environment, and the other people and things that move within and constitute part of that environment, through our bodies, whether in the museum or not. Our senses, spatial locations and movements determine how we experience and interpret the world of which we are a part, and in turn those spatial aspects and our senses themselves are culturally constituted: rather than simply biologically determined givens, they fluctuate not just within our individual mental realms but also across time, places and cultures (e.g. Howes 2005). This notion of contingent, embodied, sensory experience involves conceiving of human cognition, consciousness and feeling as 'extended, distributed, enactive and mediated' within the material world – including that of museums – rather than simply 'within the skull' (Malafouris and Renfrew 2008: 382, 384). The role of our senses in experiencing and interpreting the world is an important aspect of the wider role played by our bodies. Too often we forget that we live *in* the world and too often we interpret that world – whether subconsciously in the course of our individual everyday lives, or whether deliberately as part of interpretive endeavour in museums, heritage sites, journalism, academia or wherever – not as we should, from *within* it, but as if we were outside it, disembodied, looking on.

Really engaging with objects in museums is on one level clearly not a rare occurrence at all: curators engage with the material object at the moment of acquisition, during documentation and beyond; geologists and other natural scientists, for example, intently study the material characteristics of the things before them and seek to comprehend each tiny datum embodied in the objects' very physicality. However, they tend not to do so in an in-depth, critical way that focuses explicitly on the material object and how an embodied subject – such as a museum visitor – might engage sensorially with it. Furthermore, engagement with the physical, material aspects of the object is most often neither obvious nor widely sensorially accessible in museum displays. In visual display, for example, where touch is impossible, something vital is lost: '[w]hile the visual provides only distant access to textured surfaces, such as woven structures, the haptic defines the affective charge – the felt dimensionality of the spatial content' (Zimmer and Jeffries 2007: 5; see also Diaconu 2006). To permit rich engagement with objects in museums in a material and properly embodied way, rather than as a purely visual exercise, would, as Candlin points out, necessitate 'a paradigm shift' via which museum staff would recognize 'that sight is not the sole route to aesthetic experience and knowledge' (2007: 103). It would entail questioning how a predominantly visual paradigm can enable us fully to experience the objects' physical characteristics. How can it enable us really to imagine and empathize with the makers and previous owners of the objects, 'the feelings of those who originally held the objects, cherished them, collected them, possessed them?' (Greenblatt 1991: 45). How far do conventional approaches to the public display of objects optimize our imagination, beyond the visually apparent, of material and sensory qualities? To what extent do such approaches enable our own, performative engagements with real, three-dimensional things and encourage subsequent empathetic responses to other people's habitual interactions with those objects in the past? How many of the physical traces, indeed scars, of those past interactions are evident to the contemporary viewer (for an exploration of this in relation to trying to display past acts of performance art, see Scarborough, this volume; for an artistic interpretation of the traces of

past interactions with visually represented objects [in this case, shrines] rather than the objects themselves, see Nakashima Degarrod)?

Although museums remain essentially visual modes of experience, many institutions have explored wider sensory approaches to their objects, of course. Education departments' use of handling collections has long demonstrated the value of physically interacting with 'the real thing', as have more recent initiatives such as the Victoria and Albert Museum's *Touch Me* exhibition (2005).[4] Museums have also used touch in reminiscence and therapeutic work (e.g. Arigho 2008, Jacques 2007, Noble and Chatterjee 2008, O'Sullivan 2008, Phillips 2008). New, digital, touch technologies that permit the user to 'feel' a distant or fragile object are being explored too, for example at the Fisher Gallery at the University of Southern California (McLaughlin *et al.* 2002, cited in Zimmer and Jeffries 2007; see also Geary 2007, Onol 2008, Prytherch and Jefsioutine 2007). All such projects acknowledge the value of sensory modalities beyond the visual alone, particularly that of touch – a physical engagement that

> provides the satisfaction of a corporeal encounter. By touching a collected object the hand of a visitor also encounters the traces of the hand of the object's creator and former owners. One seems to feel what others have felt and bodies seem to be lined to bodies through the medium of the materiality of the object they have shared.
>
> (Classen and Howes 2006: 202)

Nonetheless, museums remain essentially visual, don't-touch places. Their journey into modernity to become and remain so, necessitated that museum visitors accept several related ideas, including 'that they were less important than the exhibits on display and thus must behave deferentially towards them … that to touch museum pieces was disrespectful, dirty and damaging … and that touch had no cognitive or aesthetic uses and thus was of no value in the museum' (Classen 2005: 282). In part, of course, the establishment of such a paradigm is related to, and certainly justified by, the importance of conservation. Touch is particularly damaging, and even for those professionally permitted to handle objects is often not supposed to happen without the material barrier of gloves. Conservators themselves have been described as 'the ultimate border guards … uniquely possessed of the right to change the material states of objects through touching, cleaning, dismembering, fumigating, freezing, and other activities' (Edwards *et al.* 2006b: 20). This contemporary emphasis on preserving the object is, as Classen and Howes observe, 'the expression of a changing ideological and sensory model according to which preserving artifacts for future view is more important than physically interacting with them in the present' (2006: 216: cf. Classen 2005). In contrast, Ouzman argues, could we not foreground the fact that material objects are perpetually 'in states of transformation, some of which may be called "decay"', in order to enable greater understandings of those objects and their cultural and temporal specificities (2006: 270)?

None of this, of course, renders the visual unimportant; neither does it substantiate touch as the only other sensory modality of significance. It does, however, emphasize that the visual needs to be thought of in intimate relationship to the other senses, and vice versa (Taussig 1993: 26). In reality, all the senses are intertwined, and all objects are experienced multisensorially (as Edwards demonstrates in this volume). The challenge for museums, as for philosophy and psychology, 'is not to replace the visual by the tactile, but to explore the complexity of the senses in aesthetic experience' (Fisher 1997: 11, cited in Paterson 2007: 86), and to reflect upon how the world touches us, not just vice versa (c.f. Berenson 1909, Paterson 2007). This means accepting too that while almost all objects presented without information are mute in terms of their earlier

contexts and context-dependent meanings, we the observer can still have a response to their sensible attributes. Indeed, some objects may still 'say' much to us even when we are utterly ignorant of their original cultural, historical or other contexts – even when we have no idea what the thing actually *is*; in such a situation, the relationship between us and the object is silent only in respect of one (admittedly very important) set of potential meanings and values of the object, not necessarily all of them. Our responses are subjective, dependent on all sorts of things ranging from the object's setting when we experience it to our own background, knowledge and culturally and historically constructed ways of seeing and of integrating imagined other sensory qualities with the visual.

Subject–object distinctions

Integrating the visual with other sensory modalities and acknowledging the subjectivity of experience, is potentially still limited as a new approach – at least, it is if it assumes a fundamental duality or distinction between person and object and emphasizes the influence of human subjectivity disproportionately to the effects of object's physical characteristics. From a more phenomenological perspective, the interesting part is the process of perception lying *between* oneself and the object; it bridges object and person, causing them, at the moment of perception and interpretation of the object, to exist only in relation to each other. In this view, it matters not that you experience the same object differently from someone else – both of you are still having an embodied, sensorially engaged experience of the object that, certainly, is partly determined by your own characteristics, but is equally dependent upon the object itself: your response would not be what it was if the object were not what it is. Subjectivity of response, and material qualities, are intertwined with each other, and *both* (together of course with the framework within which you see the object) determine the experience and interpretation of objects. To take the example of historical artefacts, Prown defines them as 'the only class of historical events that occurred in the past but survive into the present', arguing that as materialized events they permit past events to 'be re-experienced' (1993: 2–3). But is/was the artefact really the 'event'? Or is the event now the object-subject engagement, the moment in which the physical thing and its sensory attributes are experienced by the perceiving person? What matters, in other words, is the way in which things instigate or trigger a particular set of perceptions and response in the human subject – a repeated set of events perpetually open to change, including once something has become a museum object. At the same time, it is not the person's subjective experience and response alone that matters, either. The specific, objective attributes of a particular object also play a part. As a result, neither object nor subject has the last or only word; rather, it is in their mutual intersection that sensory responses and subsequent ideas are generated (c.f. John Dewey's notions of transactional experience, in which the object is as much a part of the experience as the subject [1937]). It is, in other words, in the space in between object and subject, the space in which they meet, that the two impact upon – indeed form – each other, in what Ting (this volume) describes as the object–human manifold.

Undoing Cartesian mental/material distinctions, and re-emphasizing the mutual embeddedness of sensory modalities, sensible material qualities and the personal influences individual perceiving subjects bring to bear, has the potential to inform museum practice in creative ways (e.g. Golding, Dorsett, Wehner and Sear, Watson, this volume). Seeing the things that matter as whole subject-object engagements, rather than thinking of objects as simply materialized human action or natural form rendered meaningless without the ample provision of textual explanation, constitutes not just a theoretical position but a real opportunity. New

approaches to museum interpretation may exist in simultaneously rejecting the modernist view that it is only the human imposition of meaning onto objects that renders them meaningful in the first place, and accepting that while objects are not meaningful in themselves it is through their involvement in the material world and their interactions with each other, that both objects and persons influence and give meaning to each other (Gell 1998, Gosden 2005).

This book is not intended as a manifesto for the fetishistic setting apart of objects: the social reality of objects, their inextricability from human social life, their *engagement* (cf. Taylor, this volume), is well established across a range of academic and museum disciplines. However, the sociability of material things is still largely discussed without much attention being paid to the details of their physical realities, in museum contexts or elsewhere. To see objects not as background scenery to the drama of human life but as actors within it, bridging the realms of the physical, the social and the mental, has been an important part of the recent turn towards the material (c.f. Miller 1987). Can we now reconsider those realms – even if only for heuristic purposes – as not being separate at all, or argue that the engagements which matter happen not in objects, nor in minds nor social relationships but, physically as well as emotionally and cognitively, in the spaces in between all three?[5] This is not to contradict arguments that have been advanced over the past twenty years: it would difficult to deny that objects can bring about particular social effects (Gell 1998) or that they have biographies and, in a sense, social lives of their own (Appadurai 1986; Gosden and Marshall 1999). Indeed, many of the chapters in this book incorporate and are informed by such perspectives. But to focus within this on the material and the sensual aspects of objects in social life, and on their emotional and physical, as well as social, effects is simply to attempt to return some deserved attention to the object and human engagement with it – something which all chapters in this book, in different ways, do.

This book thus seeks to contribute significantly to a turn to the material within the specific context of the museum or gallery. The book is bounded by a foreword (Pearce) and afterword (Morphy) by long-standing scholars in the fields of museum material culture studies and anthropological material culture studies. Its central part is then divided into three parts – *Objects*, *Engagements* and *Interpretations* – with the aim of breaking down their more conventional elision (although in practice, of course, almost all chapters address some elements of two or three of these ultimately intersecting areas). The first part of the book, *Objects*, includes chapters which discuss a particular category of objects and their qualities (Edwards on photographs), specific objects in two different museums (Witcomb and Wingfield), materiality and immateriality in art practice and audience participation (Pheby), and a scientific examination of the visual perception of art objects (Saunderson *et al.*). The book's second part, *Engagements*, is concerned with characteristics and implications of engagements with objects by people in and through museums and galleries. Chapters cover such topics as the artistic and subsequent manipulation of materiality (Stevenson), memory and emotion (Hancock), visitors' aesthetic responses to images of beauty and violence (Nakashima Degarrod), constructing museum exhibitions so as to enable visitors to analogize between displayed and personal objects and experience (Wehner and Sear), encounter and enthrallment in the art museum (Rees Leahy) and affect and authenticity in the perception of art (Taylor). The final part of the book, *Interpretations*, addresses the implications of object qualities and of sensory and emotional engagements with them for various interpretive strategies in museum and gallery spaces. It covers attempts to enhance the multi-sensory – indeed, sensuous – experience of objects' formal qualities (Ting), uses of sound, light, photographs and the exploitation of sensory experience in representing history (Watson), working with senses and emotions in educational programming with disadvantaged school groups (Golding), artistic intervention as interpretation (Dorsett) and issues of authenticity, movement and absence in

trying to exhibit performance art – or, at least, its traces (Scarborough). Overall, the questions raised in this volume about the nature of the object itself and our experiences of it in public institutions of display, are basic and fundamental in thinking about objects in museums and galleries – yet together they constitute far from an established or orthodox approach.

Acknowledgements

The book builds upon 'The sensory experience of materiality in the museum', a panel convened by the editor at the Royal Anthropological Institute's 2007 'Beyond Text' conference at the University of Manchester. Contributors to this volume include participants in that panel and additional invited authors. I am grateful to them, and to students and colleagues at the University of Leicester, for discussions which have stimulated the development of this volume. I am also appreciative of the useful comments made by Routledge's reviewers of this book at its proposal stage and, more personally, thankful to all those family, friends and colleagues who have supported me so well.

Notes

1 Interestingly, Marinetti, in his 1921 *Manifesto of Tactilism*, also used the example of woven textiles (cited in Zimmer and Jeffries 2007: 5). Riegl was another thinker in this area who was particularly immersed in textile objects. Current research by Zimmer and Jeffries (2007) also focuses on textiles.

2 Distance of a physical and emotional kind, and the detached and critical contemplation it facilitates, is of course a fundamental aspect of the traditional Western mode of viewing art. It is, however, a model which tends to disallow the impact of bodily and emotional engagement – something which van de Vall interestingly reflects back upon in the light of the aesthetic experience of new media art and other contemporary visual artworks (2008).

3 Cf. Durand's development (1995) of Riegl's notion of the 'optical-haptic' (1893), discussed by Edwards and Hart (2004: 9) as an example of how 'when we look at photographs we often move from pure opticality to the optical-tactile as our attention moves from a thing being represented to an awareness of the texture of that thing (for example, the grain of skin or the weave of foliage), until a point is reached where we identify this with the very texture of the photograph itself'.

4 http://www.vam.ac.uk/vastatic/microsites/1376_touch_me/ (accessed 2 March 2009).

5 Of course one important further area for consideration, in relation to the engagements between people and objects, is the very space, including the architecture of the building, within which they happen. This is an area well set up in Macleod 2005, and considered in relation to architecture more generally by authors such as Pallasmaa (2005).

References

Alpers, S. (1991) 'The museum as a way of seeing', in I. Karp and S. Lavine (eds) *Exhibiting Cultures: the poetics and politics of museum display*, Washington, DC: Smithsonian Institution Press, pp. 25–32.

Ames, M. (1992) *Cannibal Tours and Glass Boxes: the anthropology of museums*, Vancouver: University of British Columbia Press.

Appadurai, A. (ed.) (1986) *The Social Life of Things: commodities in cultural perspective*. Cambridge: Cambridge University Press.

Arigho, B. (2008) 'Getting a handle on the past: the use of objects in reminiscence work', in H. Chatterjee (ed.) *Touch in Museums: policy and practice in object handling*, Oxford: Berg, pp. 205–12.

Baker, J. (2008) 'Ghosts of freedom: Ellis Island's living legacy', *Common Ground*, Winter: 16–27.

Bennett, T. (1995) *The Birth of the Museum: history, theory, politics.* London: Routledge.

Berenson, B. (1909) *The Florentine Painters of the Renaissance*, London: G. P. Putnam's Sons.

Bourdieu, P. (1977) *Outline of a Theory of Practice*, trans. R. Nice, Cambridge: Cambridge University Press.

Candlin, F. (2007) '"Don't touch! Hands off!" Art, blindness and the conservation of expertise', in E. Pye (ed.), *The Power of Touch: handling objects in museum and heritage contexts*, Walnut Creek, CA: Left Coast Press, pp. 89–106.

Cannon-Brookes, P. (1984) 'The nature of museum collections', in J. M. A. Thompson, D. A. Bassett, D. G. Davies, A. J. Duggan, D. G. Lewis and D. R. Prince (eds) *Manual of Curatorship: a guide to museum practice*, London: Butterworth, pp. 500–12.

Chatterjee, H. (ed.) (2008) *Touch in Museums: policy and practice in object handling*, Oxford: Berg.

Classen, C. (2005) 'Touch in the museum', in C. Classen (ed.) *The Book of Touch*. Oxford: Berg, pp. 275–86.

Classen, C. and D. Howes (2006) 'The museum as sensescape: Western sensibilities and indigenous artifacts', in E. Edwards, C. Gosden and R. Phillips (eds) *Sensible Objects: colonialism, museums and material culture*, Oxford: Berg, pp. 199–222.

Clifford, J. (1997) *Routes: travel and translation in the late twentieth century*, Cambridge, MA: Harvard University Press.

Crary, J. (2000) *Suspensions of Perception: attention, spectacle and modern culture*, Cambridge, MA: MIT Press.

Crimp, D. (1993) *On the Museum's Ruins*, Cambridge, MA: MIT Press.

Csordas, T. J. (ed.) (1994) *Embodiment and Experience,* Cambridge: Cambridge University Press.

De Bolla, P. (2005) *Art Matters.* Cambridge, MA: Harvard University Press.

Deleuze, G. and F. Guattari (1988) *A Thousand Plateaux: capitalism and schizophrenia*, trans. B. Massumi, London: Athlone.

Dewey, J. (1937) *Art as Experience.* New York: Capricorn Books.

Diaconu, M. (2006) 'Reflections on an aesthetics of touch, smell and taste', *Contemporary Aesthetics*, no page nos. online, <http://www.contempaesthetics.org/newvolume/pages/article.php?articleID=385> (accessed 11 March 2009).

Durand, R. (1995) 'How to see (photographically)', in P. Petro (ed.) *Fugitive Images: from photography to video*, Madison, WI: University of Wisconsin Press, pp. 141–51.

Eastop, D. (2006) 'Outside in: making sense of the deliberate concealment of garments within buildings', *Textile* 4 (3): 238–55.

Edwards, E. and J. Hart (2004) 'Introduction: photographs as objects', in E. Edwards and J. Hart (eds) *Photographs, Objects, Histories: on the materiality of images*, London: Routledge, pp. 1–15.

Edwards, E., C. Gosden and R. Phillips (eds) (2006a) *Sensible Objects: colonialism, museums and material culture*, Oxford: Berg.

Edwards, E., C. Gosden and R. Phillips (eds) (2006b) 'Introduction', in E. Edwards, C. Gosden and R. Phillips (eds) *Sensible Objects: colonialism, museums and material culture*, Oxford: Berg, pp. 1–31.

Feldman, J. D. (2006) 'Contact points: museums and the lost body problem', in E. Edwards, C. Gosden and R. Phillips (eds) *Sensible Objects: colonialism, museums and material culture*, Oxford: Berg, pp 245–68.

Fiennes, C. (1949) *The Journeys of Celia Fiennes*, London: Cresset Press.

Fisher, J. (1997) 'Relational sense: towards a haptic aesthetics', *Parachute* 87 (1): 4–11.

Gathercole, P. (1989) 'The fetishism of artefacts', in S. M. Pearce (ed.) *Museum Studies in Material Culture*, London: Leicester University Press, pp. 73–82.

Geary, A. (2007) 'Exploring virtual touch in the creative arts and conservation', in E. Pye (ed.), *The Power of Touch: handling objects in museum and heritage contexts*, Walnut Creek, CA: Left Coast Press, pp. 241–52.

Gell, A. (1998) *Art and Agency: an anthropological theory*, Oxford: Oxford University Press.

Gibbs, A. (2002) 'Disaffected', *Journal of Media and Cultural Studies*, 16 (3): 335–41.

Gosden, C. (2005) 'What do objects want?', *Journal of Archaeological Method and Theory* 12: 193–211.

Gosden, C. and Marshall, Y. (1999) 'The cultural biography of objects', *World Archaeology*, 31 (2): 169–78.

Graves-Brown, P. (2000) 'Introduction', in P. Graves-Brown (ed.) *Matter, Materiality and Modern Culture*, London: Routledge, pp. 1–9.

Greenblatt, S. (1991) 'Resonance and wonder', in I. Karp and S. Lavine (eds) *Exhibiting Cultures: the poetics and politics of museum display*, Washington, DC: Smithsonian Institution Press, pp. 42–56.

Gurian, E. (2005) *Civilizing the Museum*, London: Routledge.

Heidegger, M. (1962) *Being and Time*. New York: Harper & Row.

Hein, H. (2006) 'Assuming responsibility: lessons from aesthetics', in H. H. Genoways (ed.) *Museum Philosophy for the Twenty-first Century*, Oxford: AltaMira Press, pp. 1–9.

Hooper-Greenhill, E. (2007) *Museums and Education: purpose, pedagogy, perfomance*, London: Routledge.

Howes, D. (ed.) (1991) *The Varieties of Sensual Experience: a sourcebook in the anthropology of the senses*, Toronto: University of Toronto Press.

Howes, D. (2003) *Sensual Relations: engaging the senses in culture and social theory*, Ann Arbor, MI: University of Michigan Press.

Howes, D. (ed.) (2005) *Empire of the Senses: the sensual culture reader*, Oxford: Berg.

Ingold, T. (2000) *The Perception of the Environment: essays on livelihood, dwelling and skill*, London: Routledge.

Jackson, M. (ed.) (1996) *Things as They Are: new directions in phenomenological anthropology*, Bloomington, IN: Indiana University Press.

Jacques, C. (2007) 'Easing the transition: using museum objects with elderly people', in E. Pye (ed.) *The Power of Touch: handling objects in museum and heritage contexts*, Walnut Creek, CA: Left Coast Press, pp. 153–61.

Kavanagh, G. (1989) 'Objects as evidence, or not?', in S. M. Pearce (ed.) *Museum Studies in Material Culture*, London: Leicester University Press, pp. 125–37.

Knell, S. J. (2007) 'Museums, reality and the material world', in S. J. Knell (ed.) *Museums in the Material World*, London: Routledge, pp. 1–28.

Levin, D. M. (1993) *Modernity and the Hegemony of Vision*, Berkeley, CA: University of California Press.

McLaughlin, M., J. Hespenha and G. Sukhatme (2002) *A Haptic Exhibition of Daguerreotype Cases for USC's Fisher Gallery: touch in virtual environments*, Englewood Cliffs, NJ: Prentice-Hall.

MacLeod, S. (ed.) (2005) *Reshaping Museum Space: architecture, design, exhibitions*, London: Routledge.

Malafouris, L. (2008) 'Beads for a plastic mind: the 'Blind Man's Stick' (BMS) hypothesis and the active nature of material culture', *Cambridge Archaeological Journal* 18 (3): 401–14.

Malafouris, L. and C. Renfrew (2008) 'Steps to a "neuroarchaeology" of mind, part 1: introduction', *Cambridge Archaeological Journal* 18 (3): 381–5.

Marinetti, F. T. (1921) *The Manifesto of Tactilism*, unpublished manifesto read at the Theatre de l'Oeuvre, Paris.

Merleau-Ponty, M. (1992) *The Phenomenology of Perception*, trans. C. Smith, London: Routledge.

Miller, D. (1987) *Material Culture and Mass Consumption*, Oxford: Blackwell.

Miller, D. (ed.) (1998) *Material Cultures: why some things matter*, London: University College London & University of Chicago Press.

Morphy, H. (1994) 'For the motion (1)' in J. Weiner (ed.) *Aesthetics is a Cross-Cultural Category*, Manchester: Groups for Debates in Anthropological Theory, pp. 255–260.

Moshenska, G. (2009) 'Resonant materiality and violent remembering: archaeology, memory and bombing', *International Journal of Heritage Studies*, 15 (1): 44–56.

Noble, G. and H. Chatterjee (2008) 'Enrichment programmes in hospitals: using museum loan boxes in University College London Hospital', in H. Chatterjee (ed.) *Touch in Museums: policy and practice in object handling*, Oxford: Berg: pp. 215–23.

O'Neill, M. (2006) 'Essentialism, adaptation and justice: towards a new epistemology of museums', *Museum Management and Curatorship*, 21: 95–116.

Onol, I. (2008) 'Tactual explorations: a tactile interpretation of a museum exhibition through tactile art works and augmented reality', in H. Chatterjee (ed.) *Touch in Museums: policy and practice in object handling*, Oxford: Berg: pp. 91–106.

O'Sullivan, J. (2008) 'See, touch and enjoy: Newham University Hospital's nostalgia room', in H. Chatterjee (ed.) *Touch in Museums: policy and practice in object handling*, Oxford: Berg: pp. 224–30.

Ouzman, S. (2006) 'The beauty of letting go: fragmentary museums and archaeologies of archive', in E. Edwards, C. Gosden and R. Phillips (eds) *Sensible Objects: colonialism, museums and material culture*, Oxford: Berg, pp. 269–301.

Pallasmaa, J. (2005) *The Eyes of the Skin: architecture and the senses*, London: John Wiley & Sons.

Parry, R. (2007) *Recoding the Museum: digital heritage and the technologies of change*. London: Routledge.

Paterson, M. (2007) *The Senses of Touch: haptics, affects and technologies*, Oxford: Berg.

Pearce, S. M. (1994a) 'Museum objects', in S. M. Pearce (ed.) *Interpreting Objects and Collections*, London: Routledge, pp. 9–11.

Pearce, S. M. (1994b) 'Objects as meaning; or narrating the past', in S. M. Pearce (ed.) *Interpreting Objects and Collections*, London: Routledge, pp. 19–29.

Phillips, L. (2008) 'Reminiscence: recent work at the British Museum', in H. Chatterjee (ed.) *Touch in Museums: policy and practice in object handling*, Oxford: Berg: pp. 199–204.

Pietz, W. (1985) 'The problem of the fetish I', *Res* 9: 5–17.

Prown, J. D. (1993) 'The truth of material culture', in S. Lubar and W. D. Kingery (eds) *History from Things: essays from material culture*, Washington, DC: Smithsonian Institution Press, pp. 1–19.

Prown, J. D. (1994) 'Mind in matter: an introduction to material culture theory and method', in S. M. Pearce (ed.), *Interpreting Objects and Collections*, London: Routledge, pp. 133–8.

Prytherch, D. and M. Jefsioutine (2007) 'Touching ghosts: haptic technologies in museums', in E. Pye (ed.) *The Power of Touch: handling objects in museum and heritage contexts*, Walnut Creek, CA: Left Coast Press, pp. 223–40.

Pye, E. (ed.) (2007) *The Power of Touch: handling objects in museum and heritage contexts*, Walnut Creek, CA: Left Coast Press.

Riegl, A. (1893) *Grundlegungen zu einer Geschichte der Ornamentik* (*Foundations for a History of Ornament*), Berlin: G. Siemens.

Sandell, R. (ed.) (2002) *Museums, Society, Inequality*, London: Routledge.

Spence, C. (2007) 'Making sense of touch: a multisensory approach to the perception of objects', in E. Pye (ed.) *The Power of Touch: handling objects in museum and heritage contexts*, Walnut Creek, CA: Left Coast Press, pp. 45–61.

Spyer, P. (2006) 'The body, materiality and the senses: introduction', in C. Tilley, W. Keane, S. Kuchler, M. Rowlands and P. Spyer (eds) *Handbook of Material Culture*, London: Sage, pp. 126–30.

Strathern, M. (1988) *The Gender of the Gift*, Berkeley, CA: University of California Press.

Strathern, M. (1999) *Property, Substance and Effect: anthropological essays on persons and thing*s, London: Athlone Press.

Straw, W. (1999) 'The thingishness of things', keynote address for the Interrogating Subcultures conference, University of Rochester, March 27, 1998, *In-Visible Culture: an electronic journal for visual studies,* issue 2, online <http://www.rochester.edu/in_visible_culture/issue2/straw.htm> (accessed 2 February 2009).

Stoller, P. (1989) *The Taste of Ethnographic Things: the senses in anthropology*, Philadelphia, PA: University of Pennsylvania Press.

Taussig, M. (1993) *Mimesis and Alterity: a particular history of the senses*, New York: Routledge.

Tilley, C. (2004) *The Materiality of Stone: explorations in landscape phenomenology*, Oxford: Berg.

Tomkins, S. S. (1962–1992) *Affect, Imagery, Consciousness,* 4 volumes, New York: Springer.

van de Vall, R. (2008) *At the Edges of Vision: a phenomenological aesthetics of contemporary spectatorship*, Farnham: Ashgate.

Vogel, S. (1991) 'Always true to the object, in our fashion', in I. Karp and S. Lavine (eds) *Exhibiting Cultures: the poetics and politics of museum display*, Washington, DC: Smithsonian Institution Press, pp. 191–204.

Willumson, G. (2004) 'Making meaning: displaced materiality in the library and the art museum', in E. Edwards and J. Hart (eds) *Photographs, Objects, Histories: on the materiality of images*, London: Routledge, pp. 62–80.

Zimmer, R. and J. Jeffries (2007) 'Accessing material art through technologies of mediation and immediation', *Journal of Futures,* online <www.elsevier.com/locate/futures,> doi: 10.1016/j.futures.2007.05.007.ff

Part 1

OBJECTS

Sandra H. Dudley

The first part of this book explores museum and art gallery objects and object qualities, and their impacts on perception, experience and emotional response. It pays attention to memory, emotion and the sensory apprehension of objects, and problematizes notions of materiality. Three of the five chapters focus on specific objects or particular object types (Edwards on photographs, Witcomb on a model of Treblinka, and Wingfield on the Sultanganj Buddha in Birmingham Museum and Art Gallery). The fourth (Pheby) addresses issues surrounding the materiality – or not – of artists' media, and the final chapter (Saunderson *et al.*) gives a view of the sensory perception of art from the perspective of the cognitive sciences (specifically, experimental psychology).

Edwards' chapter extends insights into both the emotive and affective power of objects, and, relatedly, the performative nature of our sensorially informed engagements with them. Indeed, what she describes as the 'performative material culture' of photographs, through which they may be embraced, spoken to, cried over and so on, can, as surely we have all witnessed, apply to so many other material parts of our world, too. How many of us have not cherished, perhaps stroked and held close, something belonging to a lost loved one or, more prosaically, cursed the washing machine or some other item when it refused to operate properly? These active engagements with things not only perform and come to represent other aspects of our lives through physical items and what we do with them; they also, as Edwards' photographs exemplify, blur the dividing line between subjects and objects, ourselves and things. Edwards thus problematizes notions of materiality and of museum objects and collections as representations of the past, in the process examining the place of emotion and the senses in experiencing material things. Drawing on work in sensory, visual and material anthropology, and studies of emotion, memory, photography, orality and history, she explores the tensions, expectations and potential of an embodied and sensory engagement with photographs (including the digital) within, around and through the museum.

Witcomb's chapter continues the focus on memory and affect developed in the previous chapter, turning particularly to the role of the material world in processing and communicating the experience of human suffering. Witcomb's interests in the affective power of objects centre on a miniature model of the Treblinka concentration camp, made by a survivor of the camp and now exhibited at the Jewish Holocaust Museum and Research Centre in Melbourne, Australia. Witcomb examines why she found her own encounter with this object to be so poignant and intense. Why was it that out of so many objects in the museum – many of which are items from the 'lost world' of pre-Holocaust European Jewry – it was this model rather than any other artefact that aroused for Witcomb an inkling of the pain and complexity of feelings survivors of the Holocaust must have felt and continue to feel? Witcomb argues powerfully that the model of

Treblinka is not a historical trace, but an actual memory materialized, given life. Contextual and personal elements combine with the model's material form to give it the potential to generate a transformative museum experience. Sensorial immediacy of the object is important too – as was movingly demonstrated by the maker's reaction to the museum's decision to encase it in glass.

Wingfield also attempts to uncover why a particular object has the apparent power that it does. He deals with the Sultanganj Buddha, a 2m high copper figure from India's Gupta age (fourth to seventh century AD) in Birmingham Museum and Art Gallery, and frames his exploration with the Weberian concept of charisma. Interestingly, he applies this notion to an object (rather than, as is more conventional, a person), and links it with the object's cultural contexts, social history and mythologies, as well as its material and formal qualities. In recent years, the Sultanganj Buddha statue has formed the focus for an annual regional gathering at the museum for the Buddhist festival of Vesakh, when local Buddhists have offered chants and worship before it. Examining why people feel an urge to stop and look at, indeed touch, this Buddha figure, Wingfield places in historical context and utilizes not only the notion of charisma, but also Pattison's idea of 'illicit' relations with objects (2007) – an idea which helps us to accept that people often simply do not know why they do such things as reaching out to put their fingers on a museum artefact on display.

Pheby's chapter continues questions about objects and materiality, specifically in relation to the changing approaches of artists toward the materials they employ in their creative practice. Focusing particularly on contemporary art, she explores artists' inventive manipulations of materials and of the role of viewers/visitors. After a historical overview of artists and their materials, she moves into a discussion of projects in which Yorkshire Sculpture Park – where she is deputy curator – has been involved with the artist James Turrell. A consideration of works such as Turrell's 'Deer Shelter', allows an examination of the extents to which not only tangible but also intangible materials – such as sound, weather, memory, time and, here, especially light – can be considered to be the fabric through which an artist communicates with the sensorily perceiving gallery visitor.

In the last chapter in this part of the book, Saunderson *et al.* describe some experimental research into the visual perception of objects – specifically, artworks. This remains a surprisingly under-researched area, as they outline. Their chapter draws on the apparently disparate disciplines of psychology and fine art in order to present a scientific examination of potential differences between viewing an original artwork and a replica. This examination involved a laboratory experiment in which subjects' with varying expertise in art had their eye movements recorded as they viewed originals – with a real three-dimensionality on the paint surface – and digitally produced, paper and on-screen reproductions. The chapter argues that while an object's material qualities – such as paint on canvas versus ink on glossy photographic paper – appear experimentally to have a relatively small influence upon how people look at art, there may still be differences at a cognitive level. Anecdotal evidence, for example, suggests a variation in thinking processes for originals and replicas. The chapter also raises some raises interesting questions about authenticity – questions which, together with the other themes in this part of the book, such as materiality, sensory experience, memory and emotion or affect, as we shall see arise again in later sections of the volume.

2

PHOTOGRAPHS AND HISTORY

Emotion and materiality

Elizabeth Edwards

Introduction

> We smile as we remember the old family groups, some of them stiff and inappropriate, some of them a bit faded and dim with the years, but close to every smile there lurks a tear, for 'the touch of a vanished hand and the sound of a voice that is still comes vividly to memory'.
>
> (Jessie Robinson Bisbee, 1917, quoted in Langford 2001: 5)

What do photographs 'feel' like? Despite over three decades of critical theory around the nature of the photograph and similar movement in critical museology, there has been surprisingly little overlap between the two to challenge the status and function of photographs in museums. For despite the theoretical demolition of the photograph's reality effect, this position has largely failed to register in museum consciousness, never mind practices, where photographs continue to be seen as unproblematic documents, direct fragments of past time, records of what was. Yet photographs constitute one of the most emotionally intense classes of museum objects: they are not imprinted representation in abstract, but imprinted objects that are both representational and material. They are 'made, used, kept, stored for specific reasons which do not necessarily coincide … they can be transported, relocated, dispersed, damaged, torn, cropped … because viewing implies one or several physical interactions' (Porto 2001: 38). That is, they are multi-sensory objects which in turn must elicited multi-sensory responses that shape and enhance the emotional engagement with the visual trace of the past. My purpose in this chapter therefore is to consider the implications of a multi-sensory and emotionally negotiated photographic meaning for museums.

Such a position constitutes, in museum terms, a radical reconceptualization of photographs, moving them beyond the idea of the visual document to a space where their significance is not necessarily in the forensic, and in which sensory modes beyond the visual are integral to the constitution of photographic meaning and usage – for as the quote above suggests, photographs function within a multi-sensory domain – the touch, sound and the feeling of tears as Jessie Robinson Bisbee 'looked and listened with her heart'. The potential of such a position is complicated further because it also occurs at a moment of challenge to the materiality of the

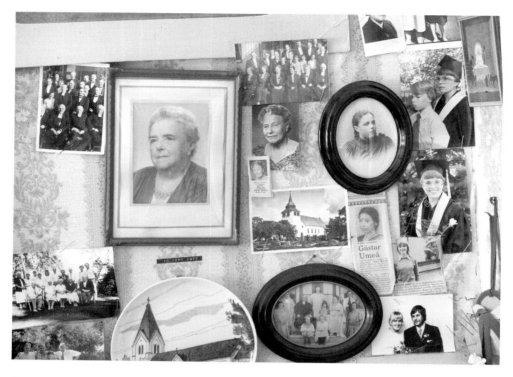

Figure 2.1 Photograph by Kajsa Hartig, 2008

historical object in the digital environment (Sassoon 2004). Indeed, ironically, the moment of material recognition is also the moment of profound material reconstitution of images, as material and sensory registers of the photograph and the historical work expected of them, are dispersed and atomized in a digital age. This raises questions about where 'the archive' is located and about its relationship with institutions.

Positionings

Encircling photographs in museums are massive questions concerning the nature of memory, history and cognition – all of which have attracted a voluminous literature (for instance Cubbitt 1998, Radstone 2000, Hutton 1993; Le Goff 1992; Connerton 1989 and references therein) and the potential of emotion as a modality of history (Harkin 2003). Whilst one can only mark their saturating presence here, within this broader discourse many studies of photography have engaged with the power of photographs as memory texts, as foci for oral practices, as negotiations of identity and excavations of power relations. While the ground was perhaps laid in the 1960s by Pierre Bourdieu's analysis of bourgeois photographic practices (1965), and Giselle Freund's study of photography and society (1980 [1974]), much of this work has been developed either in relation to trauma, notably Holocaust memory (see for instance Hirsch 1997; Baer 2002), and in relation to the shaping of memory through family photography and the family album (for instance Kuhn 1995, Spence and Holland 1991, and Langford 2001) as further analysis emerged in the field of gender studies and sociology of familial power relations.

For instance, Kuhn's *Family Secrets* (1995) explores the entanglements of public and private histories, memory practice, structures of feeling and questions of identity class and gender across a wide range of cultural productions including film and photography. Conversely the attraction of 'old photographs' has been seen as integral to the discourse of heritage and nostalgia (e.g. Green-Lewis 2000, Samuel 1994: 359–61). However powerful, these arguments are nonetheless grounded in the analysis of the image itself and the indexical functions of the trace, and they have largely failed to engage with the material existence of photographs, and the power of their materiality, as both carriers of signs and instigators of affect.

Recent work in material culture studies and phenomenological anthropology, which addresses the experiential and embodied condition of 'being-in-the-world' (Csordas 1994; Jackson 1998), and in anthropology of the senses (Howes 1991, 2003), has put a new inflection on these diverse debates and suggested the question 'to what extent can we understand photographs as being "beyond the visual"?' (for instance, Edwards 2006, 2008; Wright 2004; Rose 2004). Indeed, the promise of material culture studies lies precisely in the concern with the ways in which 'things' are actually used by people, and thus how sensory apprehension is impacted by, and impacts upon, objects (Myers 2001: 5). A gathering analytical interest in socio-material visual practices has shifted the analytical focus of photographs from questions of signification and the analytical translation of meaning into semiotic and linguistic models of apprehension, to questions of effect, affect and agency as powerful and active players in a 'practical mediating role […] in the social processes' (Gell 1998: 6).[1] In this, there is a broader recognition at the heart of both material culture studies and museum studies, that 'human interpretations of reality are not to be understood in terms of textual and linguistic structures only,' such as those that have dominated analytical approaches to photographs, 'but also as mediated by artefacts' (Domanska 2006: 341).

Consequently, another key strand here is recent work on the photographic object as material culture. This has stressed the social dynamics of photographs in specific cultural environments, as photographic objects are handled, caressed, stroked, kissed, torn, wept over, lamented over, talked to, talked about and sung to, in ways that blur the distinction between person, index, and thing.[2] Furthermore, the performative material culture of photographs stresses their physical presence in the social world. They are written on, exchanged, displayed, and performed in a multitude of ways in that they are placed in albums, wallets, frames or lockets, stuck on walls, hidden in shoes, or buried in biscuit tins away from the eyes of the secret police. Clearly, of course, it is the image itself that motivates these actions and embodied responses, but, just as Barthes (1984: 6) has argued there is an inseparable 'lamination' of signifier and signified, so materiality and image are likewise inseparable.

Materiality is central to this because, I shall argue, it is the fusion and performative interaction of image and materiality, such as the actions I have just noted, that gives a sensory and embodied access to photographs. In this photographs become memory texts, trigger emotion, elicit feeling, create affect, not merely through visual apprehension of content but through their material and sensory qualities as objects. The sensory frames, gives access to and heightens the affective – holding and stroking a photograph is more powerful a gesture than just looking. Photographs are 'history objects' in that they demarcate and reserve a sense of the past and collective memory (Hoskins 1998: 2); they are made precisely to project a present becoming past into the future. They anticipate memory; they are objects through which 'memory becomes sensible and visible through imaginative recollection and representation' (Crane 2000: 1); they are objects which are made to engage the emotional, whether love (family photographs), anger (some acts of photo-journalism perhaps) or hate (some propaganda) for instance.[3]

The precise nature of that emotion – is it biological or cultural? – is beyond the scope of this paper; indeed philosophers, cognitive scientists, neuro-physiologists and psychologists for instance have grappled with such questions for centuries (see Reddy 2001 and Leavitt 1996 for summaries).[4] For my purposes, I am using 'emotion', or the more internalized 'feeling', to mean an intense, individual and subjective embodied, sensory experience related to a state of mind, in relation to contexts, determined through practices of non-verbal communication of which the sensory, here sound, touch and gesture around photographs, is formative. Feeling, as used here, also carries an intentional quality expressed through the act of making and indeed looking at photographs:[5]

> [I]t is a feeling of "something", the lovable, the hateful [for instance]. But it is a very strange intentionality which on the one hand designates qualities felt *on* things, *on* persons, *on* the world, and on the other hand manifests and reveals the way in which the self in inwardly affected.
>
> (Tuan 1977: 9)

In feeling 'an intention and an affection coincide in the same experience' (ibid.). I would argue that photographs are the result of such an intention toward the world, of feeling, love, the desire for future remembrance, the desire to be something (perhaps something one is not), experience compounded of feeling and force. In this meaning is made in both the body and the mind, thinking and feeling, as the very experience of feeling is linked to meaning – it is neither 'pure sensation or … pure cultural cognition' (Leavitt 1996: 515).

Further, Miller has argued that thinking about 'how things matter' as opposed to signify, brings things into relations with practices and experience, rather than, as 'signifying' implies, a distanced analytical category which intellectualizes responses to objects. The question 'why do things matter?' is therefore a way of allowing a space for the subjective. 'Mattering' has, he argues 'a more diffused, almost sentimental, association that is more likely to lead us to the concerns of those being studied than those doing the studying' (Miller 1998: 3, 11). This might be linked, as Pinney has done, with Jean Lyotard's 'figure' which 'invokes a field of active intensity', a 'zone where "intensities are felt"' (Pinney 2005: 266). Here, 'materiality' is a form of 'figural excess' which cannot be encompassed within linguistic and semiotic practices alone. Such approaches place photographs in subjectivities and emotional registers which cannot be reduced to the visual apprehension of an image, for as will have become clear, the stories told with and around photographs, the image held in the hand, features delineated through the touch of the finger, an object passed around, a digital image printed and put in a frame and carefully laced, dusted and cared for, are the registers in which photographic meanings are negotiated.

Visual documents or bundled objects?

Central to the power of photographs is the indexical trace of the real – the mechanically assured relationship between the photographer and its referent or subject matter. It is the visual trace of the appearance of a past moment in its apparent entirety that is privileged both in the social expectation of photographs and museum rhetorics of the image (Porter 1988, Edwards 2001: 184–8).[6] As I have suggested, the assumption that photographs are merely *visual documents* constitutes a discursive regime in which 'in order to see what the photograph is *"of"* we must first suppress our consciousness of what the photograph *"is"* in material terms' (Batchen 1997: 2) and elides photographs' potential as a broader yet powerfully constituted 'affective system' (Leavitt

1996: 532). Recent work in anthropology and visual culture has pointed to the problems with thinking merely in terms of 'the visual'. Mitchell has argued that there no 'visual media' as such, rather that 'all media are, from the standpoint of sensory modality, "mixed media"' (2005: 257). Instead, he presents images as 'braided', in that 'one sensory channel or semiotic function is woven together with another more or less seamlessly' (2005: 262). Likewise, Bal had pointed out the absurdity of an essentialized or pure form of 'the visual':

> The act of looking is profoundly 'impure'…this impure quality is also …applicable to other sense-based activities: listening, reading, tasting, smelling. This impurity makes such activities mutually permeable, so that listening and reading can also have visuality to them.
>
> (Bal 2003: 9)

A similar position has been argued in relation to material culture by anthropologist Webb Keene, who describes the 'bundling' of sensory and material effects in which an object is defined through the co-presence of the visual with other qualities – such as texture, weight or size (2005: 188). In these models, one sensation is often integrally related to, and followed by, another to form continuous patterns of experience, representing a dense social embedding of an object.

The shift towards a more embodied and affective way of thinking about photographs is also part of a broader response to concern about the analytical domination of strategies which translate images into linguistic or semiotic modes as discursive tropes, rather than thinking about what photographs actually do at the intersection of the social, the material and the iconographic. In this, postmodern approaches to the social construction of the photograph and its instrumentality seems 'inadequate to cope with the personal and deeply felt meanings' resulting in a tendency to collapse into microscopical forensic analysis (cloths worn, street furniture etc) on the one hand and an abstract metaphorical and ideological reading on the other (Merriman 1996: 384). This is not to say that such approaches are invalid, but they cannot claim to offer a penetrating understanding of photographs as social objects. It is precisely from a concern to reinstitute the analytical significance and weight of performative embodiment within the everyday usage of images, in 'understanding photographs', that Pinney has developed the term 'corpothetics' as 'the sensory embrace of images, the bodily engagement that most people … have with artworks' (2001: 158). It indicates not a lack in images but a rich and complex praxis through which people articulate their eyes and their bodies in relation to pictures (2001: 161–2).

This becomes patently clear when one considers the social practices around everyday photographs, for the apprehension of the photographic inscription may start with the visual but cannot be contained or explained by it. Gell (1998) drew analytical attention to the performative dimension of artefacts and it is precisely in this way that photographs might be said to have agency in that their inscriptions elicit responses through indexical power of the image engaged with sensorially and affectively. Photographs connect to life as experienced, to 'images, feelings, sentiments, desires and meanings' but they also have the potential for 'a process of enactment and rhetorical assertion' and as 'nodes where various discourses temporarily intersect in particular ways' (Hoskins 1998: 6).

For as I have suggested, acts of looking at photographs are also acts of touching, speaking and listening through which photographs trigger narratives in ways which would not have happened had they not existed. Perhaps the most powerful sensory form is the entanglement with sound, the human voice. Photographs are spoken about and spoken to – the emotional impact articulated through forms of vocalization. We could say that the oral penetrates all levels of historical relations with photographs to the extent that spoken and seen cease to be separate

modalities – indeed Kracauer sees the oral as necessary to making to photograph historically sufficient (1995a: 48). However, the oral is not simply the verbalizing of content – 'this is how the street looked when I was a child' – 'I remember that dress, my aunt gave it to me'. Rather, photographs both focus and extend verbalization as they have dynamic and shifting stories woven around and through them, imprinting themselves and being played back repeatedly through different tellings. Nor should we understand the oral only in terms of the spoken word, but also, in the excavation of 'affect', the paralinguistic sound of emotion – of sighing, weeping and laughing – and of tone of voice in shaping narratives with and around photographs. Photographs, sound and voice are thus integral to the performance of one another, connecting, extending and integrating the social function of images. The affective qualities of photographs connect people to people.[7]

Photographs are also looked at in silent contemplation or explained through banalities, precisely because they are beyond words.[8] Rose has explored the apprehension of family photographs and the way in which emotion places them beyond words in terms of Barthes' notion of *punctum*, a visceral and highly subjective response which fractures the social surface (the *studium* or descriptive content of an image and its social forms) (1984: 40–5). In this the ordinariness of the image as photograph – the baby having a bath for instance – is interrupted by a visceral response to the emotional weight of the photograph: 'the thinness of these explanations is not an indication of these women's banality, but the difficulty of articulating the pull of something excessive to codes of culture' (Rose 2004: 560). Rather meaning was in the tone of voice, the weight of the word 'so' in 'he was just so beautiful', 'she was so tiny'. Here photographs are understood through feeling – 'a punctual spectating at the limits of meaning' (ibid.) – in which the visual, the oral and the emotional cluster around the photograph which can only be registered beyond the visual through hearing.

Touch is equally significant, for such comments are often accompanied by haptic gestures which embrace the photographic object. Touch is in many ways the most intimate of the senses, and as Barthes (1973: 90) argues, it is 'demystifying', for it registers the body to the outside world. This not only pertains to the way in which Barthes (1984: 80–81) talks about the touch of the indexical as 'a sort of umbilical cord [that] links the body of the photographed thing to my gaze' (1984: 80–81) but a haptic performance of this as the finger is run over the image. Touch gives solidity to the impressions of the other senses: it again connects people to things and people to people. It is arguably the act of touching the photograph that accentuates a sense of the presence of the subject, confirming vision, as touch and sight come together to define the real (Ong 1982: 168–69, see also Rose 2004). Photographs are held, caressed, stroked, and kissed. In family photographs, for instance, perhaps touch transfigures the indexical into the real for a moment, as fingers trace the image of the referent, a sensory accumulation which materializes historical or memorializing consciousness: 'the index finger always signals an access to reality [or an imagined reality] even when it targets a mere piece of paper' (Latour 1999: 65).

Seremetakis terms such social actions and processes as 'commensality', which she defines as 'the exchange of sensory memories and emotions and of substances and objects incarnating remembrance and feeling.' In this type of exchange, she continues, 'history, knowledge, feeling and the senses become embedded in the material culture and its components: specific artefacts, places and performances' (Seremetakis 1993: 14). As photographs become active sensory interfaces between referent and viewer, there is a perpetual movement between touching to see and seeing to touch, to the extent that touch enables seeing, in this way bringing about a blurring of the iconic, indexical, and material aspects of the photograph.

The philosopher and theorist Siegfried Kracauer argued famously that both history and photography were forms of alienation, of distancing and disembodiment (1995b: 5). However, a sensory approach suggests precisely the reverse as a merging of indexical, iconographical, material and sensory elements reconnects people, history and image. Photographs and the haptic are integral to the performance of one another, connecting, extending and integrating the social function of images.

Inside the museum

I have outlined the ways in which photographs might be understood as multi-sensory and phenomenologically-engaged objects articulating historical and social relations through emotional modalities. Museums, however, have been slow to engage with this radically enhanced hermeneutic potential of photographs. It is not only that while photographs are amongst the most collected of everyday objects in museums, their status in studies of collecting in museum environments is marginalized or entirely overlooked;[9] it is also, more importantly, the lack of critical engagement with what photographs can 'do' and with the nature and location of that potential force.

Too often museums have been content to rest with the seductive appearances and forensic promise of photographs, as if this is all that photographs can do. Assumed to function didactically and unproblematically, photographs set the 'economy of truth' for a museum (Porter 1988) whatever their ideological and political nuances. They promise to present 'real things, real places and real people' part of a 'triple notion of the power of the real' (Moore 1997: 135) as photographs provide 'context' for other classes of objects (Porter 1988). In this photographs are stripped of the meaning that made them function as multi-sensory objects within social relationships. This assumption of the 'window on the world' informs a wide range of museum activities from display to oral history projects in which photographs are used to elicit information. However, even in this latter, admirable as such work is as a piece of salvage ethnography, emphasis remains on inscriptions, the forensics of the photograph and the sonic tracking, taping, of the voice in informational terms to 'augmenting archival holdings and to generate particularly uses documentary material' (Hamilton 2002: 215). The emotional and sensory qualities, which hold image and voice together as inseparable modalities, do not form part of this, even if their traces are present, because oral and visual are conceptualized as separate documenting forms. This is of course part of an extensively critiqued 'museum effect' (Alpers 1991); it is not unique to photographs. However, is perhaps more marked with photographs, because of the intensity of their reality effect as offering unmediated conduits to the past, yet remaining subservient to a rhetoric framed by deep-seated cultural assumptions in relation to expectations of the medium. These are used to reinforce certain kinds of knowledge, hierarchies of objects, and arrangements of information, premised on the indexicality and authenticating rhetorics of photographs.

It is not that questions of 'feeling' and 'affect' in museums are not recognized in museums; to the contrary. The problem of the 'museum effect' is now a given in museums, with the recognition that museums are a 'cold medium … asking for the active participation of the beholder's imagination' (Ernst 2000: 31). Thus there is enormous concern about sensory experiences and 'affect', especially in relation to museums as memory practice, and to museums' ability to create 'affect' in terms of visitor experience 'where people can be transported from the present to an earlier time through sight, smell [and] perception of their own bodies' in relation to objects (Sepúlveda dos Santos 2003: 37; see also Crane 2000; Kavanagh 2000). Indeed, the

more senses are engaged the more effective a piece of historical engagement is deemed to be (Moore 1997: 144). This approach has been developed in sophisticated ways in memorializing museums, such as Holocaust museums or the Museum of Genocidal Crimes, Tuol Sleng, Cambodia, which use the affective impact of the massing of photographs of victims to perform, both literally and metaphorically, the scale of atrocities. It also applies in 'sensory displays' such as London's Imperial War Museum's Blitz Experience and Trench Experience which promise an experiential encounter with sounds and smells,[10] and in the affective 'wonder factor' of the blockbuster exhibition such as the British Museum's massively successful 'Terracotta Warriors' (2007–8).

But despite the extensive use of photographs within these rhetorics, as I have suggested, almost no attention has been given to what and how photographs constitute that 'feeling' beyond the assumption that they 'show what it was like' in visual terms or that they might serve to establish an unspecified pastness. Yet what is significant is the way in which photographs slide from an articulated economy of truth – visual statements of 'this is how it was' into an unarticulated emotional economy integral to the production of the affective or 'feeling-tone' of the museum created through multiple performances of the embodied and sensory affects of photographs. How many of us can look at a photograph, particularly an original, carrying the marks of time and its own historicity, of a class of English schoolboys taken in 1910 or of Jewish shopkeepers in Poland in 1925 without a unarticulatable, visceral sense of what is to come?

Moore asks how 'real people' can be experienced within the museum (1997: 142). Photographs mark experiences, encapsulate social being, from the banal and mundane to the traumatic and cataclysmic – they mark experiences that someone actually lived through (Baer 2002: 8) and 'felt' in embodied and multi-sensory ways. As I have argued, this is more than a mere apprehension of content – 'this is what our street looked like', 'this is where X lived', 'that's what us factory workers wore'. As was discussed earlier, the photographs form subjective punctual incisions beyond words where apparent banalities mask more complex historical and memorializing processes, the feeling which constitute the fuller meaning of the photograph – Jessie Robinson Bisbee's smiles and tears in feeling the 'vanished hand and the sound of a voice'. Barthes argued, in his last poetic statement on photography, that photographs were the object of three practices which were also three emotions, those of the operator, spectator and viewer (Barthes 1984: 9). Multi-sensory approaches to photographs are part of attempts to reach that experience, to connect the viewer with that experience. By positioning photographs as braided or bundled objects, visual, oral and tactile in emotionally engaged ways of doing history, not merely as sources, one can accommodate 'both human agency and structured reality' (Hamilton 2002: 216). Of course, such retrieval is seldom literal in the museum, it is in the imagination, an interconnection, a reaching out to the acknowledgement of that experience even if it remains in the imagination; but it does put into question the premise on which photographs are assumed to function within the museum.

These considerations are pertinent for museums not merely because photographs in collections can become the focus of an affective rather than merely a forensic history, but because museums constitute part of the morally and emotionally shaped social and ideological landscape through which photographs are experienced, for even if emotion is privately experienced it is socially located (Svašek 2005: 8). Of course, it is not necessarily possible or even desirable for museums to reproduce these registers around photographs – some of them are intensely private and personal. But they can point the way, and in this open up the space for historical imagination and the complex networks of relationships and association which constitute social life and the making of historical narratives, one can go perhaps a little way to bridging the gap.

A number of museums have begun to address materiality and thus the sensory potential of photographs within the museum.[11] For instance 'Picturing Paradise' (Pitt Rivers Museum, Oxford 1994) looked at the circulation, materiality and multiple performances of photographic objects in the construction of a Euro-American concept of 'Samoa' in the late nineteenth and early twentieth centuries; in this it stressed not the singularity of photographic objects but their multiplicity (Edwards 2001: 196–7). 'Collected Sights' (Cambridge University Museum of Archaeology and Anthropology 2001) took a similar 'social biography' approach to the making and collecting of photographs in anthropology (Boast, Guha and Herle 2001). Perhaps the most emotionally engaged, because it dealt with the materiality of photographs and memorialization, was 'Forget Me Not' (National Media Museum, Bradford 2005),[12] which included a wide range of material performances from over-painted photographs to frames including wedding orange blossom and plaited hair (Batchen 2004). In all these exhibitions the materiality of the historical image was paramount, opening the space for thinking about the sensory engagements with a wide range of photographic forms from daguerreotypes to tourist souvenirs. All the exhibitions, in their different ways, engaged with the possibility of photographs as affective objects active in social relations.

Although I shall return to digital environments from a different perspective at the end of this chapter, it is worth noting here that values of materiality and the affective are also being increasingly attended to in on-line access to museum photograph collections, as they engage analytically with the historicity of the photographic object and thus the affective 'feeling-tones' of history. For instance, the website of the California Museum of Photography presents carefully digitized images and the palimpsest of captions and comments on their reverse which gives a sense of their material historicity.[13] The Tibet Album developed by the Pitt Rivers Museum, University of Oxford, to articulate the complex material and forensic histories in a body of some 6000 photographs taken by the British in Tibet, uses the concept of the album as its cohering historical device, and actually includes a facility for users to develop their own exchangeable albums in a digital space with all the visual qualities of the material album.[14] In gallery spaces there is increasing use of software such as Page Turner, which not only give access to more images, but also a sense of the historicity of the object; for instance, 'How We Are', an exhibition on photography and British identity at Tate Britain (2007), showed the emigration album of the Ragged School Union (c.1870) with the digital, touch screen copy below, in a way which enabled multi-sensory apprehension of the object.[15]

However, because of the nature of museums and because of the nature of photographs there are probably limits to what can be achieved within the museum. Perhaps, following Ernst, we could say that photographs too often are 'cold museum objects' whose true meaning can only emerge through a sensory and emotional imagination, despite the seductive surfaces of the document. Barthes effectively describes the conundrum of the 'museum effect' and emotion when he explains why he does not show to his readers the photograph of his mother as a child in the Winter Garden which had so moved him:

> I cannot reproduce the Winter Garden photograph. It exists only for me. For you, it would be nothing but an indifferent picture, one of a thousand manifestations of the 'ordinary'; it cannot in any way constitute the visible object of science; it cannot establish objectivity, in the positive sense of the term; at most it would interest your *studium*: period, clothes, photogeny; but in it, for you, no wound.
>
> (Barthes 1984: 73)

It is perhaps in this, the collapse into *studium* (content), that we recognize the impossibility of museums delivering the radically reconceptualized photograph – as sensory and emotional object, not a window of the past – that renders photographs resistant to the museum process. It is the challenge for museums to translate a sense of the way in which surface description, an engagement with the content 'this is where X lived' 'here is Y's dog', became meaningful through oral articulating, the finger run over the photograph, perhaps gently stroking it. For as I have argued, it is here that photographs literally make sense, through embodied, sensory and emotional registers of, for instance, amusement, sadness, happiness, or longing.

In this connection it is finally worth noting that the intense subjectivity demanded for understanding such photographs is perhaps why some of the more successful projects in affective terms have been framed as art works – for instance, Jannane Al Ani's family history piece *Untitled 1 &2* ['I Once Knew a Man'] (1996),[16] or community histories such as the still and video oral portrait installation on Britain's first Yemeni community *The Last of the Dictionary Men* by Tina Grahavi and Youssef Nabil (Baltic Exchange, Newcastle upon Tyne 2008). Both these works used photographic images, oral histories and the affective sound of the human voice to articulate affective histories in gallery spaces, yet remained profoundly 'photographic' in their values. To communicate such values is the challenge for museums.

Outside the museum

I want to look finally at the radical shifts in the sensory and emotional landscapes of historical photographs in the dematerializations and rematerializations of digital environments. Robins has asked 'will the image still move us in the digital age?' (1995: 48). I shall argue that historical photographs remain sensorially and emotionally potent in cyberspace, indeed expansively so, in ways which return the museum, perhaps, to be simply a custodian of documents whose power lies elsewhere.

This will be, of necessity, a brief incursion into a sprawling and wide ranging territory which, in relation to photographs and history would merit whole book in its own right. Not only is there a voluminous literature on museums, access and the translation of museum objects into digital environments, but a mass of widely dispersed uses of photographs which include local history projects, such as the Totnes Image Bank and Rural Archive, Devon or the Island History Project in London,[17] family historians and genealogy enthusiasts,[18] and image-sharing websites covering a multitude of interests. What characterizes all is that the desire for photographs assumes an almost visceral quality in which the visual forms merely an historical catalyst. Museums, and the accessibility of photographs in museum collections, are an integral part of this flow of images within the emotional landscapes of historical engagement. Digital access heralds potentially profound shifts in the institutional biography of photographs brought about through pressures and demands generated at the intersection material recognition, digital technologies and increasing social expectations of the work that photographs do.

It has been argued (Sassoon 2004) that the dematerialization necessarily intrinsic to the digital archive, undermines precisely the kind of materiality and sensory engagement I have been discussing in relation to photograph collections. At one level this is so. Failure to engage with the material nature of photographs can be seen, in a material argument, both to constitute a serious misrepresentation of the photograph and severely limit the potential of photographs as an historical resource. Perhaps we are indeed seeing a final 'delamination', to return to Barthes' metaphor, between photographic image and its materiality. But I am not convinced that this is so, at least not in any terminal sense. Maybe, caught in the dichotomy of 'real

and virtual' (see Parry 2007: 61–2), we are confusing and conflating different performances, different appropriatenesses, different sets of question and different needs. For digitization can enliven photographs, moving them into new spaces – but spaces where the material continues to resonate despite the appearances of dematerialization. Reproducibility has always been a key characteristic of photograph and indeed one which shaped the social desires and expectations of the medium, as it carries their information through various transmutations of material form. While material forms through which photographs are experienced are changing as an increasing amount of photographic historical activity occurs through the internet and exchange flows of digital images, technology alone does not necessarily determine shifts of meaning in images, for arguably photographs maintain an integrity of their own as images which can be spread across multiple forms. It was ever thus since the beginning of the medium.

What it does do is shift the everyday *experience* of images (Henning 1995: 228, see also van Dijck 2008) that is reconnecting photographs to the sensory, and thus to the emotional, through the touch of images, printed out in different formats, performed through different material configurations, including that of the computer screen. Arguably there is a paradox in that it is through digital formats flowing through internet social networking sites, including social and community networks that photographs become most affectively powerful. Even a cursory glance through historical exchange groups on Flickr photographic exchange and streaming website,[19] and other such sites, will reveal that much of the commentary and response to historical photographs is not on the forensic alone, although there is plenty of posting about identifying military uniforms, trams or railway engines, but on how the photographs make people *feel,* even people apparently unconnected to the image; it is one of affect, for instance 'Thanks for saving this photo. Someone will want it and cherish the fact you saved it',[20] while others talk of beauty, being moved, desire, sadness or the joy of recognition.

Further, it is clear that people are making affective and sensorially informed decisions about the translation of the digital world, in a flow between the conventionally material, the dematerialized and the rematerialized through a dispersed archival and museological practice. For instance, as Rose has noted in her study of the social and emotional practices of young mothers in relation to the family digital archive, enormous attention is given the processes and formats, of print size, frame and album, of the rematerialization of images in social space (Rose 2004). The affective choices made around the material performance of the photograph remain, regardless of the technology, analogue or digital, that produced that image.

The signifying properties of material forms are used extensively in digital environments, not only in the use of the language of analogue photography, but through the digital reproduction or simulation of the material practices of placing in albums, vignetting and toning to restore the affective tones of the historical object. Indeed it is interesting how material qualities, such as sepia toning, *carte de visite* cards and the surface of the daguerreotype not only become irreducible markers of the past but are intended to produce affects as photographs are made to work in specific emotional environments, standing for different sensory and embodied desires around photographs. Significantly it is these material forms of sepia, a sense of fading (but not too much so as not to obscure the legibility of the photograph), 'Victorian' frame and album forms which are reproduced and simulated on family history and 'scrapbooking' softwares, merging forensic and sensory desires: the warm-brown and gold tones of a sepia photograph also feel more alive to some viewers, it 'evokes a sense of nostalgia'[21] that is to set up certain materialities associated with the 'feeling-tones' of the past.

However, there are significant differences in the values given to material attributes. Whereas museums may see marks and creases on the image as integral to its social biography

– for instance the creases and thumb marks on a photograph of a young woman, perhaps endlessly handled, folded and refolded, or the palimpsest of captions, marking, crop marks on a photograph's reverse which track usage – outside the museum the valued material qualities are those that suggest a sense of age and pastness in an almost Rieglian 'age-value' which, in its mass-appeal, 'manifests itself ...through visual perception and appeals directly to our emotions' (Riegl 1999 [1903]: 33), but which do not interfere with visual clarity. Indeed, a number of softwares available to family historians allow users to 'restore their old damaged and faded photographs' in ways that constitute both a return to the original experience of the image and, importantly, an emotional restitution related to individual identities of the users (van Dijck 2008: 67).[22]

Importantly, while these new technologies may bring about changes in the immediate material reality through which photographs are experienced and determine forms of attention and precise modes of perception (Henning 1995: 229),using such facilities involves their own sensory and embodied practices: the proxemics of viewing in groups around a screen, the finger on the keyboard, the sweeping movement of the mouse, the flicker of the screen or the stroking movements of the touch screen – almost stroking the photograph into life (see Cubbitt 1998) or even touching or kissing the screen itself: for instance, a mother in her late thirties told me how she had a photograph of her young son as her computer desktop. She would touch it and kiss it goodnight, especially when away from home (personal communication, August 2007).

These may appear different from the material experiences of analogue photographs I described earlier, but they are ultimately remarkably similar – expressed through registers of sound, touch and gesture – and are constituted by the same social relations and the same desires for material forms to perform in certain ways. Photographs will continue to be important because 'the technological revolution not withstanding ... they mediate so effectively, and often movingly, between inner and outer realities' (Robins 1995: 50).[23] Thus we can argue that there is a corposthetic experience of the digital image, and such practices relocate photographs in expanded spaces where they can actually produce meaning over the full range of their braided and bundled potential.

A final question remains about where archival meaning located. As has been argued, the concept of the archive is loosening and exploding 'within the apparently limitless opportunities for both the collection of new sorts of archived material and the opening of access to traditional archival sources' (Bradley 1999: 117). What these practices mean is a dispersal and atomization of archival power and archival 'location' – is it in the museum? in the computer? or in the head and the heart? Is it about document or affect? This is not merely a question of physical location, although this is becoming increasingly blurred as both institutions and community projects are choosing to photostream their images on the web through facilities such as Flickr, a facility shared by such disparate groups as the Smithsonian Institution, in their Smithsonian Photography Initiative, and North Ormesby Community History Group in Teesside.[24] It also heralds shifts in the affective historical work demanded of photographs within atomized, individualized, sensorially and emotionally engaged concepts of the past, where the document qualities of photographs remain only part of the way in which images make meaning.

In historical terms, there are perhaps ontological and conceptual links between the nature of the photographic document, the expansion of that fragment through subjective engagement and the atomization of broader historical narratives into complex and subjective relations between grand narratives and personal narratives of the past. It is through emotional and multi-sensory connection with for instance, a photograph of a relative in World War I uniform, held in the hand, that the Great War is understood. In this, photographs move understandings away from

the event-led towards the mundane, yet because of the way in which photographs still time and create fragment, they figure the banal as 'significant', both in sense of impact and the creation of meaning. This position suggests not only an atomization of the concept of 'archive' as its management and meaning are decentralized across multiple sites, but the precise nature of the 'histories' imagined through such relationships, the role of photographs in individualization of investment in history and an intensification of experience which fuses photography with the daily experience of communication in a digital age (van Dijck 2008: 62). It is here, perhaps outside institutions, that photographs 'matter': 'Photos are material evidence of connectedness to what is now "past". The more photos connect, the more they are valued. Photos are stories about connections through time, affirming the existence and significance of the past in the present' (Macdonald 2003: 236).

Pierre Nora's well-known argument that the emergence of modernity and the nation state saw a shift from memory to 'history', and from the head and the heart to the archive (1989: 13), does not necessarily explain photographic archives or collections in digital environments. As we have seen, they retain the potential for an emotional register, that is, their meaning can still be 'in the heart'. This is not only simply because of the photograph's infinite recodability, but that the fragmentation of the archive and the explosion of potential meanings across the sensory and emotional range cannot be contained within the archive. Their different materials and dynamically redistributed locations of meaning simultaneously place them both in the archive and in the heart. Perhaps this is why photographs remain resistant museum objects because ultimately their archival significance is not on the surface of the print but elsewhere. Of course museums can respond by facilitating such engagement, by showing local and community exhibitions, but ultimately the sensory and emotional significance of 'the archive' is dispersed through different spaces inside and outside the museum as technology empowers people outside the traditional structures of institutional and curatorial systems. This constitutes an 'exponential flow of signs and images unleashed by the culture of an information society and the electronic archive' (Bradley 1999: 117–18) as knowledge and the making of history 'break out of [their] contained space and …become distributed in communicative networks and information flows' (Lynch 1999: 80). Museums are part of this. Maybe the museum's role now is precisely to explore the materiality of the photograph and to reassert the sensory values of the original object as it was experienced by its original users, as a contribution to the wider recognition of the emotional force of photographs for present users.

Conclusion

Photographs are caught in a continual tension between visual document and emotional conduit. If photographs constitute sets of objects, meanings and social relationships, it is essential that fuller ways are found to understand their apprehension and reflect this in museum practice. I have argued that if, as Miller has suggested more generally, we move our sense of photographs from signifying alone to mattering we can position photographs not as documents which tell us what people wore or what a street looked like but objects at 'the heart of a radiating web of associations, reflections and interpretations' (Kuhn 1995: 4). This places photographs in subjectivities and emotional registers that cannot be reproduced the visual apprehension of the image. What emerges from the material and sensory character of photographs is not merely a greater appreciation and complication of the historical object but the opening up of the possibility of a primary register of meaning in a photograph, that of emotional engagement as it is framed, concretized and heightened through touch, sound, gesture and embodied relations.

The strands that I have outlined should not be thought of in terms of oppositions, of original and copy, analogue or digital, of inside or outside the museum, but a fluid set of overlapping and ambiguous imaging practices, sensory and embodied emotional registers through which people engage with the past in different ways. Yet within this, perhaps we are looking at different layers of sensory engagement, defined not through those dichotomies but through a divergent, non-linear, social biography spread over divergent multiple material originals and multiple, dispersed and atomized performances. These divergent layers constitute multiple concepts of the location of the archive and historical affect, and the potential of material forms to reveal historical experience as photographs are talked about, talked with, touched, exchanged in ways that transcend the visual – 'a productive diversity… in a world of possibilities' (Robins 1995: 48).

Perhaps the problems that museums face are in the conflation of these diverse performances, as photographs present the digitally augmented challenge of their time-honoured act of infinite recodability as they shift meaning across time, space and material performance. Perhaps in this photographs become many 'things'. But likewise, perhaps describe is all photographs can in fact do in a museum: that the project to engage with the potential of photographs in the performance of an affective history is impossible, hence the site of the photograph's resistance. I cannot pretend to be certain of this. But does it mean we should not be curatorially sensitive to the multiple sensory relevances of photographs?[25] Maybe it strengthens the argument for museums to attend to the material forms of their historical photographs because that is what they do best – attend to 'things' – but be cognisant of the different series of sensory experience and affects in the shifting biography of photographic images, all of which have the potential for engaging the historical past. In this they should be equally mindful of the likelihood that perhaps a majority of engagements will be outside their walls and outside their control as their images become absorbed into other narratives and into other groups of photographs. Maybe ultimately we need to think of photograph collections in museums not as a series of documents but a series of sensory and emotional enablers in which the indexical and the forensic on the surface of the object are also merely the surfaces of possible meaning.

Acknowledgements

I am grateful to Clare Harris, Chris Morton, Laura Peers and Annabella Pollen whose various and wide-ranging conversations about museums, the everyday practices of photography, history, recollection and feeling helped my thinking in this and resonate through this paper.

Notes

1 Gell's arguments about objects, agency and social production resonate through my argument here.
2 For work on photographs and materiality, see Edwards (1999), Edwards and Hart (2004), Pinney (2004), Wright (2004), Batchen (2004).
3 It is significant that in many of the exhibitions where there has been protest about the content of the exhibition, the focus of anger (emotion) has been on photographs (see Edwards 2001: 189–90). Scientific photographs are structured specifically to suppress the subjective and emotional (see Daston and Galison 2007: 161–83, Tucker 2005).
4 There is also a massive literature on the emotions in psychology, anthropology and social studies. Positions have largely followed either a universalist approach which assumes emotional responses are common to all humans, or a social constructivist argument which breaks down into two strands: social concept and social role and their complications. See for instance, Reddy (2001), Lutz and White (1986), Griffiths (1997), Milton and Svašek (2005). Leavitt (1996) has argued ways around this dichotomy through the concepts of affective resonances and 'feeling-tones'.

5 Although of course subsequent readings might diverge from that intention as the photographs move across time and space. But readings still carry intention.

6 I should note here that throughout I am discussing 'non-art' photographs, such as those in social history or ethnographic collections, although art photographs, and indeed scientific photographs, have their own material tones and discourses.

7 For a more extended consideration of the relational qualities of orality, sound and photographic meaning see Edwards (2006, 2008). For a more formalist approach, drawing on the work of Walter Ong, but one none the less engaged with the oral nature of photographs, see Langford 2001.

8 In silent contemplation photographs might of course be entangled within inner speech 'which links disconnected and incomplete yet saturated predicate language to images' (Burgin 1986: 57, following Vygotsky).

9 Almost every museum has photographs of some sort even if they deny it. Many photograph collections have emerged from ephemeral accruals around object collections rather than through any systematic process of active collection. The uneven, and even cavalier, approaches to curating photographs in museums which I have encountered in my own research and consultancy range from the excellent to the downright shocking. Things happen to photographs in museums which would constitute a local, or even national, scandal if they happened to any other class of object. For instance, digitization with no regard for the historicity of the object, copying and cropping without record, destroying 'duplicates' again without record, destroying original negatives because 'they've been digitized so it doesn't matter', rudimentary (if any) accession records, and less-then minimal standards of documentation with basic information such as size material and format not recorded.

10 Visitor information for these holistic and embodied experiences promise 'Appropriate sights sounds and smells evoke for visitors a sensation of being caught in a bombing raid' (http://london.iwm.org. uk/server/show/ConWebDoc.1476 [accessed July 29 2008]).

11 'Material curating' could be said to be as much a mind-set, a kind of analytical understanding of the objects to be curated, as it is a set of specific techniques.

12 This exhibition was also shown in Amsterdam, Reykjavik and New York.

13 http://www.cmp.ucr.edu (accessed 28 July 2008).

14 http://tibet.prm.ox.ac.uk (accessed 24 July 2008).

15 There are a number of softwares which, together with Flash graphic animation technology, deliver this effect. Some uses even simulate the sound of pages being turned.

16 This work won the National Portrait Gallery's John Kobal Photographic Portrait Prize, 1996.

17 http://www.islandhistory.org.uk/; http://www.totnesimagebank.org.uk/ (accessed 24 July 2008). Gateways such as http://www.untoldlondon.org.uk/index.html link into a wide variety of community photographic projects (accessed 24 July 2008).

18 For example websites such as http://www.bbc.co.uk/history/familyhistory/your_photos/ (accessed 15 November 2007), a plethora of local societies and magazines such as *Family History* which valorize photographs as a direct, and profoundly desirable, route into the past, giving a sense of 'completeness' and emotional connection.

19 http://www.flickr.com (accessed 24 July 2008).

20 http://www.flickr.com/photos/1183192824/#DiscussedPhoto (accessed 28 July 2008).

21 http://hubpages.com/hub/digital-photography-sepia-tone. See also http://www.familytreesphotorestoration.com (both accessed 28 July 2008).

22 As a discussion on Flickr puts it: 'how should old photographs be restored [digitally]? To look like it was (may be add some blurriness?) or to sort of get it looking sharp and bright?' http://www.flickr.com/photos/szening/492093109/#DiscussedPhoto (accessed 30 July 2008).

23 Cameraphones rather than digital cameras as such, carry newly configured imaging practices which, it has been argued, can be related to the increasing sense of the contemporary and transitory in the construction of the social self (van Dijck 2008).

24 http://photography.si.edu linking to http://flickr.com/photos/smithsonian which invites public participation in their collection; http://www.flickr.com/photos/8601677@NO3 (all accessed 24 July 2008).

25 It is this, after all, which has informed a number of visual repatriation projects in anthropology museums; see, for instance, Brown and Peers (2006).

References

Alpers, S. (1991) 'The museum as a way of seeing', in I. Karp and S. Lavine (eds) *Exhibiting Cultures*, Washington, DC: Smithsonian Institution Press, pp. 25–32.

Bal, M. (2003) 'Visual essentialism and the object of visual culture', *Journal of Visual Culture* 2 (1): 5–32.

Baer, U. (2002) *Spectral Evidence: the photography of trauma*, Cambridge, MA: MIT Press.

Barthes, R. (1973) *Mythologies;* trans. Annette Levers, London: Paladin.

—— (1984) *Camera Lucida;* trans. Richard Howard, London: Flamingo.

Batchen, G. (1997) *Photography's Objects,* Albuquerque, NM: University of New Mexico Art Museum.

—— (2004) *Forget Me Not: photography and remembrance,* New York: Princeton Architectural Press.

Boast, R., S. Guha and A. Herle (2001) *Collected Sight: photographic collections of the Museum of Archaeology and Anthropology, 1860s–1930s,* Cambridge: Cambridge University Museum of Archaeology and Anthropology.

Bourdieu, P. (1965) *Un Art Moyen: essai sur les usages sociaux de la photographie,* Paris: Editions de Minuit.

Bradley, H. (1999) 'The seductions of the archive: voices lost and found', *History of the Human Sciences* 12 (2): 107–22.

Brown A. and L. Peers (2006) *Pictures Bring us Messages,* Toronto: University of Toronto Press.

Burgin, V. (1986) *The End of Art Theory: criticism and postmodernity*, Basingstoke: Macmillan.

Connerton, P. (1989) *How Societies Remember,* Cambridge: Cambridge University Press.

Crane, S. A. (ed.) (2000) *Museums and Memory*, Stanford, CA: University of Stanford Press.

Csordas, T. J. (ed.) (1994) *Embodiment and Experience,* Cambridge: Cambridge University Press.

Cubbitt, S. (1998) *Digital Aesthetics,* London: Sage.

Daston, L. and P. Galison (2007) *Objectivity,* New York: Zone Books.

Domanska, E. (2006) 'Material presence of the past', *History and Theory* 45: 337–48.

Edwards, E. (1999) 'Photographs of objects of memory', in M. Kwint, J. Aynesley and C. Breward (eds) *Material Memories: design and evocation,* Oxford: Berg, pp 221–36.

—— (2001) *Raw Histories: anthropology, photographs and museums,* Oxford: Berg.

—— (2006) 'Photographs and the sound of history', *Visual Anthropology Review* 21 (1–2): 27–46.

—— (2008) 'Thinking photography beyond the visual?', in J. Long, A. Noble and E. Welch (eds) *Photography: theoretical snapshots,* London: Routledge, pp. 31–48.

Edwards, E. and J. Hart (eds) (2004) *Photographs Objects Histories: on the materiality of the image,* London: Routledge.

Ernst, W. (2000) 'Archi(ve)textures of museology', in S. A. Crane (ed.) *Museums and Memory,* Stanford, CA: University of Stanford Press, pp.17–34.

Freund, G. (1980 [1974]) *Photography and Society,* London: Gordon Fraser.

Gell, A. (1998) *Art and Agency,* Oxford: Clarendon Press.

Green-Lewis, J. (2000) 'At home in the nineteenth century: photography, nostalgia, and the will to authenticity', in J. Kuclich and D. F. Sadoff (eds) *Victorian Afterlife: postmodern life rewrites the nineteenth century,* Minneapolis, MN: University of Minnesota Press, pp. 29–48.

Griffiths, P. (1997) *What Emotions Really Are: the problem of psychological categories,* Chicago, IL: University of Chicago Press.

Hamilton, C. (2002) 'Oral histories, material custodies and the politics of archiving', in C. Hamilton, V. Harris, J. Taylor, M. Pickover, G. Reid and R. Salah (eds) *Refiguring the Archive,* Cape Town: David Philip, pp. 209–27.

Harkin, M. E. (2003) 'Feeling and thinking in memory and forgetting: towards an ethnohistory of the emotions', *Ethnohistory* 50 (2): 261–284.

Henning, M. (1995) 'Digital encounters: mythical pasts and electronic presences', in M. Lister (ed.) *The Photographic Image in Digital Culture,* London: Routledge, pp. 217–35.

Hirsch, M. (1997) *Family Frames: photography, narrative and postmemory,* Cambridge, MA: Harvard University Press.

Hoskins, J. (1998) *Biographical Objects: how things tell the story of people's lives,* London: Routledge.

Howes, D. (ed.) (1991) *The Variety of Sensory Experience,* Toronto: Toronto University Press.

—— (2003) *Sensual Relations: engaging the senses in cultural and social theory,* Ann Arbor, MI: University of Michigan Press.

Hutton, P. (1993) *History as an Art of Memory,* Hanover, NH/London: University Press of New England for the University of Vermont.

Jackson, M. (ed.) (1998) *Things as They Are: new directions in phenomenological anthropology,* Bloomington, IN: Indiana University Press.

Kavanagh, G. (2000) *Dream Spaces: memory and the museum.* London: Leicester University Press.

Keene, W. (2005) 'Signs are not the garb of meaning: on the social analysis of material things', in D. Miller (ed.) *Materiality,* Durham, NC: Duke University Press, pp. 182–205.

Kracauer, S. (1995a) *History: the last things before the last*, edited and completed by Paul Oskar Kristeller, Princeton, NJ: Markus Weiner Publishers.

—— (1995b) *The Mass Ornament,* Cambridge, MA: Harvard University Press

Kuhn, A. (1995) *Family Secrets: acts of memory and imagination,* London: Verso.

Latour, B. (1999) *Pandora's Hope: essays on the reality of science studies,* Cambridge, MA: Harvard University Press.

Langford, M. (2001) *Suspended Conversations: the afterlife of memory in photographic albums,* Montreal/Kingston: McGill-Queen's University Press.

Le Goff, H. (1992) *History and Memory,* New York: Colombia University Press.

Leavitt, J. (1996) 'Meaning and feeling in the anthropology of emotions', *American Ethnologist* 23 (1): 514–39.

Lutz C. and G. White (1986) 'The anthropology of emotions', *Annual Review of Anthropology*, 15: 405–36.

Lynch, M. (1999) 'Archives in formation: privileged spaces, popular archives and paper trails', *History of the Human Sciences* 12 (2): 65–87.

Macdonald, G. (2003) 'Photos in Wiradjuri biscuit tins: negotiating relatedness and validating colonial histories', *Oceania* 73 (4): 225–42.

Merriman, N. (1996) 'Understanding heritage', *Journal of Material Culture* 1 (3): 377–86.

Miller, D. (ed.) (1998) *Material Cultures: why some things matter,* London: UCL Press.

Milton, K. and M. Svašek (eds) (2005) *Mixed Emotions: anthropological studies in feeling,* Oxford: Berg.

Mitchell, W.J.T. (2005) 'There are no visual media', *Journal of Visual Culture* 4 (2): 257–66.

Moore, K. (1997) *Museums and Popular Culture,* Leicester: Leicester University Press.

Myers, F. (ed.) (2001) *Empire of Things: regimes of value and material culture,* Santa Fe, NM: School of American Research Press; Oxford: James Currey.

Nora, P. (1989) 'Between memory and history: *les lieux de mémoire*', *Representations* 26: 7–25.

Ong, W. (1982) *Orality and literacy: technologizing the word,* London: Methuen.

Parry, R. (2007) *Recoding the Museum: digital heritage and the technologies of change,* London: Routledge

Pinney, C. (2001) 'Piercing the skin of the idol', in C. Pinney and N. Thomas (eds) *Beyond Aesthetics,* Oxford: Berg, pp. 157–79.

—— (2005) 'Things happen: or, from which moment does that object come?', in D. Miller (ed.) *Materiality,* Durham, NC: Duke University Press, pp. 256–72.

Porter, G. (1988) 'The economy of truth: photography in museums', *Ten–8* 34: 20–33.

Porto, N. (2001) 'Picturing the museum: photography and the work of mediation in the Portuguese Third Empire', in M. Bouquet (ed.) *Academic Anthropology and the Museum,* New York: Berghahn Books, pp. 36–54.

Radstone, S. (ed.) (2000) *Memory and Methodology,* Oxford: Berg.

Reddy, W. M. (2001) *The Navigation of Feeling: a framework for the history of emotions,* Cambridge: Cambridge University Press.

Riegl, A. (1999 [1903]) 'The modern cult of monuments: its character and its origin', trans. K.W. Forster and D. Ghirando, *Oppositions* 25: 21–51.

Robins, K. (1995) 'Will the image still move us?', in M. Lister (ed.) *The Photographic Image in Digital Culture,* London: Routledge, pp. 29–50.

Rose, G. (2004) '"Everyone's cuddled up and it just looks nice": an emotional geography of some mums and their family photographs', *Social and Cultural Geography* 5 (4): 549–64.

Samuel, R. (1994) *Theatres of Memory,* London: Verso.

Sassoon, J. (2004) 'Photographic materiality in an age of digital reproduction', in E. Edwards and J. Hart (eds) *Photographs Objects Histories: on the materiality of the image,* London: Routledge, pp. 186–202.

Sepúlveda dos Santos, M. (2003) 'Museums and memory: the enchanted modernity', *Journal for Cultural Research* 7 (1): 27–46.

Seremetakis, C. N. (1993) 'Memory of the senses: historical perception, commensal exchange and modernity', *Visual Anthropology Review* 9 (2): 2–18.

Spence, J. and P. Holland (1991) *Family Snaps: the meanings of domestic photography,* London: Virago.

Svašek, M. (2005) 'Introduction', in K. Milton and M. Svašek (eds) *Mixed Emotions: anthropological studies in feeling.* Oxford: Berg, pp. 1–23.

Tuan, Yi (1977) *Space and Place: the perspective of experience,* London: Edward Arnold.

Tucker, J. (2005) *Nature Exposed: photography as eyewitness in Victorian science,* Baltimore, MD: Johns Hopkins University Press.

van Dijck, J. (2008) 'Digital photography: communication, identity, memory', *Visual Communication* 7 (1): 57–76.

Wright, C. (2004) 'Material and memory: photography in the Western Solomon Islands', *Journal of Material Culture* 9 (1): 73–85.

3

REMEMBERING THE DEAD BY AFFECTING THE LIVING
The case of a miniature model of Treblinka

Andrea Witcomb

It has become almost axiomatic in contemporary museum literature that it is in highly interactive, mediated and experiential museums that the most successful affective experiences can be found. While it is true that some of the more experimental installations use contemporary media forms to generate affective responses from audiences, this chapter is interested instead in the affective power of objects and the role of interpretation in enhancing it.

While I have always had an interest in what I have previously called the irrational power of museums (Witcomb 2003) – their ability to make contact with audiences in ways that are beyond rational and didactic forms of narrative – the immediate genesis for the arguments developed in this chapter lies in my differing response to models of concentration camps in exhibitions dealing with the Holocaust. There is by now, a well established genre of models. The original model, by Mieczyslaw Stobierski, was first exhibited at Auschwitz as early as 1947 and later replicated by the same sculptor at the United States Holocaust Memorial Museum, Yad Vashem in Jerusalem and the German History Museum in Berlin; it comprises a white, rather large replica, cut so as to reveal the inside of the gas chambers at Auschwitz-Birkenau. Didactic in aim, the models show the processing of thousands of people, from the queues waiting to get into the rooms where they are told to undress, to the cramming of people into the gas chambers and the subsequent cremations. Beautifully executed, such models are informative as to the processes used to industrially kill hundreds of people. In other words they show one version of what genocide looks like. But somehow, for me at least, the final feeling when viewing these models is one of numbness rather than comprehension. I understand the process and its impact in terms of numbers killed, but I have no means to understand the meaning of what happened because I cannot personalise it – despite the attention to detail and the historical veracity of such models.

There is, however, another model, of another camp, at a much smaller museum in Melbourne. This model, of Treblinka, at the Jewish Holocaust Museum and Research Centre is completely different in its aesthetic and lineage. It is not white, it is not made by a professional sculptor or model maker and it is, comparatively speaking, much smaller. Multicoloured and almost 'folksy' in its depiction of the camp, the model is nevertheless intensely powerful in its depiction of both the process and the personal horror experienced there. Rather than numbness when viewing this model, my experience is one of intense grief. This chapter is an attempt to

understand why this is so as well as to argue for the importance of such intense experiences in a museum setting.

My interest in the importance of affect as a basis for gaining emotional insights into past experiences in a museum setting first began when I read one of James Clifford's early essays, 'Objects and Selves' in which he used a poem by James Fenton about a child's response to the Pitt Rivers Museum in Oxford. *Please Sir, where's the withered hand?* asks the child. James Clifford (1985: 236) suggests that to be this child, is 'to ignore the serious admonitions about human evolution and cultural diversity posted in the entrance hall. It is to be interested instead by the claw of a condor, the jawbone of a dolphin, and the hair of a witch'. The possibility offered by the museum is the world of imagination and, by extension, of a potential for empathy by becoming other, if only momentarily. In other words, as Ross Gibson (2006) has put it, museums are spaces in which to have sensory experiences; they are spaces in which transformative experiences are possible because of the ability of objects to reach out and literally touch someone. If properly used, I want to suggest, this potential can be used to build tolerance because the motivation comes from within rather than being produced externally through didactic means.

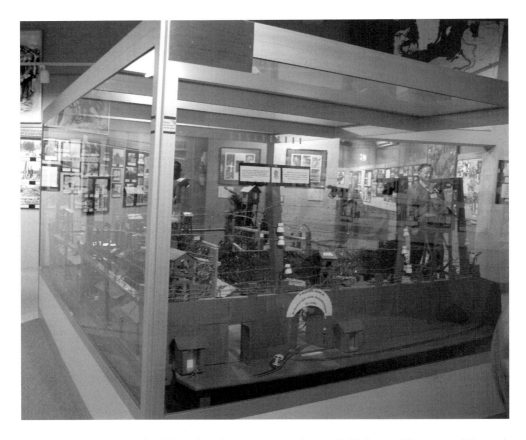

Figure 3.1 The model of Treblinka by Chaim Sztajer at the Jewish Holocaust Museum and Research Centre, Melbourne (photograph by Andrea Witcomb, 2008)

What is affect?

Affect is a pre-rational or pre-cognitive response to stimuli which can range from the pleasurable to the abject. According to psychologist Silven Tomkins, there are nine affective states which are generated out of an initial interest in an object or experience. Initially, these affects are registered in physical, sensorial responses (in Best 2001: 209) – we crouch, peer, bend over, move around, wince, look intently and so on. What we experience is a variety of sensations or feelings such as pleasure, anxiety, excitement or disgust. The point here is that these sensations are not equivalent to emotions since they occur involuntarily. As Claire Colebrook (2002) in her analysis of Gilles Deleuze's work describes it, affect works through a range of proprioceptive sensations which are outside of rational processes of thought. This makes affect akin to the ways in which involuntary memory, as described by Proust's now famous description of an encounter with a madeleine biscuit, works. The object, in this case the madeleine biscuit, is not simply a memory aide facilitating the act of remembering or recognition. Rather, the madeleine actually causes the memory to take effect; it acts on its eater by causing an involuntary response which eventually gives rise to thought, in this case a memory. While involuntary however, such physical, visceral responses are productive in that they generate feelings which, when processed, can turn into emotional and eventually cognitive insights. As Best (2001: 220) puts it, affect is linked to signification, to the process of making meanings. This is a complex process in which 'affect is an originary trace, an inherited mapping of the body and its expressive potential, that becomes the stuff of signification. In turn, this catching up of affect into signification allows affect to signify or register this corporeal bedrock of meaning' (Best 2001: 220). Affect then, while experienced at the sensorial level, becomes part of the symbolic realm.

While the study of affect has been of most interest to art and architectural critics, the range of objects that can elicit affective responses is not limited to art objects.[1] As Best points out, Tomkins' work makes it clear that while the range of affects is limited, the 'range of objects that elicit or provoke affect are not fixed or prescribed' (Best, 2001: 209). Tomkins' point that affective sensations can only be generated from an initial interest, however, has meant that art critics have had an interest in its study as it gives them the ground to argue for the transformative potential of art. This is because this initial interest in the object or experience comes from within the subject, giving him or her a 'motivational engine'. Affect therefore 'has the capacity to impel or move a spectator' (Best 2001: 209). In other words, it can lead to a transformative experience.

It is this understanding of the transformative power of affect that is important to understanding the transformative potential of museums. In being attentive to the powers of affect, museums can, as Janice Baker (2008) has argued, provide the space to do more than mere representation, more than facilitating the act of re-cognition. As she argues, 'without an affective experience, facts may be imparted and information about a subject or object accumulated but without leaving a strong impression. In re-cognition we receive what we largely expect to receive and remain contained within our usual thoughts' (Baker, 2008). Understanding affect, however, gives us an opportunity to engage with John Armstrong's (2004) argument that objects need to be understood to embody, rather than articulate, meaning. In other words, objects can do more than simply represent, in this case, the past.

I am interested in how this can be used to deal with contentious histories and difficult experiences. The historical advent of the Holocaust and the experiences of those who lost their lives during that time as well as those who witnessed and survived that experience is a case in point. How can these experiences be embodied, rather than represented, in objects? And can

the display of such objects generate an experience which leads to some form of alterity, to some kind of transformation?

While there is an extensive literature on the representation of the Holocaust in museum spaces and through memorials, it is striking that almost all of these discussions deal with spaces or objects which are highly professionalised in their approach and often have a national, or at least a governmental frame around their narrative. An example here would be the work of James Young (1993) who looks at the representation of the Holocaust in memorials and museum/memorials country by country, giving us one of the most comprehensive analyses yet of Holocaust representations. His main focus, however, is on examples from public spaces produced by professionals.

As a consequence, it is not surprising that he argues that the representation of the Holocaust, like memory itself, is never 'shaped in a vacuum' but always affected by 'national myths, ideals, and political needs' (Young 1993: 1) or the 'temper of the memory-artist's time, their place in aesthetic discourse, their media and materials' (ibid: 2). They are understood, then, to operate within the realm of rational narratives, within ideology, within public memory. Thus all of Young's examples come from memorials built for public display, following either a traditional injunction to remember on the part of Jewish communities or a nation's attempt to explain its past to its citizens.

Likewise, the majority of more recent discussions on the representation of the Holocaust, including my own, focus on the recent development of museums and specialist exhibitions dealing with the Holocaust in its entirety, such as the United States Holocaust Memorial Museum, the Museum of Tolerance in Los Angeles, the new Jewish Museum in Berlin or the revamped Yad Vashem History Museum (Cole 2004; Hasian 2004; Witcomb 2003). The focus of these analyses is on debating the museums' effectiveness as pedagogical sites, deconstructing the ideological narratives that underpin their representations of the Holocaust. As Ernst van Alphen comments, this is largely because the focus, both in the practices of memorialisation themselves and in the scholarly literature about the Holocaust and how to remember it, has been shaped by a belief that

> in the context of education and remembrance of the Holocaust it is a seemingly unassailable axiom that historical genres and discourses such as the documentary, the memoir, testimony or the monument are much more effective and morally responsive in the teaching of historical events than imaginative discourses are.
>
> (van Alphen, 2001–02: 165)

According to Young (1993), the injunction to remember results in a visual culture of memorialising in which literalness or authenticity of representation is highly valued. Thus the first memorials were in the form of books known as Yizkor Bikher, which were written by survivors who literally attempted to record the names of all those who died. These books came to be understood as equivalent to absent tombstones. The activity of reading them was understood as the creation of a memorial space. Later, physical monuments in space were created which functioned as *aides-mémoire*. Entire topographies of memorial landscapes were created. While the first of these were the camps themselves, particularly that of the Auschwitz-Birkenau complex, these were later extended to memorials away from the sites of atrocity, such as that of Yad Vashem, whose site is not only a landscape of memorials but a visible reminder for Israelis at least, that the Holocaust led to the creation of the state of Israel. Interestingly, given van Alphen's insight into the dominance of historical narrative in dealing with the Holocaust, Young (1993:

9) argues that attempts to memorialise the Holocaust via abstract sculptures are not so popular with Holocaust survivors. This is because survivors, Young suggests, are more literal in their desire to document and testify to the existence of the Holocaust in the face of Holocaust deniers. To remember, for many survivors, cannot be divorced from the activity of testifying.

To remember while also testifying is one of the motivating forces for the early and continuing desire to build miniature models of the concentration camps. The first of these at the Auschwitz State Museum was made as early as 1947 by a Polish Jewish survivor, Mieczyslaw Stobierski, based on archival research and interviews with SS officers. The most recent, that of the arrival selection process at Birkenau, by Gerry Judah for the Imperial War Museum's Holocaust exhibition in London, was also based on extensive research. Its aim was 'to be educational. It was not to be a memorial' (Judah 2000).

The desire to testify and to do so through a realist form of representation is very evident in the Treblinka model, made not by an artist but by a carpenter, in order to remember his family and document the place where they died. As with all models which are also miniatures, the attention to detail is one of its distinguishing markers – from the physical infrastructure of the camp, giving a detailed idea of the physical relationships between its different components to the names given to streets, the location of plant screens, the false red cross on the roof of the so called *Lazaret* (hospital) which was really an execution centre for unaccompanied children and the sick, the position of the guards and their dogs, and the shocking attention to dismembered and burnt bodies as well as to the fires which consumed the bodies.

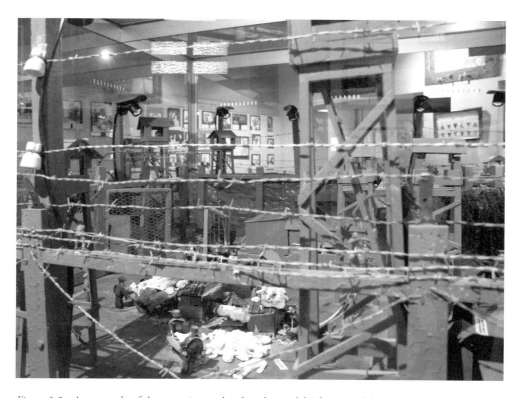

Figure 3.2 An example of the attention to detail in the model (photograph by Andrea Witcomb, 2008)

But interestingly, this object's impact reaches beyond that of providing a historical narrative as to what happened. Extending beyond documentation, beyond a personal testimony, the object also provides an opportunity for identification, for the building of a personal link. The way it does this has as much to do with the narrative surrounding is making as with its aesthetic characteristics and what it is depicting. Resisting traditional categories of classification, this object is both an educational tool and an art object, though it was not made by an artist in a conventional sense; and while representing an unimaginable horror the object also has connotations of a child's toy set, both because it is a miniature and because of its aesthetics which are rather like that of colourful cardboard cut-outs. The model was hand-made by one of 70 survivors from Treblinka, Mr Chaim Sztajer, in his living room in Melbourne over three and a half years. He began to make it when he heard that there was going to be a Holocaust Museum in Melbourne, and donated it to the Museum when it began to develop its exhibitions (Maisel 1993). Naïve in form, outside of any formal 'politics of memory', it embodies one human being's need to remember, document and communicate.

Treblinka[2] was a single-function extermination camp.[3] Over 800,000 Jews were murdered there during its 13 months of operation. A few Jewish men – about 700 to 1000 according to the brochure provided by the Museum – were picked as labourers for the camp. Some were selected to work as carpenters or cooks and so on while others were forced to deal with the dead bodies. Initially this meant removing them from the gas chambers and interring them in trenches; later it meant both disinterring the bodies of those buried, burning their remains in open fire grills and grinding any remaining bones for burial in the trenches, as well as burning the bodies of those murdered in the final months of the camp in order to cope with the numbers of those killed and the desire on the part of the camp's leadership to destroy any evidence. These men were regularly shot to avoid the possibility that they could testify as to the camp's existence.

Chaim Sztajer was one of 40,000 Jews taken to Treblinka from Czestochowa in September 1942, with his wife and two-year-old daughter. He was recognised by a Jewish prisoner who saved his life by telling a German guard that he was a good worker. While he was put to work sorting the belongings of those murdered, his wife and child were led to the gas chambers. It was only when he inquired as to when he would be seeing them, that he realised they were being killed. On 2 August 1943, Sztajer was part of an uprising whose aim was to destroy the camp so it could not be used. It was successful in so far as the workings of the gas chambers were disrupted, though there were only 70 survivors.

How do we attempt to understand this model of the camp? Clearly, it is part of a Jewish tradition to memorialise by testifying. The model stands in for narrative, being almost a diary of processes at the camp. It is also a document, as in fashioning his figures, Mr Sztajer meant to represent and therefore testify to the death of individual people he knew as well as to the identity of camp staff.[4] His figures are not stylised and generalised images of people but likenesses of actual individuals. This makes this model quite different from the more anonymous representation of a mass of people in the professional models discussed in the introduction, even though each one of them is given an individuality through the expression of their suffering. The Treblinka model is thus meant to be a historical document, a piece of evidence which uses its three-dimensionality to give shape and materiality to its enactment of memory.

The model thus acts much like a documentary photograph, in the absence of any historical photographs and given the destruction of the site itself. But if that was all it was, then this model would not have any greater impact on people than those produced by professional model-makers such as those of Auschwitz in the Imperial War Museum in London or at the German Historical Museum in Berlin. Those models are based on meticulous research

and also claim a truth-value, the status of authentic copy. What else, then, is at work in the Treblinka model?

The importance of the personal

Unlike other models of concentration camps, this one is impregnated with the emotions of its maker and his status as a survivor. By being made literally from the memory of one man, it becomes more than a re-creation and more than an interpretative tool. In some important though hardly perceptible way, this model becomes a link to the past by virtue of the fact that someone's memory and lived experience is embodied within it and given material form. This gives this model a different power from say that of a photograph, even photographs as powerful as those recently discovered in the so-called Auschwitz Album, which, taken by the perpetrators, document how the brutality of the camps was normalised as part of their everyday life. As Susan Sontag (2002) has so powerfully argued, photographs can act as a *memento mori*, as a souvenir of the dead, because of their status as a trace of their subjects' former existence. This memento status makes them a tool, in that they become an *aide de memoire*. Their usefulness is that they help survivors remember, a point also made in relation to objects in museums by Marius Kwint *et al.* (1999), who comments that one of the relations between objects and memory supported by museums is the stimulation of memory through the act of recognition.

For those who had no experience of the Holocaust, however, such photographs are a document, a way of testifying to what happened because of the common-sense faith in the technology of the photograph to capture, through light, an imprint of what the photographer saw through the camera's lens. In the case of photographs that recorded the everyday life of Jewish communities or individual people, photographs are used to record not only what was lost but also to generate poignancy about this loss. In fact, such images are frequently used to narrate and give presence, in the face of absence, to 'the lost world' of pre-Holocaust European Jewry.[5]

The model of Treblinka however, is not just a trace. Rather it is memory itself, made live by giving it material form. More than a memory aid, this model *is* memory itself. This knowledge greatly increases the affective power of the object. In recoiling at the graphic, almost surreal representation of what occurred at the camp we are also flinching from the knowledge that this happened to a man who until his death in early 2008 could speak to you about it and openly cry in front of you. The dead are not anonymous people but his family and his friends.

This is quite unlike the commissioned models which, by the public nature of the commissioning process, have to be attentive to public rather than personal forms of memorialising. Part of this attentiveness is the need to pay attention to what we might call the politics of respect. It would be impossible to personalise the suffering and to pay attention to the gruesome detail, not only out of respect for the dead but because such detail is not respectable. While historically accurate, such models avoid the personal in order to gesture to the greater whole. The cost, however, is what I earlier referred to as a certain numbness, an inability to own or understand from within the enormity of what happened. We merely understand the facts because the professional models support the historical narrative that surrounds them. They work at the level of recognition, not at the level of embodiment.

This, for example, is the case with the model of the train platform in the Holocaust exhibition at the Imperial War Museum in London. The model represents the spot within the Birkenau complex where the selection of people according to their ability to work or not was made. It is thus an attempt to capture the point at which life and death decisions were made on behalf of thousands of people without their knowledge of what was occurring. According to the model's

maker, Gerry Judah (2000), the rationale was didactic. Based on extensive archival research, interviews and site visits, the model was meant to be historically accurate as to the process it represented and the site in which it happened. But the model was also commissioned for the role it could play in a more general narrative about the Holocaust, told in the images, objects and texts which surround it. Its affective power, which is one of awe at the extent of the numbers of people impacted upon, the cruel nature of the selection and the fascination posed by our knowledge of what awaited them in the gas chambers, is the result of the large size of the model, its whiteness, and the dark, sombre lighting and colour scheme which surround it. The effect is one of silence and respect for the dead.

The Treblinka model, built in a private living room out of a personal desire to testify and memorialise as well as to display such a desire is entirely different. It is visually and physically assaulting to all the senses. Approaching it from the front, I was drawn to the colourful cut-outs of the women and children which reminded me of my paper cut-out dolls given to me by my godmother when I was a child. I only barely registered the more ominous signs of the dogs, guards and pile of clothes on the ground. Much more impressive was the greenery separating this reception area from the back of the camp which was not clearly visible from this angle. The name of the street those children and their mothers were in – Himmelstrasse (Heaven Street) – gave no sense of what was to come either. The name only became ironic as one turned the corner and was faced with the full horror of the camp's purpose. There I recoiled, physically assaulted by what I saw – dismembered bodies made of plaster, half reminiscent of the plaster cast of

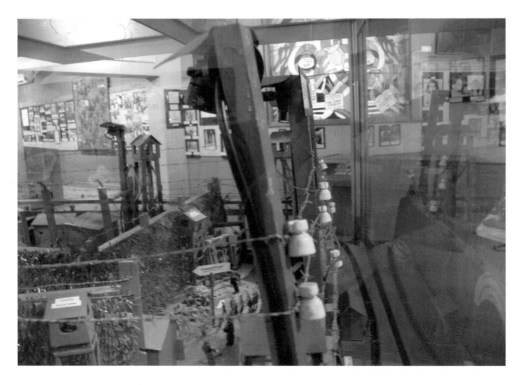

Figure 3.3 The cut-out figures in Himmelstrasse lining up in front of the gas chambers (photograph by Andrea Witcomb, 2008)

human figures taken from Pompeii, recording for posterity how they died. Only these were in miniature form as if toys. There were parts of bodies still smouldering away, bright red as if they were the remains of a burning piece of wood with the embers still alive; figures of prisoners busy taking these charred remains off for burial in pits, grinding the remaining bones in grinders or putting more bodies on the open air fires. And all under the watchful gaze of the guards and their dogs on the ground and from watch tours above. Fascinated and repelled by the scene I grimaced while also peering more closely at the scene and then looking away as if I could banish my position of onlooker.

The scene disrupted my subjectivity, my sense of who I was in relation to it – was I an innocent bystander horrified by the scene, pitying those who had died in this way and those who were forced to work in such conditions? Or did my gaze replicate that of the guards? By now, physically and emotionally shocked I sought help to comprehend this object, help which came in the form of a volunteer, who turned out to be Mr Stajer himself. He simply told me he had made it, had been there and that it was an authentic copy of the camp. He also told me his wife and daughter had been killed there. He gave me a brochure on the model while I fought tears from streaming down my face wondering how he could stand there so calmly.

If it had been the result of a public commission the model would have been considered disrespectful in its invitation to look closely at its horrible details. But the almost indecent desire to look closely, to walk around it, to look into its internal spaces, to take in its depiction of gruesome activities and to be shocked, when coupled with the knowledge of its history, tears at the heart as well as the imagination, making it just possible to begin to understand the enormity of the grief for lost family, friends and entire communities.

The importance of this personalised attempt to both represent and embody memory is still there even in Mr Sztajer's absence. As one second generation guide told me, Mr Sztajer used to stand at one corner of his memorial and look for long periods of time at it, using it to reanimate the past. In telling me this story, the guide explained that she thought Mr Sztajer was possessive, that he was really thinking that he rather wished he had not given the model to the museum but had kept it at home. Offering evidence for this theory she told me how upset he had been when the Museum decided to enclose the model in glass for its protection. She followed this up by explaining how surprised and moved she then became to learn from him just what it was that the model embodied for him. As he put it to his colleague, 'you don't understand, I am looking at my daughter'.

Mr Sztajer's presence through the materiality of his model places the viewer in a unique position. Unlike attempts to recreate the experience of being a past victim by asking people to identify with a victim though the use of cards representing the identity of specific victims at the United States Holocaust Memorial Museum, or to walk through a simulation of the gas chambers such as that at the Museum of Tolerance in Los Angeles, this model asks you to imagine yourself as a *potential* victim, not an actual one. It is that request that enables the possibility of a transformation, of action to prevent future Holocausts. The model works by activating the expression of empathy in the present, rather than for past victims. Rather than offering an unrealistic claim to experience the past or, even more simply, information about the past, this model provides a glimpse into ongoing grief. The past is not, therefore, disconnected from the present.

This also means that unlike many public memorials, the Treblinka model is not an invitation to forget. Quite the contrary. While Young and other critics, such as Pierre Nora (1984), warn of the dangers of relying on external scaffolding such as memorials to do the work of remembering, suggesting that 'in shouldering the memory work, monuments may relieve viewers of their

memory burden' (Young 1993: 5), this model of Treblinka does exactly the opposite. Rather than allowing the process of remembering to be removed from everyday life, this model suggests how memorial making can become a part of everyday life for both for its maker and his audiences, precisely because of its insistence on the personal.

The impact of the miniature on the affective power of the model

Sztajer's association of the model with the presence of his daughter also brings to mind what Susan Stewart (1984) has to say about the role of miniatures, though it also suggests a departure from her comments in significant ways. Stewart makes the point that miniature models are most frequently associated with children because of their association with dolls' houses, toy soldiers, model railway stations, as well as the more general association of the world of miniatures with children's stories such as *Tom Thumb* or *Gullliver's Travels*. In the case of the Treblinka model, this is doubly apt. The model acts as a technique for bringing his daughter back to life by embodying in a physical manner his memory and knowledge of her last moments. In a sense, by playing with the miniature at an imaginative level, Sztajer can re-enter the past. It is for this reason, perhaps, that he was so upset at the Museum's decision to encase the model in glass. The effect was to increase the distance between past and present by making it less accessible. In a real sense he was not as able to 'reach' his daughter. By making the miniature, Sztajer was also attempting to communicate with children. In his video-testimony for the Holocaust Centre's video-testimony archive, Sztajer made a point of saying he found it important though hard to communicate with children, thinking that it was important for them to know what had happened to his daughter (Maisel 1993). In this context, the folksy, cardboard-looking cut-outs that he hand-painted could be interpreted as part of an interpretation strategy to reach children by playing on the links between models and children's toys – though I cannot be sure that this was a conscious strategy on his part.

Stewart also points out that miniatures invite close attention, thereby inviting multiple significances. At the same time, however, they freeze a moment in time, collapsing many moments into one. In the case of the Treblinka model, Stewart's point is perfectly apt. Despite Mr Sztajer's claim of authenticity, he had to collapse the history of the camp's operation and its physical changes over time into one frozen moment. In a sense then, the model does not offer an exact replica at a particular point in time but a concentration of all that went on there over a period of time. It is accurate, in that all of it is true but it is not accurate in its representation of time. As Stewart (1984) explains it, miniatures offer a transcendental perspective, offering not only a complete, filled out point of view but reducing one instance to all such instances. They condense and embody meanings and thus enlarge them.

Miniature models use of the tableau as a method to represent and capture entire worlds also means that they invite action by asking the viewer to step into the model and make it come alive through imaginative play. This not only gives a tableau 'the power to etch itself in one's memory' but also gives us the power to invent our own worlds, our own associations. The Treblinka model is no exception, as we have already seen in Sztajer's own relationship to it. The model invites interest, in the way that Best, following Tomkins, suggested was necessary before affect can eventuate. Just like in the contemporary art installations that Best discusses in her article, affect is precipitated by the activity of corporeal movement around the object. We walk around the model, we gaze at it, we look deeply into its hidden spaces. In the process we recoil, we experience a sense of disgust, shock, horror, we are fascinated and repelled all at once. The horror is made even more palpable by the fact that, imaginatively at least, we can insert ourselves

into that world and play the role of either the victim or the perpetrator. The possible meanings audiences might make of the model are not exhausted by our knowledge that Sztajer would have undoubtedly wanted us to identify with the victims. Despite the narratives which surround such an object, its meanings are unstable precisely because it operates at the limits of the politics of respect and even beyond them. And yet it is, in part, this danger that makes it such a powerful object.

While for Sztajer it is his memory that activates the model and brings it alive, for us, it is a series of complex layers working in combination with one another – its physical characteristics which excite interest as well as disgust, the knowledge of what the model means to him as well as our own knowledge of events. The unique combination that results from these very different sets of knowledge, ranging from affect to emotion to cognition, combine to give us, as the audience, a place within Mr Sztajer's grief.

These associations make this miniature model different from models that Stewart discusses. While she sees miniature models as freezing time and thereby erasing history, marking it off from the present and framing it through nostalgia, an effect which is not disassociated from the association with childhood, I see this model as allowing a link to be made between past and present. This happens first of all by the model's invitation to look in detail, which inevitably leads to sensations of shock and disgust that are felt viscerally. This then leads to an emotional response, raised in part by our cultural knowledge of what happened and by the realisation that this model was made by a survivor. It is his story that allows us to move beyond disgust, beyond our initial proprioceptive responses to the object itself towards a process that internalises our experience of the object and begins to create meaning. But this cannot occur without first experiencing the physical shock of the object itself, made all the more palpable by the naivety of its production values, its use of colour – as opposed to the white of the professional models – and the fact that it is a miniature model inviting us to look closely and attentively.

A useful discussion to advance our understanding of this object beyond Stewart's critique of miniatures as inevitably tinged by romanticism and nostalgia because of their association with childhood, is van Alphen's (2001–02) provocative and extremely interesting discussion on artworks that use the notion of play to embody the Holocaust. Created by second- and third-generation descendants of survivors, such artworks have caused intense debate, upsetting many survivors. Rather than enter into a debate about morality and the role of taste within it, van Alphen asked not whether such artworks were tasteful but rather whether they were useful, whether they opened up possibilities that, it seemed to him, more didactic and historically informed genres of representation had closed off.

While recognising that many survivors consider such art practices scandalous, van Alphen argued for an understanding of such art practices as producing a space of engagement and learning which traditional Holocaust pedagogies could not do. Thus van Alphen spends considerable time describing the failures of traditional approaches which, he argues, assume that mastery over content, mastery over historical narrative, will translate into mastery of the future. Arguing against the notion that we need to know as much as possible about the Holocaust in order to prevent it from happening again, van Alphen claims instead that we need a pedagogy which allows for identification through imagination. Over-interpretation he seems to suggest, appears to have deadened the historical archive rather than keep it alive. Nor does it deal with the fact that the Holocaust has to be understood as a trauma, something that in its very nature cannot be mastered.

Moreover, van Alphen supports the artists' contentions that contemporary audiences need to identify with the perpetrators rather than the victims if we are to begin to understand how

the Holocaust could have happened. Interestingly he associates this need with the need to allow a space for affective experiences rather than cognitive ones, in the practices of Holocaust remembrance. The argument for the need to identify, however briefly, with the perpetrator rather than the victim is couched in terms of a distinction between ideopathic and heteropathic forms of identification where the former takes place by identifying with like and the latter with the other. The importance of momentary identification with the other is important for Holocaust education, he argues, if the goal is that of prevention in the future, for identification with the victim,

> although useful to realise how horrible the Holocaust was, is also a way of reassuring visitors about their fundamental innocence... In contrast, soliciting partial and temporary identification with the perpetrators contributes to an awareness of the ease with which one slides into a measure of complicity.
>
> (van Alphen, 2001–02: 16)

The Treblinka model is unusual within both conventional strategies for the representation of the Holocaust and the kinds of radical interventions discussed by van Alphen, because it sits across both of them. The model is easily understood as narrative, as personal testimony, as a form of remembrance, even a memorial. In so far as it works by establishing ideopathic forms of identification it works within a conventional form of didactics that frames the Holocaust as an 'apocalyptic inhumanity' (van Alphen 2001–02: 182). But in this case, this form of identification has a twist – it works in the present, not the past as discussed above. This means that it is not so easy for the audience to escape the net. We may not be identifying with the other but we are not uninvolved. For Sztajer himself, this involvement was even stronger and could be understood as what van Alphen refers to as an expression of traumatic memory. Using the French psychiatrist's Pierre Janet's work, van Alphen (2001–02: 185) argues that narrative forms of memory help people make sense of familiar experiences by integrating them into existing mental structures. However, with traumatic experiences it is not possible to do this. Instead, people either remember with particular vividness or resist integrating their experiences into any narrative at all. In the case of Sztajer, the intensity of detail and colour in his model would suggest that this object is an attempt to give embodiment to his traumatic memories in an extremely vivid manner which does not posit a distance from the event itself. It is this lack of distance that enables us to sense his grief and to be touched, that is transformed. For descendants of first-generation survivors, and indeed for non-Jewish people, this model affords the possibility of becoming linked into what Marian Hirsch (2001) termed a 'postmemory', whereby the children of survivors of trauma 'remember' their parents' or grandparents' experiences only through 'the narratives and images with which they grew up'. These however, 'are so powerful, so monumental, as to constitute memories in their own right' (Hirsch 2001: 9). While such memories are familial, Hirsch argues that it is possible for the wider community also to participate in these forms of remembering, in a process 'of adopting the traumatic experiences – and thus also the memories – of others as experiences one might oneself have had, and of inscribing them into one's own life story' (Hirsch 2001: 10). While Rick Crownshaw (2007) critiques Hirsch's concept by arguing that she ignores the historical context and therefore the ideological underpinnings of the photographs she discusses as her case study of how this memory works – those in the Tower of Faces at the United States Holocaust Memorial Museum – the example of the Treblinka model show how the particular history of an object, rather than just its physical characteristics, can provide the

material from which to provide a framework in which 'postmemory' might be able to function in ways which are both ethical and recognise historical context.

What then is the role of interpretation?

Clearly, some of the power of this object rests in its subject matter, which is made stronger by its naïve and private rendition. One cannot judge it using standard art history criteria. But the flinching that takes place at its gory rendition of horrible experiences and practices is undoubtedly augmented by the knowledge of who its maker was. While that knowledge needs to be communicated, it is clear from the discussion above that care should be taken as to the form of this communication. While it would be easy to communicate it through a formal means of communication such as labelling or an audio or live guide, the danger would be the reduction of its emotional impact to what van Alphen calls narrative memory. To work at the level of affect, gaps need to be created to facilitate the enactment of memory – that of Mr Sztajer as well as the emotional involvement of the viewer.

This seems to me to indicate the need to think about how to use these objects in a display context. The object needs enough space to work its wonder, to affect people in a visceral, physical way. While it would be wrong to contextualise this object to the extent that it became a cog in a larger narrative, sufficient interpretation needs to be provided to turn this affective response into some form of understanding. Moreover, it needs to be provided in a form that enhances the ability of viewers to have a transformative experience which leads to greater understanding – in this case the ongoing grief associated with the Holocaust. It seems to me that any future interpretation would do well to heed van Alphen's provocation that dramatic forms may be better at opening up a gap for the audience to engage with the memory of the Holocaust than, rather than close off that memory by articulating its meanings within a standard narrative about the Holocaust. Any artistic intervention, however, requires the full documentation of the object's history and meaning for its maker in a manner which allows the information to be used through a variety of media and forms. It is clear that this memorial cannot be fully understood if it is left to stand mute. The meanings may be embodied in it but they require explication.

Notes

1 This point is an important one given Noel Carroll's (2002) critique of an affect-oriented philosophy of aesthetics. Carroll argues that an affect oriented philosophy of aesthetics assumes not only a narrow range of affects, limiting these to the experience of pleasure but also narrows affect to aesthetic experiences. Only art can generate affect.
2 The information on Treblinka and on Mr Sztajer comes from a brochure produced by the JHMRC which is available at the model itself.
3 The primary function of most concentration camps was not the extermination of Jews by gassing. Most were labour camps and some such as Madjanek and Auschwitz had a double function as labour/ extermination camps. Treblinka was one of four camps that were entirely devoted to the process of exterminating mainly Jews by gassing.
4 This insight was gained in conversation with a volunteer guide.
5 It is interesting to note in passing that the notion of the 'Lost World' is not unique to the period immediately preceding the Holocaust. Indeed, as a narrative strategy, this notion was already prevalent at the turn of the century when Jewish museums displayed the culture of the shtetels in an ethnographic manner because there was a sense that such communities were already disappearing either through migration or through the process of gentrification. This is discussed in Roskies (1992).

References

Armstrong, J. (2004) 'The eloquence of silent objects', keynote address at the 'Futureground Design' Conference, Monash University, 17–21 November 2004. Abstract online <http://www.futureground.monash.edu.au/keynote.html> (accessed June 10 2008).

Baker, J. (2008) 'Beyond the rational museum: toward a discourse of inclusion', conference paper presented at the 'Inclusive Museum' Conference, National Museum of Ethnology, Leiden, the Netherlands, 8–11 June.

Best, S. (2001) 'What is affect? Considering the affective dimension of contemporary installation art', *Australian and New Zealand Journal of Art*, 2–3: 207–25.

Carroll, N. (2002) 'Aesthetic experience revisited', *British Journal of Aesthetics*, 42 (2): 145–68.

Clifford, J. (1985) 'Objects and selves: an afterword', in G. W. Stocking (ed.) *Objects and Others: essays on museums and material culture*, vol. 3, Madison WI: The University of Wisconsin Press, pp. 236–46.

Cole, T. (2004) 'Nativisation and nationalisation: a comparative landscape study of Holocaust museums in Israel, the US and UK', *Journal of Israeli History, Politics, Society, Culture,* 23 (1): 130–45.

Colebrook, C. (2002) *Gilles Deleuze*, London: Routledge.

Crownshaw, R. (2007) 'Photography and memory in Holocaust museums', *Mortality,* 12 (2): 176–92.

Gibson, R. (2006) 'Spirit House', in C. Healy and A. Witcomb (eds) *South Pacific Museum: experiments in culture,* Melbourne: Monash University ePress, pp.23.1–23.6, DOI:10.2104/spm06023.

Hasian Jr, M. (2004) 'Remembering and forgetting the "Final Solution": a rhetorical pilgrimage through the U.S. Holocaust Memorial Museum', *Critical Studies in Media Communication*, 21 (1): 64–92.

Hirsch, M. (2001) 'Surviving images: Holocaust photographs and the work of postmemory', *The Yale Journal of Criticism,* 14 (1): 5–38.

Jewish Holocaust Centre (no date) 'Model of Death Camp Treblinka created from memory by Chaim Sztajer'. Brochure.

Judah, G. (2000) 'Holocaust exhibition: a miniature representation model of Auschwitz-Birkenau', *Jewish Magazine*, July 2000, online, <http://www.jewishmag.com/34MAG/exhibition/exhibition.htm> (accessed 12 June 2008).

Kwint, M., C. Breward and J. Aynsley (eds) (1999) *Material Memories: design and evocation*, Oxford: Berg.

Maisel, P. (1993) 'Interview for a videotestimony with Mr Chaim Sztajer', 11 June 1993, Melbourne: Jewish Holocaust Museum and Research Centre.

Nora, P. (1984 [1989]) 'Between memory and history: Les Lieux de mémoire', trans. Marc Roudebush, *Representations* 26: 13. Reprinted from Pierre Nora (1984) 'Entre mémoire et histoire', *Les Lieux de mémoire,* vol.1 Paris: La République

Roskies, D. C. (1992) 'S. Ansky and the paradigm of return' in J. Wertheimer *The Uses of Tradition. Jewish continuity in the modern era*, New York and Jerusalem: The Jewish Theological Seminary of America, pp. 243–60.

Sontag, S. (2002 [1977]). *On Photography.* London: Penguin Books. Originally published in USA and Canada in 1977.

Stewart, S. (1984) *On Longing: narratives of the miniature, the gigantic, the souvenir, the collection,* Baltimore, MD and London: Johns Hopkins University Press.

Van Alphen, E. (2001–2) 'Toys and affect: identifying with the perpetrator in contemporary Holocaust art', *Australian and New Zealand Journal of Art*, 2&3 (2, 1): 159–90.

Witcomb, A. (2003) *Re-imagining the Museum: beyond the mausoleum*, London: Routledge.

Young, J. (1993). *Holocaust Memorials and Meaning: the texture of memory*, New Haven and London: Yale University Press.

TOUCHING THE BUDDHA

Encounters with a charismatic object

Christopher Wingfield

Introduction

On Saturday 10 May 2008, just over 200 people gathered in front of a museum object: the Sultanganj Buddha in Birmingham Museum & Art Gallery.

Figure 4.1 Buddha Day 2008 in the Buddha Gallery, Birmingham Museum & Art Gallery (photograph by Chris Wingfield)

They were celebrating Vesakh, or Buddha Day as it was billed, which occurs at the full moon of May to celebrate the birth, the enlightenment and the death of the Buddha. The event, which involved chanting by a number of Buddhist groups, culminated with a blessing by the Venerable Ottara Nyana, the abbot of a nearby Burmese monastery. This entailed sprinkling water onto the assembled crowd, as well as the Buddha, using a bunch of flowers dipped into a bowl of water. When the people dispersed, the flowers were left in the Sultanganj Buddha's half-opened hand.

Despite what has been written about the ritual and quasi-religious function of the museum (Bouquet and Porto 2005; Duncan 1995), this is not the way in which most museum visitors behave.[1] It was clear that most of those who attended the blessing and chanting had some level of religious commitment to Buddhism and directed their attention towards the Buddha. While Buddha Day is sometimes promoted by the museum as an event for the public with performances and activities later in the afternoon, these are generally directed towards the audience, in contrast to the morning's activities. The focus of the ritual was clearly on the non-human presence that overwhelmingly dominates this gallery in the museum: the Sultanganj Buddha.

While the behaviour of the humans may be unusual, so is the object towards which their behaviour is directed. At 2 m high, weighing over 500 kg and around 1,500 years old, it is superlative in many ways. It has been described as the finest and most important piece of ancient Indian art in Britain and the largest Gupta period (fourth to seventh century CE) bronze casting in existence. In terms of its local significance it is also one of the first objects to enter the collections of the Birmingham Museum & Art Gallery, and the museum's most valuable object.

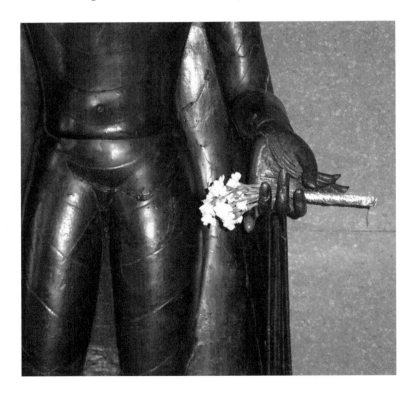

Figure 4.2 Flowers in the hands of the Buddha following Buddha Day 2008 (photograph by Chris Wingfield)

The Buddha is the only object in Birmingham Museum & Art Gallery to have a free leaflet devoted to it, and to have miniature scale models for sale in the museum shop. It is frequently featured in published accounts of ancient Indian and Buddhist art, and has been subject to considerably more scientific investigation, such as carbon and thermoluminescence dating, than any other object in the Birmingham collections. It is also the only object in the Birmingham collections that has become the focus for a regular religious ritual, and seems unusual in having capacity to attract and engage the humans who encounter it, becoming in the process the centre of all sorts of human activity.

Birmingham Museum & Art Gallery has had a gallery devoted to the Sultanganj Buddha since 1998, filled by complementary objects, many on loan from the British Museum and the V&A in London. The Buddha now stands, framed by an archway, against the end wall of the long passage formed by the Victorian wing of the museum. This enables a view of the Buddha from the Round Room, the museum's main entrance hall, through the iron-framed Industrial gallery. If ever a museum had a star object, this was it, and it could be argued that a certain amount of the attention drawn by the object is due to the theatrical staging and framing arranged by the museum. This includes the training of spotlights on the object and painting of the gallery a shade of orange to match that of a Buddhist monk's robe. However, the biography of the Buddha before 1998 suggests that it has been a focus for particularly charged forms of human engagement over a long time scale and in situations as diverse as rural India and post-industrial Britain. This suggests that there may be unusual qualities of the material object itself, beyond the details of its age, value and 'art-historical' significance, which demand a response from those humans who encounter it face to face. Indeed the fact that the object has a face seems to be significant in allowing it to engage humans. That it is an object with a human-like form may also be significant in enabling humans to treat it in ways that extend beyond their usual repertoire of everyday relationships with objects. The history of the Sultanganj Buddha as a material object suggests that it has the peculiar capacity to become the focus for human activity, in the process gathering other people and objects around it.

The Sultanganj Buddha, it seems, is a charismatic object. While this juxtaposition of terms might at first glance seem slightly unusual, it is actually in line with the notion of charisma introduced by Max Weber in his *Sociology of Religion*. He (Weber 1968: 400) uses the term to 'distinguish the greater or lesser ordinariness of the phenomena in question' and illustrates this by first suggesting that 'not every stone can serve as a fetish' and only then that 'nor does every person have the capacity to achieve ecstatic states.' Indeed Weber suggests that 'charisma' be used as a gloss for the 'extraordinary powers' designated by '*mana*,' '*orenda*' and the Iranian '*maga*' (the term from which our word 'magic' is derived)'.[2] That the Sultanganj Buddha is extra-ordinary cannot be doubted since it stands out from the thousands of other objects in the Birmingham collections in being able to elicit such a degree of human response.

The tendency to associate charisma with people rather than objects was not present in Weber's writings on religion (Weber 1968: 609) where he suggested that 'the needs of the masses everywhere tend towards magic and idolatry' (ibid: 400–1). Indeed, we might suggest that for many museum visitors, their relation with the Sultanganj Buddha falls somewhere along the scale of what Weber calls 'magic and idolatry'; a reverence bordering on awe. However the opposite reaction to the charisma of a material object might be characterized as 'iconoclasm' and it is significant that the targets for acts of destruction are almost never unproblematic everyday objects. Unlike these, charismatic objects seem more likely to polarize human opinion towards emotive and away from mere utilitarian attitudes. 'Idolatry', the worship of material objects, and 'iconoclasm', their deliberate destruction, might serve as polar opposites in the scale of

human reactions to charismatic objects. The centre of the scale in such a continuum would be characterized by disinterest, while less extreme forms of negative reaction might include attempts to obscure or remove objects. Acts of care and preservation might be seen as less extreme positive reactions on the scale towards 'idolatry'. These extreme ends of the spectrum have obviously been occupied by certain religious positions at various moments in history, but less attention has been drawn to the material qualities of the objects towards which they have been directed. It was, after all, a 'golden calf' that Moses destroyed on his return from Mount Sinai (Exodus 37) and not merely lump of clay. Both form and material seem to have been crucial in allowing this particular object to become the focus for idolatrous attention.

If we recognize, as Weber and Pacific notions of *mana* seem to, that things can have charisma, then we are faced with a problem that Weber only began to address: how certain things come to be unusual and stand out from the ordinary. Charisma, like magic, is a property far easier to recognize than to understand and explain. The Sultanganj Buddha, it seems, is an object in which the possession of charisma might be demonstrated, but getting to its roots and locating these in the material qualities of the object itself may be significantly more difficult. A key feature of the operation of charisma is the way in which it evades precise location and explanation, coming close to the effect Alfred Gell (1998) has explored in relation to 'technologies of enchantment' – not being able to fully understand how such an effect is achieved. If it were easy to identify how charisma worked it would cease to operate as effectively. The element of a magic trick that makes it appear magical is that which is unclear or obscured from view. In the case of the Sultanganj Buddha, the charisma appears not to be confined to particular social and cultural settings, and given that it is only the material object itself which has existed among humans in different times and places, it seems sensible to consider how charisma may operate within the embodied encounter between the human form and the human-like form of this non-human object.

The moment of contact

In an interview published in the museum's journal of March 2005 on her favourite museum, Clare Short, the member of parliament for Ladywood in Birmingham, described her lifelong engagement with Birmingham Museum & Art Gallery (Heywood 2005: 58). When asked about her favourite object she stated 'As a teenager I would walk through the museum. I remember a lovely old Buddha. Something always struck me enough to pause.' Short went on to choose a statue by Epstein of Lucifer as her favourite object.[3] However, the pause in relation to her choice, is similar to the pause she describes when walking through the museum. The Buddha is an arresting object that can entail a change of relation and attention from the observer, independent of any detailed knowledge of the symbolism of Buddhist sculpture.

In *The Corporeal Image,* MacDougall (2006) has discussed the moment of contact with images, when meanings emerge from experience, suggesting:

> At that point thought is still undifferentiated and bound up with matter and feeling in a complex relation that it often later loses in abstraction. I am concerned with this microsecond of delivery, of knowledge at the birth of knowledge.
>
> (MacDougall 2006: 1)

In considering the relations of people in a museum with an object such as the Sultanganj Buddha, it seems important to take seriously this 'microsecond of delivery' as the moment of contact in which the attitude to be adopted towards an object may be established. While there

are clearly ways in which cultural and religious experience may influence attitudes to objects, there are also ways in which they can be pre-conditioned by our basic perceptual and cognitive apparatus. Cognitive research has suggested that most humans are particularly sensitive to the perception of lateral symmetry (Beck *et al.* 2005) and the recognition of other human faces and facial expressions (Bruce and Young 1998). When encountering an object such as the Sultanganj Buddha, it seems likely that the fact that it has a human-like body, with lateral symmetry like most animals, and has a human face, would make it a focus of attention before any conscious realization of what had been seen was established. If these factors are rooted in the human perceptual apparatus, and experiments suggest that they are in place by birth, then these effects should be observable in humans regardless of the religious and cultural attitudes to objects in which they are exposed.

The 2001 census suggests that only 0.3 per cent of Birmingham's population of one million people, around 3,000 people, identified themselves as Buddhists (National Statistics 2003). Of these around 50 per cent were born in the Far East and around 25 per cent self-identified as white (Birmingham City Council 2001). Obviously this is a fairly small group, and in terms of major religions, manages to outnumber only Judaism in the city. The same census suggests that around 20 per cent of the population of the city identify themselves as having a South Asian ethnic identity and background and might therefore have some cultural or historic identification with an object from that part of the world. However, for the remaining 80 per cent of the Birmingham population, who neither identify as Buddhists nor have any South Asian heritage, it seems that the sculptural figure of the Buddha still has significance. Many visitors to the museum, who outwardly appear to belong to neither of these groups, will pause in front of the object, examine it closely and frequently reach out to touch it. The capacity of other similar Buddha images to have a widespread appeal across many sections of the population is suggested by the widespread sale of these in various poses as garden ornaments and home decorations. Indeed, the Jamhouse, a music venue only half a mile from the museum in central Birmingham, has a large seated Buddha overlooking the bar. While these contexts share little with either a museum or religious presentation of such a figure, the widespread use of Buddha figures suggests that there is something in the form of these images themselves, beyond the scale, age and value of the museum object, that is both suggestive and arresting.

People seem to notice the Sultanganj Buddha in ways that they do not notice other objects in the museum. They also care more about what happens to it, and this concern has generated four large museum files of notes, correspondence and cuttings relating to the object, when most objects in the museum have just a single, slim folder of notes. Among these files are cuttings relating to some of the reactions outlined above. They also contain a complaint from 1992 about the then position of the statue next to the gentleman's lavatory; an article from a practising Buddhist in 1988 which took objection to the description of the statue in a council marketing campaign as 'a relic'; and an article from 1979 concerned at people shaking hands with the statue. Areas of the statue are today worn smooth and have become shiny, because of the frequency with which they are touched. These marks of human contact invite subsequent museum visitors to reach out and do the same. Even before 1998 when the Buddha was deliberately framed by the architecture of the museum, it seems to have been an object of notice, remark and, it seems, care. This tendency of visitors to reach forward and touch the Buddha, appears to come from a desire to make a literal and physical connection with the object in front of them. This tendency appears to have been a feature of human relations with this charismatic object throughout the period of its existence. However a number of incidents in the 'biography' of the object suggest that efforts to touch the Buddha may have, at times, been driven as much urges towards 'iconoclasm' as by 'idolatry'.

Encounters: 'idolatory, iconoclasm and co-option'
Continuities in the biography of the Sultanganj Buddha

Richard H. Davis in his book *The Lives of Indian Images* (1997), has done much to explore the ways in which Indian images have been relocated and revalorized by various communities of response. Drawing on Igor Kopytoff's (1986) proposal for a 'cultural biography of things,' Davis has traced the lives of a number of Indian images. The Sultanganj Buddha does not find a place in his book, but might easily have been included, since it too has a complex biography. For Davis, whose notion of 'communities of response' is drawn from literary reader-response theory (Fish 1980; Fish 1989), the responses are highly conditioned by the framing of the images in either Museum or Temple (Davis 1997: 9). He suggests that responses are cultural forms, 'learned within particular social settings' (ibid: 8). In the case of museum displays, which he links strongly with art-historical narratives, these may 'dramatically alter' the significance of an image for new audiences (ibid: 9). This theoretical framework, however, appears to fundamentally limit the agency of Indian images as material objects in their own right, locating the nature of human responses to them as conditioned by 'social' and 'cultural' forms rather than in an embodied encounter with a material object. In the case of the Sultanganj Buddha it is unclear that such effects are necessarily so determining, since the position and framing of the object has changed many times, yet the treatment of the image in the museum continues to share features with what Davis describes as temple forms. In addition the object has been reached out to and touched by a stream of museum visitors who have little familiarity with the practices of Indian religion.

The responses to the Buddha, whether from those conditioned to South Asian religious forms or not, seem to share certain recurring patterns and continuities which range between 'idolatry' on the one extreme and 'iconoclasm' on the other. Although Davis (ibid: 8) suggests that responses to images 'are primarily grounded not in universal aesthetic principles of sculptural form or in a common human psychology of perception, but significantly in varied (and often conflicting) cultural notions of divinity, representation, and authority', it seems necessary to locate some of the observable continuities in the embodied experience of encountering the Buddha. The strength, if not the form, of reaction to the object is a demonstrable feature of human relations with it for at least 150 years, and possibly more than 1,000, in a range of different cultural settings.

Iconoclasm and the burial of the Sultanganj Buddha

The biographical mode and metaphor which Davis borrows from Kopytoff is a useful tool, and if followed, it seems that the Sultanganj Buddha has had at least two lives in the 1,500 or so years since it was made, with a rebirth following its excavation in 1861. This was connected with the building of the East Indian Railway which began in 1851.[4] Each length of track was overseen by an engineer or assistant engineer, with the chief engineer responsible for the whole development. The chief engineer at the time of the Buddha's discovery was George Turnbull, and in the region of the Jeehangeerah hills and Sultanganj in Bihar the local engineer was E.B. Harris. Little is know about Harris, but in 1860 or 1861 he was building what would become the station yard at Sultanganj. Spotting large piles of old mud bricks, he decided to use these as ballast for the track. The many Indian excavators[5] who worked for him would have been able to remove large numbers these from what it was later realized were the remains of ancient Buddhist *viharas* or monasteries – four-sided courtyards facing in upon themselves. Harris became interested in the remains and decided to investigate them further.

In describing the discovery of the Sultanganj Buddha, Harris (1864: 4) states that the 'the right foot of the copper image was met with ten feet under the surface.' He suggests that:

> The image must originally have stood in the verandah and centre of the west face of the building, it appears to have been thrown from the stone into a hole, partly cut into the floor, the stone afterwards removed a few feet to the south and then turned over; I found it upside down; it then appears that a pucka or concrete floor was constructed along this portion of the verandah, thus hiding all trace of the image, after which the building from about this level must have been destroyed, and not rebuilt most likely for several hundred years.
>
> (Harris 1864: 5)

Harris' suggestion, based on the archaeological context of discovery, is that the location of the Buddha was the deliberate result of an attempt to protect the statue from the attention of marauding iconoclasts, or at least to hide it in order to preserve it. This suggests a recognition by those who buried the Buddha that it would have been a focus for iconoclastic attention, but also provides evidence for an act of extraordinary care by humans seeking to protect a material object. Alexander Cunningham, the Indian government archaeological surveyor (Cotton 2004), in a letter quoted by Harris to the secretary of the Asiatic Society in Calcutta stated that:

> From these discoveries I conclude that the resident monks had only just time to bury the colossal copper statue of Buddha before making their escape from the *Vihár*, and consequently that numerous objects of interest must have been abandoned by them.
>
> (Harris 1864: 10)

In his account Harris mentions finding the mutilated remains of other images (ibid: 4), suggesting evidence for an historic period of iconoclasm in the area. A large stone Boddhisattva, also from Sultanganj, which was sent to Birmingham with the Sultanganj Buddha, shows signs of having been literally defaced; the faces of each of the small figures on it targeted for destruction. The extreme actions that surrounded the end of the Sultanganj Buddha's first life, only emphasize the degree to which even many hundreds of years ago the object was able to exercise strong human feelings – destructive as well as protective.

Idolatry and the resurrection of the Sultanganj Buddha

In contrast to this suggestion of extreme iconoclastic threat, is Harris' report of the reaction of the local, mainly Hindu population after the discovery. He states:

> The news spread rapidly, and by the next morning several thousands of natives had arrived, and others could be seen coming in all directions up to a late hour that night. The excitement during the uncovering of the body was extreme, and much difficulty experienced in keeping the people back from the falling earth. After the image had been taken from the vertical sides of the excavation and some of the dirt removed from it, the people were allowed to examine it as they liked: the image was immediately surrounded, many of the Hindoo women kissed it making very curious remarks; this great excitement did not, however, long continue, they soon found out that it was not of their religion, which the priests at the Hindoo temple before referred to pointed out when they found

they could not get the image, even by purchase. I believe, during the first 8 days, about 10,000 people visited the spot and image, and for months afterwards numbers came daily.

(Harris 1864: 4–5)

The enormous interest that the discovery and excavation of the Sultanganj Buddha provoked are clearly related to the form of the object, since the local population must have been frequent witnesses to the excavation of ancient mud bricks, which seems to have largely passed without comment. While the rarity of the material is probably significant, after hundreds of years in the ground the copper of the Buddha would not have shone as lustrously as it does where it has been frequently touched today. The 'great excitement' which Harris notes was undoubtedly partly related to religious expectations, as Harris suggests, but these expectations would not relate to just any ancient excavated object. Harris' determination not to let the 'priests at the Hindoo temple… get the image, even by purchase' also seem to stem from his own recognition of the Buddha as unusual, extraordinary and charismatic, and therefore something that could serve the British interest. This reaction, and that of the priests from the local temple suggests a prototype for a third common reaction to the Sultanganj Buddha as a charismatic object: co-option.

Institutional co-option

The temple Harris refers to was that at the Jeehangeerah rocks, where there was both a Hindu temple and a Mosque. Harris suggests that in the Hindu temple were examples of Buddha carvings altered into Hindu figures, and it seems had it been allowed, the priests would have performed a similar act of incorporation with the Sultanganj Buddha, perhaps in presenting the Buddha as an avatar of Vishnu. While the burial of the Buddha seems to have been precipitated by conditions of iconoclastic threat, the reverence with which it was treated by the local Hindu population following excavation suggest an opposite 'idolatrous' extreme in terms of ways of relating to the object. The attempts by the Hindu priests to 'get the image' suggest a willingness to co-opt this image and its charisma into the service of their temple. However plans were already afoot from the other side of the world to co-opt the image into a different kind of institution, then being established: Birmingham Museum & Art Gallery.

The Buddha was sent to Birmingham in 1863 at a cost of £200 which was paid by Samuel Thornton. He was a Birmingham manufacturer whose primary business seems to have been railway ironmongery. It seems likely that this transaction was carried out through George Turnbull as intermediary, the chief engineer on the East Indian Railway, who was himself returning to England in 1863. Thornton had been mayor of Birmingham in 1848, and in 1849 was involved in organizing an exhibition for a meeting of the British Association for the Advancement of Science at Birmingham. We can perhaps get the clearest indication of his intentions from his letter of 7 October 1864 when he offered:

the colossal figure of Buddha, and the large marble one, to the town, to be placed in the Art Museum, now being erected, where they may be duly and properly located for the free inspection of the inhabitants of Birmingham, and all who may be induced to visit the institution, when fully established, as doubtless they will be objects of regard and study to many who lay no claim to be decided antiquarians.

(Thornton 1864)

It was hoped that the proposed gallery would be 'a means of educating the tastes of those upon whom the reputation of Birmingham manufactures chiefly depends' (Davies 1985: 15) and Thornton states in his letter that he wishes to present the items 'for the public benefit' (Thornton 1864). For Thornton, the Buddha could be co-opted and used as a means of forcing the hand of the corporation of Birmingham to adopt a scheme to establish a public gallery, as part of a movement known as the 'civic gospel' and promoted in mid-nineteenth-century Birmingham by the Nonconformist manufacturing elites (Parsons *et al.* 1988: 47). Thornton, as a manufacturer, was likely keen that the gallery should ultimately lead to the inspiration of local craftspeople, an improvement in the quality of products and the success of the city in world terms.

The power of the Sultanganj Buddha, as a charismatic object, to lend weight to a range of different interests if successfully co-opted, meant that it could hardly be ignored. One might suggest that the mode of co-option by Thornton to lend weight to the campaign for a museum was not very different from the attempted incorporation of the statue by Hindu priests into their temple. There is a sense in which the charisma of the Sultanganj Buddha encourages different groups of people to attempt to recruit it, in order to co-opt the material and tangible support it might lend to their position in the world. By contrast, for those whose position in the world it threatens, it emerges as an obvious focus for acts of removal and destruction. The local Brahmans were not the only ones who were unsuccessful in their attempt to co-opt the Buddha to their cause, since one note in the Birmingham files (BM&AG 2008a) suggests that on its way to Birmingham, the Buddha was shown to the Asiatic Society in London and efforts were made to secure it for the British Museum. [6]

Echoes of earlier events

The Sultanganj Buddha has been a key object in the collections of Birmingham Museum since 1864, but this has not precluded it from being associated with reactions similar to those of 'idolatry, iconoclasm and co-option' which surrounded its earlier burial and then excavation.

'Idolatry' and adoption

The most obvious example of such an echo is the recent Buddha Day celebrations, which though not entirely 'idolatrous' involve an attitude of profound respect, even reverence towards the object. The attitudes taken by participants towards the Buddha may vary. In a recent web article as part of a series on Divine Art for the BBC in Birmingham, Keith Munnings, chair of the West Midlands Buddhist Council explained that 'It's always helpful for Buddhist groups to meditate and chant with a Buddha statue present because it symbolizes what we're trying to achieve in meditation.' His colleague Yann Lovelock, one of the driving forces behind the first Buddha Day, added 'I feel a great personal devotion to this and I've made it my practice to bow to this particular Buddha' (BBC Birmingham 2007). While neither would suggest that the Buddha image was a god, and that they were worshipping it, they would presumably recognize that their attitude to the Buddha is not the same as to a mundane, everyday object. However, the Buddha Day event involves aspects of co-option as well as of 'idolatry'. The 2008 Buddha Day celebration, described above, was only one in what has become a regular annual event since 2004. Normally held on a Saturday afternoon, these events have been hosted and partially funded by Birmingham Museum & Art Gallery, but the chief organizational role has come from the West Midlands Buddhist Council.[7] The Buddhist Council is able to use the museum

as a neutral and therefore non-denominational space in which Buddhist groups from different traditions can come together in order to celebrate the day together.[8]

There is a great deal to be gained by the West Midlands Buddhist Council by co-opting the Sultanganj Buddha and the museum as a venue, since the event is one of their most tangible outcomes. The museum offers a non-denominational space in which groups from across the spectrum of the Buddhist tradition can assemble. Nevertheless this would not be possible or appropriate without the enabling material presence of the Sultanganj Buddha, casting its eyes over the proceedings and forming an essential element in these events. Indeed whether the idea for such an event would have presented itself without the presence of the Buddha and a dedicated gallery in the centre of Birmingham is doubtful.

Iconoclasm and 'active repatriation'

The attention the Sultanganj Buddha has received in Birmingham has not always been of a positive kind. On 30 July 1998, an article in *The Independent* newspaper (Bell 1998) reported that Roy Pinney, a Labour councillor, then head of the city's education committee, suggested that the object had been taken immorally and might be returned to its country of origin. He was quoted as connecting Birmingham's collection, and particularly the Buddha with 'the disreputable bits of British history,' and suggesting that 'I suspect we possess some objects which have been acquired in a mildly embarrassing way and might be returned to the countries where they were found.' This at least is an improvement on suggestions by earlier generations of city councillors that the Buddha might be sold to bridge problems in city finances or taken to the National Exhibition Centre for an antiques fair (BM&AG 2008b). It is perhaps unsurprising that such a prominent and striking object might become the focus for a range of debates in relation to museum collections, such as those about repatriation. However, active and unsolicited repatriation of the kind suggested by Pinney, might be seen on a scale of iconoclastic actions which assert that such an object has no place in present-day Birmingham (in Pinney's case as part of an effort to distance Birmingham from Britain's colonial past). While returning an object to India is not the same as returning it to dust, as in the case of the Bamiyan Buddhas in Afghanistan in March 2001 (Rathje 2001), such attention is ultimately of a negating rather than affirming kind. If the Buddha were a human rather than an object, it would have acquired rights of residence, citizenship and immunity from repatriation after only five years residence in Birmingham. No request has ever been received for the return of the Buddha to India, but the question has been set as an essay topic for local heritage studies students, suggesting once again its charismatic pre-eminence among the thousands of objects in the Birmingham collections, some of which have considerably more shady and dubious provenances.

Mythology and polemic

Charismatic objects, like charismatic people, seem to become the focus for debates and polemic, but also the subjects of myths. In this case these emerge because of the prominence of the Buddha as an object, and the ways in which people and groups have sought to position themselves in relation to it. Some myths have even found their way into official museum publications. One of the most persistent is that the Buddha was the first object to enter the Birmingham collections (Birmingham Museum & Art Gallery 1999: 72). It was actually the second object donated to form the basis of the proposed museum.[9] Another frequently repeated myth is that the Buddha

narrowly avoided the melting pot after its discovery. While there was a suggestion by one of the councillors when the Buddha was offered to Birmingham in 1864 that the Buddha had originally been brought there for its material value, this was ridiculed by other members of the council (Anonymous 1864c; Anonymous 1864b).

A further related myth is that when the Buddha was discovered, the European engineers could not believe:

> such a high quality of smelting and copper casting could possibly have been achieved by Indians. They assumed it to be of Birmingham manufacture, sent out to India for sale.
>
> (Birmingham Museum & Art Gallery 1999: 201)

This myth can be found propagated in the Museum's current guidebook (Birmingham Museum & Art Gallery 2001: 12–3) and in a publication on world art in Birmingham's collections (Birmingham Museum & Art Gallery 1999: 201). It is a convenient myth, inverting the assumed Orientalist gaze and projecting it onto the British barbarians, but its roots lie far from direct historical evidence. Instead it seems to have its origins in an assertion made in a publication called *Indo-Aryans* (Mitra 1881: 151) by the Bengali antiquarian, prolific writer and polemicist Raja Rajendralal Mitra. The publication of a *Description of Buddhist Remains Discovered at Sooltangunge on the River Ganges 1862–3* by E.B. Harris in 1864, makes it clear that he was reasonably well versed in the antiquarian study of India. Also in 1864, the donor Samuel Thornton (who referred to the object as a 'Buddha' when local newspapermen were content to refer to it as an 'idol' or a 'god' (Anonymous 1864a)), published the text of a lecture on 'The Buddha and his Religion', which had been delivered at the Midlands Institute in Birmingham (Sargent and Thornton 1864).[10]

However, Mitra appears to have been engaged in an effort to co-opt the Buddha to support his own greater nationalist project, a central polemic of which was to reject suggestions of the influence of European, and particularly Greek architecture and sculpture on India (Sartori 2007: 80). In its place Mitra sought to build a notion of an Indian classical age, with objects like the Sultanganj Buddha at its centre, to parallel the position of ancient Greece for contemporary Europeans. Obviously a tale emphasizing the foolishness of European colonists fitted well with a political project that sought to throw off European influence. Mitra's ambivalent attitude to Britain, and possible resentment of the Buddha being removed there is illustrated in the same publication when he confuses England's two major provincial manufacturing towns and states that the Buddha is housed in Manchester Museum (Mitra 1881: 139). In the use made of the Buddha by both Thornton and Mitra, we can see evidence that each was keen to marshal and co-opt the statue, and its charisma, to support their own agendas. For Mitra, this meant asserting its place in a nationalist narrative of India's golden age and denigrating the context of European appropriation of the image, while for Thornton this meant promoting the object as an example of artistic achievement and skill in the history of metallurgy. In both cases it seems that it was the charisma of the object, its lack of ordinariness, which was crucial to its ability to lend weight to these positions.

Unpacking charisma

In tracing some of the events in the biography of the Sultanganj Buddha over the last century and a half, and the archaeological hints we have of its earlier life in medieval India, it should be clear that people have reacted in a number of similar ways to its charisma and attempted

to harness this force. For all the discussion of the agency of objects (Gell 1998) and their biographies (Kopytoff 1986), it is clear that not all objects have the same ability to attract human attention, both positive and negative, as the Sultanganj Buddha. There are thousands of other objects in the collections of Birmingham Museum & Art Gallery, and in hundreds of other museums up and down the country that have never been subject to the same degree of human attention. Instead, there are a small number of well-known examples of museum objects such as the Elgin Marbles, the Benin Bronzes and human remains that seem much more able than most to generate human concern, and around which many public discussions and controversies rage. While a certain amount of this is of course because of the circumstances of their collection and acquisition by museums, at least some of the reasons for the concern they generate seem to lie in the physical qualities of the objects themselves, and the manner in which they are able to generate an affecting response in humans. In many cases, as in the case of the Sultanganj Buddha, this concern manifests itself as a desire to recruit the object to a particular assemblage (Latour 2005) or cause such as a Hindu temple, the British Museum, Indian nationalism or the city of Birmingham. In other cases, the concern can lead to a desire to be rid of the object, to send it back to where it came from or destroy it, what we might call an iconoclastic urge (Latour and Weibel. 2002). In some instances however, contact with an object can lead to fascination or enchantment, a moment of wonder, of concentration and intent looking, possibly leading to the desire to reach out and touch the object, grounding visual contact in the physical sensation of touch and the solidity of material contact. This seems to be a relatively common reaction among many ordinary museum visitors who are not attempting to co-opt the Buddha for any particular purpose.

What is so exceptional about the Sultanganj Buddha, that it is able to evoke this sort of response? Age and value are often mentioned in the context of museum labels, and there is certainly a degree of wonder that surrounds encountering an object that is over 1,000 years old, but in many ways these seem to be fairly insubstantial factors that do not fully capture the experience of actually encountering an object such as the Sultanganj Buddha. Similarly the wonder generated by trying to fathom the technical skill necessary to create such an object, or what Alfred Gell (1992) has called 'the enchantment of technology', is as he has pointed out often better comprehended by those who have a sense of the techniques of manufacture and therefore understand the virtuosity achieved. We might suggest that this is part of what lies behind the attraction of the object to nineteenth-century Birmingham manufacturers and craftsmen, but may be less of a feature in the case on twenty-first-century office workers. What Gell has called the 'technology of enchantment' (ibid), the way in which the humans are made to feel what they do, cannot it seems be fully explained, in this case, in terms of 'the enchantment of technology', though of course the pure size and monumentality of the object are likely to suggest to the viewer that its production is an impressive achievement. While the notion of learned and cultural forms of response, characteristic of 'communities of response' (Davis 1997: 9) is of course useful – particularly in seeking to understand the way in which the Sultanganj Buddha was responded to by local Hindus when it was discovered, by West Midlands Buddhists, and even by the majority of the museum going public – it does not capture something of the way in which many ordinary people may feel moved to stop at, contemplate and touch the Buddha in the museum, a form of interaction normally illicit in a gallery context. Stephen Pattison (2007) has developed the notion, of 'illicit' relations with things, that escape from our culturally acknowledged and developed repertoire. Touching the Buddha is something that many museum visitors do without necessarily realizing why they do it. Weber (1968: 400–1) captured something of this when he remarked on the way in which what he called 'folk religion'

tended towards the 'naturalistic orientation' 'of the earliest religions' which he characterized as frequently oriented towards charismatic objects. This uncertainty about why people act in the way that they do in relation to some objects, and the tensions this creates with religious injunctions such as Moses' third commandment, is explored by Bruno Latour in his writing on what he calls 'Iconoclash' (Latour and Weibel. 2002). The charisma of certain objects, and the capacity of humans to recognize this and be drawn to it is clearly not a phenomenon limited to cultural and religious contexts in which such behaviour is officially endorsed.

A human-like non-human

Much of the affecting presence of the Sultanganj Buddha may perhaps be connected to its over life-size scale and its anthropomorphic form – effects that are explored in the work of the sculptor Anthony Gormley (2008) in art objects such as the famous 'Angel of the North' and the lesser known 'Iron Man' which stands in Victoria Square, just outside Birmingham Museum and Art Gallery. However, like the victims of iconoclasm, many of Gormley's anthropomorphic figures are faceless, and one of the most remarked upon features of the Sultanganj Buddha is the figure's facial expression – and specifically, its tranquillity. It seems that here we must consider factors related to the human psychology of perception, and the peculiar capacity of humans to be extremely sensitive to expressions of the human face, from which it seems even newly born infants are able to intuit emotion and attention in others (Bruce and Young 1998; Darwin 1872).

It seems that in attempting to understand the 'technology of enchantment' and the skill of the makers of this Sultanganj Buddha in creating an object so able to demand human attention over a much longer lifespan than their own, it might help to place the development of this skill in relation to what we know about the ongoing South Asian religious tradition. The practice of *darsan* (Eck 1998) which involves presenting oneself to be seen by religious images as a form of religious practice, relies on an understanding of looking as an active sort of touching, or making contact. In contrast to modern scientific notions of the eye as a passive receptor of light, in this tradition to be looked at is to be touched. The face and particularly the eyes of Indian religious images become necessary since they are made not just to be seen, but also to see the devotee and through this to create a sense of inter-subjectivity, of having been seen by another. The final stage in the installation of religious sculptures normally involves the painting on of their eyes, and an installation ceremony performed in the Birmingham Museum by Burmese monks when another smaller Buddha visited the gallery, on loan from London, was called 'opening the eyes of the Buddha.' The experience of *darsan* is not one of seeing a religious statue, but of being seen by it, and as a result being touched and affected by this contact. Perhaps it is this sense of being seen by this object in human form, with a face that can be read for its expression and eyes that seem to look, which is crucial to the charisma of the Sultanganj Buddha. Like a painting with eyes that seem to follow one around the room, the Buddha, by seeming to look creates a feeling of having been seen. In the Indian devotional practice of *darsan*, presenting oneself to be seen by a statue relies on accepting that human-created objects are able to mediate the effects of divine power, and that through more or less skilful construction, combined with the ritual and religious process of installation, the human craftsman can be the enabler of this effect.

This seems to be precisely the understanding towards which Latour and his collaborators were grasping in the exhibition and book *Iconoclash* (Latour and Weibel 2002). For Latour this understanding parallels his understanding of the scientist (Latour 1987; Latour 1999), as working, through highly trained skill and extreme manipulation, to make visible aspects of

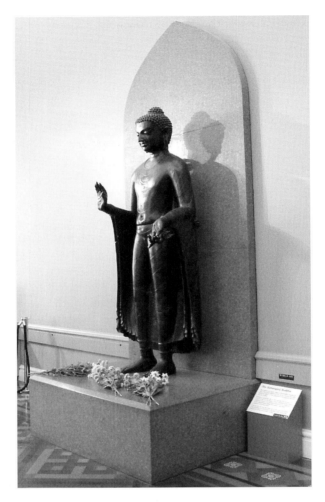

Figure 4.3 The Sultanganj Buddha following Buddha Day 2004 (photograph courtesy and copyright Oliver Buckley, Birmingham Museum & Art Gallery)

the way in which the world works. That science is socially constructed, in his argument, does not make it invalid or pure artifice, but instead shifts the question to become whether it has been well or badly constructed. The fact that the Sultanganj Buddha has managed to retain its charisma for well over 1,000 years, and in very different parts of the world, suggests that it has been extremely well constructed. That it is able to give some of those who encounter it a sense that through its regard they encounter the mediated presence of the historical Buddha bears still stronger testimony to the skill of its construction, which has enabled it to build on a series of human cognitive sensitivities to achieve this effect.

Conclusion: the multiple sources of charisma

The Sultanganj Buddha, perhaps like all charismatic things – human and non-human – seems able to combine a great many factors that in combination make it unusual and remarkable, and something which stands out in the context of the museum. The skill of its initial construction, or what Weber (1968: 400) might have called its charisma by natural endowment, seems significant in lending it an anthropomorphic form of appropriate scale and colour that make it highly resonant with human perceptual experience of the world. Nevertheless this has undoubtedly been enhanced in recent years by what Weber calls artificially produced charisma, such as its framing and presentation within the museum. Further charisma seems to be acquired by its longevity and age, with the events of its biography lending to the Buddha a patina, a recognized indicator of *mana* in Polynesia. Bruno Latour, it seems, might want to suggest that this distinction between natural and artificial charisma are unnecessary, since charisma is always produced, whether by deliberate processes of casting or upbringing, or longer term processes such biological evolution or the geological processes that were responsible for producing the copper which gives the Buddha its iridescent and evocative colouring.

That humans should attempt to co-opt and recruit an object as charismatic as the Buddha to their own position is perhaps inevitable due to the weight of support that it seems to bring with it. In addition its charisma brings a capacity to attract and convince others that far outweighs the potential of many more mundane and everyday people and objects. The skill and virtuosity of the original makers of Sultanganj Buddha has endowed this object with a charisma that can still be felt long after it was created, and in contexts far removed from the Buddhist monastic context for which it was intended. It would seem wrong, as Latour suggests, to understand this skill as an example of manipulation, trickery and an exercise in artifice. Instead it seems important to recognize the likely aim of those who made it to make present aspects of the person and teachings of the Buddha through their work (Swearer 2004), just as they might do through their ethical behaviour or speech.

Notes

1 However, for a similar case with offerings made within a museum space, see Parker 2004.

2 It has been suggested (Riesebrodt 1999) that Weber's use of the term must be understood in relation to the debate about *mana* engaged in by contemporary anthropologists. *Mana* is a Pacific concept which applies to people as well as objects, marking them out from the ordinary, and was introduced to Europe by the Anglican missionary R.H. Codrington (1891).

3 This is also an over life-size human figure, and now stands at the centre of the Round Room in the direction of the Buddha's view.

4 All of the heavy industrial material used in the railway was manufactured in Britain (Kerr 1997: 2) and it is reasonable to suggest that a fair proportion of this was manufactured in Birmingham and the Black Country. By the end of 1863, 2,764,781 tons of railway material – rails, sleepers and carriages – valued at £15,128,856 had been sent in 3,571 ships from Britain to India (Kerr 1997: 22, referencing *The Engineer*, 19 August 1864: 120). It has been suggested that each mile or railway built in the 1860s required on average a separate ship carrying some 600 tons of material from Britain (Banerji 1982).

5 Working under Harris in 1860 were 4,771 mainly local workers. Of these 2,121 were excavators and there were on average 239 workers per mile of track.

6 Following the donation by Thornton in 1864, the Buddha was first displayed in the 'Corporation Art Gallery', a room 70ft by 30ft in the Central Library. In 1876 the Buddha was sent to the city's Jacobean house Aston Hall for safekeeping during the building of the new Museum & Art Gallery (Davies 1985: 19) which opened in November 1885. Since that time, the Buddha has been moved at least five times within that building, and travelled to London in 1948 and 1965 for shows at the

Royal Academy. Requests for exhibition loans have not been considered since the 1980s when it was decided that the Buddha was in too fragile a condition to travel.

7 This organization was set up in 2002 with four aims:
 • To foster co-operation and friendship between Buddhist groups in the West Midlands.
 • To foster dialogue and joint activities between Buddhists of different schools and between Buddhists and other faiths.
 • To aid in co-ordinating the shared affairs of the Sangha and promote greater participation of lay devotees in the work of the Dharma.
 • To liaise with local government departments and other agencies who require information and advice about Buddhists and input from them.

(The Network of Buddhist Organizations UK 2007)

8 Groups that have participated in recent years include:
 • Birmingham Buddhist Vihara and Dhammatalaka Peace Pagoda – a Burmese temple in Birmingham
 • Birmingham Buddhist Maha Vihara – a dual-tradition temple catering to Sri Lankans, Indians, Chinese, Vietnamese and Westerners
 • The Buddhavihara Temple – a Thai temple now located in Kings Bromley, outside Lichfield
 • Birmingham Samatha Group – an English meditation tradition with its roots in Thailand
 • Birmingham Serene Reflection Meditation Group; The Order of Buddhist Contemplatives – a western form of the Soto Zen tradition
 • Sakya Ling – a Tibetan tradition of Buddhism (Sakya)
 • Karma Ling – a Tibetan tradition of Buddhism (Kagyu)
 • Shenpen UK – a Tibetan tradition of Buddhism (Nyingma)
 • Chua Tu Dam Temple, Birmingham – a Vietnamese temple in Birmingham
 • Birmingham Buddhist Centre – The Friends of the Western Buddhist Order
 • Buddha Vihara, Wolverhampton – a predominantly Indian tradition following Dr Ambedkar

9 The first was a bust by Peter Hollins of the Birmingham artist David Cox, accepted by the city in May 1863 (Davies 1985: 14).

10 The lecture was by William Lucas Sargent and the copy that survives in the Birmingham University Special Collections was that of the Birmingham and Midland Institute's library in Union Street. The text of the lecture provides an historical outline of the religion and a summary of the life of the Buddha, and is based on the work of Barthelemy St. Hilaire, and particularly his work of 1860 *Le Boudha et sa religion* (Hilaire 1860).

References

Anonymous (1864a) 'An Indian god in Birmingham', *Birmingham Daily Post*, 8 October, cutting in BM&AG (2008a).

—— (1864b) 'Munificent gift of Indian relics', *Birmingham Daily Gazette*, 12 October, cutting in BM&AG (2008a).

—— (1864c) 'Munificent gift of Indian relics', *Birmingham Daily Post*, 12 October, cutting in BM&AG (2008a).

Banerji, A. K. (1982) *Aspects of Indo-British Economic Relations 1858–1898,* Oxford: Oxford University Press.

BBC Birmingham (2007) *Divine Art: devotion to Buddha,* online, <http://www.bbc.co.uk/birmingham/content/articles/2006/12/22/buddha_divine_art_feature.shtml> (accessed 11 June 2008).

Beck, D.M., Pinsk, M.A. and Kastner, S. (2005) 'Symmetry perception in humans and macaques', *Trends in Cognitive Sciences,* 9: 405–406.

Bell, D. (1998) 'Give them back their Buddha!' *The Independent*, 30 July 1998, online, <http://findarticles.com/p/articles/mi_qn4158/is_/ai_n14167165> (accessed 9 December 2008).

Birmingham City Council (2001) 2001 *Population Census in Birmingham, Religious Group Profiles,* online, <http://www.birmingham.gov.uk/Media?MEDIA_ID=116871> (accessed 18 August 2008).

Birmingham Museum & Art Gallery (ed.) (1999) *World Art: from Birmingham Museums and Art Gallery,* Birmingham and London: Birmingham Museum & Art Gallery and Merrell Holberton Publishers Limited.

—— (2001) *Guidebook,* Birmingham: Birmingham Museum & Art Gallery.

—— (2008a) Birmingham Museum & Art Gallery Sultanganj Buddha Related Documents File 1.

—— (2008b) Birmingham Museum & Art Gallery Sultanganj Buddha Related Documents File 2.

Bouquet, M. and Porto, N. (2005) *Science, Magic, and Religion: the ritual processes of museum magic,* New York, Oxford: Berghahn.

Bruce, V. and Young, A. W. (1998) *In the Eye of the Beholder: the science of face perception,* Oxford: Oxford University Press.

Codrington, R. H. (1891) *The Melanesians: studies in their anthropology and folk-lore,* Oxford: Clarendon Press.

Cotton, J. S. (2004) 'Cunningham, Sir Alexander (1814–1893)' rev. J. Lunt, *Oxford Dictionary of National Biography,* Oxford: Oxford University Press. Online, <http://www.oxforddnb.com/view/article/6916> (accessed 14 June 2008).

Darwin, C. (1872) *The Expression of the Emotions in Man and Animals,* London: John Murray.

Davies, S. (1985) *By the Gains of Industry,* Birmingham: Birmingham Museums and Art Gallery.

Davis, R. H. (1997) *Lives of Indian Images,* Princeton, NJ: Princeton University Press.

Duncan, C. (1995) *Civilizing Rituals: inside public art museums,* London: Routledge.

Eck, D. L. (1998) *Darsan: seeing the divine image in India,* New York and Chichester: Columbia University Press.

Fish, S. E. (1980) *Is There a Text in This Class?: the authority of interpretive communities,* Cambridge, MA and London: Harvard University Press.

—— (1989) *Doing What Comes Naturally: change, rhetoric, and the practice of theory in literary and legal studies,* Oxford: Clarendon Press.

Gell, A. (1992) 'The technology of enchantment and the enchantment of technology', in J. Coote and A. Shelton (eds) *Anthropology, Art and Aesthetics,* Oxford: Clarendon Press, pp. 40–67.

—— (1998) *Art and Agency: an anthropological theory,* Oxford: Clarendon Press.

Gormley, A. (2008) *Anthony Gormley's Web Page,* online <http://www.antonygormley.com/> (accessed 15 August 2008).

Harris, E. B. (1864) *Description of Buddhist Remains Discovered at Sooltangunge,* London: privately published.

Heywood, F. (2005) 'My favourite museum: Clare Short', *Museums Journal,* March, p. 58.

Hilaire, B. (1860) *Le Boudha et sa religion,* Paris: Didier.

Kerr, I. J. (1997) *Building the Railways of the Raj, 1850–1900,* Delhi: Oxford University Press.

Kopytoff, I. (1986) 'The cultural biography of things: commoditization as process', in A. Appadurai (ed.) *The Social Life of Things,* Cambridge: Cambridge University Press, pp. 64–91.

Latour, B. (1987) *Science in Action,* Cambridge, MA: Harvard University Press.

—— (1999) *Pandora's Hope: essays on the reality of science studies,* Cambridge, MA and London: Harvard University Press.

—— (2005) *Reassembling the Social: an introduction to actor-network-theory,* Oxford: Oxford University Press.

Latour, B. and Weibel, P. (2002) *Iconoclash,* London: MIT Press.

MacDougall, D. (2006) *The Corporeal Image: film, ethnography, and the senses,* Princeton, NJ, Oxford: Princeton University Press.

Mitra, R. (1881) *Indo-Aryans: contributions towards the elucidation of their ancient and mediaeval history,* London and Calcutta: E. Stanford, W. Newman.

National Statistics (2003) *Census 2001 Birmingham Profiles,* online, <http://www.statistics.gov.uk/census2001/profiles/00CN.asp#ethnic> (accessed 15 August 2008).

Network of Buddhist Organisations UK (2007) *NBO Membership 2007,* online., <http://www.nbo.org.uk/home.htm> (accessed 25 June 2007).

Parker, T. (2004) 'A Hindu shrine at Brighton Museum', *Journal of Museum Ethnography,* 16: 64–8.

Parsons, G., Moore, J. R., and Wolffe, J. (1988) *Religion in Victorian Britain,* Manchester: Manchester University Press in association with the Open University.

Pattison, S. (2007) *Seeing Things: deepening relations with visual artefacts,* London: SCM Press.

Rathje, W.L. (2001) 'Why the Taliban are destroying Buddhas', *USA Today* 22nd March 2001, online, <http://www.usatoday.com/news/science/archaeology/2001–03–22-afghan-buddhas.htm> (accessed 8 December 2008).

Riesebrodt, M. (1999) 'Charisma in Max Weber's sociology of religion', *Religion,* 29: 1–14.

Sargent, W. L. and Thornton, S. (1864) *The Buddha and His Religion: a lecture at the Midlands Institute,* Birmingham: William Hodgetts.

Sartori, A. (2007) 'Beyond culture-contact and colonial discourse: "Germanism" in colonial Bengal', *Modern Intellectual History,* 4: 77–93.

Swearer, D. K. (2004) *Becoming the Buddha: the ritual of image consecration in Thailand,* Princeton, NJ and Oxford: Princeton University Press.

Thornton, S. (1864) 'Letter from The Elms, Camp Hill, October 7th, 1864'. Copy in BM&AG (2008a).

Weber, M. (1968) *Economy and Society: an outline of interpretive sociology,* trans and ed. G. Roth and C. Wittich. New York: Bedminster Press.

5

CONTEMPORARY ART
An immaterial practice?

Helen Pheby

Traditionally, the term 'artists' materials' was used to refer to a limited number of physical resources from which artists were able to create paintings or three-dimensional sculptures. Though supported by historical precedent, this definition may no longer be relevant. The aim of this chapter is to assess the materials currently used by artists in order to develop a better understanding of their intentions and of the relevance of works of contemporary art for immediate and future audiences. Through an overview of the means for deliberate mark and object making from prehistory to present-day, the chapter considers how artists represent both the world around them and their ideas. By analysing the work of contemporary practitioners James Turrell (born USA, 1943)1 and Andy Goldsworthy (born UK, 1956), with reference to further relevant artists and critical theories, the chapter serves to problematise the notion of 'materials'.

As a curator of modern and contemporary art at Yorkshire Sculpture Park (UK), I am made increasingly aware of the different approaches being employed by artists, both practically in terms of their construction and method of display, and theoretically with respect to the ways in which they may be interpreted for audiences. The materials used by artists correlate, necessarily, with those which are available to them. Although technological advances within specific media have been readily adopted, thus enabling different styles and methods, the art object for several millennia has tended to be either a two-dimensional representation rendered in pigment, or a three-dimensional carving, moulding or relief. The prevalent view is that the first works of art known to us are cave paintings, such as those discovered in Lascaux, France, and Altamira, Spain, which date back approximately 32,000 years (Gombrich 1989: 22). There is some dispute as to their precise dating, but latest techniques which carbon test the pigments themselves are believed to be the most accurate, substantiated by the fact that their animal subject matter is known to have inhabited the vicinity during the correlating period (UNESCO 2008; Janson and Janson 1982: 14). The cave paintings were made using rudimentary rocks and tools and, although the motivation behind their creation is not fully understood, they are believed to be either a form of communication or ritual. Evidence has been found of purpose-made, animal hair paint brushes dating from as long ago as c.16,000 BCE, and 1,000 years later hollow bones were used as airbrushes to blow diluted pigment onto a surface (MacPhersonART.com 2008; Saywell *et al.* 1996–7). The earliest known man-made surface for painting appeared in Egypt, when woven cotton and linen are known to have been made c.5,000 BCE and papyrus around

1,500 BCE (MacPhersonART.com 2008); paper is documented as having been created in China c.105 AD by the Chinese court official Ts'ai Lun (Fang n.d.).

Alongside such developments in two-dimensional representation, early humans also created three-dimensional objects using naturally found materials such as clay and stone. The oldest recorded examples of sculpture were discovered by the archaeologist Nicholas Conard of the University of Tübingen in a cave in the south west of Germany. These animal-hybrid carvings in ivory were made using flint tools and date back approximately 30,000 years (Conard 2003: 830–2). The traditions of carving stone and wood and moulding clay have continued and developed during the intervening years; Pliny the Elder documented sculpture making in Ancient Greece (Bruneau 2002: 11), and surviving work attributed to Praxiteles (390–c.330 BCE), including *Hermes with the Infant Dionysus,*2 evidences a sophisticated understanding of form and technique (Tarbell 1905). Objects have been cast in bronze since the Bronze Age through the sand or lost-form processes3 and a few examples of cast bronze statuary remain from ancient times, including a kouros warrior figure from Piraeus created in the third quarter of the sixth century BCE (Buschor 1921: 77; Bruneau 2002: 33).

The available evidence indicates that the materials used to create sculpture changed little over the next two millennia, a premise supported by art conservation techniques, which have only necessarily had to adapt to the introduction of new materials for works from the nineteenth century onwards. Jackie Heuman, sculpture conservator and restorer for the Tate Galleries, describes some of the first introductions of non-orthodox materials by artists and their reception:

> although most nineteenth century sculptors, such as Lord Leighton, Edward Onslow Ford and Edgar Degas, used traditional materials like bronze, stone and wood, newer materials and experimental techniques were also being introduced. Ford used an innovative combination of resin and pigment as an 'enamel' in *The Singer* (1889). Degas combined traditional techniques with more unusual materials, such as dressing his wax figure of *The Little Dancer Aged Fourteen* (1881) in real clothes and a wig. These media are unexceptional to us today, but when the work was displayed in 1881, many viewers and critics were shocked as much by this use of unconventional materials as by the realism of the figure.
> (Heuman 1999: 9)

An important element of the painter's craft, on the other hand, has always been the creation of pigments derived from a wide variety of sources including cadmium, lapis lazuli and even mummified human remains (Eastaugh 2004: 81). Pigments were first mixed with gum arabic to create pastels around 1450 (MacPhersonART.com 2008); by 1500 canvas had been stretched onto wooden frames for the first time (MacPhersonART.com 2008), and the first wood-cased graphite pencil was created by Friedrich Staedtler in 1662 (Saywell *et al.* 1996–7). Very recently, oil paintings have been discovered in a series of caves in Afghanistan and verified by the National Research Institute for Cultural Properties in Tokyo as being from the seventh century (Sample 2008).

In the West, the Dutch artist Jan van Eyck (c.1390–1441) (Pioch 2002) worked extensively in oil-based pigment. The Italian architect and artist Giorgio Vasari (1511–1574) wrote an important history called *Lives of the Most Excellent Painters, Sculptors, and Architects*, first published in 1550 (Vasari 1987), in which he mistakenly credited van Eyck with the invention of oil painting, when subsequent research suggests van Eyck perfected a technique invented by others (Pioch 2002). Pigment mixed with water dates back as far as the first known paintings and the German artist Albrecht Dürer (1471–1528) (Pioch 2006) worked with the medium

occasionally in the fifteenth century.4 However, watercolours in the sense that we understand them today were not popular until the late eighteenth century, coinciding with supplies of less expensive paper made available by the invention of the first paper-making machine in 1798; subsequently developed in England by Donking and the Fourdrinier brothers (Confederation of European Paper Industries 2008). A noted example of the widespread use of watercolour is the documentation of Captain Cook's third expedition in 1776 by its official artist, John Webster (Ayres 1985: 28).

One of the most significant inventions determining the way in which artists used their materials was the collapsible paint tube of 1822 (patented in 1841), developed by John G. Rand (Katlan 1999: 21–33), a painter from South Carolina living in London. This meant that pre-made colours could be kept fresh and enabled working in the open air, rather than confining an artist to their studio. The Impressionist movement promoted the benefits of painting directly from life in changing light and weather conditions, and the artists are noted for the immediate and spontaneous capturing of their contemporary age (Stamberg 2006).

The rapid technological advancements of the twentieth century were parallelled by, and often prompted, experimentation in the visual arts. Many products became synthesised, such as canvas and brushes, and new means of creation including photography, film (and with it the ability to record and edit moving images) and, most recently, digital technology have developed; the internet has also facilitated a more direct means of reaching wider audiences.

Alongside the practical concerns of available media, there has been a fundamental shift in what both the maker and viewer consider to be a work of art. Traditionally an artwork is an 'object', something tangible made by an artist, which often represents an actual or idealised reality. One of the radical departures from this definition occurred when the French artist Marcel Duchamp (1887–1968) infamously submitted a urinal for inclusion in the 1917 exhibition of the Society of Independent Artists in New York.5 Duchamp was a board member of the organisation and entered the piece, which he titled *Fountain*, under the name R Mutt. Most significantly, Duchamp claimed that it was art because he, as an artist, had selected it; thus transforming it from an ordinary object into an artwork through consciously acknowledging it as such:

> Whether Mr Mutt made the fountain with his own hands or not has no importance. He CHOSE it. He took an article of life, placed it so that its useful significance disappeared under the new title and point of view – created a new thought for that object.
>
> (Duchamp1917, cited in Gayford 2008: 10–11)

Duchamp's decision to introduce mundane material into the art gallery environment has historical precedent; the conscious inclusion of the fabric of everyday life is a recurring theme in the modern and postmodern periods of the twentieth century. The Spanish-born and highly influential artist Pablo Picasso (1881–1973) incorporated an actual Italian stamp into his painting *The Letter* (untraced but documented (MoMA 2008)) and used a section of printed oil cloth in *Still Life with Chair Caning* (1912), proceeding to frame the collage with rope. Similarly, the French artist Georges Braque (1882–1963) worked with paper printed with a wood grain pattern and other found ephemera. The artists' decision to employ material 'such as newsprint, table cloths, ring or rope was expressive of their struggle to extend the context for their canvas beyond paint' (Rush 2005: 7).

The desire to blur the boundaries between art and life has theoretical implications; it implies that artists have the power to transform the ordinary into the extraordinary simply

through their conscious acknowledgement. Duchamp's action was in part a protest against the commodification of art and he argued that without his intervention as an artist the urinal would have remained a urinal; this suggests that it is his idea and act, not his creation, which constitutes the work of art, this being more difficult to sell and resell. Indeed, the intangible quality that imbues an object with the status of 'artwork' and the implications of transferring this status to 'ready-made' objects is the subject of much discussion and debate. The German cultural critic Walter Benjamin (1892–1940 [Walter Benjamin Research Syndicate 2008]) believed that the ability of machines to duplicate works of art created a crisis of representation (Benjamin 1936). Benjamin argued that it was the art object's uniqueness that gave it its 'aura', and that, in the industrial age, the 'aura' could be applied to the experience of art, the artist or the creative act itself, rather than simply the resultant object.

Practically, the premise that anything chosen by an artist can be art means that the definition of 'artists' materials' is potentially as limitless as the things that exist in the world: 'anything that can be parsed as a subject or a noun has probably been included in a work of art somewhere by someone' (Rush 2005: 7). This is not restricted to those things that are tangible, but has included the intangible and conceptual, including natural human activity and ways of living, if (according to Duchamp's rationale) they are consciously selected and acknowledged by an artist. This is a boundless remit that has led to a multitude of varied and confusing practices.

In 1975, the sculptor William Tucker (born to English parents in Egypt, 1935) curated an exhibition at the Hayward Gallery, London, entitled *The Condition of Sculpture*. Through his selection Tucker intended to redefine sculpture as an object-based and physically evident practice:

> my aim was simply to bring together work done in the last two or three years by artists who appear consciously or intuitively to accept the condition of sculpture as I understand it and who, instead of regarding the physicality and visibility of sculpture as an inhibition, rather take it as a challenge, and a natural and necessary one. Sculpture is the language of the physical: and as with any living language, new thought finds form by stretching the medium itself, not by learning an alien language, or by attempting to invent a wholly new one… sculpture's very existence demands that it is made of some material, as some form is necessitated by its boundedness.
>
> (Tucker 1975: 7)

Tucker's choice included several artists loosely described as the 'New Generation'. In 1963, the influential English curator and art theorist Bryan Robertson (1925–2002) (Marlow 2002) had begun a series of annual exhibitions at the Whitechapel Gallery, London, called the *New Generation*, which included William Tucker, Phillip King (born Tunisia, 1934) and Anthony Caro (born UK, 1924). Both King and Caro had been assistants to the important English artist Henry Moore (1898–1986) and their practice can be traced through a traditional perception of the sculptural object, albeit using new materials including rusted and painted steel and industrial techniques such as welding. Through *The Condition of Sculpture* exhibition, Tucker sought to firmly re-establish the lineage of contemporary practice within the historical convention of the three-dimensional object.

Although working within the apparent boundaries of creating a physical art object, this generation of artists made the radically important decision to put their work directly on the floor, subverting the tradition of placing objects to be viewed on a plinth. This important

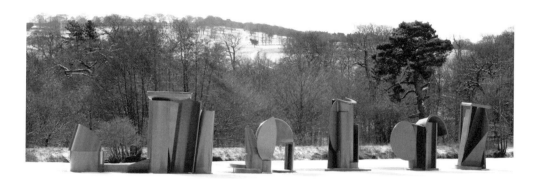

Figure 5.1 Promenade, Anthony Caro, 1996 (welded steel, painted) pictured at Lakeside, YSP (photograph by Jonty Wilde, courtesy of the artist and Annely Juda Fine Art, London)

change enabled the viewer to become a participant in the artwork; a development that relates to installation art in which artists create environments for audiences to temporarily occupy.

One such artist is James Turrell, who works with light to create environmental experiences and is now widely considered to be one of the most important living artists. Born in Los Angeles in 1943, Turrell was brought up in a Quaker household and studied perceptual psychology, mathematics and art history at Pomona College in California from 1961 to 1965; he graduated to read fine arts at the University of California in Irvine from 1965 to 1973. In 1966 he rented the former Mendota Hotel in Los Angeles where he experimented with allowing only carefully controlled light into certain rooms (Guggenheim 2009). Turrell has since developed a highly respected career using light, both man-made and natural, as his medium.

Although light is immaterial in the sense that it cannot be touched, there are parallels between the way in which Turrell creates works that appear to be three-dimensional and traditional sculptural techniques and their appreciation:

> When we look at a piece of sculpture we form the light and shadows as solid substance in our mind's eye. At this stage this 'solid' is just an hypothesis, and we seek to test it by our other senses. We may experience the urge to touch it, but we have been conditioned against this sort of behaviour in a museum, so we test our hypothesis by changing our point of view just by taking a few steps to one side... when a sculptor models clay, leaving imprints of his fingers, he is actually modelling with light. Each impression of his hand and tool on the pliant substance directs the traffic of light and shade. The dialogue between his hand and his material is echoed in a dialogue between the surface and the light illuminating it.
>
> (Papaliolios 1965: 11)

Turrell is not the first artist to work with light as their medium. In 1965, the Hungarian-born artist Gyorgy Kepes (1906–2001) organised the exhibition *Light as a Creative Medium* at the Carpenter Center for the Visual Arts at Harvard University. Kepes, who founded the Center for Advanced Visual Studies at Massachusetts Institute of Technology, worked to break down the barriers between art and technology (Driscoll and Greenberger 2002) and believed light to be fundamental to human wellbeing:

> our human nature is profoundly phototropic. Men obey their deepest instincts when they hold fast to light in comprehensive acts of perception and understanding through which they learn about the world, orient themselves within it, experience joy in living, and achieve a metaphoric symbolic grasp of life.
>
> (Kepes 1965: 3)

In his catalogue essay, Kepes proposes that the industrial age has brought about a deterioration in the essential relationship between humanity and natural light:

> Washing away the boundary between night and day has lost us our sense of connection with nature and its rhythms. If our artificial illumination is bright and ample, it is without the vitality, the wonderful ever-changing quality of natural light.
>
> (Kepes 1965: 2)

Sight is the most immediate of all the senses and having studied perceptual psychology Turrell, like Kepes, is keenly aware of the effect that natural, or carefully managed artificial, light can have on the human brain, intellect and emotion:

> First, I am dealing with no object. Perception is the object. Secondly, I am dealing with no image, because I want to avoid associative, symbolic thought. Thirdly, I am dealing with no focus or particular place to look. With no object, no image and no focus, what are you looking at? You are looking at you looking. This is in response to your seeing and the self-reflexive act of seeing yourself see. You can extend feeling out through the eyes to touch without seeing.
>
> (Turrell and Holborn 1993: 12)

Turrell is an important example of a number of artists who aim to create an experience for an audience that can prompt greater awareness. He explains:

> We eat light, drink it through our skins. With a little more exposure to light, you feel part of things physically.
>
> (Garofalo 2007)

> Light is a powerful substance. We have a primal connection to it. But, for something so powerful, situations for its felt presence are fragile. I form it as much as the material allows. I like to work with it so that you feel it physically, so you feel the presence of light inhabiting a space. I like the quality of feeling that is felt not only with the eyes.
>
> (McCaffrey 2008)

In 1974 while flying over the Arizona desert, Turrell discovered Roden Crater, which he was able to buy with associated land in 1977 through funding from the Dia Foundation for the Arts and a Guggenheim grant (Hogrefe n.d.). He has since devoted his time to transforming the geological feature into a monumental artwork that is aligned to celestial events for the next 12,000 years; for instance, once every 18.6 years the moon will register a detailed reverse image of itself on a monolith and on certain dates visitors can view their own shadow by the light reflected from Venus.

(McCaffrey 2008)

The South Space functions as a naked-eye observatory, conceived based on knowledge of the celestial alignments that have informed many ancient monuments. The central, dish-shaped telescope marks the saros pattern, the relationship between the sun, moon and earth allows observers to predict eclipses. Looking through the telescope, visitors will be able to sense the rotation of the earth by observing the changes in the location of stars and planets in the sky.

(McCaffrey 2008)

Not only does the viewer become engaged with the work, and thereby its creator, but also their place within the universe. Whereas artists in previous generations may have commanded awe through a near perfect or romantic depiction of natural phenomena, Turrell encourages direct involvement with the event itself – significant in an age in which technology increasingly creates a distance between people and natural processes.

Besides Roden Crater, Turrell has become especially well known for the creation of *Skyspaces* for public and private collections around the world. These constructions consist of a room with an aperture in the ceiling, carefully designed in such a way that the sky appears to be framed like an ever-changing painting. This apparently simple device, especially when viewed at dawn or sunset, allows the viewer a concentrated experience of the sky in all its vast array of colour, movement and beauty.

You can sit, or better still lie, on the bench and watch the sky move across the aperture. Everything speeds up: you realise how fast things change when you concentrate on the same bit of sky. Clouds unravel. For a while – if you're lucky – the sky turns completely blue

It's impossible to see it as empty space. Instead you experience the illusion that the sky is a dome. This perceptual shift is called 'celestial vaulting'. Lying here, it makes you feel part of nature. Stumbling out of the Skyspace into a landscape of felled trees and mossy stones, you are more aware of the texture of light, the colours in the sky.

(Jones 2000)

In 1993, James Turrell lived for several weeks on the Bretton Estate, home of Yorkshire Sculpture Park (YSP), during the development of his project for the Henry Moore Sculpture Trust at the nearby Dean Clough studios in Halifax. During the evening, when the grounds are closed to visitors, the artist spent many hours walking the landscape and familiarising himself with its features (Turrell, pers. comm., 1993). He proposed at that time to create a *Skyspace* in the derelict, eighteenth century deer shelter. In 2006, with the aid of a generous grant from The Art Fund, Yorkshire Sculpture Park was able to realise the artist's vision and open the *Deer Shelter Skyspace*, accompanied by a temporary exhibition in the Underground Gallery of three light installations.

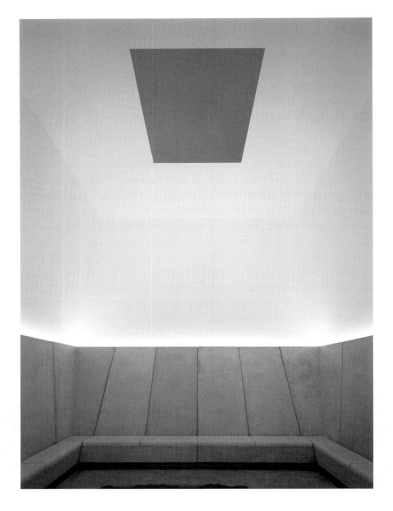

Figure 5.2 Deer Shelter Skyspace, James Turrell, 2006 (an Art Fund Commission, photograph by Jonty Wilde)

Although both his natural and man-made light works are made using materials such as stone, wood, paint and other necessary constructions, Turrell refutes that such things are his media:

The physical structure is used to accept and contain light, and to define a situation. But the light can determine the space, and it can be experienced more than the structure if the surface does not call attention to itself. Extreme attention must be paid to making perfect surfaces so you don't notice them.

(Brown 1985: 15)

Ultimately Turrell aims to communicate an experience that aspires toward enlightenment and often relates his childhood memory of attending Quaker meetings where he was told by his grandmother to 'go inside and greet the light':

In working with light, what is really important to me is to create an experience of wordless thought, to make the quality and sensation of light itself something really quite tactile. It has a quality seemingly intangible, yet it is physically felt. Often people reach out to try to touch it. My works are about light in the sense that light is present and there; the work is made of light. It's not about light or a record of it, but it is light. Light is not so much something that reveals, as it is itself the revelation.

(Brown 1985: 43)

Turrell's Underground Gallery exhibition at YSP contained three artificial light installations: *Wedgework V* 1974 suggests a remarkable three-dimensional space achieved only through the careful angling and combination of coloured beams. *Ganzfeld: Tight End* 2005 is a total environment of blue light that the viewer can physically enter and which culminates in a deep drop, designed precisely to suggest an infinite void beyond.

Turrell's mastery at manipulating visual perception is keenly evident in the final work, *Gray Day* 1997: upon entering the room the visitor is faced with apparent total darkness, an effect heightened when entering on bright, sunny days. Gradually, as the eye's pupils expand to allow in more light, a rectangular form becomes visible that increases in intensity and hue, suggesting the colours that one senses when staring into dark grey cloud. While still using light as its medium, the effectiveness of this work relies on the time taken for the eye to adjust.

Time is an implicit factor of all art appreciation but *Gray Day* is an example in which the artist incorporates the passage of time as a necessary enabler of the experience and one that he sees as fundamental to the state of mind he hopes to communicate:

Figure 5.3 Wedgework V, James Turrell, 1974, Yorkshire Sculpture Park Underground Gallery, 5 November 2005 to 7 January 2007 (photograph by Jonty Wilde)

These are things of the senses, and those often do take time. And so, at the same time we have this sort of rush toward 'media oblivion', we're having places where we do take that time. Quality is now appearing where it didn't appear when we were younger. I think that is very interesting.

So it goes both ways. In the same way technology is going like this (gestures), the organisation of society is asymptomatically going the other way. Both are interesting contradictions that we actually need to think about.

(Whittaker 13 February 1999)

Turrell regards the consideration of time as especially relevant in an age when machines enable activities, such as travel, to be completed much more quickly than is humanly possible. Turrell suggests that there is a human intuitiveness toward balancing this with allowing time for experiences to penetrate the every day sense of haste.

Some contemporary artists have gone further than factoring in the time taken to appreciate a work of art and have chosen to work with time as their medium, particularly those who work in the field of 'new media' which encompasses film, video and virtual reality. These technologies allow artists to manipulate the perception of time. Anne-Marie Duguet is Professor of Fine Art at the University of Paris and a leading theorist in the field of new media art; it is her belief that since the 1960s, 'time emerged not only as a recurrent theme but also as a constituent parameter of the very nature of an art work' (Rush 2005: 12). In 2000, the Palm Beach Institute of Contemporary Art in Lake Worth, Florida USA, organised an exhibition of new media art with particular emphasis on time as its material. In her essay the Curator of the show, Amy Cappellazzo, traces an art historical precedent that supports the premise that 'time' should be considered as a valid material of contemporary practice:

… from the semiotic investigations of Joseph Kosuth in the 1960s to the memorial-like works of Felix Gonzales-Torres in the 1980s and 1990s, conceptual art in its various manifestations has always incorporated the value and passage of time into its meaning. Minimalism led the way for performance, conceptual art, and film and video to expound upon the meaning of time as both a subject and a material in contemporary art.

(Cappellazzo 2000: 20)

One of the first video artists was the South Korean-American, Nam June Paik (1932–2006). Paik was part of the international 'Fluxus' movement that promoted a simple, anti-commercial approach to creative practice. Paik was inspired in part by the ideology of the North American composer John Cage (1912–92) who often incorporated everyday sounds into his work. Paik declared that 'it must be stressed that my work is not painting, not sculpture, but rather a Time art: I love no particular genre'.6

The technological capability of capturing a moment in time has prompted some to view time and memory as fundamental to the recorded image, a notion developed through photography and film, both commercially and in the arts. As well as a device employed in plot narrative, some artists have come to regard the manipulation of time in the way that some consider the working of solid material, creating a piece that considers and works with the inherent qualities of their chosen medium. This example of an acknowledged art material reveals the complexities of the physical and non-physical means through which contemporary artists choose to create artworks.

Bruce Nauman (born 1941, USA) used his own body as 'sculptural material' in video works. Nauman stated that it was the expression of an idea, rather than the vehicle for that expression,

that was of supreme importance, writing that video was '… only one other medium of his artistic practice… the materials [were] at once unimportant and all important in that there were no limitations on what could be used to make art' (Rush 2005: 107).

Performance art, action art and interventions in which the event displaces the object have become a common facet of contemporary art and emphasise the notion that the act of creation is more important than any physical outcome. Although such works can be documented or evidenced through photographs or artefacts, these are considered to be relics of the event. Action art often exploits the artist's body as its medium, eloquently described by exponent Joan Jonas (born 1936, USA) in an interview:

> For me there were no boundaries. I brought to performance my experience of looking at the illusionistic space of painting and of walking around sculptures and architectural spaces. I was barely in my early performance pieces; I was in them like a piece of material or an object that moved very stiffly, like a puppet or a figure in a medieval painting I didn't exist as Joan Jonas, as an individual "I," only as a presence, part of the picture.
>
> (Jonas 1995, cited in Rush 2005: 42)

Dan Graham (born 1942, USA) created an important piece in 1975 entitled *Performance/Audience/Mirror,* which turned the focus of the artwork back on the audience so that they became simultaneously the medium, subject and viewer and subverting the traditional relationship between the artist, audience and object. This work is an illustrative example of the complexities of artists' materials of the last 100 years as not only do those things that constitute 'material' become debatable, so does the definition of what we mean by 'artists' material'.

The conventional definition of historical artworks as used by museums, galleries and collectors for archival or insurance purposes documents the fabric of construction as the art material, such as oil on canvas, marble and bronze. Should this physical object be destroyed or damaged so the artwork is destroyed or compromised. A fundamental difference, and one to which institutions and conservators are having to adapt and accommodate, is that the evidence of a contemporary art work in the physical realm may be destroyed but the work itself continues to exist as long as the idea remains. For example, following the YSP exhibition of light installations by James Turrell the works were removed by dismantling their physical presence. However the works still exist conceptually and, indeed, the owner has a certificate stating that the specific works belong to him. This is why, despite being built in 2006, each of the works was titled according to their first inception.

Overviewing artists' materials to the present day thus shows a trend away from the traditional means of rendering image and artefact toward various practices that have promoted the artist's idea or concept as being of higher importance than any resultant physical object. Indeed, the defining movement of the twentieth century is considered to be conceptual art. One of the main protagonists of conceptual art and of great significance is the North American artist Sol LeWitt (1928–2007). In 1967, LeWitt wrote a seminal text *Paragraphs on Conceptual Art* in which he clarified the ideology of the movement:

> I will refer to the kind of art in which I am involved as conceptual art. In conceptual art the idea or concept is the most important aspect of the work. (In other forms of art the concept may be changed in the process of execution)… no matter what form it may finally have it must begin with an idea… when an artist uses a conceptual form of art, it means that all of

the planning and decisions are made beforehand and the execution is a perfunctory affair. The idea becomes a machine that makes the art.

(LeWitt 1967: 79–83)

This leads, logically, to a deliberate repression of the relevance of materials being used, a view supported by the performance, video and installation artist Vito Acconci (born 1940, USA) in his statement:

if I specialise in a medium, I would be fixing a ground for myself, a ground I would have to be digging myself out of, constantly, as one medium was substituted for another – so, then instead of turning toward 'ground' I would shift my attention and turn to 'instrument', I would focus on myself as the instrument that acted on whatever ground was available.

(Acconci 1979, cited in Rush 2005: 52)

Lucy Lippard (born 1937, USA) is an art theorist particularly associated with conceptual art and a contemporary and associate of Sol LeWitt. In 1973, Lippard compiled a book, *Six Years: The Dematerialisation of the Art Object from 1966 to 1972*, which documented conceptual art works within a contextualising critique. It had a profound influence not only on scholarly understanding of the aims of the movement, but also on subsequent practitioners. Lippard defines conceptual art as 'work in which the idea is paramount and the material form is secondary, lightweight, ephemeral, cheap, unpretentious and/or "dematerialised"' (Lippard 2001: vii). She continues:

It has often been pointed out to me that dematerialisation is an inaccurate term, that a piece of paper or a photograph is as much an object, or as 'material',' as a ton of lead. Granted. But for lack of a better term I have continued to refer to a process of dematerialisation, or a de-emphasis on material aspects (uniqueness, permanence, decorative attractiveness).

(Lippard 2001: 5)

Through her critique, Lippard develops the theory that artists allowed the form of their work to be suggested by their chosen medium and that this was transferred from the physical to the intangible:

reflected in the ubiquity of temporary 'piles' of materials around 1968 (done by, among others, Andre, Baxter, Beuys, Bollinger, Ferrer, Kaltenbach, Long, Louw, Morris, Nauman, Oppenheim, Saret, Serra, Smithson). This premise was soon applied to such ephemeral materials as time itself, space, non-visual systems, situations, unrecorded experience, unspoken ideas, and so on.

(Lippard 2001: 5)

Some examples of work from this period reveal the radical direction that art was taking away from the painting and sculpture tradition. Yoko Ono (born 1933, Japan) made a series of tape recordings of found and imagined sound that evoke a poetic engagement with the world: *Listen to the sound of the earth turning* (Spring 1963); *Take the sound of the stone ageing* (Spring 1963); *Take the sound of the room breathing: at dawn, in the morning, in the evening, before dawn…. Bottle the smell of the room of that particular hour as well* (tape piece, Autumn 1963). Ono's work demonstrates a motivation within conceptual art not to create something new and possibly

artificial, but to metaphorically frame, and so draw considered attention to, that which already exists.

How and why artists worked in such a way at this time is a matter of much critical debate and conjecture. Lippard argues that Duchamp has been hijacked as the forefather of the movement; certainly his notion that the item chosen by the artist constitutes art is compelling justification for an art movement in which concept takes priority. But Lippard states that most conceptual artists didn't find his work that interesting. It is possible that artists were seeking the most direct means to communicate their ideas, so cutting out the 'medium' of the physical. Hans Haacke (born 1936, Germany) is another important exponent of the movement who believed that:

> Information presented at the right time and in the right place can potentially be very powerful. It can affect the general social fabric....
>
> The working premise is to think in terms of systems: the production of systems, the interference with and the exposure of existing systems... systems can be physical, biological, or social.
>
> (Haacke 1971, cited in Siegel 1971: 21)

Lippard cites a socio-economic motivation toward egalitarianism and a wish to uphold the romantic idea that art is above being a commodity, as it resists being bought and sold. This is a notion reinforced by Carl Andre (born 1935, USA) when he writes that his outdoor line of hay bales at Windham College, Vermont '... is going to break down and gradually disappear. But since I'm not making a piece of sculpture for sale... it never enters the property state' (Lippard 2001: xiv). Lippard continues: 'This attack on the notion of originality, 'the artist's touch' and the competitive aspects of individual style constituted an attack on the genius theory, the hitherto most cherished aspect of patriarchal, ruling-class art' (Lippard 2001: xiv).

During the research and development of Andy Goldsworthy's most ambitious project to date, his 2007 exhibition at Yorkshire Sculpture Park, the artist emphasised the importance of working outside the studio. In particular, the idea that art could be made from materials made available by location, weather, season and time of day correlated strongly with his own practice. As a student at the University of Central Lancashire from 1975–1978,7 Goldsworthy expressed a desire to connect with 'the sandness of sand' and the 'seaness of sea'; to develop and share an understanding of the natural world and its inherent beauty, rather than try to recreate it through paint or chisel. Through discussions with the artist it is clear that he perceives his working method as a way of life and hopes to communicate a certain philosophy of being that heightens awareness of natural processes (Goldsworthy pers. comm., July 2006–February 2007). Goldsworthy emphasises that this is not a romantic or bucolic perception of the natural world, such as that illustrated in the tradition of English landscape painting, but an effort toward genuine understanding. This is a view that correlates directly with the artist and critic Amy Goldin's (1926–1978, USA) (SIRIS 2008) belief that art 'at its most inventive, has the mystery and charm of life itself' (1969, cited in Lippard 2001: xix).

Conceptual art can be difficult to present to audiences both practically and theoretically and may be viewed with suspicion by those who feel they lack the art-historical knowledge to understand its precedent or why it has diverged so far from what is traditionally referred to as being 'art'. One way of interpreting contemporary conceptual art for new audiences is to relate it back to its real world relevance, to shared experiences and the liberation of being able to engage directly with the creative act, free from art historical reference. Indeed, one of the most popular exhibitions of recent times is Olafur Elliasson's *The Weather Project* installation in the

Turbine Hall of Tate Modern, in which the artist simply but eloquently represented the sun and atmosphere (May 2003).

Conceptual art has become a highly influential genre of contemporary art and has led to some denouncing the 'end of art', as they believe it to have exhausted all options. Clement Greenberg (1909–1994, USA) (Rowan University n.d.) was an influential art critic and historian of the 1950s and1960s. An advocate of abstract expressionist painting and promoter of New York as the new capital of contemporary art, Greenberg believed that 'the meaning of art was to be found within the object itself' (Rush 2005: 82). Indeed, one of the main criticisms levelled at conceptual art is its intangibility: 'In the case of Van Gogh we can say there is a work that is apparently mobile, that hangs in a museum, waiting for me, that the body of Van Gogh was there, et cetera' (Derrida 1994, cited in Brunette and Wills 1994: 16). This comparison leads to the conclusion by some that conceptual art is not art, because it does not conform to the tradition of an act by an artist resulting in an object: the manifestation of the artist's concept made real through his/her manipulation of material (even the use of the ready-made by Duchamp subscribed to this definition).

Perhaps what is now most appropriate is to consider experiential art as the defining characteristic of the twentieth and early twenty-first centuries and that it is not the aim of contemporary artists to undermine or replace the art that precedes them, but to reflect current ways of living. Rather than considering artistic materials in the traditional sense, perhaps it is more pertinent to consider life itself as the medium, expressed, for instance, through making conscious an appreciation of the changing colours of the sky or the sensation of laying on the ground in a snow fall; an infinite documentation of personal and universal experience. The Japanese artist On Kawara (born 1932 Japan, now lives in New York) has made a *date painting* almost daily since 1966 and in a series of postcards entitled *I met* and *I went* lists every person and place that he encounters during each day. Artworks such as these do not necessarily require an education in art criticism or history to be appreciated as they are not art referential; rather they draw attention to the detail of life itself and so are more readily engaging.

Writing in the recent *Folkestone Triennial* catalogue, the curator Dr Andrea Schlieker describes a tendency in the last twenty years toward art that is relevant to everyday life and is a 'socially engaged practice' (2008: 12). She cites the French curator, Nicolas Bourriaud's theory of 'relational aesthetics', which in the late 1990s 'propagated artistic approaches and methods that were to help us to 'learn to inhabit the world in a better way' (Bourriaud 1995, cited in Schlieker 2008: 30). Schlieker continues: 'The role of artworks is no longer to form imaginary and utopian realities, but to actually be ways of living and models of action within the existing real' (2008: 30).

Crucially, artists appear to be trying to communicate a pause in the everyday that reveals the profound in order to render and make more conscious the human experience, rather than attempting to create an object of beauty for its own sake. For contemporary art to have meaning it requires the audience to make a leap of faith that they are witnessing 'art'; it is no longer a case of learning schools of artists and interpreting the message in the material object; now it is essential to enable participation within the artist's concept.

Joseph Beuys (1921–1986) was a German artist often cited as being of great significance in contemporary art. He described himself as a social sculptor and in an interview in 1968 stated:

Art alone makes life possible – this is how radically I should like to formulate it. I would say that without art man is inconceivable in physiological terms. There is a certain materialist doctrine which claims that we can dispense with mind and with art because man is just a

more or less highly developed mechanism governed by chemical processes. I would say man does not consist only of chemical processes… Man is only truly alive when he realises he is a creative, artistic being. I demand an artist involvement in all realms of life. At the moment, art is taught as a special field which demands the production of documents in the form of art works. Whereas I advocate an esthetic [sic] involvement from science, from economics, from politics, from religion – every sphere of human activity. Even the act of peeling a potato can be work of art if it is a conscious act.

(Beuys 1969, cited in Sharp 1969: 43)

A contemporary of Beuys, the German artist Wolf Vostell (1932–1998) substantiates the idea that contemporary art is now concerned less with 'art', as traditionally understood, and more with trying to understand life:

Marcel Duchamp has declared ready made objects as art, and the futurists declared noises as art – it is an important characteristic of my efforts and those of my colleagues to declare as art the total event, comprising noise/object/movement/colour and psychology – a merging of elements, so that life (man) can be art.

(Vostell, cited in Rush 2005: 125)

A possible blurring of boundaries between art and reality has been considered extensively by contemporary theorists. The French sociologist Jean Baudrillard (1929–2007) described this as a 'collapsing in the simulacrum', a notion that reality no longer exists but has been replaced by the 'hyperreal' (Baudrillard 1994).

The evidence available supports the premise that the traditional perception of 'artists' materials', such as marble, bronze and pigments on a base, is no longer applicable to contemporary practice. The notion of 'artists' materials' as the means through which artists render an object is also no longer relevant as the relationships between concept, medium and creative action have become so complex that to attempt to explain them to audiences may, in fact, be an obstacle to their appreciation. Rather, it may be more appropriate to interpret contemporary art for audiences through its relevance to contemporary life; art historical precedence and theory being but one aspect of this. This may not only have relevance for curators of contemporary art but may also benefit those curating historical art works: for them too it may be useful to consider a revised definition of artist's materials, based on considering the experience that the maker hopes to communicate to the viewer and which might include such intangible qualities as faith and belief. James Turrell is of the opinion that the tendency to use whatever is physically available to demonstrate a sense of being or an awareness of ideas, to convey a moment of transcendence, is not one exclusive to contemporary artists:

I think that even when you go into gothic cathedrals, where the light and the space have such a way of engendering awe, that, in a way, what the artists have made for you in this place is almost a better connection to things beyond us than anything the preacher can say. Although music, at times, can really approach that too. I think this is a place where artists have always been involved.

(Turrell 1999, cited in Whittaker 1999)

The chapter has served to problematise the notion of contemporary artists' materials, evidenced by the fact that if the physical evidence of a work is destroyed, then the artwork does

not necessarily cease to exist. It has also considered the complications subsequently involved in presenting, contextualising and conserving contemporary works of art. Through an examination of contemporary practice it is revealed that the traditional definitions of material, subject, concept and viewer are no longer relevant. It may be possible that each aspect of this research deserves further investigation to consider if it may be retrospectively relevant to other periods than that herein discussed.

Notes

1 For this and all future cited biographical detail: Artfacts.Net n.d., unless otherwise stated.
2 Discovered in 1877 and now in the Olympia Archaeological Museum (Vikatou n.d.).
3 First bronze tools and weapons, Sumer c.3000 BC Synoptic Table I (Janson and Janson 1982: 82).
4 A significant example being *A Young Hare* painted in 1502 using watercolour and gouache on paper in the collection of Graphische Sammlung Albertina, Vienna (Pioch 2006).
5 This event in art history continues to be debated a length; not least what defines a person as an artist if it is not someone who makes art. There are a number of books dealing solely with this work: e.g. Camfield 1989 and Taylor 1998, in addition to numerous titles dedicated to Marcel Duchamp and his career, in which *Fountain* continues to be highly significant (British Library 2008).
6 Nam June Paik writing in 1962 prior to his show at Galerie Parnass, Wuppertal (Paik 1962, cited in Rush 2005: 53).
7 At the time known as Preston Polytechnic.

References

Artfacts.Net. (n.d.). Online. Available HTTP: <http://www.artfacts.net/en/artist/james-turrell–1799/profile.htmlt> (accessed 27th August 2008).

Ayres, J. (1985) *The Artist's Craft: a history of tools, techniques and materials*, Oxford: Phaidon.

Baudrillard, J. (1994 [1985]) *Simulacres et Simulation*, trans. Sheila Faria Glaser, Ann Arbor, MI: University of Michigan Press.

Benjamin, W. (2008 [1936]) *The Work of Art in the Age of Its Technological Reproducibility*, Cambridge, MA: Harvard University Press.

Brown, J. (1985) 'Interview with James Turrell', in J. Brown (ed.) *Occluded Front*, Fellows of Contemporary Art, Los Angeles CA: The Lapis Press, pp. 13–46.

Bruneau, P. (2002) 'Greek art', in G. Duby and J. L. Daval (eds) *Sculpture from Antiquity to the Present Day*, Cologne: Taschen, pp. 11–114

Brunette, P. and Wills, D. (1994) (eds) *Deconstruction and the Visual Arts: art, media, architecture*, Cambridge and New York: Cambridge University Press

Buschor, E. (1921) *Greek Vase–Painting*, trans. G. C. Richards (1921), with a preface by Percy Gardner, London: Chatto & Windus.

Camfield, W. A. (1989) *Marcel Duchamp Fountain*, Houston, TX: Menil Collection.

Cappellazzo, A. (ed.) (2000) *Making Time: considering time as a material in contemporary video and film*, Lake Worth, FL: Palm Beach Institute of Contemporary Art in conjunction with Distributed Arts Press.

Conard, N. J. (2003) 'Palaeolithic ivory sculptures from southwestern Germany and the origins of figurative art', *Nature*, 426: 830–2.

Confederation of European Paper Industries (2008) *18th Century*. Online. Available HTTP: <http://www.paperonline.org/history/18th/18th_frame.html> (accessed 14th August 2008).

Driscoll Jr., E. J. and S. S. Greenberger (2002) 'Gyorgy Kepes: obituary', *Boston Globe*, 1 August 2002. Online. Available HTTP: <http://www.harvardsquarelibrary.org/unitarians/kepes.html> (accessed 15th August 2008).

Eastaugh, N. (2004) *Pigment Compendium: a dictionary of historical pigments*, Boston, MA: Butterworth–Heinemann.

Fang, D. (n.d.) *Tsai, Lun*. Online. Available HTTP: <http://www.sjsu.edu/depts/Museum/tsailun.html> (accessed 15th August 2008).

Garofalo, M. P. (2007) *The Spirit of Gardening*. Online. Available HTTP: <http://www.gardendigest.com/see.html> (accessed 14th August 2008).

Gayford, M. (2008) 'The practical joke that launched an artistic revolution', *The Daily Telegraph*, 16 February, pp.10–11.

Gombrich, E. (1989) *The Story of Art*, London: Phaidon Press Ltd.

Guggenheim (2009) *Collection online*. Online. Available HTTP: <http://www.guggenheim.org/new-york/collections/collection-online/show-full/bio/?artist_name=James%20Turrell&page=1&f=Name&cr=1> (accessed 8 March 2009).

Heuman, J. (1999) *Material Matters: the conversation of modern sculpture*, London: Tate Publishing.

Hogrefe, J. (n.d.) 'In pursuit of God's light', *Metropolismag.Com*. Online. Available HTTP: <http://www.metropolismag.com/html/content_0800/tur.htm> (accessed 28th August 2008).

Janson, H. W. and A. F. Janson (1982) *History of Art for Young People*, London: Thames and Hudson.

Jones, J. (2000) 'James Turrell Skyspace Kielder, Northumberland', *The Guardian*, 20 September 2000. Online. Available HTTP: <http://www.guardian.co.uk/culture/2000/sep/20/artsfeatures5> (accessed 28 August 2008).

Katlan, A. (1999) 'The American artist's tools and materials for on-site oil sketching', *Journal of the American Institute for Conservation*, 38 (1): 21–33.

Kepes, G. (ed.) (1965) *Light as a Creative Medium*, Cambridge, MA: Harvard University Press.

LeWitt, S. (1967) 'Paragraphs on conceptual art', *Artforum* 5, 10: 79–83.

Lippard, L. (2001) *Six Years: the dematerialization of the art object from 1966 to 1972*, Berkeley, CA: University of California Press.

McCaffrey, C. (2008) *Light and Landscape: Raemar, 1969*. Online. Available HTTP: <http://www.exploratorium.edu/lightandland/raemar.html> (accessed 14th August 2008).

MacPhersonArt.com (2007) *Timeline*. Online. Available HTTP: <http://www.macphersonart.com/maclive/getstartedpub/timeline/history.html> (accessed 14 August 2008).

Marlow, T. (2002) 'Bryan Robertson: groundbreaking director of the Whitechapel Art Gallery', *The Independent Newspaper*, 26 November 2002. Online. Available HTTP: <http://www.independent.co.uk/news/obituaries/bryan-robertson–605388.html> (accessed 14th August 2008).

May, S. (ed.) (2003) *Olafur Elliasson: the Weather Project, the Unilever Series*, London: Tate Publishing.

MoMA (Museum of Modern Art) (2008) *MoMA.org: the collection*. Online. Available HTTP: <http://www.moma.org/collection/details.php?theme_id=10064> (accessed 14th August 2008).

Papaliolios, C. (1965) 'Comments on the exhibition', in G. Kepes (ed.) *Light as a Creative Medium*, Cambridge, MA: Harvard University Press, pp.8–9.

Pioch, N. (2002) *Eyck, Jan van*. Online. Available HTTP: <http://www.ibiblio.org/wm/paint/auth/eyck> (accessed 27th August 2008).

—— (2006) *Durer, Albrecht*. Online. Available HTTP: <http://www.ibiblio.org/wm/paint/auth/durer> (accessed 28th August 2008).

Rowan University (n.d.) *Clement Greenberg*. Online. Available HTTP: <http://rowan.edu/open/philosop/clowney/Aesthetics/philos_artists_onart/greenberg.htm> (accessed 28th August 2008).

Rush, M. (2005) *New Media in Art*, London: Thames and Hudson.

Sample, I. (2008) 'World's oldest oil pictures found in Afghanistan', *The Guardian*, 23 April 2008. Online. Available HTTP: <http://www.guardian.co.uk/uk/2008/apr/23/1> (accessed 28th August 2008).

Saywell, E., L. Straus and P. A. Straus (1996–7) *A Drawing Glossary*. Online. Available HTTP: <http://www.artmuseums.harvard.edu/fogg/drawingglossary.html> (accessed 17th August 2008).

Schlieker, A. (2008) *Folkestone Triennial: tales of time and space*. London: Cultureshock Media.

Sharp, W. (1969) 'Joseph Beuys in conversation with Willoughby Sharp', *Art Forum*, 4: 43.

Siegel, J. (1971) 'An Interview with Hans Haacke', *Arts Magazine*, 45, 7: 21.

SIRIS (Smithsonian Institution Research Information System) (2004) *Amy Goldin Papers.* Online. Available HTTP: <http://siris-archives.si.edu/ipac20/ipac.jsp?uri=full=3100001~!210397!0&term> (accessed 28th August 2008).

Stamberg, S. (2006) 'How painting advanced with tin paint tubes', *Technology and Art,* National Public Radio Programs Archive. Online. Available HTTP: <http://www.npr.org/templates/story/story.php?storyId=6640315> (accessed 28th August 2008).

Tarbell, F. B. (1905) *A History of Greek Art*, vol. 2, Chicago, IL: The University of Chicago Press.

Taylor, M. R. (1998) *Blind Man's Bluff: Marcel Duchamp's* Fountain *and the reception of the readymades 1913–1968*, London: University of London Press.

Tucker, W. (1975) 'Introduction', in Arts Council of Great Britain (ed.), *The Condition of Sculpture: a selection of recent sculpture by younger British and foreign artists*, Glasgow: Learning & Teaching Scotland, pp. 6–9.

Turrell, J. and M. Holborn (1993) *James Turrell: Air Mass*, London: Hayward Publishing.

UNESCO (United Nations Educational, Scientific and Cultural Organization) (2008) *Prehistoric Sites and Decorated Caves of the Vezere Valley.* Online. Available HTTP: <http://whc.unesco.org/en/list/85> (accessed 15th August 2008).

Vasari, G. (1987 [1550]). *Lives of the Most Excellent Painters, Sculptors, and Architects*, trans. G. A. Bull, London: Penguin Classics.

Vikatou, O. (n.d) 'Archaeological Museum of Olympia'. Online. Available HTTP: <http://odysseus.culture.gr/h/1/eh151.jsp?obj_id=7126> (accessed 9th October 2008).

Walter Benjamin Research Syndicate (2008) *Walter Benjamin*. Online. Available HTTP: <http://www.wbenjamin.org/walterbenjamin.html> (accessed 20th August 2008).

Whittaker, R. (1999) *Greeting the Light: an interview with James Turrell.* Online. Available HTTP: <http://conversations.org/story.php?sid=32> (accessed 4th August 2008).

THE EYES HAVE IT

Eye movements and the debatable differences between original objects and reproductions

Helen Saunderson, Alice Cruickshank and Eugene McSorley

In a large void of space, punctuated at eye level by a sliver of shelf, are displayed the Parthenon Marbles in the British Museum.[1] The Acropolis museum, meanwhile, displays dazzling white plaster versions of the 'missing' Parthenon sculptures nestled between the other, original, sculptures.[2] The legitimate location of the original marbles is a matter of longstanding ethical, political and intellectual debate and with the planned opening in late 2008 of the new Acropolis museum, the controversy will be re-ignited. The fact that such furious disagreement is still engendered by the Parthenon marbles provides a compelling anecdotal example of the many elements that people find important when considering artefacts and art (including legitimate ownership). Amidst the mix, is the significance of experiencing genuine articles as opposed to reproductions – where 'reproductions are copies made for honest purposes' (Savage 1963: 1).

But why is viewing originals so important? A variety of potential reasons can be given, including the idea that the experience gleaned from the original is distinct from that of a reproduction. This possibility has been at the core of a philosophical discussion about the relationship between original objects and their reproductions; in particular, of art works. An especially pertinent debate in the *British Journal of Aesthetics* started with Zemach, who proposed that a 'painting itself exists wherever there is a sufficiently good replica of that painting' (Zemach 1986: 245–6), but his arguments were rebuffed in a flurry of papers (Levinson 1987; Taylor 1989) to which he replied robustly, (Zemach 1989) and a temporary full stop was reached. A new statement reopened the argument some time later, when Farrelly-Jackson proposed that 'one standard objection for treating reproductions of paintings as token of the very painting themselves is that… such reproductions will differ in certain aesthetically relevant properties' (Farrelly-Jackson 1997: 139) And so the debate remained unresolved.

Other literature, from a variety of disciplines, proposes that *originals and reproductions or replicas are experienced in different ways*. Benjamin's (2008) classic article, describes original art works as having an 'aura' that relates to their unique history and authenticity. However, this relationship is not entirely straight forward as for certain art forms (e.g. printing and film) the distinction between a single 'original' and 'reproduction' is unclear. In addition, an extrapolation of museum studies discourse about the importance of multiple sensory experiences (Classen 2005; Drobnick 2006) also has interesting implications for the relationship between originals and reproductions. Reproductions of an art work that engages explicitly more than the visual

sense will automatically be only a limited representation. For example, a photograph of part of the work *Simply Boutiful* by Christoph Buschel, illustrating the freezer in the cargo box, only fragmentally represents the experience of encountering the art work, which involved clambering into the freezer, listening to the noises of the person previously descended, and the anticipatory smell of the earth below. So, the diverse literature often identifies interesting differences and sometimes complex relationships between originals and reproductions.

In addition to compelling intellectual arguments, human actions may also provide interesting evidence – one aspect of which is the value placed upon the original objects; for example, monetary worth implies an importance: a National Gallery print of the Van Gogh's *Sunflowers* currently costs £6, yet the actual painting is worth millions. Similarly, scholars will travel across the world to gain access to original manuscripts. Andrew Motion, the poet laureate, has said that he can't 'look at the original manuscript of a poem ... still less actually put my hand on it, without feeling an extraordinary electrical charge is coming through me, and that's something that can't be replicated by things that are replicas' (Motion 2007). Therefore, human behaviour implies that originals (in contrast to reproductions or representations), especially in certain contexts, are extremely valued.

How might an approach informed by the academic discipline of psychology enlighten our understandings of responses to art? In particular, can it be used to probe the differences, if any, between experience of originals and of reproductions? Experimental psychology can give a new perspective to the debate, using scientific methodology and techniques. Examples of such inter-disciplinary work include Leder *et al.*'s (2004) five-step model of perceiving contemporary art work and Livingstone's (2002) examination of the visual qualities of famous paintings, e.g. Monet's *Impression Sunrise* (1872). The following chapter considers a psychological experiment devised and undertaken by Eugene McSorley, Alice Cruickshank and Helen Saunderson, to explore the proposed differences in original and reproduction artwork.

The discipline of psychology offers many investigative methods, four of which may have particular relevance to examining the experience of art:

1 *Self-reports.* Individuals provide subjective information by describing their own experience. As this method is shared, in various forms, by a number of other disciplines too, and as it is difficult to generalise from individual experiences to a common model, in itself it is unlikely to contribute to psychology's provision of an innovative insight into the topic.

2 *Measurement of human brain activity.* Information about which areas of the brain are most active over time can be recorded. This can help to illustrate how and where the sensory information is processed. functional magnetic resonance imaging (fMRI) and positron emission tomography (PET) both measure activity of the brain indirectly. Both provide images allowing comparison of areas which are active during different tasks and providing compelling images brains with coloured 'active' areas. Magnetoencephalography (MEG) and electroencephalography (EEG) provide records of the accurate time-course of brain activation. Together these techniques can provide an accurate picture of brain activity. However, the problem with these methods is that knowing when and where in the brain a signal is processed does not necessarily add to our understanding of how or why it is processed (Caccioppo *et al.* 2003).

3 *Analysing images of the art work.* Work in this area has predominantly focused on the visual qualities of the art work (Graham and Field 2008; Redies, Hasenstein and Denzler 2008; Wade 2003; Zanker, 2004). Livingstone (2002) analysed Monet's *Impression Sunrise*, 1872, examining two qualities of the picture: colour and luminance (the amount of light

reflected or emitted from an object). She showed that the sun was of equal luminance to the rest of the sky. Therefore, in a greyscale image the sun is invisible, it is only distinct in colour. Livingstone argues that 'by making it [the sun] the exact same luminance as the sky, he [Monet] achieves an eerie effect' (Livingstone 2002: 39). However, it is clear that this analysis includes a degree of subjective self-report of Livingstone's own experience of the picture. Deconstructing an art work in this way focuses solely upon the properties of the object, but the interpretation may become subjective, and will not necessarily reflect entirely an individual observer's full experience when encountering the object.

4 *Examining observers' behaviour when viewing an artwork.* There are many possible measures of behaviour, some easier to record than others. Measures such as body language or facial gesture require an experimenter to make a subjective judgement on the person's status while measures such as duration spent in front of an artwork, or visual behaviour, can be measured more objectively. Recording eye movements can provide several measures of observers' behaviour including: where an observer first looks; how long an observer looks at an area before moving their eyes; and which areas are looked at most. The experiment we undertook used eye-movement recording, hence the discussions in this remainder of this chapter will focus on this technique.

Eye movements are essential to enable the gathering of information about the visual properties of an object or scene (Henderson 2003). Take a moment to glance up from reading this book; try to identify which object in the scene stands out the most. It is likely that it will be the element that differs most from its surroundings in luminance, colour or relative contrast. That is, certain aspects of the scene will attract your attention, because of relational and inherent visual qualities. For example, when a visitor descends into the basement depths of the National Museum of Scotland in Edinburgh, a vision unfolds of the sections about the early Scots people from 10,000 years ago.[3] In the scene, initial attention is drawn to the abstract statue figures: they are dark in contrast to the light sandstone backdrop and within their structures are lanterns of light, where clear perspex boxes containing Celtic jewellery are literally spotlighted. The contrast, colour and brightness of various aspects of the figures in context are identified as the most salient aspects of the scene. In such examples as this, the visual qualities of a scene (or object) drive where the eyes look and therefore what information the brain receives: this is known as bottom-up processing.

In contrast, top-down processing is where prior knowledge and thoughts drive where and what is viewed. If, when visiting the early Scots gallery, you were armed with the knowledge (i) that Sir Eduardo Paolozzi, who created the sculptures within which the jewellery lies, designed them as abstract in order to reflect our lack of knowledge of how the people of 10,000 years ago would have looked,[4] and (ii) that one of the sculptures has a huge sphere instead of a hand, you might then view the scene in order, say, to search for the 'hand' – hence to a large degree ignore the overall visual qualities of the scene, except for elements that might assist you finding the 'hand'. By studying the eye movements of a person it is possible to detect the direct-end result of the combination of bottom-up and top-down processing, namely where and when we look.

Measures of eye movement are direct, objective and quantifiable, which is why this method was selected as the most appropriate for the investigation discussed here. It is possible to look at many different aspects of eye movements (e.g., size and direction of the movement) and times when the eye is relatively still (e.g., how long it is stationary, known as fixation duration) to gather different information about how an observer is viewing a scene. When looking at gaze position we record the location of the area of the eye that can process the most detail of the scene (the fovea) to determine what the observer is looking at. The fovea is relatively

small; for example, whilst reading this sentence, you are able to bring into high focus only a few letters at a time, the surrounding area is relatively blurred. When you read, you are not particularly aware of this as your eyes are moved approximately four times per second through tiny fast movements, saccades, to another location. The brain processes the information into an experience that appears seamless.

Recording eye movements when people view both original and reproduction artworks, has the potential to provide innovative knowledge. However, no one (to the knowledge of the authors) has previously used eye-movement recording to investigate this area. The closest previous eye movement investigations in essence and relevance are two classic psychological studies. Yarbus (1967) recorded eye movements and found that when displaying paintings of scenes, the largest influence on where and when the eyes looked was what task the viewer was given. For example, if instructed to work out the ages of the people in the picture, observers predominantly looked at the faces; if instructed to work out the wealth of the individuals, observers looked more at clothes and artefacts. As the intention of our investigation, however, was to mirror real life experiences as closely as possible, it was important not to give instructions to the person; rather, the viewer looked at the objects with self-directed purpose, as they usually do during a museum experience.

The importance of self, of individual differences, was also identified as key in the second classic study, by Buswell (1935). He recorded eye movements of 200 people looking at various images of aesthetic objects (including paintings, sculptures, ceramics and architecture) onto photosensitive material and subsequently analysed the resulting 18,000 feet of film. The results (including fixation durations) identified that the predominant factor influencing eye movements was differences between individuals. Clearly, this means that it is hard to compare one person to another. Therefore, in our investigation, individuals' results were compared to themselves (a method known as a repeated measures design), so that when an individual viewed the original paintings the eye movements from that would be compared to those recorded when they viewed the photographic and monitor reproductions of the artworks.

Any difference between individual viewers could also be due to individual differences in art expertise. Would there indeed be a discrepancy if art experts and novices were compared? Thus when recruiting the 24 people who took part in the investigation, half were from the Fine Art Department at the University of Reading (designated as 'art experts') and the rest from the Psychology Department and other members of staff at the same university ('art novices').

All these people were shown six original paintings (on canvas), and reproductions on photographic paper and computer monitor display. The reason for choosing the two forms of reproductions was that in the field of art it is common for people to consume images of artworks as photographs or high quality prints in books, or sourced from the internet, or viewed as part of computer presentations. Therefore, the types of material selected for the reproductions arguably related to the dominant types of reproductions of art encountered and used on an everyday basis.

The original paintings were contemporary semi-abstract designs with a limited palette of colours (Figure 6.1). The paintings were professionally digitally photographed and printed onto photographic paper, and transferred to computer format. The original and reproduced images were clearly different in visual and material qualities: in the painting, the textured canvas background and the brush strokes were clearly visible. This is in contrast to the photographic reproductions which, although they were photographed to capture the texture, had a glossy sheen finish. The material differences also had an impact on the luminance of the images (measured in candelas per metre squared, cd/m^2). The monitor reproductions had the highest luminance (27.09 cd/m^2), with the luminance of the original paintings being 16.51 cd/m^2 and

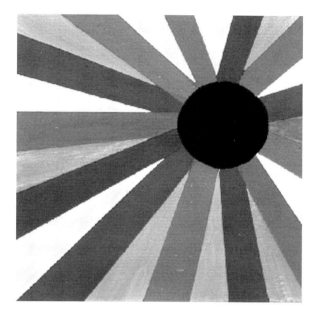

Figure 6.1 Example of the contemporary semi-abstract designs used in the experiment

the photographic reproductions, 15.81 cd/m². Since previous research suggests that luminance of objects viewed has an impact (e.g. Livingstone 2002), it seemed very likely that the monitor reproductions in particular may yield distinctly different results. 'It's like the machine in *Clockwork Orange*,' commented one individual of the contraption used to detect and record observers' eye movements. It was in fact the harmless helmet-like SR Research Eyelink 2, which works by shining a beam of infra-red into the eye, and detecting differences in how the infra-red light is reflected to track the location of the pupil of the eye. The 'helmet' also has a centrally mounted camera that picks up signals emitted by infra-red light sources on the display-monitor. This enables the eye tracker to take into account head movements when providing information about where the person was looking.

Each participant viewed the 18 images for 30 seconds. Monitor reproductions were presented on a flat computer monitor, original paintings and photographic reproductions were presented by being fixed to the screen. The order in which the type of images were shown, original painting, photographic or monitor reproduction, was varied, so that each of the six potential order combinations was adopted four times, in equal numbers for both art novices and experts. This was done to eliminate the possible effect on results of the order in which the images were presented, and/or the boredom and fatigue that can occur towards the end of an investigation. The images were shown to individuals sitting relatively comfortably. The viewing distance was the same for all observers. As images were changed over participants were asked to shut their eyes, to prevent accidental previewing of the images.

When the data were analysed comparing the original paintings to the photographic and monitor reproductions, and art experts to art novices, no significant differences were identified. However, in relation to viewing time statistically significant discrepancies were found. The graph (Figure 6.2) shows that all viewers, viewing all image types, had shorter fixation durations in the first 15 seconds than in the last 15 seconds. For example, when looking at the original paintings

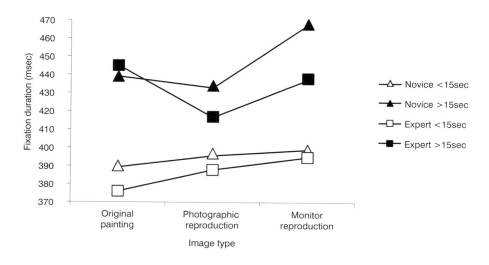

Figure 6.2 Mean fixation durations in relation to viewing time, image format and art expertise

the art experts had a mean fixation duration of 376ms during the 0–15 seconds period, and 445ms during the 15–30 seconds phase. This suggests that initially the eyes are spending relatively small amounts of time examining various large areas, and that as the viewing time goes on spend longer looking within one part of the image. For saccade amplitudes, the relationship was inverted (see Figure 6.3): saccade amplitudes were initially larger, and later smaller. For example, whilst looking at the photographic reproduction, art novices initially had averages saccade amplitudes of 2.79°⁵ and later 2.72° saccade amplitudes, while art experts had averages of 2.98° during the 0–15 seconds and 2.85° for 15 seconds and over.

Combining the results of the saccade amplitudes and fixations duration, suggests that initially the eyes are moving on a relatively large scale (hence large saccade amplitudes), and that this is interleaved with short periods of remaining at a given point (small fixation durations). Over time, however, the pattern is reversed and the eye dwells upon a certain point for longer (large fixation durations), before being relocated to a relatively nearby area (hence saccade amplitudes become smaller).

This finding was not surprising as in the classic Buswell (1935) and Yarbus (1967) studies an analogous fixation pattern was found. Buswell (1935: 142) postulated that there is a general survey followed by a more detailed examination of small sections of the image while Yarbus (1967: 193) suggested from his results that an initial, overall scanning of the image is succeeded by the eyes returning to re-examine certain important areas. The two explanations thus differ, identifying either importance or level of processing as the cause – though no-one has explicitly tested which of the ideas is correct.

However, there may be a third possible explanation; as exemplified by an encounter had by one of the authors with Tom Friedman's *Untitled* – Styrofoam and Paint, 2004, whilst visiting an exhibition at the South London Gallery. The striking pale blue of the main figure of the sculpture was the initial visual draw, and whilst navigating around, and examining, the overall form, a tiny figure was noticed. It was relatively insignificant, being looked down upon by the

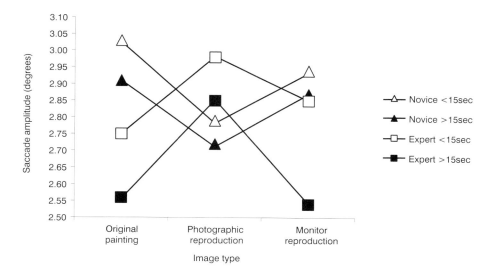

Figure 6.3 Mean saccade amplitudes in relation to viewing time, image format and art expertise

huge, blue, strangely smooth human form. The minute person was crudely hewn from wooden cubes and roughly coloured to give the shape and essence of a person, yet it was strangely angular. On noticing it, the observer started to think about their relative scale to the figures, and wondered what materials had been used to make the giant: the label for the work told them that it was recycled plastic. This personal experience anecdotally implies that when presented with an artwork, the visual elements are the initial key focus, but that gradually the attention on the visual aspects of the work lessens, and divides and become increasingly focused upon other aspects relating to the work.

What are the implications for the original question, 'is there a disparity between experiencing an original artwork and a replica of it?' The results found indicate that there was no significant difference in basic eye movements between paintings and the photographic and monitor reproductions. However, anecdotal evidence from the experiment implies that people's experience of looking at the art was influenced by the image format. For example, one art expert participant spontaneously commented that whilst he was looking at the photographic reproduction after the original painting, he started thinking about the differences in the material qualities of the images.

In addition it seems unlikely that people with art expertise have equivalent experiences with art as those with less (as our results showed). Indeed it has been proposed that art expertise mediates 'the degree to which the viewer focuses in on and takes account of, or even perceives, detail' Knell (2007: 11). For example in the investigation it may well be the case that two individuals are both looking at an area, but that the thoughts that this is eliciting, and which is driving their eye movements, are very different. Imagine an encounter with the Damien Hirst dot painting *Gelsemine*, 2006, which consists of 90 spots of household gloss paint arranged in a grid formation. An art expert may be looking at the top right grey dot that appears to be disappearing into the canvas and wondering why that colour was selected for that position, or thinking about a similar painting which was sent into space to calibrate the instruments on the

British Beagle 2 probe to Mars. A novice may be looking at the same dot and wondering why this painting is highly regarded given that they could create something similar with the contents of their shed. In these two instances very different thoughts and hence top-down and bottom-up integrated processing is driving where the eyes are positioned.

The experimental finding, of no difference in eye-movement behaviour between art experts and novices or original art and reproductions, is at odds with the other evidence mentioned in the introduction of this chapter. This could be accounted for in a variety of ways. First, individual differences – an important factor as identified by Buswell (1935) and Yarbus (1967) – result in such a wide variety of eye movement, that subtle differences between fixation duration and saccade amplitudes due to viewing original and reproductions are masked. Second, it is possible that people do not adopt a distinctive common viewing strategy for viewing an 'original' or a 'reproduction', which would be identifiable statistically. However, they may still view the image formats differently. Thirdly, it is possible that the differences between the image formats are taken into account by the viewer.

Arguably, as Western human experience generally contains numerous forms of reproductions, in various materials, adjustments are made for the differences in our overall perception of the objects: a process described as 'facsimile accommodation' (Locher et al. 1999). Locher et al. state that people are 'able to immerse themselves in the reproduction and respond to many of its properties and qualities in a fashion similar to what their reactions would be if they were encountering the original' (2001: 450). However, although differences due to materiality are mediated to a degree, knowledge that an object is original appears to still be influential. That is illustrated by the negative response by individuals to items that are a fake (Savage 1963). Further, Locher et al. (2001) conducted an experiment where individuals viewed nine original paintings in the MOMA, New York, including Breugel, Rembrant and Vermeer. Other participants viewed reproductions in slide and computer format. Locher et al. found that subjective ratings only significantly differed for the original art work when rated for interestingness and pleasantness. That evidence suggests that an experience with the art is distinctively difference when looking at originals versus reproductions in certain aspects, including subjective ratings of interestingness and pleasantness, but that in other respects differences are accounted for due to 'facsimile accommodation'.

It would be interesting to discover if the experimental results of Locher et al. (2001), and hence the hypothesis of 'facsimile accommodation', generalised from subjective to objective measures. Using objective eye movement measures appears to be a particularly lucrative angle for investigation specific to the question of originals and reproductions, and in a wider sense to the experience of the materiality of art works. Ideally experiments should use mobile art trackers in a gallery environment, and contrast to equivalent laboratory experiments. The points of these experiments would be: firstly, to consider the underpinning assumption in the majority of psychological experimental designs that using representatives of art work is generally equivalent to presenting originals – hence evaluating the degree to which an experience with an art work in a gallery equates to a laboratory represented stimuli equivalent; secondly, an explicit analysis of any objective (and the likely subjective) differences due to the different types of environments and context.

The environment and context where the original art work is situated could be particularly important in relation to the degree of validity and relevance of laboratory based experiments. There are parallels between psychology vision laboratory's 'black cube', where the impact of non-visual senses are often intentionally minimised, and the sanitised environment of the 'white cube' with its 'dynamic of display that is purely visual' (Drobnick 2006: 266). In both environments

there can be an emphasis on the predominance of the visual sense, and attempts are made to limit the input from other senses. This implies that visually focused laboratory experiments have a strong relationship to experiences in a 'white cube' type gallery. In contrast, contemporary installations and other art that involves an experience and appeals to multiple senses would pragmatically be better served by experiments taking mobile eye trackers into the gallery.

Having considered the future implications of the experiment, it is appropriate to return to the beginning of the chapter, and to discuss what the results imply for a viewer of the Parthenon sculptures. It appears that, in relation to basic eye movements (fixation durations and saccade amplitudes), an individual viewing either the original marbles or plaster reproductions would adopt the same broad strategy. The pattern of viewing would initially involve large eye movements and short fixations followed later by longer fixations and small movements of the eye, seemingly irrespective of the different material qualities of the object and art expertise. However, to state that there is no difference in experience when viewing either the original marbles or the reproductions would be counter to the evidence of human behaviour and cross disciplinary literature. Rather, what arguably occurs is 'facsimile accommodation', where the individual viewing either the Parthenon marbles or the plaster copies takes into account discrepancies due to the different materials. Further research using eye trackers, explicitly manipulating relevant factors, could explicitly test the nature and limitations of the concept of 'facsimile accommodation', enabling a fuller account of the experiential similarities and differences between standing in The British Museum gazing at the corridor filled with the Parthenon marbles, in contrast to the plaster copies in the Acropolis museum with the backdrop of the Parthenon building itself.

Acknowledgments

The first author would like to thank: Sandra H. Dudley, Susan M. Pearce, Steve Shimozaki and Sarah White, for their invaluable support and comments on drafts of the chapter; and Gary Harman for professionally photographing and creating the reproduction images. This chapter is dedicated to Derek Downey, Terry Edmond, and Kathryn Wilkinson. The work was funded by a grant from the Engineering and Physical Sciences Research Council (awarded to Eugene McSorley).

Notes

1 Description based on the personal memory of a visit by one of the authors to the British Museum, February 2006.
2 Based on the description in Hodson 2008.
3 Description based upon a visit to the National Museum of Scotland, September 2008, by one of the authors.
4 National Museum of Scotland webpage, http://www.nms.ac.uk/earlypeople.aspx, accessed on 24 September 2008.
5 Saccade amplitude is generally measured in degrees. This is a useful measure because it describes the observer's visual experience, rather than the physical size of the object. 1° of visual angle is equivalent to an object that is 1m away and is 1.75cm across or an object that is 2m away and is 3.5cm across: these two would appear the same size to an observer.

References

Buswell, G.T. (1935) *How People Look at Pictures: a study of the psychological of perception in art,* Chicago, IL: University of Chicago Press.

Cacioppo, J.T., G.G. Berntson, T.S. Lorig, C.J. Norris, E. Rickett and H. Nusbaum (2003) 'Just because you're imaging the brain doesn't mean you can stop using your head: a primer and set of first principles', *Journal of Personality and Social Psychology*, 85 (4): 650–61.

Classen, C. (2005) 'Touch in the museum', in C. Classen (ed.) *The Book of Touch*, Oxford: Berg, pp. 275–86.

Drobnick, J. (2006). 'Volatile effects – olfactory dimensions of art and architecture', in D. Howes (ed.) *Empire of the Senses: the sensual culture reader*, Oxford: Berg, pp. p265–280.

Farrelly-Jackson, S. (1997) 'Fetishism and the identity of art', *British Journal of Aesthetics*, 37: 138–54.

Graham, D.J. and D. J. Field (2008) 'Statistical regularities of art images and natural scenes: spectra, sparseness and nonlinearities', *Spatial Vision*, 21: 149–64.

Henderson, J. (2003) 'Human gaze control during real-world scene perception', *Trends in Cognitive Sciences*, 7: 498–504

Hodson, M. (2008) 'The new Greek Acropolis Museum', *The Sunday Times*, 6 July, p. 42.

Knell, S. J. (2007) 'Museums, reality and the material world', in S. J. Knell (ed.) *Museums in the Material World*, London: Routledge, pp. 1–28.

Leder, H., Belke, B., Oeberst, A. & Augustin, D. (2004) 'A model of aesthetic appreciation and aesthetic judgments', *British Journal of Psychology 95* (4): 489–508.

Levinson, J. (1987) 'Zemach on paintings', *British Journal of Aesthetics*, 27: 278–83.

Livingstone, M. (2002) *Vision and Art: the biology of seeing*, New York: Abrams.

Locher, P., L. Smith and J. Smith (1999) 'Original paintings versus slide and computer reproductions: a comparison of viewer responses', *Empirical Studies of the Arts*, 17: 121–9.

Locher, P.J., J.K.Smith and L.E. Smith, L.F. (2001) 'The influence of presentation format and viewer training in the visual arts on the perception of pictorial and aesthetic qualities of paintings', *Perception 30*: 449–65.

Motion, A. (2007) Interview on BBC Radio 4's Today Programme, 29 June, 2007.

Redies, C., J. Hasenstein and J. Denzler (2008) 'Fractal-like image statistics in visual art: similarity to natural scenes', *Spatial Vision*, 21: 137–48.

Savage, G. (1963) *Forgeries, Fakes and Reproductions*, London: Barrie Books Ltd.

Taylor, P. (1989) 'Paintings and identity', *British Journal of Aesthetics*, 29: 353–62.

Wade, N. J. (2003) 'Movements in art: from Rosso to Riley', *Perception 32*: 1029–36.

Yarbus, A.L. (1967). *Eye Movements and Vision*, New York: Plenum Press.

Zanker, J.M. (2004) 'Looking at Op Art from a computational viewpoint', *Spatial Vision 17*: 75–94.

Zemach, E.M. (1986) 'No identification without evaluation', *British Journal of Aesthetics*, 26: 239–51.

Zemach, E.M. (1989) 'How paintings are', *British Journal of Aesthetics*, 29: 65–71.

Part 2

ENGAGEMENTS

Sandra H. Dudley

In this its second part, the book moves on to an exploration of the characteristics and implications of engagements with objects by museum and gallery users. There are, of course, crossovers with Part I's focus on objects and materiality, and with Part III's emphasis on interpretive strategies and processes, but the primary theme here is the exploration of a range of different types of embodied, sensory and emotional engagements with objects. Chapters cover such topics as artistic and subsequent manipulations of materiality (Stevenson), memory and emotion in objects (Hancock), visitors' aesthetic responses to images of beauty and violence (Nakashima Degarrod), making connections between displayed and personal objects and experience (Wehner and Sear), proprioception and performativity (Rees Leahy) and questions of authenticity and affect in responses to art objects (Taylor). Stevenson's chapter deals with specifically material and cognitive engagements with objects, but the remaining chapters in this part of the book all, in different ways, address engagements which we could gloss as 'aesthetic', using that term in a broad sense and including within it a range of embodied, sensory responses to objects and the emotional states they can produce.

Stevenson's chapter has clear continuity with Part I, in that it explores a contemporary art project which problematized objects' materiality and authenticity. In addition, it examines the impacts of those qualities on perception and engagement, and, especially, on cognitive responses to objects – specifically, ideas of what they represent. Stevenson drew images of archaeological museum objects onto stretched hide before, using a technique known as palimpsestry, scraping these works in order to remove the 'polished' finish and in an attempt to demonstrate the wear-and-tear on the original artefacts. Various people from beyond the museums were then asked to respond to the artworks in interviews with the artist, in the process handling the art objects and physically degrading their readability. The interviewees' responses and the project as a whole challenged notions of interaction with 'original' and 'representational' objects, and raised interesting questions concerning the changing materiality of artworks and the nature of physical and intellectual engagements with them.

Hancock too makes us question notions of materiality and our sensory apprehension of and engagement with it, here in particular relation to emotion and memory embodied by objects on display. Her chapter is a phenomenological exploration of Monk's House and Charleston, the literary/artistic house museums of Virginia Woolf and her sister Vanessa Bell. These house museums, as Hancock demonstrates, offer peculiarly direct, and potentially intensely moving, engagements with the materiality of another's life. Through walls and floors, drapes and furnishings – the house's tactile spatiality – the material fabric of the commemorated life literally wraps itself around the visitor. Unprotected by museal glass cases, the displayed objects in these house museums are immediately sensorily apprehensible (c.f. Witcomb's chapter on

the implications for the maker of the enclosure of the Treblinka model in a glass case). Woolf's and Bell's personal possessions are enabled to take on a performative role, inviting the visitor to participate in the tangible interior worlds of past lives. The chapter focuses on the author's experience of three particular objects, in the process exploring the sensations engendered by embodied encounters with the intimate materials of others and the meanings that accumulate on the surfaces of the physical remnants of others' lives.

Nakashima Degarrod also brings out a poignancy in engagements with objects. She discusses visitors' aesthetic responses to artworks, and examines the audience's embodied and emotional knowledge, specifically in relation to one of the author's ethnographic-based art projects, *Following the Trails of Urban Miracle Seekers* (based on a Chilean popular religion), exhibited at university and commercial galleries in the USA. The chapter examines the process of creating the art object from its origin in the ethnographic field, to its making in the studio, and finally its display in the exhibiting spaces. Nakashima Degarrod demonstrates that art objects can be seen as material objects from an anthropological perspective, and argues that while the exhibiting space and display play an important role in shaping audience response, the art object itself contains forms of knowledge created previously and transmitted to viewers during the exhibitions, often without the intentions of the artist. She shows that her artworks involve not just materialized, subject sensations that the audiences were able to feel and engage with, but also the embodiment of forms of cultural knowledge which are unconsciously interacted with by the audiences. All this happens within a gallery which provided visitors with the physical space and the cultural setting in which they were able to experience, and indeed share, emotional reactions to the objects.

Wehner and Sear's chapter takes up the challenge to explore in what ways exhibition spaces can really enable visitors to experience a range of embodied, sensory and emotional engagements with objects. Focusing on *Australian Journeys*, a new 'object-rich', 'object-centred' gallery at the National Museum of Australia (NMA), Wehner and Sear describe the production of an exhibition conceptualized not – as has so often been the case at NMA and elsewhere – as a technology for the communication of historical information in which objects simply illustrate themes or stories, but as defined by the museum's collections of *things* and by ideas about embodied responses to objects and what the authors call 'object knowledge'. They consider visitors' practices of linking and connecting objects, and explore how constructing analogy and difference in materialities of form, structure and manufacture contributes to enabling visitors to make sense of museum displays. They reflect on ways to make it possible for visitors to envisage their own bodily interactions with objects and discover how their experience differs from that of others who once used and made the displayed objects. Such processes of comparison and recognition, involving objects both present in the exhibition and others remembered or imagined by visitors, are as much sensory, embodied and imaginative as they are cognitive – and delineating these multiple, non-linguistic processes is, the authors argue, central to understanding how visitors engage in, and what is peculiar to, the museum context.

Rees Leahy's chapter too asks how embodied experience affects visitors' perception in, and of, the museum. She focuses on the moving, walking, performing, engaging body of the spectator – the bodily practice of the viewer of art in the spatial location and imposing setting of the gallery. Drawing on Merleau-Ponty's process of the 'ontology of enfleshment', her chapter explores the relationship between embodiment, experience and perception of museum space and objects through an analysis of a series of artists' installations in the Turbine Hall at Tate Modern. The chapter has a particular focus on Doris Salcedo's 'Shibboleth': a 167-metre-long crack in the Turbine Hall floor, experienced via an exaggerated awareness of one's body in relation to the

edge of the work and an anticipation of physical risk to personal safety. Rees Leahy's exploration of the Turbine Hall installations allows her to consider issues of scale and spectacle, commitment to site-specificity, the nature and implications of a heightened sense of both conviviality and individuation among participants/spectators, and the relationship between performativity scripted by the installation and the diverse bodily and social performances of actual visitors. In the course of this exploration, Rees Leahy analyzes relationships between proprioception, perception and the production of meaning.

The last chapter in this part of the book also focuses on visitors' engagements with art objects in particular. In it, Taylor draws on his research at the Toledo Museum of Art in Ohio. He utilizes methods from communication studies and information studies to problematize the role of the object in the creator-object-viewer relationship and to signpost the possibilities and limitations of online engagements with and interpretations of museum objects. Taylor is particularly interested in the roles of affect and spatial context. He brings both to bear on notions of authenticity and the original (including Benjamin's idea of the aura of the original), and seeks to re-situate the emphasis, placing it not on the object alone but instead on engagement. He focuses especially on the roles of the cognitive and emotional states of the information seeker/viewer, the processes associated with information seeking/viewing, and the physical environment and the cognitive and emotional states of the information seeker/viewer. In particular, Taylor argues the implications of his work for the importance of affect in optimal engagements with digitized objects.

7

EXPERIENCING MATERIALITY IN THE MUSEUM
Artefacts re-made

Alexander Stevenson

Intention

Experiencing materiality, as it appears in this chapter, relates to participants in an art project being encouraged to physically handle and be in some way responsible for the changing material state of a set of art objects. Each such item discussed here was a re-made object based upon an original museum artefact, created by the author. The following chapter examines how changes to the physicality of these art objects may have contributed to unusual interpretations of both them and the original artefacts that had inspired them. This work was subsequently developed into an unusual audio guide: an artwork in itself, this was intended for both art and museum audiences and informed by the materiality-influenced interpretations of a group of selected experts from various fields.

In my practice as a contemporary visual artist, I use institutional collections as my art materials and institutional models for research and analysis as my artistic tools. I conduct interviews, focus groups, lectures and seminars, which form the basis of performances and exhibitions of art objects. I record my subjective observations of audience responses to artworks I have created, and emphasize the subjectivities of both myself and my audiences as an important element in the reading of the work. These processes often produce contradictory or conflicting interpretations, leading into the exciting exploration of areas of knowledge that are contentious or that challenge preconceptions. This way of working is closely related to Nicolas Bourriaud's idea of 'postproduction', in which an artwork is based on other artworks. In Bourriaud's theory, the 'commodified history' (where nothing is allowed to change) is challenged by continually 'revisiting' a historical object to use it and to try and understand how it could be interpreted, 'feeling totally free' to create new associations (Bourriaud 2002). In my way of working, I use 'interpretation' not to connote the analysis of data, evidence, etc., or to infer a honing of research or the establishment of accredited meaning in relation to data; rather, I suggest that interpretation exists as a tool with which to explore how knowledge and associations are applied (especially in relation to artefacts with little or no known provenance), and I aim to create new ways for audiences to relate to art objects and archaeological artefacts.

For the project discussed here, I borrowed several methods of academic research and analysis (including participant observation and discourse analysis) in order to produce a set of data that would be recognizable to academic researchers. One of my central objectives was to avoid traditional interpretive paths, which in this case includes those of archaeology and anthropology. Instead, I am interested in different approaches to interpretation that represent a shift in criteria towards other priorities. The experts who contributed to this work come from the fields of interpretive studies, visual and material culture, complexity theory, ecology and folklore. Importantly, I was also interested in the opinions of individuals with social or cultural backgrounds that were likely to produce a contrasting frame of reference – perspectives which further allowed me to demonstrate the subjective elements that are inherent in any interpretation. Such points of view were supplied to this project by contributors from five major religions, as well as a secularist, and even a representative for transport.

By opening up the process of interpretation, then, through a practice similar to Bourriaud's idea of 'postproduction' (re-making, ibid.), this project enabled the construction of a non-hierarchical assemblage of associations and knowledge. Within this assemblage, the roles of artist, expert and audience became diffused and intertwined.

The project

At the beginning of 2007, with the assistance of the senior curator of the Jewry Wall Museum, I began to conduct research in Leicester's museums. It was my intention to create observational drawings of a range of archaeological artefacts from within the main stores. These drawings were to represent objects both with and without known provenance, representing the full gamut of Leicester's more distinct historical periods.

The reason for this activity was to create an art project that would be of historical and symbolic significance to Leicester, as well as to open up contemporary dialogues between its inhabitants. Leicester has a rich and well-documented archaeological heritage, and also a high level of immigration in modern times which has resulted in a diverse cultural environment. By creating contemporary dialogues between cultural representatives and academic fields, I wanted

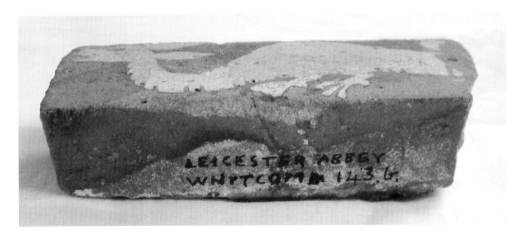

Figure 7.1 'Dragon', original floor tile, collections of the Jewry Wall Museum, Leicester. (Photograph by Alexander Stevenson, courtesy of the Jewry Wall Museum.)

to explore how Leicester's diverse cultures might relate to museum artefacts. The art objects and the participants' associations with them might not necessarily come directly from their own heritage or academic field, yet I deemed the participants to have some ownership of the art objects because the artefacts on which they are based come from the place in which the participants live.

Having examined a large number of artefacts in the Leicester stores, it became clear to me that the knowledge that surrounded these artefacts was either greatly condensed or non-existent. This prompted me to begin with the symbols, images and form of each object and to simplify them, first into sketches and observations, and then into icons depicted on parchment. Each image was depicted in a limited colour palette, drawn in ink.

The distressed areas of the museum object, or where artefacts were mere fragments of their original form, also needed to be addressed. This was done by creating 'palimpsests' (from the Greek, meaning 'scrape (and) again'): I scraped away at my images of Leicester's artefacts, removing their 'polished' finish and demonstrating (as accurately as possible) the wear-and-tear on the original archaeological objects. In several instances, the original artefacts were only a fragment of the size and form they had been at the time of their creation, and here the palimpsest process allowed me to extend the drawings beyond the limits of what remained of the originals. The drawings suggested missing areas extending from any broken edges of the depicted objects. This represented a kind of idealism about the state of the original objects at their creation, and was an additional subjective element to how the objects would later be interpreted by experts.

The next stage was to conduct interviews with a variety of people from beyond the world of the museums, including experts from various academic, cultural, and religious fields. These individuals were asked to interact with and interpret the art objects they were presented with, rather than the museum artefact on which it was based. Each interviewee was encouraged to touch and feel the parchment, and to experience its texture. Because gold and silver inks were used to depict many of the images, the participants were also encouraged to experience the effect of light across the art object's surface. This is not an experience often available to art audiences in any setting, let alone within museums. The sensation of the textures upon participants' fingertips

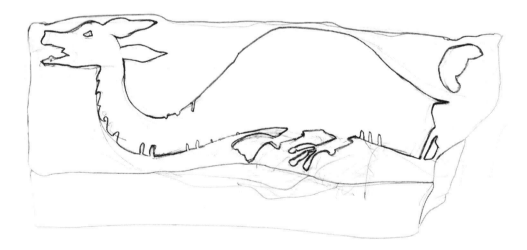

Figure 7.2 Observation drawing of the 'Dragon' (Alexander Stevenson)

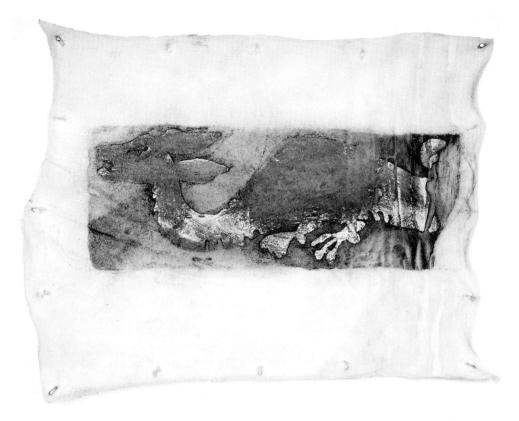

Figure 7.3 'Dragon' palimpsest (inks, stretched and scraped parchment, Alexander Stevenson)

(the smoothness of pristine ink areas and the rough grooved areas where it had been removed) helped to define the starting points for each of them as they began their interpretations.

I began by offering a definition for all of the art objects:

> These are art objects that have been created based on archaeological artefacts from Leicester. All of them were discovered in Leicester, and thus you may be able to relate to them on these grounds. Otherwise, I am interested in any other interpretations and associations you are able to bring to them from your own personal, cultural or academic background.
>
> (Stevenson 2007, interview statement)

Following this statement I offered no additional specifics about the art objects except to explain the process and purpose of the palimpsest (which acted as a visual metaphor for the degraded comprehensibility of the original archaeological artefacts). This produced several very interesting results. In at least two instances, for example, a participant handling an art object asserted that it should be a different way up. In each case the participant then relayed what they believed the inverted image depicted with as much clarity as the participants who correctly identified the orientation and subject. It is important to add that during the initial interviews I chose not to correct these misunderstandings, but allowed the participants to create their own,

entirely new associations for the image. I recorded my participants' responses to the art objects, generating almost fourteen hours of audio material – which formed an important part of the overall art project.

Importantly, the participants did not only contribute knowledge and interpretations. Throughout the interviews the materiality of each art object was affected, degraded even, by being handled by all twelve participants who were encouraged to 'experience' its material qualities. The ink on the surface was slightly friable, and in areas where the surface had already been scraped and scoured during its creation it took very little handling to cause further degradation. In essence, the participants were being encouraged to contribute to the associations and understanding of an object whilst simultaneously being asked to degrade its readability.

The processes that surrounded just one of the twelve art objects used in the project serve as illustration. This art object was based upon a tiny bronze artefact approximately 4cm in length, with the original description 'three horned bull'. The artefact was heavily corroded and had a green to black patina. Much of the 'bull' form had softened to that of a vaguely quadrupedal animal with a large head. The back end of the animal form was twisted so that the hind-legs were raised up to the left hand-side. Having initially discovered, observed and drawn this artefact, it was inescapable that I would have had some of my own preconceptions of a bovine form in the drawing. This may have been encouraged by the side-view from which the object was displayed to me and from which it was drawn. Later, during one of the subsequent interviews with an artist working with complexity theory, it was pointed out to me that animals are often depicted in this way, and that this side-profile was probably the most natural method for recognizing animal forms. A cow is rarely depicted head-on and even less often from the rear, above, or below. In all four cases the animal would be far less distinct, and in silhouette almost unrecognizable.

Furthermore, when transferring the symbolic image from my drawing to the surface of a freshly stretched piece of animal hide I had made a number of significant alterations: I had enlarged the depiction to almost fill the drawing area (35cm × 26cm), limited the colours to black ink (to illustrate the original artefact's outline, and areas of deep shadow and texture) and gold ink (to suggest the colour of the original bronze artefact when it was made), and created a palimpsest by scraping away the surface of the illustration in areas where the museum artefact had been worn or aged. On this particular palimpsest, the entire surface was scraped back significantly, in places leaving deep grooves and only patches of gold, but leaving the outline and areas of deep shadow intact.

Reproduced below are selected extracts from the transcripts of interviews that took place during 2007–8, specifically concerning this art object. These examples demonstrate the range of interpretations, associations and debates that participants applied to each of my project's symbolic images:

To me that's a very stylized cow.

(Lynne Mellor (Leicester folklorist and storyteller) 2008)

It looks almost like a feline head, but the back end doesn't look particularly cat-like to me … Could be a bear, I suppose, but I don't know.'

(Sandra H. Dudley (interpretive studies) 2007)

Well I'm tempted to say that this is a cat with two heads, one at each end, but I suspect it's a fragment of a map or something which has a particular shape, and the lines on it are accidentally where it's been torn or worn, accidentally giving it an external shape which is

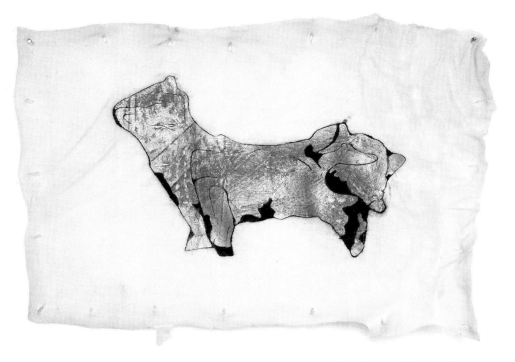

Figure 7.4 'Three-horned bull' palimpsest (inks, stretched and scraped parchment, Alexander Stevenson)

really not something I should be looking at. This is a gilded fragment with some black areas, and I'm trying to avoid turning the outline of it into anything.

(Andy Brooks (Leicester Access Forum) 2007)

Straight away I read it that way up and as a bull. And to me that was really clear, which is weird considering the sort of sketchy nature and ambiguity of some of the other images. But that one I really locked on to.

(Guy Birkin (artist working with complexity theory) 2007)

I think cultural context is the thing. Although I can find all these things really interesting to look at, as far as a direct relationship with them, that doesn't exist anymore because it's hundreds if not thousands of years on, and the whole culture's completely different. There may be the odd thread that we can pick up on, but it's a much more intellectual interaction with these things than it might have been for people at the time.

(Chris Slowe (secularist) 2007)

Because obviously as time goes on, it's going to accrue more and more historical meanings. It's never going to be the same, it's never going to be static. And then when you come along, or someone else comes along, I don't know, from another culture or women, or old, or young or whatever. They're going to just look at it in a different way anyway, from someone who's got historical knowledge.

(Gen Doy (visual and material culture) 2007)

The fact that some participants believed that the image above represented a fragment of a map, a cat (one or two-headed), or a bear, raises interesting questions about my role as an artist – a role which does not rely on the conveyance of concepts of 'truth' (at least from accredited sources) to my audience, and which resulted in apparent misconceptions I did not seek to 'correct'. This rebellious approach to 'the facts' was intended to provoke debate and challenge pre-existing, traditional academic methods for the examination of data and contribution to knowledge. What was produced were subjective associations, and work which generally aimed to raise more questions than it answered. Is this is where artistic and traditional academic interpretations divide? Whereas viewers of artworks may be content with making their own interpretations, visitors to an archaeological museum, for example, may be less content with an unexplained artefact. Audiences physically handling an object in a museum and being asked to interpret it unaided certainly challenges this, but in the context of establishing accredited meaning in relation to data, not all opinions may be as valid as others (Dudley interview 2007). You would not, for example, call upon the expertise of a visual artist to determine the provenance of an archaeological museum artefact, anymore than you would consult a philosopher to determine the physical characteristics of a human biological specimen. But it is interesting that in my creation of the 're-made' artefacts, where the symbolism was transferred onto a new material, the new objects were able to perform a dual function: they could be read and handled as objects, but they also depicted objects. The depictions were often massively enlarged to be proportionate to all of the other new images; this transferred and altered symbolism allowed for flaws and unexpected elements within the transference. The change of scale would have been a key factor in comprehending the original object in terms of use, method of creation etc. The significance of the original material, the loss of the original surface texture, illumination etc. gave way to a set of directly comparable objects with similar texture and illumination across their surfaces. Attention was focused on the materiality of the new objects by removing these 'clues', but still suggested a connection to the original symbolism. They were experienced by participants without explanation, and provoked the viewers to produce interpretations and associations based purely upon the image and material before them, whilst simultaneously representing pre-existing museum artefacts. This placed the art objects in an unusual position: should the interpretations and associations placed upon the symbolic imagery of the art objects be applied (within reason) to the symbolism of the original archaeological artefacts? As an integral part of the art experience, the role of the viewer was re-made into that of contributor, and produced numerous interpretations of the symbolic images – interpretations that in turn could provide new ways of reading of the original artefacts.

The project concluded when I took an hour of these recordings (five minutes for each art object), transcribed it, and created an audio guide comprised of my own voice reading out the transcriptions of the anonymized participants' comments. Perhaps this final stage was unnecessary to demonstrate the further degrees by which I could continue to pursue the subjective handling of artefacts and associations, but it did produce a coherent and all-encompassing audio/performance artwork. The audio guide, informed by the sum of alterations, contributions etc., when experienced alongside either the art objects or the original artefacts informs the viewer and affects how the objects are read.

The art objects themselves already conveyed both a subjective visual response to the original artefacts, and a visual metaphor for the loss of each artefact's ability to fully convey its original meaning. But in order to challenge not only my own perceptions of the artefacts but those of an audience as well, it was vital to have diverse and non-museum-based participants, chosen largely for perceptive and interpretive skills that did not necessarily subscribe to traditional

museological, archaeological, and anthropological models. The participants were challenged in a way that produced many unforeseen cognitive and affective interpretations and associations, and continually suggested new possible outcomes for the project. By creating a physical as well as a cognitive impression on the art objects each time they were handled, the changing state of the physical material had an effect on the visual impact of each object. Though being constantly and subtly altered, each new object was still acting as a material as well as visual manifestation of the original object. It also continued to act as a metaphor for multiple subjective interpretations of the original artefacts' meanings.

The continued degrading of the physical surface created an ever-increasing detachment from the provenance and content of both the art object and the original artefact it represented, yet the intellectual and affective responses of experts became ever more diverse and interesting. Where the illumination across the surface (for instance, in relation to the 'three horned bull palimpsest' (Figure 7.4) became lessened by wear, so the three-dimensionality of the depiction was lessened, and this may have been responsible for the '...fragment of a map...' (Brooks interview 2007) interpretation which had been one of the last recorded interviews, as opposed to 'Straight away I read it that way up and as a bull' (Birkin interview 2007), which had been recorded at the second interview and is more accurate to the museum description of the original artefact. These two responses are more likely to do with the expertise and imagination of the two participants, but this example does represent an opening-up of possibilities created by the unusual situation, and in direct relation to the physical state of the object they were presented with.

The project's process altered the role of the participating audience, by allowing them to freely create and assign meaning to art objects. In addition, by allowing the participants to degrade the material surface that they were examining, the only clues to the objects provenance or content became increasingly lost, yet the interpretations and associations became more and more interesting. Although these meanings have gained some permanence by being documented, they were also as fluid as the previous and subsequent subjective processes of which they formed a part.

Reflections

This chapter raises important questions surrounding both the changing physicality of artworks and their separation from artefacts they seek to represent. In this particular project, it is worth considering how many times the artist-researcher reinterpreted or affected what was presented to participants and final audiences, and asking how this was affected by the research method.

Figure 7.5 is a linear way of demonstrating the ten major transitions of the project from start to finish. Each stage represents: re-making, alterations, contributions from participants, transcription, and each represents a point at which the project was susceptible to my own subjective interpretations. But this diagram does not demonstrate the significant departure that the project made from the 'dendritic' system that the artefacts had come from, nor the opening up of interpretation that the departure allowed.

Figure 7.6, in contrast, demonstrates the opening up of interpretations and associations that this alternative 'rhizomatic' (Deleuze and Guattari 1988) approach offered, and shows it was a dynamic and unpredictable tool which, as we have seen, produced unexpected results, diverse interpretations and associations, and allowed participants to affect the outcomes of the final exhibition.

We have also seen that participants' interpretations and handling of the artworks affected their materiality. Through encouraging my interviewees to handle and experience the art

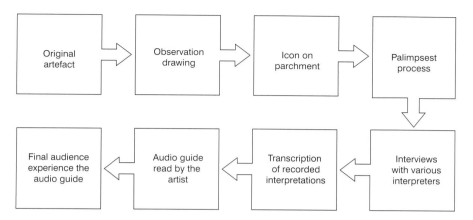

Figure 7.5 Diagram illustrating points of separation from original artefact through to final exhibition

objects, I allowed the objects to physically degrade, creating an ever-changing subject for interpretation. Participants were asked to feel and experience the art objects in a way that would not be possible with the original artefacts, and created a highly unusual sensory experience. Both art objects and museum artefacts of historical value have an aura of priceless fragility around them that requires careful handling. Thus by placing art objects into the hands of participants, the way in which the art objects 'should be' handled was tackled head-on, as well as questioning their physical function as relics (perhaps of the original artefacts too?). The art objects were not precious things, but physical and metaphorical tools with which to transfer information through the process of physical interaction. Each subsequent participant would have had a slightly altered artefact to interact with, and each described the physical qualities as part of their interpretation. Even the storage and transportation of the art objects to the interview locations could be said to have had an impact on the physical reading that each participant gave. Without doubt, the changing material state of the art objects conveying symbolic images affected the interpretations and associations placed upon them. These in turn contributed unexpected interpretations and associations that can be applied to the same symbolic images of/on the original artefacts, and could lead to a broader view of their relationship with the contemporary inhabitants of Leicester. More interesting though, might be a re-examination of how audiences could use these processes to relate to and form important links between contemporary societies and archaeological artefacts without known provenance.

Perhaps one element this project explored most succinctly is the subjective way individuals perceive and relate to their environments, and in particular the archaeological remains of the place in which they live. Several of the participants that took part in the interviews had not previously visited the Leicester museums; none had previously experienced the symbolic images that had been transferred onto parchment. Despite this, the original artefacts were discovered beneath the places where the participants live – an important reason for artefacts without clear provenance not be lost to storerooms. In many ways this project used the ambiguity of these unprovenanced objects to form links between numerous social, cultural and academic groups. This raises broad questions about the relationships between objects, people and place that I don't intend to explore within this chapter.

Figure 7.6 Visualisation of 'rhizomatic' research structure

In raising questions of how and why meaning becomes associated with material objects, this project re-made the role of the viewer into that of contributor, an integral part of the art experience. A crucial way in which this happened was through the material and embodied engagements of participants and art objects, that material being contemporary and intended to physically degrade during interaction. But does this actually contribute meaningful knowledge towards the original artefacts? Perhaps it is a matter of approach. An art object is generally considered on a personal level, through its interaction with or provocation of the viewer; yet this is not the way we generally experience museum artefacts. It is more unusual still to be encouraged to physically handle and be in some way responsible for the changing material state of an artefact or art object. In this way, a participant is able to form a physical relationship with an object and is able to create potentially unforeseen associations and interpretations. The various ways in which a participant could physically interact with an art object in this way are limitless, and thus so are the potential subjective readings. So, perhaps simply allowing people who had no relationship with the archaeological artefacts to have a means of relating to them (distinct from the usual context of the museum), has contributed to a broader perception of these artefacts in relation to the contemporary culture in which they exist.

The art objects may not adequately convey the original meaning or associations of the archaeological object, but in many cases, neither can the original object (or what is left of it). What the process of transference, of converting artefacts into icons, and my own subjective treatment of the symbolic images created, was an opportunity for objects to gain meaning and associations. What value this has to contemporary culture and to academic knowledge about the original artefacts is debatable. But it did allow people from different social, cultural and academic backgrounds to relate to artefacts that were discovered in the place in which they live. It offered them too a way to appreciate objects without known provenance, and created links between these and other social, cultural and academic signifiers.

References

Birkin, G. (2007) 'Artist working with complexity theory representative', Interview 3, Leicester, in A. Stevenson, *Gaps in Archaeology*, online, <http://www.museumcabinet.com> (accessed 10 February 2009).

Bourriaud (2002) 'Nicolas Bourriaud and Karen Moss', interview by Stretcher, online, <http://www.stretcher.org/archives/i1_a/2003_02_25_i1_archive.php> (accessed 20 July 2008).

Brooks, A. (2007) 'Leicester Access Forum representative', Interview 6, Leicester, in A. Stevenson, *Gaps in Archaeology*, online, <http://www.museumcabinet.com> (accessed 10 February 2009)

Deleuze, G. and Guattari, F. (1988) *A Thousand Plateaux: capitalism and schizophrenia,* translated by B. Massumi, London: Athlone.

Doy, G. (2007) 'Visual and Material Culture representative', Interview 2, Leicester, in A. Stevenson, *Gaps in Archaeology*, online, <http://www.museumcabinet.com> (accessed 10 February 2009)

Dudley, S. (2007) 'Interpretive Studies representative', in A. Stevenson, *Gaps in Archaeology*, online, <http://www.museumcabinet.com> (accessed 10 February 2009)

Mellor, L. (2008), 'Leicester folklorist and storyteller representative', in A. Stevenson, *Gaps in* Archaeology, online, <http://www.museumcabinet.com> (accessed 10 February 2009).

Slowe, C. (2007), 'Secularist representative', in A. Stevenson, *Gaps in Archaeology*, online <http://www.museumcabinet.com> (accessed 10 February 2009).

Stevenson, A. (2007), 'Interview statement', unpublished document, Leicester.

VIRGINIA WOOLF'S GLASSES

Material encounters in the literary/artistic house museum

Nuala Hancock

But let me find me among your things – you can't think what a shock of emotion it gives me – seeing people among their things.
 Virginia Woolf to Ethel Smyth, June1932 (Nicolson and Troutman 1982: 70)

The house museum offers a peculiarly direct encounter with the materiality of another's life. As we enter the interior spaces of the house, we immerse ourselves in the lived context of the commemorated life. Walls and floors, drapes and furnishings envelop us. The material fabric of the other's life wraps itself around us. And as we attune to the tactile spatiality of the house, we discover ourselves surrounded by objects; *thronged with things*. For the materiality of the house museum is doubly layered: this is an archive within an archive; both container and contained. For within the interior spaces of these memorial rooms, the material accoutrements of the other's life are laid out before us. Unprotected by the museal glass case, unmediated by interpretive texts, these intimate 'things' are displayed in ways that are immediately susceptible, sensorily apprehensible. Together they take on a performative role, related elements in a museal *mise en scène*, inviting us to participate in a tangible interior world wherein we might adumbrate the lived, material processes of the other.

This chapter arises from my experience of researching, in situ, the interior spaces and contents of Charleston and Monk's House, the literary/artistic house museums of Virginia Woolf and her sister Vanessa Bell.[1] Centres of Bloomsbury intellectual and artistic activity in the first part of the twentieth century, these rural retreats have become recontextualized as 'sister' house museums, intimate theatres of memory, juxtaposed across the Sussex Downs, bearing material witness to the constant reciprocity between Woolf and Bell.[2] Placement at Charleston and Monk's House during the course of this study has enabled a physical immersion in the spaces of the houses; a lived experience of the sensory richness, the atmospheric potency of these charged interiors. The embodied nature of this research has invited an investigation of the house museum as a three-dimensional archive; a phenomenological journey through the spatial layerings of another's personal archaeology.

During the course of my research at Charleston and Monk's House, certain artefacts have presented themselves as particularly compelling, sensorily laden, psychically charged. Their encounter – in some cases their literal 'unwrapping' – offers a potential 'entering in' on the felt material processes and experiences of Woolf's and Bell's lives. To be in the presence of such

artefacts is to be physically susceptible to the resonances that they impart; to the susurrations of past lives which emanate from their surfaces. What biographical disclosures might be enacted through a sensate, corporeal interaction with the intimate materials of others? This chapter offers an account of phenomenological encounters with three 'things' in particular: a dressing table mirror which bears witness to a moment of terrible loss in Woolf's and Bell's childhood; a modernist painted cupboard by Vanessa Bell, bodying forth the animated gestures of her personal decorative *écriture*; and Virginia Woolf's glasses, material surrogates for her prodigious vision, offering borrowed 'in-sights' into her ways of seeing the world.

Virginia Woolf's glasses

[CHA/MISC/247: Spectacles, Virginia Woolf's, material unknown, commercially manufactured, 4.5cm x 17cm.][3]

A search in the database at Charleston in the field 'Virginia Woolf' reveals the presence of an artefact, 'Virginia Woolf's glasses', held in Store Box 56, housed on the archival shelves in Vanessa Bell's attic. I remove the box from its shelf and, following the curator's advice, put on white cotton gloves. Sitting at the top of the box is a brown A4 envelope, folded, occupying about one third of the space (Figure 8.1).

Figure 8.1 Store Box 56, Charleston Archive (photograph by Nuala Hancock, 2007, courtesy of the Charleston Trust)

Alongside it are three longitudinal wrappings, blind and mute, with no outer indication of their contents. Written on the envelope, in a stylish, calligraphic hand, are the words: 'A pair of horn-rimmed spectacles that belonged to Virginia Woolf. Given by Prof & Mrs Bell to be sold at Sotheby's – Unsold – Returned to Charleston'.[4] Removing the envelope from the box and unfolding the flap reveals a second calligraphic inscription, underlined with a flourish: 'Virginia Woolf's Glasses'. Inside the envelope is a small parcel, thickly wrapped in white tissue. It takes seven unwrappings, seven progressive unfoldings, (the tissue paper whispering), to release the contents from their protective veil. This movement mimics a psychoanalytical unwrapping of the past: archives suddenly come to light; revelations in attics and cellars; letters released from Gladstone bags. What repressed materials might thus be released from their accumulative integuments? What memory traces exposed to the light of day?

A long black spectacle case emerges, curiously flat and spined across the ridge. The surface fabric – stretched canvas or leather – is unevenly textured; now raised, now smooth. There are tiny, white paint splatterings across the back of the case. The skin of the case is worn bare along the seams. It is rubbed flat and smooth at the point of opening. On opening the case there is an exhalation of memory; a 'terrific whiff of the past', as Woolf has it.[5] The case is lined in velvet, rich violet in colour, recalling the sensory enclosure of Benjamin's landscape of the interior. What might this receptacle disclose of Virginia Woolf's sense of 'being in the world'? Within this casket, the spectacles lie. Disrupting their repose, I lift them from the case; disinter them from their place of attachment. As they emerge, they bring with them a rush of time – a repressed accumulation of memory – the space around them suddenly unbounded – blowing out emanations of the past – interspersing with the present – flowing into now. The more vividly they present themselves, the more far-reaching their source appears to be.

And what narratives do they disclose, these archival spectacles? What auratic evocations emanate from their surfaces?

They are weightless; exquisitely fragile; inordinately narrow; impossibly ephemeral. The lenses are gone; the content, the substance, the interstitial matter, leaving only the skeletal frame – the lightweight, empty vestiges of the original object. These glasses bear the weight of material evidence, yet their handling reveals them to be of the flimsiest of substance. They have survived through time, yet are a remnant of their former selves. A small section has broken away from the circular lens holder on the left hand side. One might speculate about an accidental fall in the past. One might speculate that this 'imperfection' caused the failure to find a buyer at the Sotheby's auction in 1980, in aid of the Charleston Trust. Yet these deteriorations add to the expressivity of the glasses; they narrate their material biography. Closer examination reveals residual traces of use, apprehensible on their surfaces. There are faint grease stains on the arms; evidence of bodily deposits. These spectacles bring us into close physical contact with Virginia Woolf. They invite us to consider *her* materiality: the physicality of her head; the surface of her skin; the bony integuments of her skull – that protective shell around her prodigious intellect. Handling these spectacles, we are brought in touch with the intimate rhythms of Woolf's daily living: the putting on and the taking off of glasses; the opening and closing of the case. These quotidian things were assimilated into her daily choreography; they became extensions of her gestures. Through this tangible relic, Woolf's habitual body ballets become haptically felt; more vividly knowable.

Woolf indicates in a letter her dependency on spectacles for the central activity of her creative life: 'Having lost my spectacles' she writes to Katherine Cox in March 1913, 'I can hardly see to write …' (Woolf 1978: 19). Photographs bear witness to her use of spectacles for reading. Through this enduring artefact, then, we can intimate her process; actualize the agency

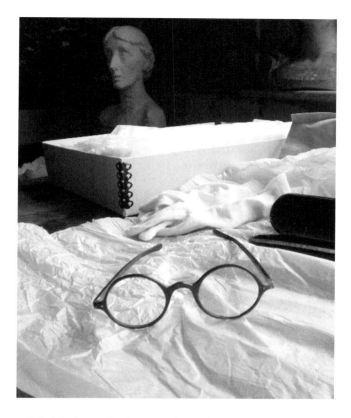

Figure 8.2 Virginia Woolf's glasses, Charleston Archive (photograph by Nuala Hancock, 2007, courtesy of the Charleston Trust)

through which she accessed other worlds through reading; reached into the spaces of another's mind; entered the internal processes of others. Through a flimsy material frame such as this, she transcribed – externalized – her own artistic processes into visible, tangible, communicable form. These glasses, then, bring Woolf more clearly into view; into focus; allowing us to see her in close up; to imagine seeing as she saw.

> Death comes; nothing matters; at least let me see all there is to be seen, read all there is to be read.

> (Woolf 1983 [1926]: 12)

How did Woolf see the world? What is the character of her idiosyncratic poetic vision? 'Why did my eye catch the trees?' she asks her diary in August 1928. 'The look of things has a great power over me' (Woolf 1981b: 190–1). But transcribing the visual into the verbal involved, for Woolf, a phenomenological engagement. Woolf translates seeing into felt texture and sensation; into material surfaces and depths; into physical tactility and excitation. Watching the rooks 'beating up against the wind', for example, she seeks words to communicate the 'tremor' of the wing as it cuts through the air 'slicing' it; 'deep breasting' it. And the substance of the air, in her eyes, is thickly palpable, 'full of ridges and roughnesses', 'rubbing and bracing' the rooks

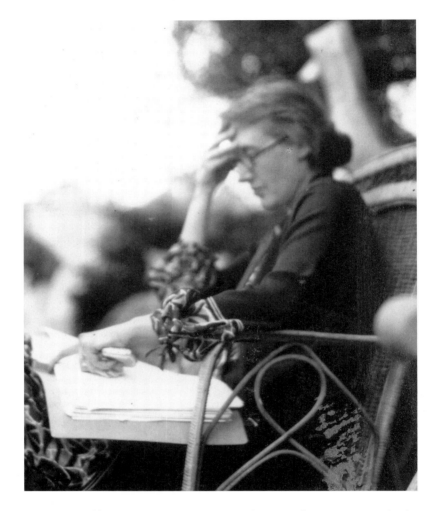

Figure 8.3 Virginia Woolf, June 1926 (photograph by Ottoline Morrell (1976 [1926]: 74), The National Portrait Gallery NPG Ax142598)

as they rise and fall in the sky (ibid.). The vividness of Woolf's vision arises from an organic interconnectivity between the senses: between seeing and feeling; between what stimulates not only the eyes but 'some nervous fibre or fan like membrane' in the spine (ibid.). Woolf's writing makes seeing felt. She connects sight with the solar plexus; the visual with the visceral. Through our own phenomenological encounter with these glasses, this conduit of Woolf's 'seeing', we sense Woolf's vision as corporeally 'enfleshed'; as vital sensation, registered molecularly, through the live material fibres of the body.

But such close bodily contact with this intimate relic transgresses the accepted boundaries of personal space. If these spectacles allow us to scrutinize Woolf, they equally remind us that she hated being scrutinized; feared perpetually *making a spectacle of herself*. 'Deeply chagrined', she was; 'never more humiliated'; a 'weathercock of sensibility!' she reports, when her hat was ridiculed in front of others by Clive Bell (Woolf 1983 [1926]: 90–1). 'Oh they laughed at my

taste in green paint', she howls a few months later in her diary with a sense of failure (1983 [1926]: 110). She constantly refers to her diffidence regarding her appearance; her 'profound trepidation' about her clothes (1983 [1932]: 104); her 'bottomless despair' when her sister 'disapproved' of the style of her hair (1983 [1931]: 11). She resisted Stephen Tomlin's desire to sculpt her in 1924, and when she yielded in 1931, she felt 'tampered with', 'pinned down', 'looked at', 'like a piece of whalebone bent' (1983 [1931]: 37). These reliquary spectacles promise us the tantalizing possibility of seeing Woolf more clearly; simultaneously, they implicate us in an act of voyeurism; 'tampering' with Woolf's past; coming between her and this lost personal remnant. As we look at these spectacles, agents of Woolf's 'looking', we are confronted with the discomfiture of investigating another's private things. Does our desire to see her more vividly justify this close material examination? Through this metonymic relic, we find ourselves at the interstice of seeing and being seen.

This focused investigation of a remnant of another's life brings to mind Woolf's own reflections on the nature of inter-subjectivity – the elusiveness of the other, even when physically, materially proximal. 'How am I to break into this other life which is 6 inches off mine in the deckchair in the orchard?' she asks her diary in August 1928 (1981b [1928]: 189). Woolf longs for something more concrete, more actualized, to represent the substance of our relationships.

> [W]hy is not human intercourse more definite, tangible; why aren't I left holding a small round substance, say the size of a pea, in my hand; something I can put in a box & look at?
> (Woolf 1981b [1928]: 188)

Woolf's glasses, precisely, offer us something tangible of her material existence; something we can, and indeed have, 'put in a box' to 'look at'. Death and the passage of time give us license to transgress accepted inter-subjective boundaries; to 'break into ' another's life; to handle, to investigate, to appropriate their private things. Such privileged encounters bring us into closer contact with the other; render the intangible tangible; offer us the possibility of 'sensing' the other through the enduring fabric of their material lives. But the viscerality of handling a relic such as this rests on a felt disequilibrium: between the survival of the object and the distant evanescence of the life it commemorates. The more vividly present through the metonymic object, the more poignantly absent the subject reveals herself to be.

Virginia Woolf's construction of her psycho-corporeal boundaries with her sister Vanessa Bell includes a desire for incorporation.[6] It is significant, then, and an expression of the poetics of space, that in the process of time, this most private of remnants, this 'body-object' – (there are no shoes; there are no clothes) – has found itself inserted, not in the commemorative interiors of Virginia Woolf's house at Rodmell, but wrapped in protective paper skins, embedded within the recesses of Bell's personal domain, in the artist's studio attic at Charleston.

Painted cupboard, Vanessa Bell's bedroom

[CHA/F/55: Cupboard, circa 1890, painted wood, manufactured to contain a folding bed by the Folding Brass Bed Company, Hart Street, London, decorated by Vanessa Bell circa 1917, 219cm × 91cm × 32cm. Prov: D. Grant][7]

This is the room where Vanessa Bell woke and slept; this is the room where she lived and died. Memories of Bell are embedded here. Two pieces of furniture in the room, large in scale and

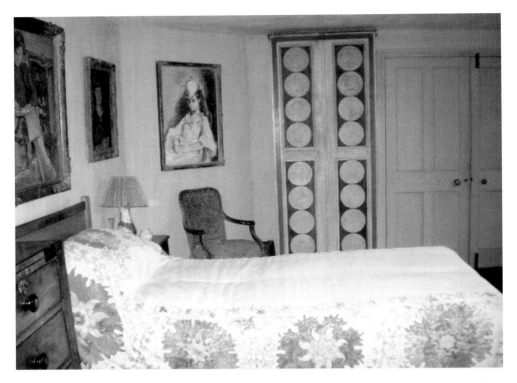

Figure 8.4 Vanessa Bell's bedroom, Charleston (photograph by Nuala Hancock, 2007, courtesy of the Charleston Trust)

anthropomorphic in character, fill the space and bear the traces of her material presence. One is the bed, connotative of the body recumbent; the other an upright cupboard, suggestive of the body perpendicular. These large-scale artefacts in the collection at Charleston work in physical relationship, enacting the daily choreographies of Vanessa Bell.

Inordinately tall, and strikingly inscribed, this cupboard was decorated by Bell in 1917, shortly after her arrival at Charleston. How does this artefact 're-member' her? In what ways does it *stand* for her? Ritualized by her decorative *écriture*, animated by the visible gestures of her body, this painted cupboard might be read as a self-portrait of Bell, in sculptural form.

It is statuesque in presentation, imposing in scale. It expresses a sense of largesse, of magnificence. (These are the qualities of Vanessa Bell's presence, as recorded by her contemporaries. Leonard Woolf remembers her 'physical splendour'; her 'monumentality' [1975: 27]). Yet, skimming the ceiling, this cupboard barely fits the room, its inordinate verticality hardly contained within the framework of the wall. Like Bell's huge scale figures dancing across the walls in her work for the Ideal Home exhibition in 1913 (Naylor 1990: 129), this sculptural piece fills the space; requires more space; strains within the frame. The tension between the monumentality of the cupboard and the constraints of the space re-enacts the feelings of entrapment expressed in Bell's decorations elsewhere in the house: gestural plants straining to express full-flowering within the tight confines of a door.[8] This lofty sculpture is at odds with the low-ceilinged room; its magnificence compressed. There is a clash of scales enacted here, as though the cupboard has outgrown its context, or the room has shrunk in size. A narrative suggests itself about

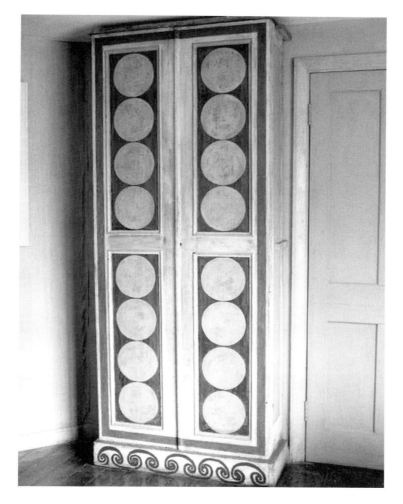

Figure 8.5 Painted cupboard, Vanessa Bell's bedroom, Charleston (photograph from the Charleston database, courtesy of the Charleston Trust)

disparity – the disparity, perhaps, between Bell's artistic adventuring and the constraints of her gender; between her appetitive modernism and the strictures of her Victorian inheritance. The conversation between exuberance and restraint is repeated across the painted surfaces of the cupboard. Four engorged circles fill the panels of the doors, barely accommodated within the narrowness of the frame. At the base of the cupboard is Bell's signature *écriture* – the enlarged volutes and swirls of her ample calligraphy. The expansiveness of Bell's gestures, it seems, can hardly be contained either within her selected frame, or, by implication, within her prescribed cultural space. Bell's palette for this piece is arrestingly organic; her repeated symmetrical motifs strikingly anatomical. The large ochre circles project from an aubergine ground. They are twice enframed in painted borders of ointment pink and Indian red. In form these quartered panels resemble a statuesque torso; articulated limbs. The carnal pigments are dark and pungent, redolent of sexuality. Bell's blood-red *écriture* suggests writing on the body; the fulsome circles

121

lunar discs, or swelling fruits on the point of fecundity. Through these gestures of self-figuration, Bell communicates her fertility; her lavish sexuality.

Yet there is tension here between the expansive gestures on the surface of this cupboard, and the narrowness of its girth and frame. This canvas is a three-dimensional sculptural form; an eloquent articulator of the poetics of space. As a body, as a house, the cupboard has a visible exterior and a hidden interior; an outer skin and a private inner world. It is both open and closed; expressive and repressed; receiving and obfuscating. It is, as Bachelard suggests, 'a veritable organ of the secret psychological life' (1994: 78). Bell was constructed by her contemporaries as inaccessibly private, offering glimpses of herself only to her intimate circle. She guarded her feelings within; repressed her anger when confronted by her histrionic father.[9] Yet this repression is complicated by the openness, the looseness, the freedom of her painting; the animated quality of her mark-making across the surface of her house. There is a mismatch between the spontaneity, the flamboyance of her painted gesture and the closure with which she is often associated.

But the metaphoric spaces of this cupboard suggest both psychic interiority and the anatomical spaces of the female body. For Bell's daughter, this cupboard represented motherhood. 'It is said that cupboards symbolize mothers, and Vanessa's design implied the amplitude and calm of her own nature' (Garnett. 1997: 107). But is there a further narrative here beyond her amplitude and calm, implicit in her autobiographical inscriptions? In 1917, Bell was both artist and homemaker; mother to two children; wife of Clive Bell; domestic provider for Duncan Grant and his lover David Garnett; host to the wider Bloomsbury entourage. As the eldest of the Stephen children, she had mothered her three siblings through their losses of their childhood; had reinvented their lives within the spaces of her reconstructed home in Bloomsbury. Throughout her life she offered maternal care to her younger sister, who constructed herself as Bell's 'first born' (Woolf 1978 [1918]: 312). Is this sculptural self portrait an expression of protest about the number of her dependants? Is this painted cupboard an act of resistance against her defined role as a capacious 'holding environment' for others? The repeated sequence of four circles on the face of the container is suggestive of the multiplying numbers of those in her care: the four Stephen siblings of the past; her own two children and Grant and Garnett in the present. Julia Stephen, her mother and 'angel in the house' had borne seven children, and was protector of eight. She cared for the sick and dying throughout her life. These reproducing circles are connotative of a many-breasted figure – a modernist Diana of Ephesus, nurturer of children and protector of others. How much succour can Bell be expected to deliver? How far must she accommodate? This life-size self-portrait enacts a conflict of interior space: a contest between the potential space for personal creative expression and the space already occupied by the clamorous needs of others. Through the expressive medium of 'liquid thought' that is paint, Bell negotiates on the surfaces of this three dimensional canvas the tensions created by her many and conflicting self-configurations: as mother, wife, partner, sister and ground-breaking woman-artist at the beginning of the twentieth century. Anticipating Louise Bourgeois and her *Femme Maison*, Bell invests an inert cupboard with the felt tensions between domesticity and artistic expression; between individual potential and defined cultural roles. The cupboard's essential dialectic of open and closed, inside and outside, is transformed in both cases into phenomenological arenas of liberation and entrapment.[10]

In her memoir of the house, Bell's daughter, Angelica Garnett, opens the door of this cupboard and gives us an appetitive glimpse of her mother's inner world – a sensuous world of rippling silks and radiant colour; a release of repressed vitality:

It was here that, later on, she kept the scraps of material she hoarded over the years, and it was these shelves that I rifled for dressing-up clothes. Textiles left over from the days of the Omega, a hand-painted, silk jacket bound with peacock blue satin … a saffron skirt from China, a cramoisy brocade from the Roman rag market … lay folded on the shelves, and formed an essential, sensuous element in Vanessa's life.

<div align="right">(Garnett 1997: 107)</div>

A coloured world spills from the interior, offering imaginative flights; alternative ways of being. According to her daughter, this cupboard was a large-scale memory box for Vanessa Bell, filled with the fabrics of her sensuously lived past. Certain pieces survive in Charleston's textile collection: in a long grey box stored in the cupboard of the spare bedroom is a 'silk damask Chinese skirt', (CHA/T/100), chartreuse in colour, and corresponding to Garnett's 'saffron skirt from China'. Attached to this skirt of piquant vibrancy, is a fragile bodice, loosely sewn on to its waist band. Sewing was a creative language shared by Bell and her daughter. 'Dinner with Clive: Janis: Nessa, Angelica …', Woolf reports in her diary in November 1937. 'We discussed education; dreams; N[essa] & A[ngelica] stitched at some private garment.' 'Stitching at private garments' was a restricted code from which the daughterless Woolf was excluded (Woolf 1982 [1937]: 117).[11] This cupboard with its vividly coloured hand-stitched garments was an exclusive site of dialogue between Bell and her daughter; a gendered artefact in which daughter returns to her mother's womb and plunders her inner riches.

Dressing table, spare bedroom

[CHA/F/152 Dressing Table, mid 19th century, walnut, glass, velvet, maker unknown, England, 160cm × 141cm × 55cm. Prov: Bequeathed Leslie Stephen to V.Bell. Formerly in the Stephen family home at Hyde Park Gate.] [12]

This dressing table (Figures 8.6 and 8.7), as the Charleston archive reports, was brought to Charleston from Hyde Park Gate, Woolf's and Bell's former childhood home. It shares this provenance with a nineteenth-century display cabinet held in the dining room at Charleston, bequeathed to Vanessa Bell by her father, Leslie Stephen (CHA/F/3). A further cupboard, a heavy Dutch cabinet in walnut belonging to William Makepeace Thackery, and so by descent to Vanessa Bell, is housed in the main studio at Charleston (CHA/F/67). These three significant archival objects are twice recontextualized: at first as familial historic objects incorporated into the household whilst it thrived at Charleston, and, secondly, redefined as listed members of the archival collection in the artistic house museum. They are, in this sense, palimpsests, inviting contact not only with the material worlds of Charleston as it was from 1916 until Duncan Grant's death in 1978, but with the layered materiality of Woolf's and Bell's earlier lived past; the tangible trappings of the Victorian interiors of their childhood. The poetics of these pieces is expressed through their presentation as containers; as though the past were stored on the deep shelves behind their glass doors, or held unseen within the shadowy recesses of their locked drawers.

If space, as Bachelard suggests, is 'compressed time' (1994: 8), then the interior spaces of these containers house the remembered past of Woolf and Bell. But the biographical narrative of the dressing table, CHA/F/152, held within the spaces of its narrow drawers and the reflective surface of its mirror, is particularly poignant. This dressing table belonged to Julia Stephen, the mother of Woolf and Bell. It once stood in her room at Hyde Park Gate (Bell and Nicholson

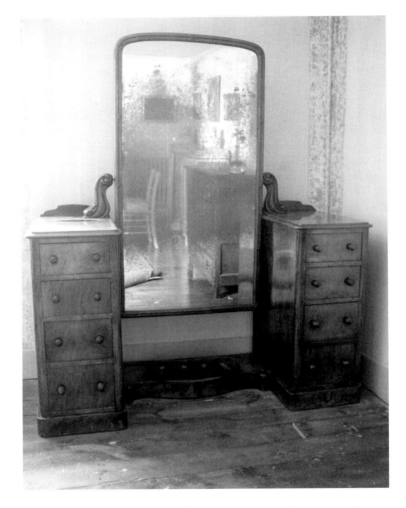

Figure 8.6 Dressing table, spare bedroom, Charleston (photograph from the Charleston database, courtesy of the Charleston Trust)

1997: 120). It was present at her death in 1895; it bore witness to her daughters in their moment of trauma. Woolf mediates the mutism of this relic; narrates its past to us in her memoir; discloses its terrible significance. Wrapped in towels and given 'a drop of brandy in warm milk to drink', she recalls, the Stephen children were led into the room to kiss their mother, 'who had just died':

> I think candles were burning; and I think the sun was coming in. At any rate I remember the long looking-glass; with the drawers on either side; and the washstand; and the great bed on which my mother lay.
>
> (Woolf 2002: 102)

Cloaked in its spectral sheet, this artefact bears the impression of an enrobed figure with outstretched arms; seeking contact, yet silenced by its muffling, obfuscating shroud. (The young

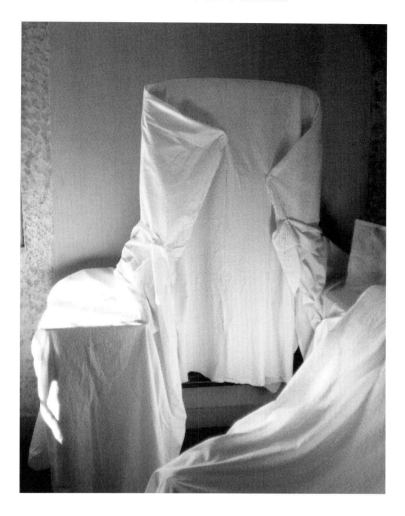

Figure 8.7 Dressing table, spare bedroom, out of season (photograph by Nuala Hancock, 2007, courtesy of the Charleston Trust)

Woolf had extended her arms to her father as he staggered from the bedroom at Hyde Park Gate, blinded by grief [ibid.]). The seasonal dialogue between revelation and concealment, the vital and the mute mimics the transition between presence and absence, animation and evanescence that is materially articulated in the process of dying. 'I stooped and kissed my mother's face', Wolf recounts in her memoir. 'She [had] only died a moment before' (ibid.). To stand in the presence of this artefact is to relive that moment of unmitigated loss. To catch oneself reflected in the 'long looking-glass' is to glimpse images of Woolf and Bell, their condition suddenly and unutterably altered. It is to see them, as they saw themselves, in a new and shocking light; as irretrievably bereaved children; as irreversibly motherless daughters. We are transported in our minds into that room at Hyde Park Gate – 'the sexual centre; the birth centre; the death centre of the house'; that room whose walls were 'soaked' with 'all that was most intense ... of family life' (ibid.: 125). We are returned to those 'shrouded and curtained rooms' following Julia Stephen's

death; the shut doors, the stifling silence, the creeping in and out; the suspension of living (ibid.: 103–4). 'I begin to be impatient of solitude', it brings to mind; 'to feel its draperies hang sweltering, unwholesome about me' (Woolf 2000: 87–8).

Implicated through our associative imaginings, this dressing table takes on an abject air: lachrymose; forlorn. In the staining patina gathered in the seams of wood, in the blighted surface of the ageing glass, it communicates its burden of distress; the grieving of its past. If the aura is an emanation apprehensible in the atmosphere, a savour redolent in the air, then this dressing table is drenched in the soured taste of sorrow. Its mirrored surfaces have become curdled with time; yeasted over with emotion. As we engage with its presence, we intimate several layers of archaeology: the object's own material history; its significance in the history of Woolf and Bell; the way it chimes with similar dressing tables in our own past; its significance in the reconstructed context of the museal room. Looking in the mirrored surface we see ourselves both past and present, here and there; then and now. Emplacing ourselves within the mirror's orbit, we challenge its inactivity by the actuality of our engagement; disturb its blurred surfaces with the vividness of our presence. But this subject/object dialogue is fraught with ambivalence. To our shock, we catch ourselves observing – 're-searching' – this most terrible of moments. We are confronted in this mirror with the prurience of our investigation – our desire to see more clearly this moment of unmitigated loss in the lives of Woolf and Bell.

That the Charleston tour includes a reference to this artefact's witness demonstrates an incorporation of 'difficult subject matter' into the museal text.[13] This expressive artefact, abject in air and drenched with sorrow, implicates the viewer in the painful emotions that surround untimely death. It dismantles visitors' expectations that Charleston offers (no more than) an encounter with artistic insouciance and bohemian living. The biographical narrative of this archival object insists, if we pay attention, that we contemplate not only death, but the moment of dying. It is the acuteness of the loss, the vividness of the memory that this mirrored relic embodies. This museal object challenges us to confront unswervingly the severity of the psychic injury of their mother's death and its emotional ramifications in the shared history and individual artistic expression of Virginia Woolf and Vanessa Bell.

Notes

1 A collaborative AHRC doctoral project with the English department of the University of Sussex and The Charleston Trust (2005–2009).
2 Monk's House, in the village of Rodmell, was opened to the public under the auspices of The National Trust in 1982; Charleston, in Firle, near Lewes, was restored by The Charleston Trust in the early 1980s and opened by the Trust to the public in 1986.
3 Text from Charleston database: Modes, The Charleston Trust.
4 The auction at Sotheby's referred to here took place in July 1980. It consisted of 130 lots 'from various sources to be sold for the benefit of the Charleston Trust, a registered charity set up to save the house of Duncan Grant and Vanessa Bell at Charleston' (Charleston Archive: Early Fundraising).
5 'Old letters filled dozens of black tin boxes. One opened them and got a terrific whiff of the past' (Woolf 2002: 44).
6 See Woolf 1978 (1921): 458. 'And why did you bring me into the world … ?' she asks her sister (March 17 1921). See also Woolf's diary entry for 20 June 1928 (1983: 186): 'I run to her as the wallaby runs to the old kangaroo'.
7 Text from Charleston database: Modes, The Charleston Trust.
8 Duncan Grant's bedroom, The Charleston Trust. See Bell and Nicholson 1997: 112–3.
9 For accounts of Bell's relationship with her father, after their mother's death, see Bell 1998: 71–3 and Woolf 2002: 147.

10 Bourgeois's *Femme Maison* series, from the 1940s, shows women's bodies trapped in buildings, as though, as Ann Coxon (2008) suggests, 'like Alice in Wonderland, they seem suddenly to have outgrown their confines'. See booklet accompanying the exhibition [Room 1] at Tate Modern, 10 October 2007–20 January 2008.

11 See also Woolf 1981a (1930): 173. 'Mummy was making a beautiful white silk petticoat', Woolf writes to Angelica, 'How I wish I could sew like you and Mummy…'

12 Text from Charleston database. The Charleston Trust.

13 Visitors to Charleston, for the most part, are 'shown' the house through a guided tour of the rooms (individual viewing is possible on Sundays in season). The 'tour' of the spare bedroom includes a reference to the original context – and Virginia Woolf's retrospective account – of the dressing table in question. For more on 'difficult subject matter' in museums, see Bonnell and Simon 2007.

References

Bachelard, G. (1994) *The Poetics of Space*, trans. M. Jolas, Boston, MA: Beacon Press.

Bell, Q. and V. Nicolson (1997) *Charleston: a Bloomsbury house and garden*, London: Frances Lincoln.

Bell, V. (1998) 'Hyde Park Gate after 1897', in Giacheri (ed.) *Sketches in Pen and Ink*, London: Pimlico, pp. 67–81.

Bonnell, J. and R. I. Simon (2007) '"Difficult" exhibitions and intimate encounters', *Museum and Society*, 5 (2): 65–85.

Coxon, Ann (2008) *Louise Bourgeois*, London: Tate Publications

Garnett, A. (1987) 'The earthly paradise', in Q. Bell, A. Garnett, H. Garnett and R. Shone (eds) *Charleston Past and Present*, London: The Hogarth Press, pp. 104–135.

Morrell, O. (1976) *Lady Ottoline's Album: snapshots and portraits of her famous contemporaries*, London: Joseph.

Naylor, G. (ed.) (1990) *Bloomsbury: the artists, authors and designers by themselves*, Hong Kong: The Octopus Group Ltd /Amazon Publishing Ltd.

Woolf, L. (1975) *Beginning Again*, New York and London: Harcourt Brace Jovanovich.

Woolf, V. (1978) *The Letters of Virginia Woolf*, edited by N. Nicolson and J. Trautmann (Harvest Edition), vol. 2 (1912–1922), New York and London: Harcourt Brace & Co.

Woolf, V. (1981a) *The Letters of Virginia Woolf*, edited by N. Nicolson and J. Trautmann (Harvest Edition), vol. 4 (1929–1931), New York and London: Harcourt Brace & Co.

Woolf, V. (1981b) *The Diary of Virginia Woolf*, edited by A. O. Bell assisted by A. McNeillie (Harvest Edition), vol. 3 (1925–1930), New York and London: Harcourt Brace & Co.

Woolf, V. (1982) *The Letters of Virginia Woolf*, edited by N. Nicolson and J. Trautmann (Harvest Edition), vol. 5 (1932–1935), San Diego, New York and London: Harcourt Brace & Co.

Woolf, V. (1983) *The Diary of Virginia Woolf*, edited by A. O. Bell assisted by A. McNeillie (Harvest Edition), vol. 4 (1931–1935), New York and London: Harcourt Brace & Co.

Woolf, V. (2000) *The Waves*, edited and with an introduction and notes by K. Flint, London: Penguin Classics.

Woolf, V. (2002) *Moments of Being: autobiographical writings*, edited by J. Shulkind, introduced and revised by H. Lee, London: Pimlico.

9

WHEN ETHNOGRAPHIES
ENTER ART GALLERIES

Lydia Nakashima Degarrod

In this chapter I explore expressions of embodied and emotional knowledge and aesthetic responses in the audiences of three exhibits in university and community art galleries of *Following the Trails of Urban Miracle Seekers*, an ethnographic-based art project. This interdisciplinary art project was created using my skills as a visual artist and as an ethnographer. To understand the relationships created during the exhibits between audiences and ethnographic-based artworks, I examine the process of creating the art object from its origin in the ethnographic field, to its making in the art studio, and finally to its display in the exhibiting space. I found that while the exhibiting space and its display, play an important role in shaping responses from the audiences, the images themselves contain forms of knowledge and sensations that have been created in the ethnographic site and in the studio which are transmitted to the viewers during the exhibits and often without the intention of the artist. This is particularly the case when the images are based on collective suffering or trauma, which tend to emotionally affect viewers.

Following the Trails of Urban Miracle Seekers consisted of 14 mixed media paintings and four text panels based on a Chilean popular religion. It was exhibited from 2004–2005 at two university galleries and one municipal community gallery. This exhibit was based on ethnographic research I conducted into a popular religion which venerates the souls of the people who have died in a violent way in the streets of Chile. As will become clear, most viewers of these exhibits expressed a form of embodied knowledge that replicated the ethnographic information portrayed in the exhibits. The viewers, like the members of the cult, used the shrines as a site for the expression of injustices.

I present first the story of the making of the project, and the reasons for combining visual art and ethnography. This is followed in turn by a discussion of the general characteristics of the cult, the making and display of the exhibits, and the responses of the audiences. I conclude with a discussion of the embodied and sensorial form of knowledge displayed by all the audiences of the exhibits. I specifically address the relation of this form of audience response to the viewers' degree of exposure to texts and images in the exhibits, the value of the images as representing different forms of social trauma or suffering, and the actual ethnographic basis for the making of the artworks.

The *Animitas* project

From 2001 to 2004 I conducted ethnographic and historical research into a popular urban religion in Santiago, Chile, the city where I grew up.[1] My interest in the cult of the *animitas* started when, as a child, I would often see in the streets shrines built in the shape of houses or churches for the *animitas* or souls of those who had died in a violent manner in the streets of Santiago. The shrines memorialize unjust deaths and contain an implicit protest against violence. They also signal the presence of souls called *animitas* who reside in the shrines and who help the living by performing miracles in exchange for prayers. The urban Chilean cult of the *animitas* is a popular religion which has undergone several changes over the last two hundred years, as it has adapted to different cultural and social conditions. It has evolved from a cult dedicated to the veneration of executed famous bandits in the rural areas of Chile in the late 1800s to an urban cult, which today includes anybody who suffered a violent and unjust death.

The generally held contemporary belief is that the souls of these victims cannot go to their final destination because of the injustice of their deaths and they need the prayers of the living to reach their final destination. A contract is established between the soul and the believer in which the soul helps the living person in return for prayers that will assist the soul to reach its destination. The shrines are built by the relatives of the dead or by people living in the vicinity of the place of the death and are normally decorated with candles, flowers, photos, and plaques thanking the soul of the deceased for the realization of a request, something which is viewed by the believer as a miracle. The number of *animitas* is hard to calculate because of the constant turnover caused by the immediate appearance of the shrines after the occurrence of urban deaths, and their demise or abandonment after the souls have lost the power to produce miracles. I estimate the number of the shrines in Santiago to have been close to one thousand in the early 1990s.[2]

This popular religion is characterized by its visual character. Because there is no institutional control over the practice of the cult, the transmission, practice, and interpretations of the cult are passed on primarily through visual cues. The physical presence of the shrines and their specific decoration inform pedestrians or drivers about the life of the *anima*, and their miracles and popularity. Pedestrians learn about the appearance of new *animita*s by seeing the recently built shrine in the streets with its fresh flowers and candles. At the same time, shrines which look abandoned visually announce that the soul is not there anymore. Photographs are used to represent the victim and plaques describe the lives of the deceased and the way they died. In addition, through the colours used in the shrines believers can identify the type of accident or victim involved. For example, shrines for incidents that were particularly bloody tend to be painted with black or red. To indicate that the victim was a girl the colour favoured is pink, whereas light blue is used for boys. The popularity and longevity of a shrine is also expressed visually. For example, there is wall near a railroad station in Santiago dedicated to the soul of Raimundito, a man who was killed almost a century ago (see Figure 9.1). As his popularity as a miraculous soul has risen, grateful devotees have individually decorated a spot at the wall which now extends to a block in length. Most of the devotees have left plaques, which serve the double purpose of providing testimony to the miracle and thanking the soul. In addition, many have decorated the space surrounding the plaque with paintings representing the miracle experienced, flowers, and personal objects representing the person who received the miracle – such as baby clothing or toys if the receivers of the miracles were babies. The decoration of the shrines and the acknowledgment of gratitude to the soul are important social practices, which allow the continuation and transmission of beliefs.

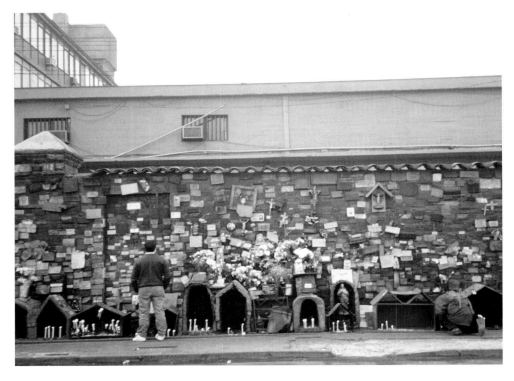

Figure 9.1 Shrines for the Animita Romualdito in Santiago, Chile (photograph by Lydia Nakashima Degarrod)

The practice of this cult involves a series of group and individual activities which are forms of embodied cognition and collective memory rooted in social life (Morgan 1998: 4; cf. Bourdieu 1977). This is a popular religion that has been practised primarily by people with little access to sources of power and limited economic means. Created originally by poor peasants over two hundred years ago, the practice of this popular religion today remains a source for the expression of perceived injustices in both urban and rural settings primarily by those who feel socially and politically marginalized. The cult has continued to evolve through the twentieth century, its transmission and continuous change dependent on the individual and social practices of the believers who are inscribing and reading new meanings into the shrines. The shrines for contemporary urban pedestrians simultaneously signal a space of unjust death, of miracles, and serve as a place for the expression of everyday grievances and sufferings.

Images as ethnographic depictions

Several aspects of this popular religion, particularly of its visual character, and representational issues raised by past ethnographic projects led me to create a series of mixed media paintings as a component of my ethnographic representations. First, in writing ethnographies, as I have discussed elsewhere (2007), there are many aspects of the ethnographic experience that are not expressed in the ethnographic text. These include the textures, emotional climates, and experiences which defy textual representation.[3] I have learned, as have many other ethnographers,

that words alone cannot fully represent all aspects of the ethnographic experience (cf. Heller 2005, Ravetz 2005). I turned to using my skills as a visual artist to depict those ethnographic textures that tend to be lost from the traditional textual ethnographic representation. In this particular case, images serve better the depiction of the emotional aspect of miracles, sentiments of injustice and urban violence.

Second, the visual nature of the cult itself required an equivalent medium of expression for its representation. Ethnographic representation involves a series of translations from the experiential information to the analytical reasoning, which has traditionally and primarily been represented in a written form. As a way of eliminating one level of this translation process from a popular religion which is characterized by its visual mode of transmission and practice, I chose an equivalent, i.e. visual, mode of representation. The shrines of the *animitas* are visual cultural products whose production, decoration and display contain social and individual activities which themselves induce religious formation and the making of collective memory.[4]

Third, I was motivated by a desire to expand the ethnographic audience from that of the solitary reading of the ethnographic text by an academic audience to one that views and interprets the work publicly and socially. The gallery provides the physical space that allows viewers to see and interact with objects socially, and has through the gatherings at the exhibition receptions the potential of creating among the viewers the social space for the expression and sharing of subjective experiences (Heller 2005). By shifting the presentation of ethnographic work to a non-traditional setting such as an art gallery, I aimed to create a social space for interaction and participation.

Finally, I wanted to experiment with the creation of new forms of ethnographic representation which locate images as central to the representation and not as merely illustrations of texts. In this regard, I have been influenced by visual anthropologists like David MacDougall (1998), Anna Grimshaw (2001) Grimshaw and Ravetz (2005), Sarah Pink (2004), Amanda Ravetz (2005) and others who are calling for an engagement with the visual not simply as a mode of recording or illustrating data, but as a medium through which new knowledge and critiques may be created.

Cultural anthropologists have recently become aware of the possibilities of the use of fine arts in the making of ethnographies, while visual artists have been using ethnographic techniques for at least the last ten years (Coles 2000, Grimshaw and Ravetz 2005). The reticence of anthropologists in the past to use fine arts in the production of ethnography has overlapped with a reluctance to use images in general. While anthropologists made use of photographs in the nineteenth century, their use diminished for most of the twentieth century, leaving only ethnographic film as the main source for images in anthropology (MacDougall 1998, Pinney 1992). This reluctance has been labelled by Lucien Taylor as a form of 'iconophobia' in anthropology, which originated early in the discipline's development in order to separate ethnography from travel literature, and has been maintained throughout the twentieth century as part of seeking to establish ethnography as a legitimate science (Taylor 1996). Since the late 1980s, however, there has been an increasing acceptance of images in anthropology, due in part to the emergence of new visual technologies, a growth in the scope of the field of visual anthropology, and a renewed interest in images across disciplines (Banks and Morphy 1997, Pink 2004). Visual anthropology, the section of the discipline which deals primarily with images, has expanded its scope of research and its forms of representation to include forms of visual representation other than film. Visual anthropologists have turned to visual art as a source and a methodological tool for obtaining and decoding ethnographic data, and for ethnographic representation (Grimshaw and Ravetz 2005, Schneider and Wright 2005).[5]

The making of ethnographic texts and images

My paintings and my ethnographic writings were made away from their ethnographic sites and from their future display sites. Thus in the making and its display the paintings are shaped by stylistic decisions and contextual elements. The making of the images relied on the personal memories of the shrines and on the ethnographic research information collected at the site. The sites of artistic production are places where artistic issues are reflected and contested, and personal, emotional and environmental textures are incorporated (Nakashima Degarrod 1998). While I aimed at keeping the experience of the fieldwork fully alive in the making of the paintings, the artworks were also influenced by stylistic and technical decisions and by emotions and images arising from the site environment. I tried to maintain my mental images from Santiago and the shrines as alive and fresh while I made the paintings, but my mind was constantly invaded by other images from my immediate surroundings and, most importantly, I was affected by the post–9/11 emotional and visual climate of the time in 2002–04.

The making of the images entailed a series of steps similar to those used in the writing of ethnographic research, from interpreting the data both ethnographic and historical, to reflection, to searching again for more data. The main difference from the writing of ethnographies was using my imagination and sense memory in the recall, interpretation and depiction of data, which resulted in types of cognitive embodiments or experiential knowledge. In other words, I had to re-live through sense memory all of my personal experiences with the *animitas* to interpret the ethnographic and historical data I had collected and analysed and to then use it in the creation of the paintings. I alternated between the re-living through sense memory and the actual making of the paintings.

The style of painting – mixed media which incorporated photographic image transfers, drawings and painting – was guided primarily by a desire to portray the emotional and spiritual aspects of the cult of the *animitas* instead of realistically illustrating the actual sites of the shrines or the cultic practices. While I made use of photographs of places in Chile which could provide an illustrative or realistic depiction in the paintings, their use in combination with drawings and paintings accentuated the emotional and atmospheric feelings associated with the shrines and the cult. The mixed media usage helped me in depicting evocations of the shrines as sites of collective suffering, injustice and spirituality.

For the selection of images I was guided by four themes that were drawn from the ethnographic research: the origins of the cult, the practice of the cult, the types of the *animitas* or souls, and the emotional climate of urban miracles and miracle seekers. After I had made 35 paintings, I selected 14 that I found aesthetically pleasing and that would fit the four major themes. I made four text panels to accompany the paintings in the exhibits. The purpose of the text panels was to provide specific information about the cult and the project itself, leaving the paintings to depict the affective aspects of the cult and the shrines. The text panels were written in a short and concise manner to describe the main characteristics of the cult to a general audience.[6]

To go with the first panel, which explains the project itself, I chose four paintings that provided an atmospheric feeling for the cult. For the second panel, I chose paintings that would explain the origins of the cult. I had traced the origins of the cult to the rural veneration of the souls of popular bandits who were killed by the local authorities. Therefore for the paintings depicting the origins of the cult, I used nineteenth-century photographs obtained from the Chilean libraries, showing Chilean bandits and farmers. I made image transfers of these photographs and assembled them in cut out windows within the paintings. For the representation of bandits, I tried to incorporate as many of the types of people who joined the bandits as possible: young

boys, Mapuche Indians, and poor farmers. I also included pictures of actual bandits who had been caught and publicly punished. I used the colour sepia to create the feeling of historical images (see Figure 9.2).

The selection of paintings to go with the text panel 'Who are the *animitas*?', posed some questions about which types of victims to depict. There are many types of *animitas*: murdered women and girls, people executed by the judicial forces of the state for their crimes, victims of horrific accidents or crimes, and the *desaparecidos*, people who were killed during the dictatorship of Augusto Pinochet. I selected only two types of *animitas* to represent: young girls raped and murdered, and the victims of the dictatorship; I chose both types because I felt more emotionally connected to them than to victims of accidents or crimes, or executed criminals. Having grown up in Chile, I have been exposed to and emotionally touched by the stories and the shrines of *animitas* of young girls who have been raped and murdered, and to the shrines and the stories of the *desaparecidos* or people who vanished under Pinochet. Hence I used my personal memories

Figure 9.2 Souls of Bandits, Lydia Nakashima Degarrod (mixed media on paper. 30 × 20 inches, 2004)

133

of the *animitas* of murdered girls and the *desaparecidos* to create the images. I made two paintings associated with the *animitas* of young girls. I was inspired by Carmencita, a well known *animita* who was raped and killed in a popular park in Santiago. Her shrine, decorated with hundreds of dolls and flowers, is located at the foot of the tree where she was found. In one of the paintings I portrayed the tree where she was found with a girl's dress hanging from one of the branches (see Figure 9.3). To signal her death I show the tree without leaves, and the empty dress without a body. To convey the location of the soul living under the tree I made use of angels. To express the crime and its location I used the colours red and brown. In another painting (see Figure 9.4), I use dolls to represent the young girls murdered as well as the toys left by believers to thank the *animitas* for the help provided to children. I also incorporated the image transfer of a nineteenth-century photograph of the wake of child, in which the dead child was dressed as an angel and placed in the arms of a statue of the Virgin Mary. These forms of wakes were customary in Chile and expressed the belief that dead children go directly to heaven as angels.

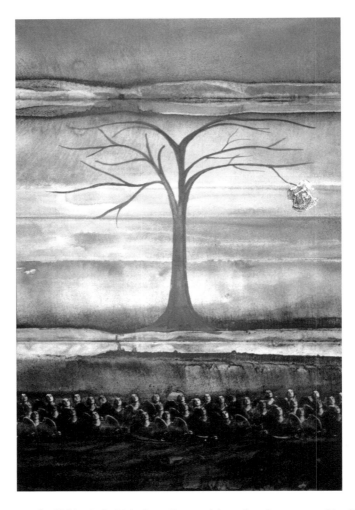

Figure 9.3 Animita of a Child 1, Lydia Nakashima Degarrod (mixed media on paper. 30 × 20 inches, 2004)

By combining the images of an abandoned doll and the wake, I wanted to convey the feeling of the injustice of the deaths of children, the sorrow of their parents, and the notion of angels and their capacity for producing miracles. For the representation of the *desaparecidos*, or victims of Pinochet's regime whose bodies have not been found, I made one painting that represented a wall with the words 'missing' repeated throughout (see Figure 9.5).

To accompany the last panel, the emotional climate of the practice of the cult, I created images which would represent the sense of loss: that precarious state that the miracle seekers feel when they seek supernatural aid, and the feeling of impotence in the face of injustice (see Figure 9.6). I was informed by photographs I took of urban scenes, and by my own memories of Santiago. I used the colour blue to convey a mood of sadness. I also used the colours brown and grey to show the smog of the city. To create the presence of miracles in the city, I used the image of angels. Chile is a Catholic country and Chilean cities have an abundance of images of angels. There are statues of angels in the streets, parks and churches. The image of angels was also used

Figure 9.4 Animita of a Child 2, Lydia Nakashima Degarrod (mixed media on paper. 30 × 20 inches, 2004)

135

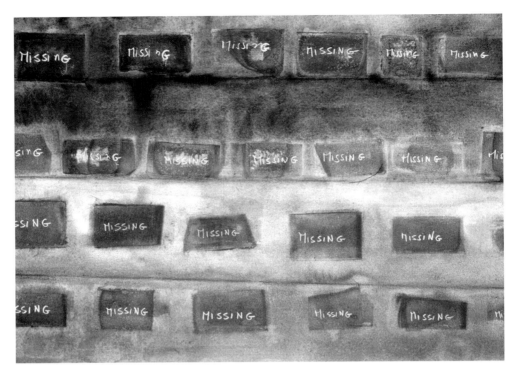

Figure 9.5 *Missing*, Lydia Nakashima Degarrod (mixed media on paper. 30 × 20 inches, 2004)

to represent the souls of the dead. In several of the paintings I located the angels at the lower section of the painting, to indicate the place where the deaths occurred.

Exhibits and audiences

Roland Barthes has suggested that the meaning of texts and images is to be found at the point of destination; that meaning comes through readers' and viewers' interpretations, not through authors' intentions (1978). In the gallery setting, meaning is created in the interaction between audiences and objects (Hooper-Greenhill 2000). This interaction is shaped by the display, the audiences, and the objects themselves. To understand the meanings of my images and texts, I will examine the comments I received, my observations of the audiences of the three exhibits during the opening receptions, and the unsolicited emails I received throughout the duration of the exhibits, as well as conversations I had with some viewers during the de-installation of the exhibits.

The paintings were shown at three galleries in 2004 and 2005. Two were university art galleries and one was a city-run art gallery. The three exhibits displayed the same artworks differently and with different amounts of accompanying text, which had a clear effect on the type of responses by the audiences. In all the exhibits, the audiences manifested a personal and experiential form of knowledge. In addition, audiences at the exhibits in which the paintings were shown alongside the prepared texts and lectures, demonstrated the acquisition of a second major type of knowledge: traditional ethnographic knowledge, which showed that the viewers understood the characteristics of the cult.

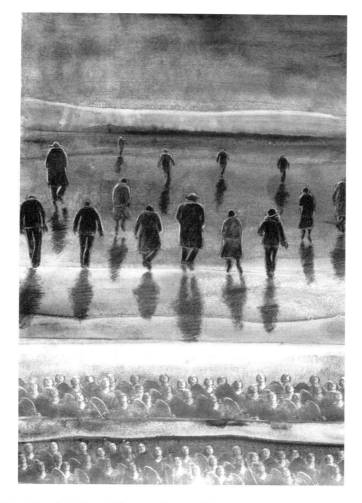

Figure 9.6 *Urban Miracles 3*, Lydia Nakashima Degarrod (mixed media on paper. 30 × 20 inches, 2004)

The traditional, ethnographic type of knowledge occurred at the two university gallery exhibits, in which the audiences had the most exposure to textual information about the cult, before and during viewing the exhibit itself. Both galleries sent out brochures with a description of my interdisciplinary project to people on their mailing list, prior to the exhibit opening. Both also included a paragraph about the project and brief information about the cult in the invitation cards for the exhibit and opening reception. Furthermore, both university galleries installed the paintings with the text panels and in the order that I specified. Both of the opening receptions included a 45-minute lecture I gave about the project and the cult itself. In one of the exhibits, the lecture was videotaped and accessible to subsequent visitors to the exhibit. Audiences at both university galleries were made up of students, faculty of the university, and people interested in the arts. These audiences demonstrated an overall understanding of the major characteristics of the cult through the types of questions and comments they made during the lectures and at the receptions.

The third exhibit at the city-run art gallery provided much less textual information about the cult. Only my first text panel, which gave general information about the project, was included in the exhibit. The paintings were arranged according to the aesthetic sense of the gallery staff, based on their ideas of colour harmonies in the images. The opening reception of this exhibit did not include a talk. The audience was comprised primarily of art lovers who normally attend the gallery's exhibits.

In spite of the differences in exposure to textual information among the audiences to the three galleries, there was one response common to each. All the audiences demonstrated an experiential knowledge which was reflected by the comments I received during the receptions and the de-installation of the shows, and through the numerous e-mails I received. The comments were in general characterized by a desire to convey gratitude to me for depicting in the paintings the viewer's own feelings, including sentiments they had hidden from themselves but recognized when they saw the paintings. These feelings centred on themes ranging from specific collective events such as the war in Iraq, the events surrounded 9/11, and the situation of illegal immigrants in the United States, to more general sentiments about living in a world that lacks spirituality, the violence numerous people experience in parts of many cities, and the loneliness of urban life, as well as a general sense of uncertainty and of a lack of guidance in the modern world. Some were more personal and were characterized by a confessional style of comment. At the city art gallery, for example, I received a striking confession from the security guard of the building who, because of his job, had seen the exhibit almost daily. The day of the de-installation of the exhibit he approached me and expressed his desire to tell me about his feelings that had been triggered by the paintings. He told me how the paintings had made him relive moments of his life that he now he regretted. He told me that he was a retired soldier and was working as a security guard to compensate his meagre retirement income. As a soldier, he had worked for the School of the Americas training the military personnel of El Salvador, Guatemala, and Chile. To my surprise he said that the images of the painting portrayed what he felt and saw during the civil wars in those countries in a way that the film and TV documentaries he had seen did not. He had contacted former members of his training group living in the vicinity, inviting them to visit the exhibit; when they saw the paintings they had agreed with him that the paintings showed aspects of the wars in Central America. Reflecting on his comments, I was struck by the power of the images to tell and convey stories from the viewers in ways and forms that I had not anticipated. In spite of the fact that he had seen the exhibit for two months and had probably read the text panel explaining the theme of the exhibit and the cult in Chile, he saw in the paintings images that made him relive an unjust, violent period of his own life.

Representing violence and audiences' reactions

The reactions of the audiences to the exhibits can be related to the various forms of display at the galleries, the images themselves as artworks, and the making of the artworks as ethnographic-based objects.

The audiences to the three exhibits had different levels of exposure to information in the form of texts and live and video-taped lectures about the material presented. Their responses reflect differences in viewers' interactions with words and objects. Eilean Hooper-Greenhill notes that objects and words create different forms of meaning in gallery settings (2000: 114–5). Words provide textual meanings to viewers while objects tend to create ambiguous meanings which relate to the body or the senses. The audiences at the galleries with access to the most textual

information and lectures demonstrated the reception of this form of informative ethnographic knowledge through the questions and comments I received during the openings, while audiences at all the exhibits expressed personal and emotional reactions to the images. The source of these two forms of knowledge appears from this small sample to lie in the difference between texts or words and images as objects. The paintings as objects elicited embodied interactions with the viewers. The emotional reactions of the audience were accentuated by images which were trauma based. Images can express violence and trauma in a different way than texts. The work of Doris Salcedo, a Colombian artist who depicts collective forms of trauma, is pertinent here. Salcedo finds that words are no longer possible when you want to represent violence, and she purposively creates works that move away from narrative and which do not include words, in order to convey the condition of a traumatic loss (Wong 2007: 175). She acts under the belief that narrative organizes unfolding events along a teleological or etiological continuum. Hence narrative imposes an artificial order upon the experience of trauma, seeking to make sense of it by transforming the event into a story. Experiencing things as a story, the viewers would not have direct access to witnessing or processing a traumatic event.

A second aspect is the value of the images themselves in depicting violence or collective trauma, and the reactions of the audiences to the work. What is the role of the images of the cult of the *animitas*, a cult based on collective suffering of trauma, in creating the experiential forms of responses? Jill Bennett, an art historian who has studied trauma-based art, finds that this type of art is a form of language of trauma itself and of the experiences of conflict and loss (2005). These forms of art contain a direct engagement with the sensations or feelings which are communicated to the audiences. These feelings or sensations trigger sense memory on the part of the viewers, who respond to the images with their own embodied knowledge of the experience of suffering. Bennett makes use of the distinction between sense and ordinary memory made by the French poet and Holocaust survivor Charlotte Delbo (ibid.: 25). For Delbo, ordinary memory is the memory connected with thoughts and words which can be communicated to others, whereas sense memory contains the physical imprint of the traumatic event. The images I created provided the audiences an entrance into the experiences of conflict and loss. They did not communicate the actual experiences in a realist manner, but as Bennett has pointed out, citing the work of Gilles Deleuze, the audiences experienced 'the encountered sign', which is felt rather than cognitively perceived (ibid.: 4). The viewers responded to the images of my exhibits with their own memories of collective suffering, or sense memories, which were triggered by the images themselves. For them, as for Deleuze and Bennett, art was an embodiment of sensation that stimulated thought.

Finally, I want to address another way of interpreting the experiential reaction of the audiences to my artwork. I am referring here to the performative aspect of the audiences who replicated one of the functions that the cult itself performed, that of expressing forms of injustice. This performative aspect lies in part in the materiality of the paintings as objects and in the images themselves. Judith Butler writes that bodies establish a performative connection with objects (cited in Hooper-Greenhill 2000: 113). Bodies attempt to enact meaning which is both dramatic and contingent (Hooper-Greenhill 2000: 113). The audience members' response to the paintings as objects initiated a performative type of response in which their bodies attempted to depict what they were feeling and recalling expressed through the communal sharing of feelings and stories about injustice. Galleries provided the audiences with the physical space and the cultural setting to share their emotional reactions.

The impact of the images on the audiences is important to examine too. What I am proposing is a relationship between the lived experience contained in the artworks themselves through their

making, and the audience's response to these experiences. Again, I look at the work of Doris Salcedo because her method of work is similar to mine. Her sculptures and installations are based on research she conducts through interviews with people who have directly experienced the collective trauma she aims to depict. She uses this type of information to create the material objects of her installations, and in the process, as artist becomes a witness of a witness who reproduces the victim's experience. Her installations create a participatory form of spectatorship in which the viewers are required to enter into and share the space of the other. Art practice for Salcedo is a process of continual recontextualization in the passage from individual to collective signification. As Salcedo's work shows in the specific and unique aspect of the performative reaction of the audiences, there appears to be a relationship between the making of the artworks and the audience reactions (Wong 2007: 177).

Artworks can be seen, too, as material objects from an anthropological perspective. As such, the objects contain within them a series of cultural practices that may or not be known to the viewers. The making of the pieces involves not just the sensations that the audiences were able to feel and react to, but also the embodiment of forms of knowledge which are unconsciously responded to by the audiences. As Alfred Gell has noted, artworks cannot be apprehended exclusively within a visual/aesthetic response-theory, because objects represent 'unfolding patterns of social life and constitute embodied emotional and sensory responses – of terror, awe, fascination, or desire – that are inherently entangled within specific dimensions of temporality' (1998: 6, cited in Edwards *et al.* 2006: 8). Art objects contain forms of knowledge that have been created in the making of the piece and which are transmitted to the viewers during the exhibits, often without the intentions of the artist. Edwards *et al.* have argued that art or ethnographic objects are also bundles of sensory properties which respond to specific sets of relationships and environments (2006: 8).

What is the value of the forms of knowledge created by my paintings? In themselves, they inform the viewers at an emotional and experiential level that does not normally occur with a textual form of representation, thus closing the gap between the self and the other by accentuating the personal and the universal. Nonetheless, many questions remain about the creation of this type of knowledge and its role in ethnographic representation, providing much scope for further explorations about the use of art in the making of ethnographies – and of ethnography in the making of art.

Notes

1 For information about the cult, see Nakashima Degarrod 2004.
2 Ximena Bunster, a Chilean anthropologist, calculated that 900 shrines were distributed in Santiago in 1989. Personal communication with Ximena Bunster, 28 June 1999.
3 For an ethnographer writing about the limitations of the textual representation of ethnographic work see Nakashima Degarrod 1998. For the study of the senses in anthropology see, among others, Stoller 1989, Classen 1993, Seremetakis 1996, Desjarlais 2003, Howes 2005.
4 The making of the shrine is one of the first practices in which the devotion to the soul is socially expressed. The shrines are spontaneous constructions which can be made by individuals or sometimes represent a communal task that has been undertaken over a period of several years. The decoration of the shrines informs the pedestrians that there is a miraculous soul, as the number of candles and plaques advertises its power. The decoration of the shrines informs not only of the power of the miracles, but also provides information about the biography of the person and the story of his or her death. For example, shrines decorated with toys and children clothing inform the people passing by that a child was killed, and or that this soul is known for helping children. Depending on the popularity of a shrine different people are involved over time in its decoration, which can in some cases tends to alter the original story about the life and death of the soul of the person. For example,

a shrine that originally was created because of the death of an adult woman with time can come to be interpreted to be as the shrine of young girl. If one person leaves a toy at the shrine, it is because the soul had saved a child. This toy can be incorrectly interpreted by others as an indication of the soul being that of a child. Visual cues determine the creation of stories about the shrines.

5 A recent interest in the use of art in ethnographic representation and associated issues has been shown in a several conferences dedicated to this topic in Europe in the last three years; a recent one is the 'Beyond Text?' conference at the University of Manchester, UK, in July 2007 (a panel at which led to this book).

6 The text of the panels:

First panel: 'Following the Trails of Urban Miracle Seekers.'

These paintings are based on a popular religious practice which venerates the *animitas* or souls of those who have died a violent and unjust death in the streets of Chilean cities. According to believers, their power to produce miracles is derived from the unjust nature of their deaths. It is this injustice that impedes them from resting in the afterlife. Thus they are forced to remain forever at the sites of their deaths, helping the living in their plights. 'Following the Trails of Urban Miracle Seekers' is an interdisciplinary project combining both anthropological and visual art in order to depict and understand the extraordinary aspects of the everyday in people's lives. It is based on ethnographic and historical research conducted over three years in Santiago, Chile. As ethnographer and visual artist I am both observer and interpreter. With this dual role, I attempt to depict those textures lost in the ethnographic text as well as imbue the artistic work with ethnographic reality.

Second panel: 'Origin and Practice of the Cult of the *Animitas*.'

Currently an urban popular religion, this practice originated in the countryside and was brought to the cities by rural migrants in the nineteenth century. Prior to this massive migration, peasants venerated the souls of famous bandits killed by the Chilean authorities. These bandits were known in popular lore for sharing their riches with the poor. The veneration consisted of conducting prayers and leaving flowers and candles in the actual places where the bandits had died in exchange for miracles. When the new urban residents joined the workforce and experienced a wide range of oppressive circumstances, this practice became widespread in the cities. They struggled with inadequate housing, epidemics, high crime and exploitative, unhealthy working conditions, finding in the souls of those who had died violent and unjust deaths supernatural allies who could sympathize with their problems. Throughout the twentieth century, the cult of the *animitas* has become one tool used by subordinated classes to obtain help the institutionalized religions don't provide and to express the injustices of everyday life.

Third panel: 'Who Are the *Animitas*?'

The *animitas* are usually those who have suffered a violent and unjust death in the streets of major cities. They tend to be the victims of horrific murders, traffic accidents, state executions and anybody else whose death has captured people's imaginations by its sheer injustice. Examples of some popular *animitas* in Santiago are: Carmencita, a young girl killed and murdered in a public park fifty years ago; Romualdito, a man robbed and killed a century ago upon his discharge from the hospital after a prolonged illness; the 'Jackal of Nahueltoro' an executed criminal who had repented of his gruesome crimes and undergone a radical change during his time in prison; and some of the *desaparecidos* – those people believed to have been brutally killed during the dictatorship of Augusto Pinochet.

Fourth panel: 'Praying to the *Animitas*.'

There are thousands of *animitas* venerated at shrines in the cities and roadsides. Built like a house or church at the site of death, these shrines are decorated with crosses, candles and flowers. Most have metallic plaques with the names of the dead, as well as written testimonies of the miracles given by the *animita*. The testimonies appear in the form of letters, or sometimes as paintings representing the miracle. These objects narrate not only the miracles performed by the souls, but also their life and death. The transmission of miracle accounts and stories about the life and death of the *animitas* are passed on visually through the display of objects decorating the shrines, and orally through storytelling. Changes in the display of objects influence the stories created by believers, who receive these visual clues and recreate the stories about the life and death of the *animitas*. Although these individual stories change through time by narrating different types of death and suffering, the shrines remain as sites for the expression of injustice for those who feel disempowered.

References

Banks, M, and H. Morphy (eds) (1997) *Rethinking Visual Anthropology*, London: Yale University Press.

Barthes, R. (1978) 'The Death of the Author', in *Image-Music-Text*. New York: Hill and Wang.

Bennett, J. (2005) *Empathic Vision: affect, trauma, and contemporary art*, Stanford, CA: Stanford University Press.

Bourdieu, P. (1977) *Outline of a Theory of Practice*, Cambridge: Cambridge University Press.

Butler, J. (1990) *Gender Trouble: feminism and the subversion of identity*, London: Routledge.

Classen, C. (1993) *Worlds of Sense: exploring the senses in history and across cultures*, London: Routledge.

Coles, A. (ed.) (2000) *Site Specificity: the ethnographic turn*, London: Black Dog Publishing.

Deslarjais, R. (2003) *Sensory Biographies: lives and deaths among Nepal's Yolmo Buddhists*, Berkeley, CA: University of California Press.

Edwards, E., C. Gosden amd R. Phillips (2006) 'Introduction', in E. Edwards, C. Gosden and R. Phillips (eds) *Sensible Objects: colonialism, museums and material culture*, Oxford: Berg, pp. 1–31.

Gell, A. 1998. *Art and Agency: an anthropological theory*, Oxford: Oxford University Press.

Grimshaw, A. (2001) *The Ethnographer's Eye: ways of seeing in modern anthropology*, Cambridge: Cambridge University Press.

Grimshaw, A. and A. Ravetz (eds.) (2005) *Visualizing Anthropology*, Bristol: Intellect.

Heller, R. (2005) 'Becoming an artist-ethnographer', in A. Grimshaw, and A. Ravetz (eds.) *Visualizing Anthropology*, Bristol: Intellect, pp. 133–142.

Hooper-Greenhill, E. (2000) *Museums and the Interpretation of Visual Culture,* London: Routledge.

Howes, D. (ed.) 2005. *Empire of the Senses: the sensual culture reader,* Oxford: Berg.

MacDougall, D. (1998) *Transcultural Cinema,* Princeton, NJ: Princeton University Press.

Morgan, D. (1998) *Visual Piety: a history and theory of popular religious images*, Berkeley, CA: University of California Press.

Nakashima Degarrod, L. (1998) 'Landscapes of terror, dreams, and loneliness: explorations in art, ethnography, and friendship', *New Literary History*, 29: 699–726.

Nakashima Degarrod, L. (2004) 'Souls of bandits, virgins, and victims: searching for miracles and justice in the Chilean roadsides and streets', in J. Clark (ed.) *Roadside Memorials*, Armidale, NSW: University of New England, pp. 157–179.

Nakashima Degarrod, L. (2007) 'Paintings as ethnographic representations', *International Journal of Arts in Society*, 1 (7): 147–156.

Pink, S. (2004) 'Introduction: situating visual research', in S. Pink, L. Kurti, and A.I. Afonso (eds) *Working Image: visual research and representation in ethnography*, London: Routledge, pp. 1–9.

Pinney, C. (1992) 'The lexical spaces of eye-spy', in P.I. Crawford and D. Turton (eds) *Film as Ethnography*, Manchester: Manchester University Press, pp. 26–48.

Ravetz, A. (2005) 'News from home: reflections on fine art and anthropology', in A. Grimshaw, and A. Ravetz (eds) *Visualizing Anthropology*, Bristol: Intellect, pp. 69–79.

Schneider, A. and C. Wright (eds) (2005) *Contemporary Art and Anthropology*, Oxford: Berg.

Seremetakis, C. (1996) *The Senses Still*, Chicago, IL: University Of Chicago Press.

Stoller, P. (1989) *The Taste of Ethnographic Things: the senses in anthropology*, Philadelphia, PA: University of Pennsylvania Press.

Taylor, L. (1996) 'Iconophobia: how anthropology lost it at the movies', *Transition*, 69: 64–88.

Wong, E. (2007) 'Haunting absences: witnessing loss in Doris Salcedo's *Atrabilarios* and beyond', in F. Guerin and R. Hall (eds) *The Image and the Witness: trauma, memory and visual culture*, London: Wallflower, pp. 173–188.

10

ENGAGING THE MATERIAL WORLD
Object knowledge and *Australian Journeys*

Kirsten Wehner and Martha Sear

In early 2009, the National Museum of Australia opened a new exhibition in its permanent galleries. *Australian Journeys* explores the transnational qualities of Australian experience. It traces the passages of people to, from and across the Australian continent and examines how migrants, sojourners, tourists and travellers have built and maintained connections between places in Australia and places overseas. It also considers how such place-making has shaped Australian life more broadly.

In producing *Australian Journeys*, we were centrally concerned with developing an ethnographic or ethnohistorical approach to experience. Like many museums around the world, the National Museum of Australia has a strong cultural mandate to engage its audiences with the complexities of living in a pluralistic, democratic society. We responded to this mandate by conceptualizing *Australian Journeys* as a programme that connects visitors to the richness and detail of others' life worlds, that invites visitors to engage imaginatively with others' subjective experiences and understandings and that asks visitors to consider how those experiences and understandings have shaped and been shaped by broader socio-historical contexts.

Described in this way, *Australian Journeys* constitutes an interpretive programme that might be accomplished in many different communicative media. We, however, were developing a museum exhibition and for us that meant focusing anew on the question of how object displays can reveal, represent and communicate a rich ethnohistorical understanding of Australia's transnational histories. How, we asked ourselves, can objects (understood broadly to include things, images, media and text objects) connect us to others' life worlds? This chapter explores some of the answers we discovered to this question in the course of developing *Australian Journeys*.

We began developing *Australian Journeys* by searching for a better understanding of how objects participate in, shape and express transnational historical experience. In a sense we were searching for insight into how objects connect people, across time and space, to their own historical selves as well to origin and destination communities.

In the first part of this chapter, we outline how we used a method of 'object biography' to interrogate and understand the historical agency of particular objects and collections in mediating transnational experience. Given our location within the museum, however, we were concerned not only to understand how objects have participated in historical experience, but equally to develop an exhibition practice that communicates something of objects' historical

agency through the museum environment. This context led us to ask how objects – in general – could be understood to embody or produce knowledge about human experience.

In the second part of this chapter, we argue that objects distinctively encode information about the material, and consequently sensory and experiential, worlds of human subjects. When people engage with objects they generate what film-maker David MacDougall (2006) has called 'being knowledge' and what we call 'object knowledge' – embodied understandings of the forms of the world that constitute the foundation for any understanding of others' lived experiences.

As we developed *Australian Journeys*, we consequently came to ask how we could use the distinctive qualities and operations of object knowledge to connect visitors to the transnational experiences of historical others. We aimed to create in the exhibition a kind of resonance between how objects have performed in mediating the lives of migrants, sojourners, tourists and travellers, how they performed in shaping our own curatorial practice and how they perform in creating visitors' experiences in the exhibition.

In the third part of this chapter, we outline some of the display techniques we have used in *Australian Journeys* to render objects in the exhibition space as active – as historical agents in both the lives of represented others and the lives of visitors. We conclude by considering how these techniques will (we hope) generate rich ethno-historical understandings of Australia's transnational histories.

Re-discovering objects

When we began developing *Australian Journeys*, we often vowed to our colleagues that it would be an object-centred exhibition. This might seem like a strange thing to say. After all, aren't all exhibitions organized around the display of objects? At the National Museum of Australia, this has not always been the case. Between 1997 and 2001, the Museum developed a major new exhibition and public programmes facility on Acton Peninsula in Canberra. During this phase, the Museum was strongly, if complexly and not without contest, imagined as a 'museum of ideas' or a 'museum of stories'. The then Director, Dawn Casey, for example, often described the museum as a:

> forum, a place for dialogue and debate … We intend the museum to speak with many voices, listen and respond to all, and promote debate and discussion about questions of diversity and identity.
>
> (Casey 2001: 6)

Exhibitions were conceptualized not so much as displays of collections but rather as technologies for the communication of historical and cultural information and the provocation of questions and discussions. Exhibitions were understood to describe, and were framed by, historical themes, often derived from contemporary text-based academic scholarship, and were defined by quite abstract 'key messages'. Objects were seen to illustrate themes, ideas or stories, rather than as functioning as the primary carriers of information or creators of meaning within displays. The work of 'communication' in the museum was predominantly held to be performed by words, presented in various media, but most usually in exhibition text panels.

This vision for the museum tended to produce an exhibition practice that associated large or numerous text panels summarizing themes or narratives in Australian history with a small number of objects, each displayed without significant contextualization in terms of associated non-textual material or even extended object labels. Individual objects tended to lose meaning

deriving from their particular histories, becoming instead interchangeable markers for historical figures, events or themes.

It seemed to us, as we reviewed the exhibitions in the context of commencing work on *Australian Journeys*, that as particularity had been leached from the objects, so too had been much of their power to excite and inspire curiosity. Somehow the objects had lost their capacity to inspire that slightly dislocating delight that comes from recognizing that an object was 'there' at another time and another place and in another person's life and that it is now 'here' in this time and this place and in our own life. As words had been privileged as the carriers of meaning in the Museum, the objects had become passive and consequently rather bland and uninteresting.

We also began to reach the rather troubling conclusion that if exhibitions were really about the communication of themes, narratives and ideas – if objects were simply illustrations for knowledge best summarized for visitors in words – then it hardly seemed worthwhile building them. It would certainly be cheaper for curators to write books than for museums to build and maintain complex three-dimensional display environments. There had to be, we concluded, something about exhibitions that justified them as distinctive communicative media. Intuitively, we knew that objects held a distinct kind of interest and power, that they generated a unique and valuable form of knowledge, even if we found it hard to describe in words. What we wanted was an exhibition practice that embraced, rather than worked against, its own peculiar characteristics as a communicative medium organized around the display of objects.

In developing *Australian Journeys*, we consequently began with an ambition to, if you like, give objects their due. We wanted to embrace the idea that museums are defined by their collections of things. We consequently envisaged *Australian Journeys* as not only rich in numbers of objects, but we also assumed that displays of objects would constitute the generative elements of the exhibition. We steadfastly resisted the calls from some of our colleagues to define the exhibition's key messages to ensure that *Australian Journeys* adequately surveyed the nation's transnational history, and instead indulged our curatorial fascination with the serendipitous peculiarities of the National Museum's collections. We determined to develop the exhibition from the object up, as it were, beginning with identifying collections we felt were connected to Australian trans-nationalism, completing detailed research around the particularity of each collection, and endeavouring to let the objects' suggestive knowledge resolve the exhibition structure and content.

Object biography

The National Museum of Australia defines itself as a 'social history' museum. It collects to represent the broad diversity of historical experience in Australia and although it holds some typological and representative collections, it generally and increasingly favours what we might call secular 'relics' – objects deemed significant by virtue of their association with a particular event, person or community. Curators at the museum like, best of all, to collect objects with a strong 'personal story', meaning provenance linking the object to an identifiable person's life history.

The museum's collecting practices suggested that we develop *Australian Journeys* through a process of interrogating and deepening our understanding of the individual histories of particular collections. The *Journeys* curatorial team began exhibition development by identifying a series of 'key objects' – objects which instinctively attracted us through their aesthetic qualities, their cultural resonances, or by virtue of what we already knew about the drama of their individual histories. Drawing on recent scholarship in material culture studies, we then developed an

'object biography' for each key object. We conceptualized objects, to quote Janet Hoskins, 'as in some way similar to persons' and considered how they might form the subjects of narrative and analytical accounts of their life histories (Hoskins 2006: 78).[1]

Drawing on this framework, we envisaged that an object biography might encompass:

- the physical form of an object and its status as an example of a style, locating the object in relation to its ancestors and exploring how it has inherited and perpetuates certain physical characteristics;
- the materials from which an object is made and the techniques used in its manufacture, and an analysis of how these embody ambitions, practices, skills and material and social conditions;
- the life history of an object, providing a diachronic account of its history that encompasses its production, circulation, use and destruction;
- the social contexts in which an object has 'lived', perhaps taking the form of a synchronic slice in which an object is located within a complex of objects and as a node in social relations;
- the values associated with an object and the meanings attached to it by people as they produce, use and engage with it – these might include significances, memories, identities and concepts of personhood, and might range from personal associations to broad cultural frameworks;
- the enactment or performance of an object's meaning, including those moments in an object's life when the meanings and social relationships it embodies are performed, elaborated, witnessed and reproduced within a community.

In producing object biographies, we were particularly concerned to draw out the *agency* of objects in forming human experience and in shaping cultural forms and historical changes. We wanted to understand how objects functioned not simply as symbolic artefacts 'standing for' human experience, but equally as performative material forms that embodied and shaped the experiences and actions of human subjects. This was not to impute will or intention to objects, but rather to recognize how action, sociality and meaning are produced through situated interactions between people and things. It was to focus, in Chris Tilley's (2006) words, not only on how people make things, but equally on how things make people.

The most successful object biographies produced for *Australian Journeys* married together analysis of the material qualities of an object with information, drawn from associated objects, archival images, written sources and associated places, suggesting the broader individual and cultural understandings informing human engagement of the object. This approach worked equally well for objects without a specific provenance, and for objects closely associated with a known individual's history.

Curator Laina Hall, for example, chose to focus her biography of this gold-washing cradle on how the form of the technology shaped social relations on the nineteenth-century Victorian goldfields. She explored how cradles became widespread on the fields, in part because they were highly portable and cheap and easy to make – this one is handmade and not particularly expert in its manufacture. Cradles were democratic in their effect, enabling people from all socio-economic backgrounds to join the search for gold.

Cradles also, however, had anti-democratic consequences, with their physical characteristics promoting the skills of particular sections of the goldfields' population. The technology enabled more dirt to be washed more quickly, encouraging prospectors to abandon their solitary pursuit

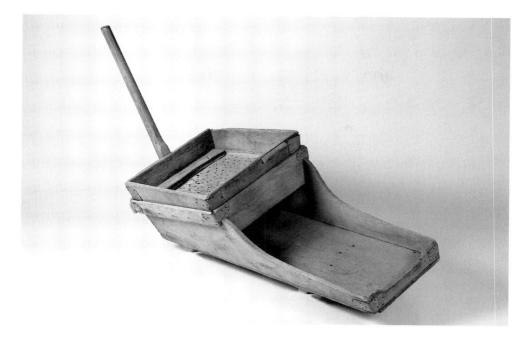

Figure 10.1 A wooden gold-washing cradle, believed to have been used in Ballarat in the nineteenth century, from the collection of the National Museum of Australia (National Museum of Australia, Claude Dunshea Collection number 1, nma.img-ci20041120–034-wm-vs1.jpg; photograph by George Serras, National Museum of Australia)

of gold with a pan or dish and to form groups of two to four people to work a cradle. Not everybody was equal in this labour market. Operating a cradle was hard physical work, and, the chance of the lucky find aside, the most successful teams must have been those composed of working class men already accustomed to this level of toil.

On a daily basis, as people shovelled dirt, carted water and rocked their cradle, the technology shaped the demography of gold-fields society and the forms of people's bodies. The cradle promoted the value of physical labour and created new forms of association, bringing people into close teams where they had ample opportunity to discuss, as they worked together, the legal and social conditions governing the goldfields. Arguably, the cradle generated an arena in which new ideas could germinate about how individuals shared common interests in relation to the community and how people might act in pursuit of shared goals.

Taking a different tack, curator Rebecca Nason asked how this snuff-box revealed the subjective experiences of Lieutenant James Grant of the Royal Navy. Grant presented this box, as its engraving narrates, to Philip Gidley King, Governor of New South Wales, on the occasion of the sovereign's birthday on 4 June 1801. He did so three weeks after he returned from a not entirely successful voyage of exploration along the south-eastern coast of Australia. Was Grant attempting to elicit King's forgiveness for his recent failures or was it presented in appreciation of King's unshakeable support?

Current materials analysis of the silver used in the snuff box sheds some light on this question and consequently on Grant's experience of his time in Australia and the systems of patronage shaping his life. Initially, it appeared that the silver hailed from India, Grant's posting before he

147

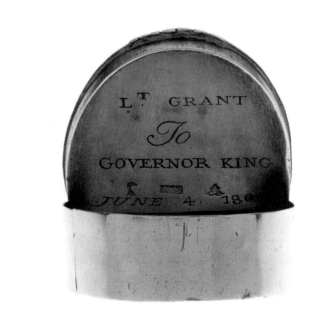

Figure 10.2 A silver snuff box given by Lieutenant James Grant to Governor Philip Gidley King in 1801, from the collection of the National Museum of Australia (National Museum of Australia, nma.img-ci20061633–001>003; photograph by Dragi Markovic, National Museum of Australia)

arrived in New South Wales, which suggested that Grant planned the gift as the latest instalment in his longer solicitation of King's support and that it is not tied specifically to his experience in Australia. It now seems certain, however, that the silver was sourced and the box made in Australia, so it is presumably a gift of apology, as well as one of the earliest convict-made pieces of silverware in Australia.

In developing the object biographies for *Australian Journeys*, we were particularly focused on how objects participated in the movements of people to and from Australia and in how they mediated trans-national experience. Objects exerted agency in diverse ways: as repositories of memories, mechanisms for the transfer of skills and sites for negotiating cultural frameworks, as arenas of imaginative escape, modes for connecting with lost family, as metonyms for other places, and so on. Notably, many different functions were often intertwined, pointing not only to the mutability of object meanings but also to how all the objects worked as conduits to simultaneous experience. Objects collapsed geographical, temporal and perceptual distances. As people engaged with them, they enabled people to simultaneously experience and mediate multiple times, places and modes of being.

This phenomenon of simultaneity is perhaps most evocatively expressed by the Latvian national dress created by Mrs Guna Kinne over a period of twenty years. She donated it to the National Museum in 1989. *Australian Journeys* curator Karen Schamberger discovered that Mrs Kinne began the costume in Riga in 1939, sewing the blouse as a high school student. The same year, her father purchased the headdress for her birthday. Mrs Kinne made up the skirt while still at school in 1941 and her boyfriend bought her the brooch, made of imitation silver

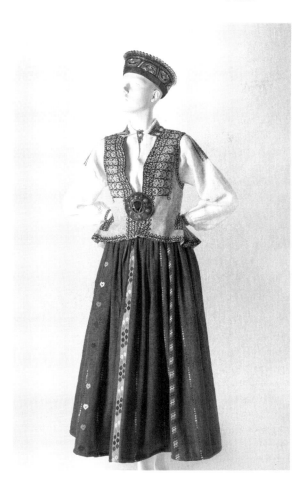

Figure 10.3 Latvian national dress made by Guna Kinne, from the collection of the National Museum of Australia (National Museum of Australia, Guna Kinne Collection, nma.img-ci20051391–030-wm-vs1.tif; photograph by Dean McNicoll, National Museum of Australia.)

due to wartime restrictions, in 1942. In 1945, Mrs Kinne fled Latvia for Germany in the face of Soviet invasion, taking with her the unfinished costume and her government-issued pattern book for Latvian 'district gowns'. She finished the jacket hiding from Russian forces in a town in Germany, and wore the completed ensemble for the first time at a dance at a displaced persons camp near Hamburg.

Mrs Kinne migrated to Australia in 1948, and in 1957 updated her costume with a new bonnet appropriate to a married woman. In Australia, she has worn the costume at social Latvian gatherings, celebrations of Latvian culture, and to political rallies – including in protest against Australian recognition of the Soviet incorporation of Latvia. The dress encompasses Mrs Kinne's entire journey through life, performing and collapsing the distances between Riga, Germany and Wangaratta, her childhood and old age, the dreams of her ancestors for Latvian independence and her political action.

The process of producing object biographies for *Australian Journeys* focused on how objects could be understood to exert agency in shaping and mediating others' trans-national experiences, but it also attuned the curatorial team to the agency of objects in shaping how we interpreted them and consequently in shaping the exhibition itself. This is not, of course, to argue that some objects wanted to appear in *Australian Journeys* and managed to convince us of their ambition. It is rather to note how our understanding of certain collections, and our investment in them, developed through a dynamic process of imagination, interrogation and re-imagination of object meanings.

The curators responded differently to different objects, drawn to some and uninspired by others as the objects resonated with their own interests and experiences. Similarly, the focus developed in each object biography often reflected the personal and cultural frameworks each curator brought to bear on the central framework of the gallery. These curatorial responses did not emerge purely in the linguistic realm, through our work talking with or reading or writing about people associated with objects. They were also powerfully developed in the material realm, as we viewed and manipulated objects, arranged collections in different formations, and asked how these actions enabled us to imagine the experiences and subjectivities of those who had produced and used these collections.

Object knowledge

Anybody who has worked in a museum knows that producing an exhibition is a highly collaborative and multidisciplinary process. Curators are often identified as the authors of exhibitions, and indeed generally carry the role of developing the intellectual and communicative aims of an exhibition, of identifying the material to be exhibited and of setting the creative shape and structure for displays. Realizing an exhibition, however, proceeds through extensive negotiation with other museum staff, including audience advocates, education and public programmes staff, designers and fabricators and publishing, marketing and merchandizing officers.

The *Australian Journeys* curators produced their object biographies as illustrated written texts and, as they developed, shared them with colleagues across the museum. Discussions, particularly with staff from our Audience and Programs Division, which incorporates Education staff, prompted us to articulate more fully how our focus on the agency of objects in transnational experience might re-shape our exhibition practice. Our colleagues generally loved the object biography approach, responding positively to the dramatic narratives of travel, endurance and survival recorded in many of them. They tended to warm particularly to those biographies which closely linked an object to the journey of an individual person, evidently seeing the objects and their stories as 'hooks' for associated human stories rather than as artefacts with the more complex capacity to dynamically locate individual experience within broader material and cultural contexts.

Our colleagues worried, however, about how we would realize the object biographies in the exhibition space. They tended to assume that we would have to explain – in words – the multiple resonances of each object and, given the length of the written biographies, were anxious about the number of text panels we would need in each display. We explained that the biographies mapped out historical interactions between objects and people, but that these would not necessarily be defined in words in the exhibition. This practice, we argued, would leach interest from the objects in precisely the way we wanted to avoid. We intended to create meaning in displays by associating objects (including images, media and text elements) in ways that evoked the

particular dynamic historical interactions between people and their things. How, our colleagues asked, would people get it? What would they learn from looking at groups of objects?

In part, these questions reflected an important division in the professional culture of the museum. We – the curatorial staff – tend to understand exhibitions as open, performative environments in which meaning, or rather multiple meanings, are created as visitors observe and interrogate displayed objects and recognize and construct relationships between object elements, drawing on both new and known knowledge. We are not too worried about visitors 'learning' any one idea, except in the broadest sense that we hope *Australian Journeys* encourages them to reflect on transnational histories, and we tend to talk about the exhibition as a creative environment designed to be a social experience that stimulates the imagination, the senses and the emotions.

In contrast, some of our colleagues in Education and Public Programs tend to see exhibitions as educational technologies which should convey to visitors some authoritative knowledge about Australian history. They are focused on what visitors 'learn' from exhibitions in terms of conceptual, propositional and generalized knowledge. As our colleagues responded to the *Australian Journeys* content, they often expressed this understanding through arguing that the object biographies were 'too particular', too focused on one object or collection, and that they would need to be explicitly contextualized as 'examples' of broader trajectories in Australian history.

National Museum education officer Helena Bezzina pointed out to us that our conversations with our colleagues in the Museum's Audience and Programs Division reflected discussions circulating more broadly within the museum profession about what it is that people gain from visiting exhibitions. Scholars interested in visitor experience now strongly differentiate between visitor 'learning' and visitor 'education' (Falk and Dierking 2000, Kelly 2007, Prince 1990). In 'learning', visitors engage actively with the museum and its exhibitions, pursue activities according to their own tastes and interact with objects, information and other people in order to make sense of themselves and the world around them. In contrast, 'education' is a passive activity in which the museum systematically imparts information to visitors.

As Kelly (2007) has argued, following Hooper-Greenhill (2003), many museums have now made a conceptual shift to value visitor learning above education, mostly because research indicates that people like and look for learning experiences but are bored to tears by educational ones. We agree that museums, including the National Museum of Australia, now by and large embrace an ambition and a rhetoric that prioritizes learning – as an active, experiential, visitor-driven practice – as central to its practice. We would also argue, however, that this shift in ambition has not yet been accompanied by an increased understanding of how visitors learn in museums and, in particular, in exhibitions. Discussions about maximizing learning opportunities and outcomes for visitors often seem to fall back on questions about what kind and how much information – in the sense of generalized knowledge – visitors will acquire from their engagement with the museum.

Our colleagues' questions about what visitors would learn from displays in *Australian Journeys* that were organized primarily through the association of objects without extensive explanatory text quite rightly pointed to our failure to produce a clearly articulated statement about how we saw objects communicating. If we wanted to argue that objects constituted the primary carriers of meaning in an exhibition, then we needed to articulate how people produced knowledge as they engaged with objects. We needed to define what we began to call 'object knowledge'.

Object knowledge is, we would argue, embodied knowledge. When we encounter an object, we observe its size, shape and proximity. We notice its colours and register its textures. We

may respond, perhaps subconsciously, to its smell, and, if we can touch it, we catalogue how it feels, how much it weighs and perhaps how it tastes. These sensory engagements are relational and interactional. We know how large or small something is by comparing it to other objects around it. And we know how large or small they are by comparing them to our own bodies. We recognize and register colour, texture, taste and weight by comparing new sensory data to our existing knowledge of blue and green, rough and smooth, sweet and sour, light and heavy. An object, for example, is never simply heavy. It is implicitly 'as light as a feather' or 'too heavy for me to carry'. As Mark Johnson writes,

> we have to learn the meaning of physical objects, which we do by watching them, handling them, subjecting them to forces, and seeing how they can be used – in short, by forms of interactive inquiry that are at once bodily and reflective.
>
> (Johnson 2007: 46)

Through observing and interacting with an object, we learn something about it. This information about how an object looks, smells, feels etc is, however, little recognized as constitutive of knowledge. David MacDougall has recently written about images in a way that centrally illuminates this problem. MacDougall recognizes that 'some would say that images … are not in any sense knowledge; (that) they simply make knowledge possible, as data from observations', but he argues that images do, in fact, constitute a distinct kind of knowledge:

> [Images] are what we know, or have known, prior to any comparison, judgement, or explanation. There is a perceptual as well as a conceptual kind of knowledge. This knowledge has no propositional status (of generality, or explanation) except the proposition of its own existence.
>
> (MacDougall 2006: 5)

MacDougall argues that knowledge arising from images constitutes a 'knowledge of being', distinguishing it from propositional or analytical explanations that constitute a 'knowledge of meaning'(2006: 6).

It is no great leap of the intellect, and indeed MacDougall arguably proposes this, to apply MacDougall's analysis of two-dimensional images to three-dimensional objects. Just as images provide us with information about how the world looks, which we can organize and analyze to create knowledge of the appearance of the world, similarly objects provide us with information about how the world looks, feels, smells and even tastes, which we can organize and analyze to create knowledge of the form of the world. Both images and objects enable us to know the material conditions of existence.

The 'knowledge of being' stimulated by objects, as MacDougall goes on to argue for images, does more, however, than simply reveal to us the form of the material world. As we look and engage with an object, we begin to notice how it is put together. What are its parts and how are they articulated? Of what kind of stuff are they made, how have they been manufactured from raw materials, and from where did those materials come? Could I make it myself, or what would I need to know to make it? What, for that matter, is it – this object? What does it do? Who made it? And why? Why did they choose to make it in that particular way? How would I use it? How does it differ from similar objects that I use? How would it feel to use it? Do you use it with somebody else or on somebody else?

These are questions that lead us from an interrogation of the form of the world to engagements with both experiences of living in the world and the broader material and social processes through which the world is produced and reproduced. Objects, like images, invite us to observe and understand the material conditions of existence in particular times and places and further to imagine the meanings, sensibilities and experiences produced as people engage with those material conditions. Objects, potentially at least, invite an empathic engagement with others' life worlds and experiences across time and space.

It is evident that many visitors to the National Museum are seeking precisely this experiential engagement with others. Focus group studies we conducted while developing *Australian Journeys* repeatedly showed that what visitors wanted from the exhibition was a better understanding of, for example, 'what it was like to live on the 1850s goldfields' or 'what it was like to be a Vietnamese refugee'. When pressed, visitors asked not for a summative description of these conditions, but rather for information that would enable them to physically imagine a different life. They wanted to see real things from other times and places, and they wanted information about how other people's bodies had interacted with these objects. They wanted to be able to touch, lift, move and use the objects in order to allow them to compare their interaction with the objects with that of other people.

In developing *Australian Journeys*, we came to the position that the challenge was to engage visitors with the materiality of objects on display. We wanted to encourage visitors to a kind of intense, interactive looking, asking them to first notice and focus on the physical qualities of objects, and then to progress to consider how these might suggest larger dimensions of experience and culture. In other words, we wanted to invite visitors to activate their production of object knowledge, to dwell in the process of gathering and responding to sensory data, pondering 'What is it?' and 'How can I imagine using it?' and then moving to ask 'Who else has used it?' and 'Why?' and 'What was that experience like?'

We argued to our colleagues at the museum that visitors to Australian Journeys would engage with the broadest themes in Australia's transnational history, but they would not do so by encountering these themes as generalized propositions about historical events and patterns. We maintained that objects, by their very nature, most powerfully connect visitors to the past when their particularity, and especially the particular histories of their interactions with humans, are emphasized, when their capacity to evoke and communicate about specific histories and locations and conditions of use is activated. In Australian Journeys, we envisaged, visitors would engage first with particular material worlds and, through their imaginations, with the experiences and subjectivities of those who have participated in Australia' transnational histories. These engagements would suggest and illuminate, but not define, broader questions about the themes and patterns of Australian history.

Visitors', and indeed curators', imaginative and empathic engagements with objects – the acts of imagining somebody else's subjectivity through encountering objects that have formed part of their world – are not unproblematic processes. The fact that we share with others a similar body, and consequently similar physical modes of engaging with objects, does not necessarily mean that we share the social and cultural frameworks within which our bodies and our selves are enmeshed. A physical action that may seem impossibly difficult to us may have been a piece of cake for someone else. An object that we find revolting, or terrifying or pleasurable may have elicited completely the opposite reaction in the person who made it. And a collection that appears to us as evidence of a repressive social system may have felt like a vehicle of liberation to the individual who used it, depending on the cultural meanings and social frameworks within which that collection and person was embedded.

153

Historian Inge Clendinnen has recently written on the problems of relying on empathy as a tool for understanding the lives of historical and cultural others. She maintains that imagination is of little use in accessing the subjectivities of people in the past because the 'real past is surrounded by prickle-bushes of what I have to call epistemological difficulties':

> Access to the actual past is slow, always problematic, and its inhabitants can be relied on to affront our expectations. I was cured of any residual faith in the utility of empathy by spending rather more than a decade in company with Aztecs. I knew they were human. I was reminded of that a dozen times a day. But it quickly became obvious that their minds and their emotions were ordered differently from mine. This meant that if I were to penetrate any distance at all into the Aztec world of the imagination, I would have to keep my own imagination on a very short leash, because my imagination, like my emotions and assumptions, has grown organically out of my own experiences within my own cultural milieu.
>
> (Clendinnen 2006: 22)

The only reliable means for understanding others, Clendinnen continues, is 'to become increasingly knowledgeable about the contexts in which particular actions … took place':

> We do this not by empathetic time-leaps, which would condemn us to live forever sealed into our own narrow cultural and temporal world, but by reconstructing as delicately, as comprehensively and as subtly as we are able, not only the material but also the cultural settings in which other people, once living, now dead, lived out their lives.
>
> (Clendinnen 2006: 27)

In the process of developing *Australian Journeys*, Clendinnen's argument powerfully reminded us of the importance of the interplay between object and context in the exhibition. We envisaged objects working to stimulate visitors' engagement with others' lifeworlds through embodied and imaginative responses; but we also recognized that this engagement had to be framed as an open-ended process. It had to raise questions about understanding others' experience, rather than suggesting that visitors could simply and instantaneously imagine what it was like to be someone else. We aimed to create in the exhibition a kind of inter-subjective arena, in which visitors were engaged in constantly grasping something of an other's subjectivity and simultaneously becoming aware of how their own understanding and subjectivity differed. The key to generating this kind of playing back and forth, we maintained, was through the creation of multiple frames for objects in the exhibition, each of which contributed to a sense of the complex cultural context within which the objects held meaning.

An object-centred exhibition

Over the last two years, the *Australian Journeys* curatorial team has worked with the design team to realize the exhibition. This is the process through which information and ideas articulated in object biographies and intellectual and creative arguments about object knowledge can re-connect with the on-going curatorial processes of what Paul Carter (2005) calls 'material thinking' – the work of producing meaning through bringing objects into relationship with each other. Designing *Australian Journeys* brought us to the point at which we needed to understand how we could physically create displays that allow objects to perform their materiality in

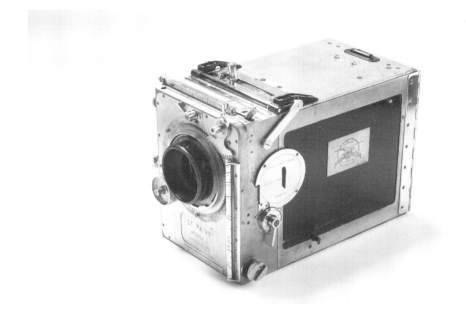

Figure 10.4 The Debrie Parvo model L 35-millimetre camera used by Frank Hurley from 1929, from the collection of the National Museum of Australia (National Museum of Australia, nma.img-ci20051391–007-wm-vs1.tif; photograph by George Serras, National Museum of Australia)

the exhibition environment, complexly connecting visitors through object knowledge to an imaginative engagement with the transnational experiences of historical and cultural others.

Australian Journeys is, first and foremost, object rich, signalling to visitors that objects constitute the primary elements for constructing knowledge within the exhibition and ensuring that much of visitors' time is actually devoted to looking at objects. The exhibition as a whole is divided into some forty smaller exhibits, each bringing together a collection of objects that relate to the life and experience of one person or a small group of inter-related people. Each exhibit is built out from a key object, prominently positioned and lit to mark to it as the central node of the display and then associated with groups of objects evoking different threads of the transnational histories of the collection and the people whose lives it has mediated and embodied.

One exhibit, for example, traces the journeys of Australian cinematographer Frank Hurley to Antarctica in 1929–31. The key object is this Debrie Parvo 35mm film camera, purchased by Hurley for the expedition and used in Antarctica and then later in the Middle East during World War II. The camera will be displayed with three groups of associated objects. From one side of the case, the camera will be viewed together with camera equipment such as lenses, carry bags and film canisters, much of it home-made or modified by Hurley and used by him with the camera, that illuminate the technological conditions of Hurley's film-making. On a second side, the camera is displayed together with Douglas Mawson's proclamation claiming Antarctica for the British crown during the 1929–31 expedition, and the canister, made of old food tins, within which the proclamation was sealed and left on Antarctica. A third group of objects relates to the scientific work of the expedition and the conditions of living and working at the Antarctic base station.

In addition, a multi-media screen positioned outside the case – for conservation and operational reasons – plays a 'media object', Hurley's heroic film narrative of the expedition, *Siege of the South*. Through drawing together these eclectic collections, we hoped to invite visitors to consider how these objects resonate and inflect each other in multiple ways, building up a complex sense of Hurley's experience in the Antarctic and how his experience shaped Australians' sense of that landscape.

We have adopted a relatively simple design language for *Australian Journeys*. Most exhibits are housed in four-sided glass cases. This technique enables visitors to move around and inspect objects from different angles, giving them more agency and control over how they view the objects, and also enables us to bring key objects into relationship with multiple other objects, thereby creating multiple contexts and suggesting different ways in which the objects can be understood. In the Hurley exhibit showcase, for example, the camera, positioned centrally at a height Hurley might have used when filming with a tripod, is a visible part of every group. As the visitor moves around the case, different views, with diverse combinations of objects in the foreground and background, form. In order to direct visitors' attention to objects we have endeavoured to carefully separate interpretive textual elements such as labels from the objects themselves. We aimed to locate only object elements within display cases, with text and graphics appearing in an interpretive 'ribbon' or graphic rail running along one side of each showcase. The ribbon houses a combination of story panels, place images, an eight-page flipbook, multimedia, and sensory stations particular to each exhibit. The barrier of the glass case acts interpretively to signal to visitors that the objects inside the case are the object of interpretation, that it is our job to seek to understand them; while the context offered outside the case should be understood as participating in the visitors' work of making sense of the display. This technique also allows us to widen our sense of what constitutes an object without losing interpretive clarity, enabling us, for example, to position certain text elements as objects, thereby asking visitors to consider the artefactual nature of written or spoken words.

As the design for *Australian Journeys* resolved, we did not quite manage to maintain this strict division between objects on the inside of the case and interpretive text and graphics on the outside. In some exhibits, pressure on ribbon real estate has meant we have had to place some object labels adjacent to objects inside the case. In these instances, however, we have used only small and unobtrusive labels that directly identify the objects in order to retain the visual and consequently interpretive primacy of the objects.

In some ways, this development strengthened rather than undermined our attempts in the exhibition to encourage visitors to dynamic practice of looking. We aimed to have visitors, as they engage with an exhibit, move their attention frequently between the key object and contextual groups of multiple objects, and between objects, images and written interpretive text. We believe this process will stimulate visitors to identify similarities and differences between objects, to draw comparisons and make connections between objects – in other words, to attend to the detailed materiality of objects that is key to activating their production of object knowledge. Arguably, the blurring of the boundary between object and text through the placement of some object labels within showcases facilitates this process, inviting visitors to feel variably closer to and more distant from the objects as text labels first attract their attention to the inside and then the outside of the showcase.

We also sought to invite visitors to dynamically observe and interrogate the *Australian Journeys* displays by focusing on the exhibition text as a kind of curatorial choreographic tool. In writing and designing the text we sought to develop a conversation between visitors, objects and curators. Labels accompanying exhibits describe how people made and used the objects on

the display and narrate stories in which people's uses of the objects reveal their experience and understanding. They do not seek to explain what an object means, nor define why the curators feel an object is significant. They may connect objects and the people associated with them to broader trends and trajectories in Australian history, but we have sought to do so in ways that provide context for particular narratives but do not reduce individual stories to exemplary tales. Text labels provide information that is particular and open-ended, encouraging visitors to engage with the details of histories of interactions between people and objects to ask how these might reveal others' experiences.

We also wrote the exhibition text in ways that encourage visitors to look from text to object and back again, making reading more interactive. In the flipbooks accompanying most exhibits, for example, words and images both provide broader context for the objects on display and sometimes overtly direct a visitor's attention towards object details. They seek to respond to questions that close looking might raise, such as: what is an object made of, where did the materials to make it come from and why did someone make it. Each exhibit's graphics are also designed to create visual connections with objects on display. Colours derived from key objects are used in the main story panels introducing each exhibit, and flipbook pages blend together text, archival images and images of object details.

Activating visitors' engagement with object knowledge and their capacity to use that knowledge to connect with others' experience also relies on the physical position and orientation of objects relative to visitors. As we argued above, object knowledge is embodied knowledge, generated as we engage with the material world through our own physical form. Often visitors' most memorable encounters with objects are ones where the size and scale of an object brings their own physicality into consciousness. We have all experienced, for example, standing next to a large object such as a giant steam engine and feeling deliciously small.

In *Australian Journeys*, we attended closely to the rhythm of size in the gallery and considered interpretive possibilities raised by displaying an object close to the ground or above an adult's eye line. We aimed to bring visitors into a greater consciousness of the relationship of their own body to the surrounding spatial environment and the displayed material world as they move through the gallery. Interestingly, it was not always possible to realize our ambition to activate visitors' bodies. Museum policies and design best practice guidelines do not encourage display practices that ask more rather than less of visitors' physical capabilities. Objects positioned low or high are often seen to contravene accessibility requirements, and many exhibition elements that more explicitly ask visitors to use their bodies to engage with objects – such as rocking a gold-washing cradle, for example – are difficult to construct safely.

We sought, however, carefully to position objects in relation to visitors in order to facilitate understandings of specific ethnohistorical experiences. It is interesting to consider, for example, the different contexts created when a visitor views this object – a *dàn tre* – from different sides.

This is a bamboo musical instrument created by Minh Tam Nguyen who migrated to Australia from Vietnam in 1982. Viewed from one side, a visitor is invited to understand themselves in the role of audience, as seeing and hearing the instrument played. Viewed from the other side, a visitor is invited to understand themselves in the role of performer, as playing the instrument. These different physical orientations invite two different engagements with Nguyen's experience. In the audience orientation, visitors might, for example, consider occasions on which Nguyen played the instrument in public concerts and ask how his performance inflected how white Australians understood 'being Vietnamese' and 'being Australian'. In the playing orientation, in contrast, visitors might imagine how Nguyen experienced those concerts and ask how he subjectively understood his performance.

Figure 10.5 The *dàn tre*, a bamboo musical instrument created by Minh Tam Nguyen (National Museum of Australia, nma.img-ci20082088–189-vi-vs1.jpg)

Inviting visitors to these imaginative engagements with Nguyen's instrument relies, of course, not only on the orientation of the object but also on its contextualization with other kinds of material. In addition to associated objects, such as objects associated with Nguyen's on-going career as a music teacher, we plan to include interpretive elements that more directly help visitors imagine the instrument in use. A multi-media installation will enable visitors to see and hear Nguyen playing the instrument, a 'sensory station' will invite experimentation with the complex string structure and tonal scale of Nguyen's instrument, and graphic elements will describe Nguyen's system of musical notation.

'Sensory stations' – things you can smell, touch, manipulate or hear while looking at the objects – accompany most of the exhibits in *Australian Journeys*. Visitors are often underwhelmed by displays where they cannot touch, lift, move and use the objects in order to engage with them. It is no easy thing to create displays that captivate visitors to the extent that they persist beyond a

cursory observation of an object to the deeper interrogation that will lead them to imaginatively connect with the experiences of historical and cultural others. Engaging a visitor's senses while they are looking seemed to us a way to extend and deepen this engagement. It allows visitors to access the perceptual knowledge that visitor research tells us they are seeking.

We defined the sensory stations not as interactives with learning outcomes, but rather as a way for visitors to access information about the objects that cannot be communicated with words. The stations are positioned close to the objects they relate to. A visitor's finger can follow the stitches on an embroidered map, copied from the map sampler they can see in the case in front of them. The pungent smell of dried sea cucumber accompanies a display of the cauldrons used on northern Australian beaches by Trepang fishermen from Makassar, now in Indonesia. Visitors standing in front of an exhibit of convict love tokens – defaced coins engraved with messages of remembrance for loved ones left behind – will be able to hold a token in their hand, feeling its weight and stippled surface.

Multimedia too was developed to show objects and bodies in relationship with each other. In several exhibits, we produced ethnographic films that show the sights and sounds of objects moving and being used. Treating archival footage as an object brought it into a productive relationship with other objects in exhibits, emphasizing its 'being knowledge'. This also encourages visitors to explore the agency of objects and people in its creation or reception. A visitor watching *Siege of the South* at the exhibit about Frank Hurley's camera sees many of the objects displayed, including the camera, in use. Hands slippery with algae and cold water, scientists tip sea gunk into glass jars from trawl nets hauled on pulleys from the deep ocean. Sailors bend their backs lugging the filmmaker's equipment off a landing boat and up a rocky beach. The shadow figure of Hurley himself, rhythmically turning the Debrie's crank handle, appears momentarily on the face of an iceberg.

In many dimensions, *Australian Journeys* draws on interpretive techniques standard in contemporary exhibition practice – particularly as it has evolved in social history museums. What is somewhat distinctive, however, is the way that we use these interpretive elements to engage visitors with objects in an embodied mode and to connect them more complexly with how historical experience emerges through interactions between people and things.

In a sense, we aim to signal the ethnohistorical use and significance of the objects in *Australian Journeys*, but not to recreate definitive historical contexts. To do so would be to close down the imaginative possibilities created by object knowledge, pinning objects to singular times and places and losing their potential to articulate to both visitors very physically and specifically in the present and simultaneously to others very physically and specifically in the past. Moreover, an exhibition technique that re-creates rather than suggests historical contexts for objects would also close down the inter-subjective exchange between visitors and people represented in the exhibition. Historical recreations tend to subsume the visitor's own subjectivity, inviting them to understand that they can unproblematically experience another person's life in a remote time and place. We, however, were anxious to create a dynamic inter-subjectivity in which visitors are invited to imaginatively engage and empathize with others' experience, but also to be returned to their own subjective position to develop an understanding of how their own experience differs from others and why.

Conclusion

In *Australian Journeys*, we aim to communicate to visitors a rich ethnohistorical understanding of Australia's trans-national histories. We hope, through object collections, to engage visitors

with others' experiences and understandings and with the broader socio-historical contexts that have shaped and been shaped by them. In developing this gallery, we have been centrally focused on the agency of objects in shaping trans-national experience. We produced a series of object biographies designed to draw out how certain 'key objects' have shaped, reproduced, embodied, expressed and mediated particular human experiences located in time and space. Our aim, however, was not merely to record how these objects have participated in making people, just as people have made them. We were also, obviously, keenly interested in finding ways to communicate this historical agency in the exhibition medium.

The concept of 'object knowledge' is key to this interface between understanding and expression. We have argued in this chapter that object knowledge constitutes a 'knowledge of being', a form of embodied knowledge that recognizes, records and makes sense of the form and texture of the material world. Object knowledge, we would argue, constitutes the mechanism through which objects exert agency. As people engage with objects, they understand through them the material conditions of existence, and as they act on that knowledge, objects have effect in reproducing and reshaping the world. This is a mechanism that operates – in exactly the same way – both out there in the world and in the particular time and space of an exhibition.

This is not to argue that objects can simply 'speak for themselves', as it is sometimes put, as visitors' constructions of object knowledge and its broader connections to experience may differ considerably from those of others who have engaged with the objects. It is nevertheless to argue that object knowledge constitutes the key technique through which exhibitions can connect visitors to others' experience. It is also to argue that exhibition practice therefore needs to be driven by questions about how to engage visitors sensorially and imaginatively to objects and through objects to others' subjective experiences.

The views represented in this paper are those of the authors, not the National Museum of Australia.

Note

1 For works relating to object biography, see also Kopytoff (1986) and Gosden and Marshall (1999).

References

Bezzina, H. (2007) 'Learning@NMA', unpublished paper prepared for the National Museum of Australia.

Carter, P. (2005) *Material Thinking*, Melbourne: Melbourne University Press, Melbourne.

Casey, D. (2001) 'The National Museum of Australia: exploring the past, illuminating the present and imagining the future', in D. McIntyre and K. Wehner (eds) *National Museums: negotiating histories*, Canberra: National Museum of Australia.

Clendinnen, I. (2006) 'The history question: who owns the past?', *Quarterly Essay*, 23: 1–72.

Falk, J. and L. Dierking (2000) *Learning from Museums: visitor experiences and the making of meaning*, Walnut Creek, CA: AltaMira Press.

Gosden, C. and Y. Marshall (1999) 'The cultural biography of objects', *World Archaeology*, 31 (2): 169–78.

Hooper-Greenhill, E. (2–6 November 2003) 'Museums and social value: measuring the impact of learning in museums', paper presented at the ICOM-CECA Annual Conference, Oaxaca.

Hoskins, J. (2006) 'Agency, biography and objects', in C. Tilley, W. Keane, S. Küchler, M. Rowlands and P. Spyer (eds), *Handbook of Material Culture*, London: Sage Publications, pp. 74–85.

Johnson, M. (2007) *The Meaning of the Body: aesthetics of human understanding*, Chicago, IL and London: University of Chicago Press.

Kelly, L. (2007) 'Visitors and learning: adult museum visitors' learning identities', in S. Knell, S. Watson and S. Macleod (eds), *Museum Revolutions: how museums change and are changed*, London: Routledge, pp. 276–90.

Kopytoff, I. (1986) 'The cultural biography of things: commoditization as process', in A. Appadurai (ed.) *The Social Life of Things: commodities in cultural perspective*, Cambridge: Cambridge University Press, pp. 64–94.

MacDougall, D. (2006) *The Corporeal Image: film, ethnography and the senses*, Princeton, NJ and Oxford: Princeton University Press.

Prince, D. (1990) 'Factors influencing museum visits: an empirical evaluation of audience selection', *Museum Management and Curatorship*, 9: 149–68.

Tilley, C. (2006) 'Theoretical perspectives: introduction', in C. Tilley, W. Keane, S. Küchler, M. Rowlands and P. Spyer (eds), *Handbook of Material Culture*, London: Sage Publications, pp. 7–12.

11

WATCH YOUR STEP

Embodiment and encounter at Tate Modern

Helen Rees Leahy

The delectation of loungers and youngsters is no more the purpose of a great national Museum than the raison d'être of the Royal Mint is to instruct visitors in mechanical processes ...

W. Stanley Jevons (1883: 61)

To enter the museum through the exhilarating space of the Turbine Hall is also to escape, momentarily, from the onslaught of everyday life and work. Fabulous for people-watching, as well as London's coolest party venue, the Turbine Hall is first and foremost a vast and hugely challenging project space for contemporary art

Francis Morris (2006: 21)

The emergence of art exhibitions and museums in the eighteenth and nineteenth centuries constituted a new public arena for looking, walking, standing, talking, reading, writing, sitting and, occasionally, touching. The museum's explicit regulations (rules and bylaws) and implicit codes (spatial and visual) combined to instruct visitors in the acquisition of a repertoire of appropriate 'bodily techniques' (Mauss 1973). Crucially, the emulation of more practised spectators has always been an important aspect of art education (and civic instruction) performed within the arena of the exhibition: if visitors could be made to walk properly, they would also learn to look properly (Duncan 1995; Bennett 2004, 2006; Rees Leahy 2007). Such training produces both the competence and confidence to navigate the physical and social space of the museum with ease and self-assurance – or, to quote Merleau-Ponty, to demonstrate 'a flexible power of action and reaction' (Crossley 1996: 109).

Conversely, failure to master the museum's productive alliance of walking, looking and learning elicited censure and anxiety. In the 1850s, the *Daily Telegraph* correspondent in Paris rebuked the succession of English families who marched through the galleries of the Louvre too fast to absorb any of their contents, yet loudly passed opinions on what they had not properly looked at (Bayle 1855: 7). Back in England, William S. Jevons doubted whether the lessons of the museum really could be absorbed by the majority of people: 'There seems to be a prevalent idea that if the populace can only be got to walk about a great building filled with tall glass-cases, full of beautiful objects, especially when illuminated by electric light, they will become civilized' (Jevons 1883: 55). As these comments demonstrate, the body of the visitor has always been viewed as a register of their capacity to interiorize the museum's message, and hence an index of

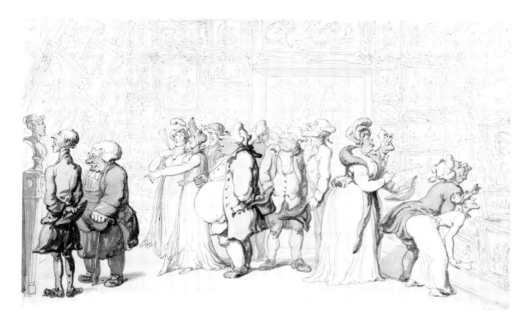

Figure 11.1 Thomas Rowlandson (1756–1827), *Viewing at the Royal Academy*, c.1815 (courtesy of the Yale Center for British Art, Paul Mellon Collection, USA)

their cultural habitus.[1] The museum's audience has been consistently scrutinized, both formally and informally, as evidence of the individual's capacity to respond to what Fred Wilson calls 'the silent message of the museum' (1994); see Figure 11.1.

The silent (and not so silent) messages of the museum operate through what Judith Butler terms a series of 'performatives' which make the body both legible and manageable (1993). Performatives are, she says, 'forms of authoritative speech: most performatives, for instance, are statements that, in the utterance, also perform a certain action and exercise a binding power' (1993: 225). As Elizabeth Grey Buck puts it: 'The "hey you, don't touch" or "silence please" produces a museum body that is never unwieldy, noisy, smelly, or dirty … This body, described and conditioned by nineteenth century museum guidebooks, is only an eye that roams demurely' (1997: 16). Yet our own experience also tells that our recalcitrant bodies frequently rebuke the museum's performatives; in other words, we resist the official script and as Butler says, we never quite comply with the norms that would compel us to act according to its strictures. Sometimes our response to the exhibition's lessons is half-hearted, tiring or mentally and physically confusing (Stendhal 1959: 302; Valéry 1960). Sometimes our resistance is more purposive; as this chapter shows, the *performances* of visitors may simultaneously engage with museological spaces and objects while resisting the prescriptive institutional *performative*. Either way our incorporated responses reveal a degree of 'habit acquisition' (in this context, familiarity with the operation of the museum) that provides us with a repertoire of potential, appropriate and situated actions (Merleau-Ponty 1962: 142).

Locating debates about visitor comportment in the nineteenth century also reminds us that museum mores – or performatives – are always in flux, and that the history of museum visiting is a history of negotiation of norms and conventions. Fashions in visitor practices come and go. For example, Andrew Hemingway describes the short-lived craze for note-taking in early

nineteenth-century art exhibitions: according to the *Morning Herald* (1810), '…all are furnished with tablets, and affecting to write criticisms upon subjects of which they have no knowledge themselves and of course are utterly incapable of communicating to others' (Hemingway 1995: 102). Inevitably, as soon as such a practice becomes common (in both senses) it loses its cachet among those who started the trend. Such behaviours function both to register and simultaneously to produce the body politics of the museum: at the same time as the regulatory injunctions of museum act upon the bodies of its visitors, so too visitors orientate their bodies to construct new relationships with each other and with the institution. As Margot Lyon says, one can 'characterise social institutions in terms of the bodily relations they entail and which in turn make them possible…' (1997: 89). Taking this as my cue, the remainder of this chapter focuses on the production and meaning of space–body relations in Tate Modern, the repertoire of visitors' performances that have been staged there over the past eight years and, finally, how the Tate has harnessed diverse bodies and behaviours as tools for the targeted expansion of its audience.

Merleau-Ponty describes how, in an art gallery, we position ourselves in relation to the paintings or sculptures on display so as to achieve the optimum 'balance between the inner and outer horizon' (1962: 302). In other words, the practised gallery-visitor knows how and where to position herself in relation to the object so that 'it vouchsafes most of itself' (ibid.). The viewing body of the visitor is attuned to the requirements of the object on display; each exists in a relationship of dynamic symbiosis with each other, as well as with the space they occupy and everything within it, both human and non-human. Yet, as Brian O'Doherty observes, within the trajectory of modernism that leads to Tate Modern, the art 'Spectator' is also an uncertain and clumsy figure whose presence violates the immaculate tableau of the 'white cube' gallery as 'he staggers into place before every new work that requires his presence' (O'Doherty 1976: 39).[2] The question of 'where to stand?' was repeatedly invoked by illegibility of modernist painting when viewed close-up, and O'Doherty's 'dark-adapted wanderer' through the gallery is often confused, although usually eager to please and be pleased (ibid.: 41). Not surprisingly, the Spectator's unpredictable body is conspicuous by its absence in installation shots of the pristine gallery, in which only his 'snobbish cousin', the disembodied Eye is permitted to gaze on the works on display, all seeing and yet itself unseen (Figure 11.2).

O'Doherty's critique of gallery practice exposes a central conceit of modernism – namely, the disembodiment of perception – and the perpetuation of this conceit within display schemes that ignore the inconvenient presence (and comfort) of diverse and wayward bodies. To a large extent, this is the model to which the galleries at Tate Modern conform: moving through the circuit of rooms, the perceiving body of the Spectator functions only to support the roving Eye. Walking and looking, looking and walking. O'Doherty notes that the Spectator is 'mostly a back' as he 'stoops and peers' at each successive work (1976: 39). By contrast, in the adjacent Turbine Hall, the body of the Spectator is fully and deliberately on display, especially to himself. And it is here that the embodied encounter with both museum space and installation art is both acknowledged and endowed with institutional agency.

Soon after the opening of Tate Modern in 2000, Nick Stanley (2001) analyzed the psychological effect of entering the massive, hybrid vestibule-gallery space of the Turbine Hall from the west entrance of the museum. He described how the visitor first encounters the exterior of the building as a 'cliff-like' curtain wall, the scale of which is emphasized by a vertiginous ribbed window that scales its entire height.[3] The visitor then enters the Turbine Hall itself at ground level, through a range of low, wide glass doors that are entirely dwarfed by the wall above. There is a deliberate sensation of compression as the visitor crosses the threshold beneath the soaring

Figure 11.2 Tate Modern gallery space (© Tate, London)

cliff wall, at which point, she is 'immediately released down a monumentally-sized ramp into the vast cavernous length of and height of the Turbine Hall' (Stanley 2001: 43). According to Stanley, the architecturally-induced release is a strong form of psychic manipulation. Specifically, the decompression effect produces a powerful self-consciousness of the scale, position and movement of one's body within this gigantic, ambiguous space.

By stacking the Tate Modern galleries on three floors, above the shop, café and auditorium along the edge of the Turbine Hall, the architects Herzog and De Meuron preserved the massive verticality of the hall, and then increased it by sinking the floor down to the former basement level of Bankside Power Station. Moving around the rest of the building, the visitor's gaze is repeatedly pulled by the view of the Turbine Hall, looking down and across from the vantage points created by internal windows and glazed balconies. Simultaneously, as people enter the Turbine Hall, there is an answering play of glances upwards from the floor of the hall as visitors' eyes are caught by the radiance of the glazed light boxes that frame the 'bay windows' projecting out from the third and fifth floors (Searing 2004). The realization of being overlooked compounds the visitor's self-consciousness on entering the massive space. James Meyer described the experience of being eclipsed and overwhelmed by its scale: 'I look up: Where am I? I am a speck in a distant, cavernous space, surrounded by the minuscule reflections of the many visitors who surround me. I am a remote, disembodied image; I am small' (2004). If the Brobdingnagian scale of the Turbine Hall can induce feelings of insignificance and unease, then its scale and ambiguity have also been co-opted by a series of artists' commissions that have mobilized these body–space relations to create new practices of cultural consumption. Each of these projects has orchestrated an awareness of the visitor's 'perceiving body in the gallery space' (Meyer 2004) while cumulatively, producing and authorizing new forms of sociality in response

to both art and architecture. As a result, two contrasting regimes of reception and comportment have emerged within the institution: the roaming eye attached to ambulatory spectator in the galleries, and the self-conscious, haptic body within the Turbine Hall.

Analyses of the architecture of Tate Modern have focused on the spatial and programmatic asymmetry between the Turbine Hall and the adjacent suites of galleries that accommodate the collections displays and temporary exhibitions. Writing in the 2006 edition of the *Tate Modern Handbook*, Andrew Marr compares the galleries with 'side chapels' in relation to the axial 'cathedral' of the Turbine Hall. According to Marr, each gallery raises a 'different clutch of images and questions', but for many visitors, they remain subsidiary to the main event of the Turbine Hall 'where the communal acts take place' (2006: 14). De-centred within the architectural frame of the converted power station, the galleries (and by extension, their contents) have become a figurative and actual side-show (Rees Leahy 2005). According to the architect of Tate Modern, Jacques Herzog, visiting them is optional: 'You can go into the great hall and spend time there without coming into contact with the museum' (quoted in Mack 1999: 37). The change of scale between the two parts of the building is palpable: 'The forays one makes ... along little lanes and alleys carved into the former boiler house where the museum proper lies, are but *movement in a minor key*' (Searing 2004: 101; my italics).

The phrase 'movement in a minor key' is telling: the contrast between the architectural dimensions and exhibitionary practices of the Turbine Hall and the gallery spaces is also marked by different codes of visitor behaviour. And although the staff at Tate Modern emphasize that very few of the galleries conform precisely to the hermetic white cube, their scale, architectural and display produce a familiar pattern of walking, looking, talking ... For O'Doherty, every picture hang feeds 'subliminal clues [that] indicate to the audience its deportment' (1976: 24). The directional, ambulatory, ocular-centric experience that is countenanced by the galleries is reinforced by the paucity of seating,[4] as well as conventional prohibitions on eating, drinking, the use of mobile phones and photography. By contrast, such restrictions are not applied in the Turbine Hall, where sitting, picnicking and lying on the floor are allowed, and where the casual encounters of 'stranger sociality' (Warner 2002) are prompted by the transformation of the shared experience of the work of art from the optical to the haptic. To paraphrase Robert Morris, the art commissioned for the Turbine Hall is in 'your space' and you have to confront it with both body and eye (2000).

Since 2000, the Turbine Hall has been the site of a series of annual commissions in which the triangular relationship between body–artwork–space has been interrogated and re-staged by the artists Louise Bourgeois, Juan Munoz, Anthony Gormley, Olafur Elliasson, Bruce Nauman, Rachel Whiteread, Carsten Höller and Doris Salcedo. The revelation of each successive project is a major public relations event for the Tate: in short, the spectacle of sculpture keyed to the architectural scale of the Turbine Hall fills newspapers and draws a crowd. As Mieke Bal observes, scale has become the common denominator of the series: 'In an exhibition space so monumental as to require works especially made for it, one expects something huge. The Turbine Hall of Tate Modern is so enormous that one needs the spatial reassurance of an artwork that fills it' (2007: 40). Not surprisingly, the projects that have been most successful in conceptually and actually 'filling' the hall, have elicited the visitor's physical, rather than (merely) visual, engagement. To adapt Merleau-Ponty's formulation that our bodies are things that are 'caught in the fabric of the world', in the Turbine Hall they are (sometimes literally) caught in the fabric of the work (1964: 163). Here art is experienced not as a discreet 'acting out' of perception (Garoian 2001), but through a heightened consciousness of one's body *installed* in relation to the object in space. As Kirshenblatt-Gimblett observes, all museums activate 'propriocepsis or how the body

knows its own boundaries and orientation in space' (1999); in the Turbine Hall, propriocepsis is overtly sensational, in both meanings of the word. In Merleau-Ponty's terms, this performance of perception is an ontological process that occurs at the intertwining (or chiasm) of the body and the world or, more specifically, at the intersection of the visitor's embodied subjectivity and the materiality of the museum.

The opening commission in 2000 by Louise Bourgeois was entitled 'I Do, I Undo and I Redo'. The installation comprised a massive metal spider ('Maman') and three tall steel towers, at the top of which was a platform reached by a flight of stairs. Limited numbers of people were allowed on to the platforms at any time and queues formed at the base of each tower, as visitors waited for their turn to climb the stairs and then, having reached the platform, to sit, stand, talk and look around, before making their descent – all the while being watched by other visitors, looking down from the surrounding balconies and up from the floor. The visual and physical encounters between climbers and onlookers, architecture and artwork were, in turn, captured and reflected in the large mirrors suspended above the platforms. Within the context of the newly opened Tate Modern, this interplay of mutual self-regard, reflexive panopticism and self-display was entirely novel. Bourgeois' work also signalled the start of a sustained intersection between the space of the Turbine Hall and the space of contemporary art practice that takes 'as its theoretical horizon the realm of human interactions and its social context' (Bourriaud 2002: 14). In the context of Bourriaud's theorization of relational aesthetics, a work like 'I Do, I Undo and I Redo' functions as 'a machine provoking and managing individual and group encounters' (ibid.: 30). Thus, according to the Tate, the platforms on Bourgeois' towers functioned as 'stages for intimate and revelatory encounters between strangers and friends alike'.[5] By the time that Bourgeois' installation was dismantled six months later, the possibility had been established that the Turbine Hall could function as a site in which an expanded art public would henceforth be constituted via managed and random practices of embodied sociality, self-conscious performance and mutual self-regard.

However, the brooding presence of Bourgeois' giant spider and steel towers was hardly conducive to the more relaxed and playful occupation of the Turbine Hall that would be licensed by subsequent projects by Elliasson and Höller. The most vivid display of stranger sociability to date was produced by the fourth commission for Tate Modern, 'The Weather Project' by Olafur Elliasson (Figure 11.3). In making the project, Elliasson used the ubiquity of its ostensible subject (the weather) to trigger the visitor's awareness of the mediation of the museum in her perception of the artwork via the transformation of the Turbine Hall into a gallery of special effects. Each day, the space was filled with a fine mist which accumulated as faint, cloud-like formations, before dissipating across the hall.[6] The ceiling itself 'disappeared' behind mirrored panels, so that an image of everything and everyone in the hall below was caught in their vast reflection, and the mass of visitors became the object of its own fascination. At the east end of the Turbine Hall, a giant semi-circular form made up of hundreds of mono-frequency lamps was similarly captured in the ceiling's reflection, thereby forming the illusion of a dazzling sphere. The golden light of Elliasson's 'sun' was produced by his use of mono-frequency lamps which emit light at such a narrow frequency that only the colours yellow and black are invisible.

For Elliasson, the interplay of reflection and reflexivity were central to the project: in his words, 'our ability to see ourselves seeing allows us to evaluate and criticize ourselves' (quoted in Meyer 2004).[7] The phenomenological ambition of the project (to render the visitor conscious of his perception) was therefore entwined with its critical ambition (to render the visitor conscious of the conditions of seeing and thus of the institutional frame [ibid.]). Accordingly the Tate exposed the mist-making machines attached to the walls of the Turbine Hall and the lamps that

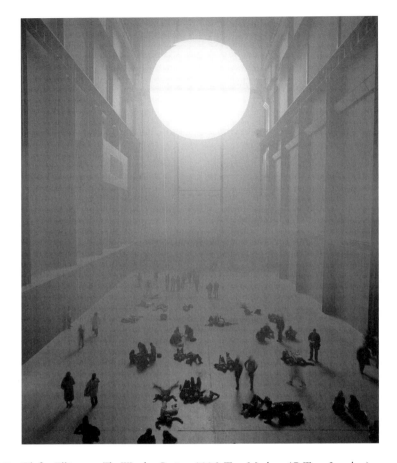

Figure 11.3 Olafur Elliasson, *The Weather Project*, 2006, Tate Modern (© Tate, London)

illuminated it, so as to dispel deliberately the installation's illusory effects and reveal its own mechanism of production. Whether or not the tactics of institutional critique were evident to the mass audience that revelled in the novelty of the installation is another matter. Meyer argued that the magnitude of the installation was itself overwhelming and as a result, 'the museum is not so much "revealed" as transformed into a destination, an event', while the most compelling aspect of 'The Weather Project' was 'the work's social effects' (ibid.). In response to Elliasson's manipulation of effect inside the Turbine Hall, visitors sat and lay down on the gallery floor, the better to see their own reflection in the huge overhead mirrors. Individually or collectively, people arranged their bodies to form shapes like stars and snowflakes, watching themselves as they opened and closed their limbs in rotational symmetry. Other visitors, looking down from the internal balconies and viewing platforms, formed an auxiliary audience for this collective performance. Marr described the play of sociality produced by 'The Weather Project' as a moment when 'contemporary art folded into mass experience, if not an act of collective worship then perhaps a silent, optical rave' (2006: 14). It was also the moment when visitors finally abandoned the decorum of the white cube gallery and occupied the Turbine Hall with their lying, sitting, touching, talking, embracing, eating, drinking, dozing, self-absorbed, consuming bodies.

Two years later, Carsten Höller's project called 'Test Site' provided an even more ludic experience of contemporary art when he installed three, dramatic slides that spiralled through the Turbine Hall, from the upper levels of the building down to the floor. The idea of the 'test site' was to experiment with the sensation and the spectacle of sliding (which Höller believes could be an efficient as well as enjoyable mode of transport in cities) within the incongruous setting of an art museum. The Tate reported that, for Höller, the experience of sliding is best summed up in a phrase coined by Roger Caillois as a 'voluptuous panic upon an otherwise lucid mind'.[8] As well as the 'inner spectacle' (the state of simultaneous delight and anxiety of the descent) experienced by the sliders themselves, onlookers (in the museum and online via a webcam) were drawn into the unusual public spectacle of people propelled through transparent tubes suspended mid-air inside an art museum. Dorothea von Hantelamann wrote that Höller's sides 'strive towards a subversion and reorganization of precisely those values that the museum cultivates. Against the museum as a machine for control and rationalization, they propose ecstasy and euphoria. Against the self-reflected and self-controlled visitor, they produce or provoke a visitor who is ready to lose his mind and to be transformed' (2006: 35).

If the embodied experience and casual conviviality stimulated by both 'The Weather Project' and 'Test Site' was initially contrived by the artists, it was also permissive and inclusive; both Elliasson and Höller resisted a single or correct reading of their respective projects. On the contrary, each installation was framed as if everyone involved was conducting some kind of investigation into open-ended questions that visitors would actually be able to answer: how often do you talk about the weather each day? What does it feel like to hurtle down a slide? By contrast, Doris Salcedo has articulated a very specific reading of 'Shibboleth', her site-specific commission for the Turbine Hall in 2007 (see Figure 11.4). Salcedo's work was a jagged fissure that ran across the floor of the Turbine Hall, beginning as a hairline crack and gradually growing wider and deeper. At its furthest extent, it was some six inches wide and about two feet deep. The sign at the entrance to Tate Modern alerting visitors to 'watch your step' was a response to the number of people who lost their balance or caught their feet by stepping too close to, or into, the crack, and thus formed a category of visitors known as 'trippers'. As soon as the piece was revealed to the press and public, the tantalizing notion that it posed a trivial physical risk only increased its popularity among amused visitors who explored the boundaries of the crack as if to test the limits of their balance. Following the installations by Elliasson and Höller, Shibboleth soon became another site of physical play and mutual self-regard; this time, at odds with the artist's intended meaning.

According to Salcedo, the work represented the fault-line in society between rich and poor, included and excluded. This, she says, is the dark legacy of racism and empire that underlies the modern world: 'Shibboleth is a negative space: it addresses the w(hole) in history that marks the bottomless difference that separates whites from non-whites. The w(hole) in history that I am referring to is the history of racism, which runs parallel to the history of modernity, and is its untold dark side' (Tate 2007: frontispiece). According to the Tate: 'In breaking open the floor of the museum, Salcedo is exposing a fracture in modernity itself'.[9] However, despite the efforts of both the artist and the institution to fix the meaning of 'Shibboleth' via interviews, press statements, the website, leaflets and a book, the official account of its 'meaning' was evidently at odds with how it is perceived and performed by many of its many visitors. Even the name, 'Shibboleth', was displaced in the media by its popular pseudonym, 'The Crack'. Just as Carl Andre's piece 'Equivalent VIII' has always been better known as the 'The Bricks' since its purchase by the Tate attracted the attention of a sceptical press in 1976, so too the gallery has lost control over the naming of 'Shibboleth', as the media currency of the work exceeded

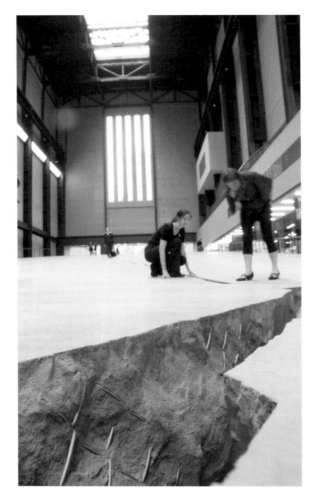

Figure 11.4 Doris Salcedo, *Shibboleth*, 2007, Tate Modern (© Tate, London)

the boundaries of aesthetic critique. The displacement of its designated title with a popular colloquialism simultaneously signalled both a loss of official meaning and also its success as a publicity *coup*, talking point and visitor attraction. Unlike the scandal of 'The Bricks' which was triggered by the banality of Andre's ready-made materials (120 firebricks) and their arrangement on the gallery floor, the mystery of how 'The Crack' was made became a source of fascination. The Tate's refusal to be drawn on this question inevitably fuelled speculation among visitors and in the media.

However, the disjunction between the intended meaning of the artist and its popular currency became evident in visitors' physical engagement with the work. Writing for the Tate, Achim Borchardt-Hume prescribed how the work should be experienced: 'visitors have to commit the time it takes to walk its 150-metre length… Akin to a procession, this walk invites us to look at what we have been conditioned to look away from…' (Borchardt-Hume 2007: 20). In fact, very few visitors walked up and down its entire length compared with those who followed it

some way, and then when the crack became wide enough, stepped into it, strode across it, lay down next to it, and peered into it. Borchardt-Hume also asserted that 'while the Turbine Hall's monumentality feeds the hunger of a profane culture for sublime experiences, Shibboleth quietly refuses to be comfortably consumed…' (ibid.). Observing the audience for 'Shibboleth' at different times of the day and week suggested that the opposite was the case: it may have been intended as a more unsettling work than either 'The Weather Project' or 'Test Site', but as Lisa Jardine commented after visiting the Tate on a Saturday evening, '… those roaming up and down the Turbine Hall last weekend seemed to be making their own meaning, rather than following an itinerary mapped out by the artist' (Jardine 2007). And for many, this process of 'making meaning' was a physical and social performance: 'hands were held across the crack at its widest points. Children stood arms akimbo over it, peering downwards. Groups clustered as if in consultation at the points where it deepened, or changed direction' (ibid.).

On another day, visitors stuck their feet into the crack, lay down next to it, jumped over and straddled it, while invariably being caught in the act by their companion's digital camera or mobile phone. Inculcated by works such as 'Test Site' and 'The Weather Project' into the consumption of the Turbine Hall as playground and photo opportunity, it became impossible for 'Shibboleth' to project its more sombre message on to the flow of leisured, entertainment-seeking and self-conscious bodies. The issue was not whether certain behaviours were more or less appropriate responses to the work, but the recognition that the bodies of visitors were interpretative agents that were generating new meanings of Shibboleth through their actions and reactions. For a moment, the audience for Shibboleth functioned as a 'counter-public' acting against the grain of institutional intention by encountering the work on its own terms (Warner 2002). The moment of dissent was, however, fleeting as the museum immediately reincorporated these transgressive bodies into its strategy of audience development.

Writing about 'Shibboleth' before its public opening, Paul Gilroy argued that the museum is a space 'where the detachment and complicity of a public that routinely dwells in denial might be challenged … By dramatizing this fundamental cut and bringing it into the public space of quiet reflection, Salcedo exposes the divisions we prefer to ignore' (2007: 27). But the Turbine Hall has never been a 'public space of quiet reflection' and visitors' response to Shibboleth showed that the work was too ambiguous to resist its own transformation into another event by the body-space relations enacted within it. Meyer was nearer the mark when he argued that there is no possibility of retreat from the throng of spectacle in the Turbine Hall; instead it functions to instrumentalize 'the phenomenological encounter of the work of art, within a scenario of unrelenting global museological competition' (Meyer 2004). The 'museological competition' that Meyer has in mind is the international rivalry among the most high-profile, prestigious and powerful art galleries in Europe and North America. Within that field, the Unilever Series denotes the ability of Tate Modern to mount a programme of cutting-edge commissions by major contemporary artists. Closer to home, the programme is equally critical to the success of Tate Modern in attracting new – and specifically, young – audiences.

Like all national museums in England, the Tate's grant-in-aid from the Department of Culture, Media and Sport (DCMS) is conditional on its delivery of specific targets, stipulated in a rolling three-year funding agreement. The 2005/06–2007/08 agreement identifies key targets for audience development, in the dual sense both of increased numbers and also increased diversity of visitors. Although young people are not specifically targeted in the funding agreement with DCMS, the *Tate Report 2006/07* acknowledges their strategic importance to the growth and diversification of its audience: 'Developing new audiences is central to our ability to promote enjoyment, understanding and knowledge of art. We … organise programmes and activities …

with the specific aim of attracting new and target audiences such as young people and families.' Ostensibly available to all visitors, programmes such as Tate Tracks (new music commissioned in response to a particular work of art) or UBS Openings: The Long Weekend (a festival of art, music and performance with DJs, a chill-out lounge for 15- to 23-year-olds, and a hip-hop radio station Choice fm) are clearly directed at teenagers and young adults who are invited in to hang out. The success of such activities is evident in the fact that six out of ten visitors to Tate Modern are under thirty-five: more than a million young people a year whose presence in the museum constitutes a valuable form of symbolic capital (Marr 2006). As Lawrence Hass says, the 'experiential field is also political' (2008: 92).

Central to the success of this strategy is the meaning and use of the Turbine Hall itself, and in particular, the ways in which Tate emphasizes the hybrid status '....as a space that may be perceived simultaneously as outdoors and indoors, industrial and museological' (Searing 2004: 98). The current director of Tate Modern describes it as a 'transitional' space 'between the streets of Southwark and the museum galleries' (Tate 2007: 7).[10] The scale, effect and function of the Turbine Hall resist easy categorization, and the space has been variously described as an avenue, galleria, vestibule and basilica. But the Tate's own favourite analogy is with a 'street' with its connotations of hip cosmopolitanism, everyday practice and popular culture. And in fact, due to its size, the Turbine Hall *is* officially designated as a covered street (Wagstaff 2006: 33). According to this logic, it is no surprise to find an ATM there; anathema to the purity of the white cube, but logical in a space where the boundary between museum/street is deliberately blurred.

Prior has argued that the success of Tate Modern is due to its strategy of double-coding whereby it has 'mutated to cater for a more fickle audience hankering after spectacle, but in many ways it has done so by combining elements of tradition with consumer populism, drawing on, while transforming, cultural modernity' (2003: 53). This chapter has also called attention to the Tate's 'allotropic' capacity to accommodate within a single building the contrasting bodily regimes of the modernist white cube gallery and the permissive 'street' of the Turbine Hall. Now Tate is planning the next stage in its development: a new building, designed by Herzog and De Meuron, adjacent to Tate Modern that will increase its overall space by 60%, is due to open in 2012. As well as galleries, education rooms and a performance space, it is intended to 'provide more places to eat, read, study, picnic, shop and just relax, to improve our visitors' experience' as well as 'spaces designed specifically by young people for young people'.[11] Evidently, the evolution of the institution will continue to be predicated on its ostensible desire to attract and accommodate specific bodies differentiated not by ethnicity, class or gender, but by age and embodied practices of cultural consumption.

Finally, why did visitors fall into Salcedo's 'Shibboleth'? Despite the massive publicity surrounding the work, were they somehow unprepared for their embodied encounter with it, thereby failing to achieve an appropriate 'balance between the inner and outer horizon', between perceiving subject and object? Some people seemed unaware that it was an actual break in the fabric of the gallery (one visitor is reported to have stumbled into the crack because she had thought it was painted on to the floor) and some tried their luck by walking along its edge, only to catch their shoe at its jagged rim. Others simply stumbled because they were talking to their companions and forget to look down. But accidents aside, a fissure was an unsettling presence: Shibboleth was designed to de-stabilize, and it did, literally.

Notes

1 For the relationship between habitus and bodily hexis, see Bourdieu 1990 – especially the chapter entitled 'Belief and the body' (pp.66–79).
2 O'Doherty insists the Spectator is more male than female (1976: 39).
3 The dimensions of the Turbine Hall are: 115 ft high, 75 ft wide, 500 ft long.
4 Seating for the galleries was designed by the project architects, Herzog and De Meuron. However, the curved wooden benches were deemed too 'artistic' by the curator, Francis Morris, and removed from some of the galleries so as to ensure that they did not compete with the art on display (Sabbagh 2000: 320).
5 http://www.tate.org.uk/modern/exhibitions/bourgeois/default.htm (accessed 3 March 2009).
6 http://www.tate.org.uk/modern/exhibitions/elliasson/about.htm (accessed 3 March 2009).
7 See also see Tate 2003.
8 http://www.tate.org.uk/modern/exhibitions/carstenholler/default.shtm (accessed 3 March 2009).
9 http://www.tate.org.uk/modern/exhibitions/dorissalcedo/default.shtm (accessed 22 February 2008).
10 'Director's Foreword' in Tate, *Doris Salcedo Shibboleth*, London, 2007. p.7.
11 http://www.tate.org.uk/modern/transformingtm/ (accessed 3 March 2009).

References

Bal, M. (2007) 'Earth aches: the aesthetics of the cut', in Tate, *Doris Salcedo: Shibboleth*, London: Tate, p. 40.

Bayle, S.-J. (1855) *The Louvre, or Biography of a Museum*, London: Chapman and Hall.

Bennett, T. (2004) *Pasts beyond Memory: evolution, museums, colonialism*, London: Routledge.

Bennett, T. (2006) 'Civic seeing: museums and the organization of vision', in S. MacDonald (ed.) *A Companion to Museum Studies*, Oxford: Blackwell, pp. 263–81.

Borchardt-Hume, A. (2007) 'Sculpting critical space', in Tate, *Doris Salcedo: Shibboleth*, London: Tate, pp. 12–21.

Bourdieu, P. (1990) 'Belief and the body', *The Logic of Practice*, Cambridge: Polity Press, pp.66–79.

Bourriaud, N. (2002) *Relational Aesthetics*, Paris: Les Presse du Réel.

Buck, E. G. (1997) 'Museum bodies: the performance of the Musée Gustave Moreau', *Museum Anthropology*, 20 (2): 15–24.

Butler, J. (1993) *Bodies that Matter*, London and New York: Routledge.

Crossley, N. (1996) 'Body-subject/body-power: agency, inscription and control in Foucault and Merleau-Ponty', *Body and Society*, 2 (2): 99–116.

Duncan, C. (1995) *Civilizing Rituals: inside public art museums*, London: Routledge.

Garoian, C. R. (2001) 'Performing the museum', *Studies in Art Education*, 42 (3): 234–48.

Gilroy, P. (2007) 'Brokenness, division and the moral topography of post-colonial worlds', in Tate, *Doris Salcedo: Shibboleth*, London: Tate, p. 27.

Hass, L. (2008) *Merleau-Ponty's Philosophy*, Bloomington, IN: Indiana University Press.

Hemingway, A. (1995) 'Art exhibitions as leisure-class rituals in early nineteenth-century London', in B. Allen (ed.) *Towards a Modern Art World*, New Haven, CT and London: Yale University Press, pp. 95–108.

Jardine, L. (2007) 'Making contact', BBC news article, online, <http://news.bbc.co.uk/go/pr/fr/-/1/hi/magazine/7075030.stm> (accessed 3 March 2009).

Jevons, W. S. (1883) 'The use and abuse of museums', in *Methods of Social Reform and Other Papers*, London: Macmillan, pp. 53–81.

Kirshenblatt-Gimblett, B. (1999) 'Performance studies', in Rockefeller Foundation, *Culture and Creativity*, online, <http://www.nyu.edu/classes/bkg/issues/rock2.htm> (accessed 3 March 2009).

Lyon, M. L. (1997) 'The material body, social processes and emotion: "techniques of the body" revisited', *Body and Society*, 3 (1): 83–101.

Mack, G. (1999) *Art Museums into the 21st Century*, Basel: Birkhauser Verlag AG.

Marr, A. (2006) 'The magic box', in F. Morris (ed.) *Tate Handbook*, London: Tate, pp. 12–19.

Mauss, M. (1973) 'Techniques of the body', trans. B. Brewster, *Economy and Society*, 2: 70–88.

Merleau-Ponty, M. (1962) *Phenomenology of Perception*, London: Routledge.

Merleau-Ponty, M. (1964) *The Primacy of Perception*, Evanston, IL: Northwestern University Press.

Meyer, J. (2004) 'No more scale. The experience of size in contemporary sculpture', *Artforum,* online, <http://artforum.com/inprint/id=6960&pagenum=> (accessed 3 March 2009).

Morris, F. (ed.) (2006) *Tate Handbook*, London: Tate.

Morris, R. (2000) 'Size matters', *Critical Inquiry*, 26 (3): 474–87.

O'Doherty, B. (1986) *Inside the White Cube: the ideology of gallery space,* California CA: Lapis Press.

Prior, N. (2003) 'Having one's Tate and eating it', in A. McClellan (ed.) *Art and its Publics*, Oxford: Wiley Blackwell, pp. 51–76.

Rees Leahy, H. (2005) 'Producing a public for art', in S. Macleod (ed.) *Re-shaping Museum Space*, London: Routledge, pp. 108–117.

Rees Leahy, H. (2007) 'Walking for pleasure? Bodies on display at the 1857 Manchester Art-Treasures exhibition', *Art History*, 30 (4): 545–65.

Sabbagh, K. (2000) *Power into Art*, London: Allen Lane.

Searing, H. (2004) *Art Spaces: the architecture of the four Tates*, London: Tate Publishing.

Stanley, N. (2001) 'Moving people, moving experiences: novel strategies in museum practice', in I. Cole and N. Stanley (eds) *Beyond the Museum: art, institutions, people*, Oxford: Museum of Modern Art Oxford, pp. 42–7.

Stendhal (1959) *Rome, Naples and Florence*, trans. R. N. Coe, London: Calder.

Tate (2003) *Olafur Elliasson, The Weather Project*, London: Tate Publishing.

Tate (2007) *Tate Report 2006/07,* online, <http://www.tate.org.uk/about/tatereport/2007> (accessed 3 March 2009).

Valéry, P. (1960) 'The problems of museums', in J. Matthews (ed.) *The Collected Works of Paul Valéry*, Vol 12, New York: Pantheon Books, pp.202–5

von Hantelamann, D. (2006) *Carsten Höller, Test Site*, London: Tate Publishing.

Wagstaff, S. (2006) 'Raw materials: Tate Modern programme', in F. Morris (ed.) *Tate Modern The Handbook*, London: Tate Publishing, p. 33.

Warner, M. (2002) *Publics and Counterpublics*, New York: MIT Press.

Wilson, F. (1994) 'The silent message of the museum', in J. Fisher (ed.) *Global Visions: towards a new internationalism in the visual arts*, London: Kala Press in association with the Institute of international Visual Arts, pp. 152–60.

RECONSIDERING DIGITAL SURROGATES

Toward a viewer-orientated model of the gallery experience

Bradley L. Taylor

While libraries and museums continue to push ahead with the digitization of art and three-dimensional artefact collections, questions persist as to the role such surrogates will play in the museum of the twenty-first century (Frost 2002, Smith 2003, Jinbo and Mehrens 2007). Educators readily acknowledge the potential application for digital images in outreach and education efforts (Romer, 1996, Frost *et al.* 1997, Cameron and Kenderdine 2007) but others are quick to voice concern over the nature of the likeness being purveyed and the decontextualization of works of art from the gallery experience (Jussim 1977, Thompson 1981/82, Jones 1990, Panofsky 1995). In addition, recent research (Taylor 2001a, 2003) has shown that museum visitors respond to the affective content of original works of art in ways that are significantly different from the ways in which they respond to the affective content of works of art reproduced as black-and-white photographs, pictures in books, colour slides, and even digital images. All of this, points to a growing awareness that creating digital reproductions that are accurate representations of an 'original' is much more complicated with image-based materials than it is for text-based materials, a fact frequently overlooked in the rush to digitize. And, while technologists have been able to refine some of the physical limitations of digital surrogates (i.e. relative density of the image, colour fidelity), a shortfall in other critical physical considerations persists (lack of dimensionality, limited sense of scale, a restriction to the single sense of sight) and, most important, little progress has been made in capturing the affective response individuals are likely to experience when faced, for instance, with a Rubens painting, a copy of the Magna Carta, a heritage peony garden in full bloom, or the 'martyred village' of Oradour-sur-Glane in France's Limousin region.

Even more problematic is that researchers have overlooked a possible paradigm shift that might have led them in beneficial new directions – a fundamental reorientation from object to viewer, from data points associated with the object to a deeper understanding of the complexities of the viewing experience. Rather than yielding several generations of anaemic surrogate images, we might have developed websites or viewing mechanisms that captured – or at least acknowledged – the complex confluence of cognitive and affective responses evoked by physical space and personal circumstance within the museum gallery. The purpose of this chapter is to begin to redress this oversight by proposing for consideration several theoretical models from the area of information seeking, that might provide a starting point for arriving at a fully-fleshed,

viewer-oriented, gallery-based model of conceptualizing the interaction between the observer and the observed which can then lead to new ways of organizing, accessing, retrieving, and, most of all, *experiencing* museum content online.

Historical context

Much of the image-based research conducted over the past two decades within the library and information science (LIS) community was undertaken with the greater aims of enhanced information retrieval as a desired end goal. By the 1980s, library technology had advanced to the point that not only could information about the text-based holdings of an institution be retrieved but image files could also be created, displayed, and accessed remotely. Much of the earliest LIS work on visual materials centred on attempts to develop documentation standards (i.e. what was to be recorded), formats for recording information in an organized manner (i.e. the order in which this information was to be arranged), and controlled vocabularies (i.e. what things would be named) that would help organize geographically distributed repositories of visual materials into similarly catalogued collections that scholars and the interested public could search remotely, across institutions, and without mediation. The emphasis of this early work was largely 'classification and cataloging' in orientation, where ways of naming and organizing collections of like materials were given priority. Thirty years since these earliest efforts, progress has been made in the development of discipline-specific, controlled vocabularies and in the creation of documentation standards and formats for recording that information (in the United States, the *Art & Architecture Thesaurus*, Chenhall's *Nomenclature*, MARC records, the Dublin Core, etc.). That said, the roadblocks posed by the costs of retrospective conversion of existing paper-based catalogue records, the historic under-documentation of many museum collections, the endemic orientation toward local rather than global solutions within the museum community, the failure to create a single documentation standard that works equally well for e.g. tree frogs, Chinese export porcelain, herbarium specimens, or presidential campaign buttons, a preponderance of 'solutions' that, in fact, work mostly within single disciplines or from discipline-specific points of view, and the ultimate lack of applicability of subject-level cataloguing in many types of object collections (a paradigmatic hold-over from *Anglo-American Cataloging Rules* [second edition] which asks of cataloguers e.g. what is the 'subject' of a Model T, an antimacassar, or a Vienna regulator clock?), have largely proscribed the goals that the cataloguing and classification community may have wished for. The work of the academy has fallen short in creating meaningful solutions that acknowledge the realities of most museums.

Above and beyond this, even more of the image-based LIS research from the past few decades has centred not on cataloguing and classification but on information retrieval (Markey 1984, Mostafa 1994, Romer 1996, Sarasan 1984), the process of developing largely automated systems to support the (usually) remote retrieval of images and attendant information. As part of this effort, researchers have focused close attention on defining the characteristics of the artefacts to be retrieved, frequently favouring schemes predicated on using parameters such as artist, title, medium, provenance, or subject (as problematic as that has proven to be, even for works of fine art), almost always concentrating on collections of like materials when the solution often needed is the ability to search across collections of frequently disparate materials. Even studies that attempt to consider retrieval points beyond those just mentioned have often found their results proscribed by a reliance on surrogate images in testing, providing, at best, problematic data with which to work (Hardiman 1971, Kettlewell 1988, Cupchik and Gebotys 1990, Kettlewell *et al.* 1990, Cupchik *et al.* 1992, Winston and Cupchik 1992, Franklin *et al.* 1993, etc.).

The 'object centrality' of such research has allowed for the subsequent creation of searchable databases and museum websites that purvey flattened reductions of museum artefacts while failing to reproduce any of the affective response individuals are likely to experience while standing in a museum gallery face-to-face with an original work of art. Even if the intent of this research was never to capture the more complicated relationship that exists between viewer and object, from a purely 'informational' perspective, such databases/websites fail to deliver not only an important dynamic, but a defining one; those qualities most important to access have been lost absolutely in information 'systems' that fail to capture the quintessence of the relationship between object and viewer. Stated most persuasively in Walter Benjamin's concept of the 'aura of the original', the locus of the artefact/viewer relationship has most frequently been seen as residing within the object itself. But, what if that were not the case? What if the key to understanding the unique nature of viewer response in the museum setting lay not in further studies centred on the object but in redirecting our attention toward an enhanced understanding of the individual and the museum setting itself?

Recasting the object/viewer paradigm: examples from information seeking theory

The literature within the LIS community has also produced important theoretical models for consideration in this regard. While the objective for most of these studies has been a desire to refine the provision of reference services in library settings, these studies afforded increasingly sophisticated insight into a wide variety of factors that involve the interaction between individuals and collections within an institutional setting. Within the specific area of 'information-seeking behaviour' or 'information behaviour', studies by a handful of individuals over several decades served to define cognitive and affective states and related activities associated with the information seeking process, thus providing user-centred theoretical models to enhance library practice. These studies examined the nature of the relationship between information seeker and institution (as personified by a reference librarian), the personal circumstances of the information seeker, the physical setting in which the interaction occurred, affective cues and activities that corresponded with cognitive states of understanding (which would thus inform an appropriate response by the librarian), and the process-oriented nature of the overall exchange. Within each of the models to be reviewed here are elements that might be considered further to better understand the nature of the interaction between viewer and art/object within a museum setting.

Robert S. Taylor proposed one of the earliest models for information seeking in works published in 1962 and 1968. Taylor's contribution was in presenting the reference interview not as a single exchange but as a dynamic interaction that was open ended, negotiable, and user centred. Taylor identified various stages of information need within the user (visceral, conscious, formalized need, and compromised need) that managed to encompass the notions of affective feeling, cognitive knowing, and concomitant action. Taylor's model offered a new means of imagining the relationship between library and user, one rooted in characteristics of the user and less in the characteristics of a static collection, a simple orientation that seems to have escaped many of those who were to conduct image studies several decades later. A generation later, T.D. Wilson (1981, 1984, Wilson and Walsh 1996) offered a model of information seeking that sought consideration of the 'social context' for the information need as a means of connecting individuals with the information being sought – in Wilson's model individual needs are rooted in affective motivations and desires. Knowing the user's 'need' isn't enough; understanding the

larger circumstances for the need are essential. Wilson's is the first model that builds a case for the importance of context, albeit initially only an affective/personal one. Nonetheless, it points the way to new ways of imagining the object/viewer relationship in the museum, one that places greater emphasis on the viewer and circumstances surrounding her/his various 'contexts' within the gallery setting.

Carol Kuhlthau's work (1988a, 1988b, Kuhlthau *et al.* 1988, Kuhlthau *et al.* 1990, Kuhlthau 1991, 1993a, 1993b) extends the pioneering work of Taylor and Wilson, offering a fully-rounded picture of the information-seeking process, with the user/seeker clearly at the centre of the model. Using as the focus of her research the information-seeking processes of high-school students seeking assistance with class writing assignments, Kuhlthau identifies seven stages of behaviour, each with associated levels of cognitive understanding about one's research topic (ranging from ambiguity to specificity), feelings associated with the search process (moving from uncertainty to satisfaction), and specific actions associated with the different stages of the search process (involving searching for relevant information to searching for pertinent information). Finally, Brenda Dervin (1977, Dervin and Nilan 1986, Dervin 1992), a communication studies scholar looking at information seeking, further argues against the collection-centric nature of libraries, asserting that the personal construction of knowledge, not the systematic transmission of information is the key to successful information seeking – here the emphasis is clearly on the user and understanding the user's query, not on the collection itself nor on whatever automated tools the institution has designed to provide assistance.

Lest this seem like too far a stroll from the museum gallery, it is important to underscore the importance of the models offered forth by these scholars of information seeking. In this very brief review of the work of four individuals we can see elements that lead to a theoretical framework for thinking about providing museum collections 'information' in a way that does not emphasize an over-reliance on decontextualized, two-dimensional reproductions that fail to preserve any aspect of the tremendously rich viewing environment offered by the museum gallery. At very least, these four models offer the following features:

- an emphasis on the circumstances of the viewer as opposed to the circumstances of the collection;
- appreciation of the impact of the physical environment on the encounter;
- attention to the immediate personal circumstances of the viewer and how they might affect one's response to the collection;
- awareness of the changing states of a viewer's cognitive understanding and affective response;
- an understanding of the experience as being dynamic and evolving over time.

It now becomes possible to see how user-centred information theory could provide a new framework for challenging existing object-centred paradigms about the relationship between objects and viewers in the museum gallery.

Toward a theoretical model of the 'gallery effect'

Theoretical models of information seeking provide user-centred frameworks that allow us to reconsider the complex interrelationships that exist between object, viewer, and space within the museum gallery. New models will be critical to re-imagining the digital museum experience which relies, much to its detriment, on the purveyance of flattened, two-dimensional surrogates,

limited to the single sense of sight, which fail to convey the complexity and richness of the gallery experience. Data gathered during research on users in museum gallery settings, however, can begin to suggest a number of elements that factor into a viewer-based theoretical model for understanding the complex dynamics at play within the museum. The study (Taylor 2001b), conducted at the Toledo Museum of Art in Toledo, Ohio, involved the participation of over 80 test subjects in selecting words from a controlled vocabulary that best described the feelings/emotions subjects identified in a set of twenty nineteenth- and twentieth-century Western oil paintings shown to test subjects in five different viewing formats – four surrogate formats and an 'original'. Each subject saw all twenty pictures but in a different showing order and in different formats – each saw four originals, four digital images, four black and white glossy photos, four black and white pictures from books, and four colour slides. Each format was shown in typical viewing conditions (i.e. the slides in a darkened theatre) and a repeated Graeco-Latin squares research design controlled for the possible effects of type of picture shown (five categories were used in the selection of the 20 pictures) and showing order.[1] While no overall effect for surrogation was seen in the statistical analysis of results (the overall number of test subjects proving insufficient to determine a positive correlation, 200–300 test subjects later being judged a minimum number required to best assess this effect), important positive correlations were established in a series of questions at the end of the test in such categories as age, gender, frequency of attending museums, etc. The anecdotal evidence that surfaced during the administration of this study has never before been made public, however, and would seem to have direct bearing on the current topic.

Some of the most interesting findings to come from the Toledo Picture Study came in the form of informal conversations that occurred while test subjects were being escorted from one testing location to another within the Toledo Museum of Art. This required not only moving test subjects between screening rooms (for slides) and offices (to look at digital surrogates on the computer or photographs or pictures in books), but from one gallery to another as subjects were moved from e.g. Impressionism to American art to contemporary art, etc. During this 'travel time', test subjects spoke openly about the works of art on display, the presence of others in the galleries, etc. but also about their own personal experiences with the museum. While none of these observations were directly relevant to the questions being asked as part of the Toledo Picture Study, they do provide additional insight into those factors that might contribute to what one might term a 'gallery effect', and bear some discussion here.

The effect of physical space

Test subjects commented on either the presence or absence of other people in the galleries at the time they were looking at test paintings. They mentioned the effect of the other works of art on the gallery walls and how that contributed to a specific 'mood' or 'feeling' they experienced, being surrounded by multiple pieces of a similar period/style. Several test subjects made special mention of the rich tones of the parquet floors in the Toledo Museum of Art galleries and the similarly lush background paint colours (burgundy, olive, gold) used on a number of the gallery walls. In the case of several of the large canvases (the Doré, the Tissot, the Sargent), some subjects commented on the relative size of the pieces and the dominating feeling they conveyed. One of the most telling examples in this regard emerged from a pre-test for the Toledo study that was conducted at the University of Michigan Museum of Art. About half way through that study, one of the paintings being used was physically moved from a gallery setting to basement storage. Since the need to use a controlled vocabulary was the focus of the pre-test, I continued to

include the painting in the pre-test, not thinking that the strict identification of emotions being depicted would hinge on the location of the painting within the museum. As it turned out, the average number of emotions perceived by test subjects dropped once the painting was moved into storage, as did subjects' accounts of the degree to which those emotions were present. All of these examples suggest the presence of a variety of visual stimuli within the gallery setting that surely merits further examination. Since many image studies have relied on the use of surrogates, this particular dimension of the human response to works of art within museum space has been little observed in the literature.

The effect of the five senses

Lest we forget that humans experience the world about them using all five senses, other examples remind us that the gallery experience transcends mere viewing. On Friday evenings at the Toledo Museum of Art, patrons can arrive after regular business hours for social gatherings that feature wine, live classical music, and an opportunity to engage with others in close proximity to the galleries. On several evenings during the formal test period I led test subjects through the galleries looking at art while live piano music played in the background. When reviewing the quantitative data from these test subjects in particular, I noticed a significant increase in the degree to which respondents said that they experienced the emotions observed in the paintings they were asked to view; these same individuals recorded a greater number of emotions associated with the originals they were shown than did test subjects who observed without a musical background (cf. Ting, this volume). In another example, a pre-test subject at the University of Michigan Museum of Art confessed to his love of art as a means of connecting with famous individuals from the past. An art collector himself, this pre-test subject admitted an irresistible need to physically touch canvases as a means of establishing this connection with the past … and then proceeded to draw his finger lightly across the bottom of the painting he had been asked to view. Such observations underscore quintessential distinctions between works viewed in a gallery setting (or at very least in their original form) and works viewed as digital surrogates. The gallery setting presents a complex multisensory environment that can directly inform the nature of one's emotional response to museum artefacts. While the Toledo environment offered one type of stimulus, consider the essential role played by the senses in shaping one's understanding of a hearthside cooking demonstration, Beethoven's violin, the feel of silk versus cotton, or the totality of sensations that come from a visit to a working nineteenth-century Michigan farm on a cold March morning, etc. Where is *this* information in the world of digital surrogation?

The effect of personal experience

In addition to the contextual setting provided by the gallery space itself and the richness derived from the use of all five senses when encountering original works of creation, it is equally important to consider the personal circumstances and experiences of the viewer when trying to comprehend the emotional response to works of art. In the Toledo Picture Study informal conversation once again led to the notion that the personal circumstances and experiences of test subjects factor into the emotional response to museum objects and merit further investigation. One subject over 60 years of age mentioned that she had come to the museum 'all her life' starting with 'years of studio art classes as a girl'. A male subject revealed that his daughter had recently been married in the museum's cloisters installation and that many of the important moments in his family's life had involved the museum. A third individual shared that she had

begun attending the museum more often after participating in a community art show where works from local artists were hung for a summer in the museum's lower level. Each of these individuals participated with enthusiasm in the Toledo Picture Study and shared these stories as they travelled through the museum. One might surmise that an important dimension of the affective response to an original work of art in a museum gallery setting might be derived from one's prior knowledge of and experience with museums or specific museum collections in particular. Those with long histories or positive experiences with museums may, in fact, be more responsive to opening themselves up to engaging on an emotional level with a work of art. This category, of personal context/circumstance, points to a potentially limitless number of possible influences – situated in the viewer, not the object – that, when combined with other external stimuli, create a unique, personalized response to museum objects.

A viewer-oriented model of the gallery experience

This examination of information theory and evidence from the Toledo Picture Study allows us to propose a model of the gallery experience that is centred on the viewer, not on static objects in a collection. This fundamental re-orientation would impact the future development of the digital museum experience, currently predicated on the provision of surrogate images; as we have seen, such digital surrogates fail to provide an accurate physical representation of an 'original' and, more importantly, fail to capture the quintessential nature of the viewer's affective response to an original. Creating a theory-based model focused on the viewer as opposed to the object will re-direct attention to the complex set of circumstances that combine to affect viewer response. Through a deeper understanding of these factors, it will become possible to create ways to map these qualities to the digital environment, thus creating more accurate representations of museum artefacts *and* a greatly enhanced viewing experience.

This new model is situated within the realm of the viewer, not the world of the object. Human response to the object contains both cognitive and affective components; psychologists and art theoreticians alike tell us that cognitive recognition and affective response are processed in different parts of the brain, with affective response being processed fastest and *having primacy over cognitive response* (Barry 1997; Arnheim 1974). Thus, the ability to emulate affect or emotion is not only an essential part of understanding museum objects; it is, in fact, the single quality that matters most. Knowing that we are operating with a viewer-based experience rooted in feeling or emotion, we can then examine those factors that influence or affect viewer response. Information theory and data from the Toledo Picture Study suggest that primary influences are the viewer's immediate physical surroundings, the viewer's interactions with others in museum space, and the history or personal circumstances of the viewer – everything from prior knowledge of art or a particular collection, to one's socio-economic status, gender, education, even multiple circumstances as narrow as whether the viewer wanted to come to the museum, concerns about a personal problem, even whether the viewer had difficulty finding parking on the way to the museum.

Unlike earlier efforts that attempted to assign fixed fields of meaning to museum objects through cataloguing and classification, it is now clear that human beings and the processes associated with them are varied, dynamic, and never entirely predictable. It must be understood then that the responses individuals will have to objects will be dissimilar, subject to multiple influences, and likely to evolve over time. While such truths are likely to confound a search for pat answers, they suggest a need to develop online access systems/websites that anticipate multiple populations, allow for differences in content expertise, and are flexible enough to support the inevitable changes in approach driven by advances in technology. While the dynamic, evolving

nature of individuals is likely to be the most daunting aspect of this new model to address practically, the flexibility of the digital environment might, in fact, provide an ideal venue for supporting multiple means of connecting with/experiencing museum artefacts, as long as such systems are built with humans, not objects, at their conceptual core. Advances in understanding along any of these parameters will enhance the ability of the technologist to better emulate the affective response of the viewer in the gallery. Such progress will offset the present reliance on surrogate images in representing a complex confluence of physical, psychological, social, and cultural factors while taking full advantage of the web's ability to extend the reach of the museum.

Final observations: viewer-orientation in the era of customized content

A theoretical reconsideration of the relationship between object and viewer in the digital world invariably needs to be reconciled with the realities of museums. Few museums have the luxury of discarding records and files that have been built up over the course of generations. Not only are the financial and human resources required not likely to exist for a wholesale re-imagining of documentation and access, but the costs of retrospective conversion of existing records and the problem of creating records for undocumented collections present seemingly insurmountable challenges. That said, other research suggests that such consideration needs to be taken seriously. A recent speaker on the University of Michigan campus offered a review of the field of experience design that underscored the need for considering the issues raised in this paper – with great haste (Mallwitz 2009).

 In creating user-centred experiences in museums and theme parks, those involved in the field of experience design closely monitor social phenomena that stand to affect the way they conceive their work. Among the most notable recent observations have been changes in the way people consume information/entertainment. Mallwitz notes a surge in the demand for 'customized content' (fuelled by the iPod and the iPhone) and, in an era of unprecedented choice, the possible impact on museum visitors. Mallwitz posits that strong attraction to customized content will create the expectation of interacting with museums in ways that put *visitors/consumers* at the centre of the museum experience. Individuals will be less interested in the agenda or authority of the museum and will demand the ability to craft an experience of their own using the museum's collections, research, and expertise as a large database of information/experience which they can then control/edit/customize. The degree to which this is likely to be true might be argued, though the phenomenon clearly suggests a seismic shift in our notions of how visitors interact with museums and their collections. To that end, further consideration of a theory that advances the role of the viewer at the centre of the object/viewer relationship will not only have merit but may well determine the relevance of museums themselves for future generations.

Note

1 A repeated Graeco-Latin squares research design was used to form the basis for an exercise designed to test the ability of viewers to identify emotions and feelings in a set of twenty pictures presented in a variety of formats. The Graeco-Latin squares research design assures both the randomization of which pictures test subjects see in which reproductive format and which picture the test subjects see in which order. The basic 5×5 grid design that forms the basis of the Latin square allows the researcher to map out a sequence of 'viewings' of five pictures for test subjects that controls for the overall effect of varying genres and formats. To help control for the possible effect of showing order, another 5×5 grid is superimposed on the Latin square, creating a Graeco-Latin square; and because each test

subject needs to be shepherded through a total of twenty pictures, the pattern is repeated four times, making the basic design for the experiment a repeated Graeco-Latin square design. With the three intervening variables – genre, format, and showing order – thus built into, and counterbalanced by, the research design, the researcher can focus directly on the responses given by test subjects without having to be concerned about the fact that, for example, portraits preceded landscapes, digital images followed original works of art, or the fact that, for example, the Sargent immediately preceded the Monet. Because the Graeco-Latin squares themselves are configured so that no two same Latin square patterns overlap, orthogonality has been preserved in the overall design. Each Graeco-Latin square will thus assure different random patterns for each square that is configured.

References

Arnheim, R. (1974) 'Expression', in R. Arnheim, *Art and Visual Perception: a psychology of the creative eye,* Berkeley, CA: University of California Press, pp. 444–61.

Barry, A. M. S. (1997) *Visual Intelligence: perception, image, and manipulation in visual communication*, Albany, NY: State University of New York.

Cameron, F. and S. K. Kenderdine (eds) (2007) *Theorizing Digital Cultural Heritage,* Cambridge, CA: Massachusetts Institute of Technology Press.

Cupchik, G. C. and R. J. Gebotys (1990) 'Interest and pleasure as dimensions of aesthetic response', *Empirical Studies of the Arts,* 8: 1–14.

Cupchik, G. C., A. S. Winston and R. S. Herz (1992) 'Judgements of similarity and difference between paintings', *Visual Arts Research,* 18: 37–50.

Dervin, B. (1977) 'Useful theory for librarianship: communication, not information', *Drexel Library Quarterly,* 13: 16–32.

—— (1992) 'From the mind's eye of the user: the sense-making qualitative-quantitative methodology', in J. D. Glazier and R. R. Powell (eds), *Qualitative Research in Information Management,* Englewood, CO: Libraries Unlimited.

Dervin, B. and M. Nilan (1986) 'Information needs and uses', *Annual Review of Information Science and Technology,* 21: 3–33.

—— (1995) 'Pictorial information retrieval', *Journal of Documentation,* 51: 126–70.

Frost, C. O. (2002) 'When the object is digital: properties of digital surrogate objects and implications for learning', in S. G. Paris (ed.), *Perspectives on Object Centered Learning in Museums*, Mahwah, NJ: Erlbaum.

Frost, C. O., K.M. Drabenstott and J. Janes (1997) 'Integrating an image database into Gopher (School of Information Art Image Browser)', Ann Arbor, MI: University of Michigan School of Information.

Hardiman, G. W. (1971) 'Identification and evaluation of trained and untrained observers' affective responses to art objects: final report', ED 052 219, Urbana, IL: University of Illinois, Dept. of Art.

Jinbo, C. and C. Mehrens (2007) 'Art in the Indiana State University Library: Why have original artworks in an academic library?', *Indiana Libraries,* 26: 40–2.

Jones, L. S. (1990) *Art Information: research methods and resources*, 3rd edn, Dubuque, IA: Kendall/Hunt Publishing Co.

Jussim, E. (1977) 'The research uses of visual information', *Library Trends,* 25: 763–78.

Kettlewell, N. (1988) 'An examination of preferences for subject matter in painting', *Empirical Studies of the Arts,* 6: 59–65.

Kettlewell, N., S. Lipscomb, L. Evans and K. Rosston (1990) 'The effect of subject matter and degree of realism on aesthetic preferences for paintings', *Empirical Studies of the Arts,* 8: 85–93.

Kuhlthau, C. C. (1988a) 'Developing a model of the library search process: cognitive and affective aspects', *RQ,* 28: 232–42.

—— (1988b) 'Longitudinal case studies of the information search process of users in libraries', *Library & Information Science Research,* 10: 257–304.

—— (1991) 'Inside the search process: information seeking from the user's perspective', *Journal of the American Society for Information Science,* 42: 361–71.

—— (1993a) 'A principle of uncertainty for information seeking', *Journal of Documentation,* 49: 339–55.

—— (1993b*) Seeking Meaning: a process approach to library and information services,* Norwood,NJ: Ablex.

Kuhlthau, C. C., B. J. Turock and R. J. Belvin (1988) 'Facilitating information seeking through cognitive models of the search process', in C. L. Borgman and E.Y.H. Pai (eds) *ASIS '88: information technology: planning for the next fifty years,* Medford, NJ: Learned Information, pp. 70–75.

Kuhlthau, C.C., B.J. Turock, M.W. George and R.J. Belvin (1990) 'Validating a model of the search process: a comparison of academic, public and school library users', *Library & Information Science Research,* 12: 5–31.

Mallwitz, S. (2009) 'Experience design for non-profit institutions, for profit corporations and everyone in between', lecture presentation, University of Michigan, Ann Arbor, MI, 17 February.

Markey, K. (1984) 'Visual arts resources and computers', in M. E. Williams (ed.) *Annual Review of Information Science and Technology,* Medford, NJ: Learned Information, pp. 271–309.

Mostafa, J. (1994) 'Digital image representation and access', in M. E. Williams (ed.) *Annual Review of Information Science and Technology,* Medford, NJ: Learned Information, pp. 91–135.

Panofsky, E. (1995) 'Original et reproduction en fac-similé', *Cahiers du Musée national d'art moderne,* 53: 45–73.

Romer, D.M. (1996) 'Image and multimedia retrieval', in D.M. Romer, *Research Agenda for Networked Cultural Heritage,* Los Angeles, CA: The Getty Art History Information Program, pp. 49–56.

Sarasan, L. (1984) 'Visual content access: an approach to the automatic retrieval of visual information', in L. Corti (ed.), *Automatic Processing of Art History Data and Documents*, Pisa: Scuola Normale Superiore, pp. 388–405.

Smith, D. (2003) 'The surrogate vs. the thing', *Art Documentation,* 22: 11–15.

Taylor, B.L. (2001a) 'The effect of surrogation on viewer response to expressional qualities in works of art', unpublished PhD dissertation, Ann Arbor, MI: University of Michigan.

—— (2001b) 'The effect of surrogation on viewer response to expressional qualities in works of art: preliminary findings from the Toledo Picture Study', in R. Bearman and J. Trant (eds) *Proceedings from the Museums and the Web Conference,* Pittsburgh,PA: Archives and Museum Informatics, online, <http://www.archimuse.com/mw2001/papers/taylor/taylor.html> (accessed 2 March 2009).

—— (2003) 'Enhancing the value of museum websites: lessons from the practical engagement front', *Journal of Library Administration,* 39: 107–22.

Taylor, R.S. (1962) 'The process of asking questions', *American Documentation,* 13: 391–6.

—— (1968) 'Question-negotiation and information seeking in libraries', *College and Research Libraries,* 29: 178–94.

Thompson, C. (1981/82) 'Why do you need to see the original painting anyway?', *Visual Resources,* 2: 21–36.

Wilson, T.D. (1981) 'On user studies and information needs', *Journal of Documentation,* 37: 3–15.

—— (1984) 'The cognitive approach to information-seeking behavior and information use', *Social Science Information Studies,* 4: 197–204.

Wilson, T. and C. Walsh (1996) *Information Behaviour: an inter-disciplinary perspective,* Wetherby: British Library Research and Innovation Centre.

Winston, A.S. and G.C. Cupchik (1992) 'The evaluation of high art and popular art by naïve and experienced viewers', *Visual Arts Research,* 18: 1–14.

Part 3

INTERPRETATIONS

Sandra H. Dudley

This final part of the book deals with the implications of object qualities and of sensory experience of them for a range of potential interpretive strategies within museum and gallery spaces. Inevitably, there are intersections with Part I's direct emphasis on objects and materiality, and with Part II's focus on a diversity of physical, sensory and emotional engagements with objects. The primary direction of gaze here, however, is towards a range of interpretive strategies and forms within museum and gallery practice. Chapters deal with subjects ranging from efforts to deepen the experience of the sensory and sensuous qualities of object forms, with an emphasis on Chinese ceramics (Ting), through the possibilities presented by sound, light, photographs and the manipulation of sensory experience in the history museum (Watson), the roles of the senses and emotion in working with disadvantaged groups (Golding), artistic intervention – in museum stores as well as public gallery spaces – as interpretation (Dorsett), and questions of absence, authenticity and action in trying to exhibit past performance art or its traces (Scarborough).

Ting's chapter starts from the premise that museum interpretation of objects such as Chinese ceramics tends to reduce the complexity of the artefacts' materiality and aesthetic qualities to a visual narration of object typology. Ting argues that such a conventional, reductive approach risks numbing visitors' bodily senses – at least, those of non-specialist visitors – and confines object-person interactions to narrow disciplinary frameworks (such as art history or archaeology). Drawing on a community-led project the author conducted in Bristol, the chapter explores ways in which museums might better foster a sensorily-based, object-human communication. In it, Ting describes how the project's participants explored the formal qualities of Chinese ceramics in relation to emotions, music and personal experiences, producing their own creative, sensuous, reflective and personal interpretations of the objects. She argues that museum experience should not be limited to detached viewing, but be open to feeling, listening and imagining, in the process encouraging and enabling visitors to become co-creators of an artwork as they explore its multiple potential interpretations.

Sensory experience and its possibilities in a museum space continue as a primary theme in Watson's chapter. Outlining the premise that the past of historians tends to be located in text and the photographic image and, as a result, often lacks sound and movement, Watson goes on to explore ways in which museums might use sound, light, space and photographs to interpret and communicate aspects of past individual lives and their contributions to history, and to stimulate visitors' emotions, imagination and memories. She focuses specifically on how Churchill's character, life and role in the national story, and indeed nationalism itself, are evoked in certain areas of the Churchill Museum in London. Locating her detailed analysis of the exhibition within a critical understanding of the possibilities and limitations

inherent in the public representation of history – particularly relatively recent, politically and emotionally powerful history – Watson considers the extent to which emotional engagement in the Churchill Museum experience stimulates, supports or contradicts a national narrative and collective memories. In the process, she examines whether the use of sound, light and photographs may offer a more complex sense of the past and, as a result, relocate the museum away from its modernist roots.

The multiple potentials of sensory and emotional aspects of museum objects and displays and their uses, is also central to Golding's chapter, in which the author explores the multi-sensory experiences and embodied knowledge(s) that can be gained through using material culture in educational work with disadvantaged children in an anthropology museum. The chapter focuses on embodied engagement with objects originating from traditional and contemporary sub-Saharan African communities, regarded as 'art' within the museum where they are displayed. Part of the Horniman Museum's internationally curated *African Worlds* exhibition, these objects, and the linking of them to creative and sensitive story-telling and other techniques, as Golding shows facilitated a range of emotional and cognitive explorations by school groups. In particular, the chapter examines young children's creativity flowing from innovative affective experiences related to touch, sound, balance and dance, time and space, healing and wellbeing, which were made possible in workshop sessions. In the process, Golding explores how sensory engagement with objects on display, and access to 'Other' ways of being and knowing, is facilitated through direct physical engagement with artefacts in the museum's handling collection.

In the next chapter, Dorsett shifts us from curatorial and educational perspectives on the interpretive and communicative potentials of museum materialities, into an examination of the possibilities of artistic interventions in and with museum spaces and collections. However, rather than remaining within the familiar rhetoric of artists challenging the interpretive conventions of audiences, Dorsett instead turns to the 'making' of museum meanings beyond exhibition viewing. The chapter describes his own behind-the-scenes projects involving storage and conservation at Cheltenham City Art Gallery and Museum (*Resurrection Shuffle*, 1999), a way of working he has also pursued through biodiversity fieldwork at the Institute for Amazonian Research, Manaus (*Between Interpretative Communities*, 2003), and research into economic botany at the Royal Botanic Gardens, Kew (*Trees Walking*, 2005). Drawing on semiotic theory and on work on interpretation by Fish and Hooper-Greenhill, Dorsett explores artists' ways of overlapping contradictory and inconsistent views about artworks – of responding creatively not only to our encounters with museum materiality but also with the communities that shape its meaning (a theme picked up again strongly in Howard Morphy's Afterword at the end of this volume).

The last chapter in the book, by Scarborough, examines interpretive strategies applied to the museum materiality – or, often, the *absent* museum materiality – of past action, specifically that of contemporary performance artists. Scarborough explores exhibitions of their work, which rely on the display of objects to tell stories, in material terms, about an art form that is actually about process, performative authenticity, and live audience interaction in the moment of action. While acknowledging the artist's body as the primary object of focus, the exhibitions Scarborough discusses typically include documentary and supplementary objects produced in relation to performances – preparatory sketches, documentary photographs, videos and artefacts. Such objects link stories about the corporeal 'liveness' of past actions to stories about creative activities which took place before, during and after performances. When so exhibited, these objects are transformed into culturally valuable souvenirs, relics

and traces, which challenge viewers to reconstruct stories of past performance and raise important questions about the place – and scope for manipulation – of authenticity in the relationships between objects and people and in the socially-constructed, relational nature of viewer interpretations. This far at least, the objects and themes of the exhibitions on which Scarborough focuses are no different from those discussed elsewhere in the book – indeed, the questions raised by her chapter about past action and present material traces, and about differences between past and present audience interaction, social context and the meanings accordingly attributed to material forms and what they are used to represent, in a variety of ways are recurrent throughout this volume.

DANCING POT AND PREGNANT JAR?

On ceramics, metaphors and creative labels

Wing Yan Vivian Ting

Silent object

In the quiet and dim space of the Schiller Gallery at the Bristol City Museum (BCM), a white *Ding* bowl, a porcelain ware named after its production kiln in Dingzhou (Hebai province), is supposed to demonstrate, through its thin biscuit, subtle whiteness and simplistic design, the exquisite craftsmanship of the tenth to twelfth centuries. However, like most of the BCM's Chinese collection, it is presented in an old-fashion display case without a text label. How does this object speak to visitors?

A visitor taking into account the plain design of the *Ding* bowl and its modest setting, sees it as an object of daily life from which common people ate in the past, rather than as a refined ceramic praised highly by generations of connoisseurs (Ting 2008). It seems that the distinctive artistic expression embodied by this Chinese bowl helps little in magnifying its simplistic beauty. Also, the lack of information makes the object mute, unable to communicate the museum's intended meanings to the visitor. Looking at this Chinese ceramic, in other words, for most people denotes a less than robust and reflective object–human relationship.

Yet potentially the object speaks a tactile language that invites visitors to experience different facets of its form, if those visitors are willing to look at its formal qualities *per se*. Unfortunately, however, museum interpretations tend to focus on disciplinary research and to offer detached and technically-loaded information that is of little use in helping visitors to connect with the collection through a tactile language. My question is: how could museum interpretation change visitors' perceptions and empower them to listen to the sensual, tactile language of Chinese ceramics?

In this chapter, I devise an interpretive principle, metaphorical association (from Christopher Tilley's notion of 'object as metaphor', 1999), that relates the formal qualities of objects to visitors' personal experiences and imagination in order to foster a dynamic, object–human communication in the exhibition space. Then I discuss 'Creative Space', a community interpretive project at the BCM, demonstrating how the principle can be applied to museum labelling that illuminates the intrinsic qualities of objects and recognizes various aspects of human experience within a visitor's personal context. I shall argue that an object embodies the sensations, feelings and personal experiences of those who created, used or valued it. It can be considered as an active means of communicating diverse experiences from the past and continuously exchanging new

messages with contemporary society, including museum curators and visitors. By turning to aesthetic imaginations, the interpretive principle proposed here aims at encouraging visitors to explore the essence of materials and develop an intimate and diverse understanding of the world.

Object as metaphor

I conducted interviews at the Schiller Gallery in November 2006 to investigate visitors' interpretive approach to the formal qualities of objects (Ting 2008). Out of 158 visitors 93 instinctively made an aesthetic judgement about the formal qualities of an object and/or its craftsmanship – an interpretive approach which neutralized the spatio-temporal differences between an object's origin and the present, and assimilated it into a context of personal taste. The approach offered a temporary sense of enjoyment that convinces visitors it is worthwhile looking at a museum object that actually may mean very little to them. Meanwhile, the technically-loaded museum text fails to help the visitors develop a multi-layered, aesthetic viewing of objects. Instead, in most cases the text is likely to offer facts describing the historical development of the arts, production information, and, occasionally, the cultural significance of the object. Seldom, however, does it suggest any sensual clues which would show visitors how to interact with the objects – how to bring together the intrinsic qualities of objects and the sensuous imagination.

In unifying materiality and creative association, Christopher Tilley's notion (1999: 6–8) of 'object as metaphor' is useful in encouraging an absorbing aesthetic experience. Informed by cognitive science, he suggests that we are living within a complicated network of objects, events and texts, and our interpretation of the world is obtained through translating an unknown into something familiar and tracing this relationship to others. Tilley argues:

> Cognition is essentially a process of seeing something as something and this is the core of metaphorical understanding. Seeing something as something is grounded in culturally mediated bodily experiences.
>
> (Tilley 1999: 34–5)

At first glance, Tilley seems to be suggesting that our interpretation of the world is constituted by a process of mapping, in which objects are read in a way analogous to text. This would be rooted in Levi-Strauss's structuralism, which argues that language and material culture can be structured in revealing underlying patterns of cultures. To a certain extent, Tilley does not deny that objects carry symbolic meanings in communicating abstract concepts to the human world. However, importantly he positions '*bodily* experiences' (my emphasis) at the core of the object-human relationship, implying metaphorical understanding is not merely a mental construction but an ambiguous and multidimensional interpretation that synthesizes objects, action and events (ibid.: 8, 34). This suggests the object signifies cultural values structured on a macro-cultural level only through its first-hand interaction with people. Metaphor is therefore a blurring boundary, cross-referencing with the materiality of the object and the bodily experiences of people in understanding our world.

Unlike language systems, in which meanings are assigned by grammatical rules and arbitrary definitions of words, the object–human relationship is far less stable and structured so that meanings are generated by visual representations, emotional projection, and/or tactile association within a network of objects, people and situations. Ignoring the fact that it is a cultural practice or abstract concept which an object signifies, Tilley suggests that metaphorical mapping is not merely an imitation of reality nor a reflection of pure thoughts, but a sensuous experience, which

embraces philosophical insight, emotional impulse and carnal desire. In this sense, the object is a communicative agent in conveying tactile experiences, such as the emotional response of a life event, the aesthetic pleasure of form and shape and bodily memory of production process within its socio-cultural context.

Extending Tilley's notion to an appreciation of Chinese ceramics, I argue that metaphor is a critical interpretive strategy that equips visitors with the means to associate familiar concepts or experiences with the translating of the 'lifelessness' of the collection into a dynamic and stimulating object-human manifold. That is bringing together two ideas in a meaningful union to relate material culture from different spatial and/or temporal contexts to the contemporary cultural life familiar in visitors' personal histories (Golding 2005: 53). The Creative Space community labelling programme demonstrates how creative metaphors can be applied in museum practice.

Creative Space at BCM

The Creative Space project was an outreach programme I ran in 2006–7, working with non-regular visitors in order to improve interpretation of Chinese ceramics in the Schiller gallery.[1] With the help of Miss Reethah Desai, the BCM's outreach officer, I recruited students from two adult colleges: four local students learning literacy and ten ESOL (English for speakers of other languages) students who were new immigrants from Africa and Eastern Europe. These participants may not have had any insight into the Chinese collection, yet their involvement was important in helping the museum consider how to accommodate visitors' diverse needs and interests and enable them to connect with the objects.

To develop participants' confidence, creativity and skills in working with the collection, the project was divided into three basic units, including an introduction to Chinese ceramic art, trips to the Schiller gallery, and label writing. The students were encouraged to examine the formal qualities of Chinese ceramics and to associate materiality with emotions, music and personal experiences. Each participant selected a favourite ceramic piece in the Schiller Gallery and researched it both factually and creatively through various art media such as music, literature and drawing. Inspired by music clips and creative metaphors, the participants wrote interpretive labels introducing their favourite pieces to a wide range of audiences. Unlike conventional museum text, their creative labels attempted to show that looking at ceramics could be personal, sensuous, and imaginative, and could inspire others to turn to their own personal histories and bodily experiences in developing an intimate dialogue with objects.

A 'biscuit for bisque'

My visitors' studies at the BCM had indicated that while museum interpretations tend to focus on the technical qualities of ceramics, this is the area in which visitors are least interested. However, in order better to cultivate interest and confidence in connecting with Chinese ceramics, it was critical that the Creative Space participants were not intimidated by technical terms and the complicated process of pottery making.

A 'biscuit for *bisque*' activity was developed, informed by the notion of metaphorical association and based on the view that mapping pottery making onto participants' personal experiences would enable connection with not only the techniques and skills as such, but, through sensory perception, the ceramic materials themselves. The activity was designed to associate dry, technical facts with the sensuous pleasure of having tea and biscuits. Participants

already knew that a biscuit is a crisp dry baked snack, but not that in ceramic art it means a piece of unglazed pottery, also referred to as *bisque*. Technically, both forms of biscuit can be considered as raw material that has undergone the process of firing, which results in different textures according to the ingredients and the temperature of the fire. Biscuits were, then, served in the workshop to encourage a sensory understanding of the basic materials of pottery making. First, participants were encouraged to match a piece of biscuit from an assorted pack to one of the handling collection objects, and to share their thoughts with the whole group. Most participants matched their two forms of biscuit on the basis of similar colour and decoration. For instance, Terrina, a participant from the literacy group, associated a Jammie Dodger biscuit with a white plate decorated with pink roses because 'the red of the jam is like the flower centres' (Ting 2008). In contrast with each of their choices, I also made a match that suggested an alternative connection according to the *texture* of the biscuits, and introduced the differences in texture between porcelain, stoneware and earthenware. To experience the varying textures of *bisque*, the participants were invited to bite into the biscuits and compare them with the unfired parts of different ceramic objects (Figure 13.1). The idea of glazing was then introduced by dunking different biscuits – including chocolate digestives, oat biscuits and custard creams – in tea or coffee, to investigate how the liquid penetrated the biscuits.

By connecting these two forms of biscuit, the activity attempted to give some tactile clues about how an object or medium would have felt during the production process, and thus to illustrate why the finished work would be made in a particular manner. It was through bodily experiences that the metaphors offered the participants sensuous points of entry to the appreciation of techniques and skills involved in the making of ceramics. The permeable nature of metaphor thereby added a personal touch to technical process, encouraging visitors to share the craftsmen's point of view and associate the technical process with real life experience rather than textbook information. The Creative Space participants were very fond of this activity, not only because of the tea and biscuits, but also because of the sensuous and fun approach to looking at ceramics. Many said explicitly that they had learnt how to identify differences between porcelains and stoneware and therefore felt more confident about exploring ceramic art. Metaphorical interpretation of technicality can, then, serve as a means of conveying the experiences shared by craftsmen and the ceramic medium during the making process, and consequently offer participants' tactile clues for looking at the texture of clays and glazing materials, an important dimension of ceramics.

Looking with the mind's eyes

Having introduced the basic elements of ceramic art, Creative Space further explored the capacity of metaphors in associating the perceptual qualities of ceramics with aesthetic imaginations, through various sensory activities. These activities were designed to develop participants' tactile sense and creative imagination in relating to some seemingly uninteresting qualities of objects. By enabling participants to adopt an artist's or connoisseur's perspective, they demonstrated how various elements of a ceramic work can instigate insightful reflection about our world and empower visitors to seek beauty from the most common things. This differs from a conventional art-historical interpretation, which relates the provenance of the object to a particular genre, technique or style and aims to construct a typology through identification and production information (Pearce 1992: 100–101). My interpretive approach, in contrast, advocates an aesthetic experience by making sensuous pleasure, conveyed by a ceramic work, its priority. By integrating imaginative metaphors into ceramic appreciation,

Figure 13.1 Project participant breaks a biscuit in half to compare its texture with a ceramic work. (photograph by Wing Yan Vivian Ting)

the sensory activities return to the object itself, in order to recover visitors' tactile sense of novelty.

A blindfolding activity, for example, was designed to encourage the participants to explore fully a ceramic piece, through tactile language instead of the visual sense. While playing soft and relaxing music in the background, I posed various questions to guide them through this process. First, I suggested that the blindfolded visitors should feel the physical qualities of the piece – such as form and shape, texture, temperature and decoration – and translate tactile sensation into visual images of how this object might look. This set of questions highlighted aspects of materiality that would be neglected by sight alone. The next set asked visitors to imagine the character of the piece as if it were a human being, encouraging visitors to violate their accustomed mode of connecting with ceramics and embrace their own creative interpretation of this object-human communication. Afterwards, they were asked to remove the blindfolds and compare the differences between their tactile experiences and visual responses. Ange, a

literacy student, holding a black bowl with floral motifs engraved inside stated, '[It feels] like a baby you could cradle in your arms. [It is] soft and smooth outside so it could be a girl. The gritty inside is like when the baby is crying' (16 November 2006, Ting 2008). She was amused when she discovered that the object was an ordinary black bowl that one could easily get from a department store, not a delicate, light-coloured work as she had imagined. It was interesting that some participants, as this example shows, extended the tactile data of their 'mind's eye' to include imagined visual qualities such as colour and painted decoration. However, an enticing sense of mystery was created by the fact that tactile perceptions are partial, and difficult to translate accurately into visual images. This enticement motivated participants to be more perceptive of tactile data and more imaginative in reducing the gap between the visual and the tactile as they sought to produce a relatively complete, imagined idea of the work. Most people found this blindfold activity helped their understanding of ceramic construction, enabling them to discover that a vase might not be as symmetrical as it seems, or that the curve of a vase's mouth rim feels satisfying to touch.

Equipped with the interpretive technique of metaphorical association enabling them to look at ceramic creatively, participants then chose a favourite ceramic piece in the Schiller gallery in order to develop further an aesthetic dialogue with objects. Given examples such as how traditional Chinese connoisseurs refer to a pearly white glaze as 'moon white' (Zhao 1973: 98), or name a form of vase as 'phoenix tail shaped' (*feng wei ping*, Xu 1994: 245), visitors were encouraged to use their own language to describe their feelings about formal qualities. By applying imaginative metaphors that associated formal qualities with sensory enjoyment, my intention was to inspire participants to look at those seemingly unappealing qualities of ceramics with fresh eyes. For instance, Ghania, one of the ESOL participants, compared a geometric decoration in blue and white to 'an abstract painting of blue jeans and white paper' (Figure 13.2) while Nursen, another ESOL student, compared a big wine jar to 'a pregnant woman with a softly swelling belly tapering to the foot rim' (Figure 13.3) (Ting 2008). Though the majority of the participants were willing to stretch their imaginations to describe the object creatively, many of their descriptions turned to personal experiences, such as relating a vase to something they had seen before; for example, a decoration of lake scenery was compared to a holiday destination where one participant had stayed. It was clear that more encouragement was needed if participants were to develop more in-depth dialogues with the objects.

Some participants were less expressive and imaginative than others, in associating with a ceramic piece personally. Their reluctance may have been due to their personalities or interests, but low self-esteem was significant too, with participants framing themselves as unintelligent and empty in terms of language capacity and creativity. The emotional pottery activity was therefore introduced to assure participants that it is meaningful to associate personal experiences with aesthetic appreciation, given that personal experience is grounded by materiality. The participants, working in pairs, were assigned to consider one particular emotion and to find one piece of ceramic work that could express that feeling through tactile language. Eight emotional responses – happy, excited, inspiring, relaxed, sad, lonely, stressed and angry – were used to elicit a deeper level of metaphorical association by considering how an object itself might feel about its formal qualities. For instance, they thought a Jun ware fixed with a golden patch was angry because its chipped rim was patched with gold, and a red stroke indicated an angry glare regarding its own status. It was through asking how *the object* feels that visitors listened to what the object was saying to them, and they gradually infused their personal feelings into their observations. In short, through humanized metaphors a ceramic ceases to be a lifeless being

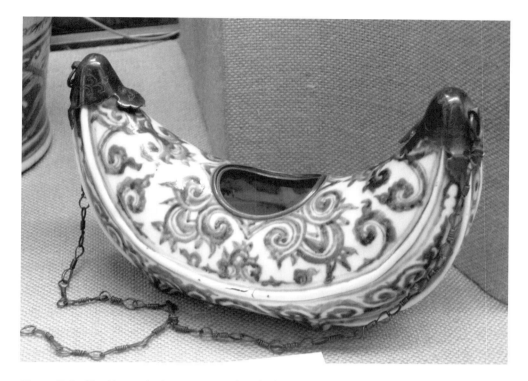

Figure 13.2 The blue and white pattern is described as 'an abstract painting of blue jeans and white paper'; blue and white drinking bottle, Ming dynasty, about 1550, 21cm wide (photograph by Wing Yan Vivian Ting, by kind permission of the Bristol City Museum and Art Gallery)

and becomes an active enterprise, sharing with participants sensual and emotional experiences embodied by its formal qualities.

These sensory activities suggest that the power of metaphors here lies in bringing the 'boring' and 'detached' ceramics to visitors' daily life and personal context, pointing to potentially limitless possibilities for how one can relate to an object imaginatively. Focusing on the object *per se*, metaphorical association encourages visitors to look at the collection from technical and aesthetic perspectives, synthesizing personal feelings, creativity and craftsmanship.

The object sings

Informed by the notion of metaphors, then, the activities discussed thus far were designed to arouse participants' interest and to get them 'to look at ceramics for more than seconds'. Nonetheless, as they were ultimately expected to produce creative labels for the Schiller collection, more means of inspiration were necessary to unleash their imagination and sustain their interest in transforming aesthetic experience into words. Therefore, I proposed to map music listening together with ceramic appreciation, encouraging the experience of ceramics at another layer of sensations. Though there is no obvious link between music and an appreciation of Chinese ceramics, I argued the very nature of music that is direct and engaging would be a crucial means of conveying the aesthetic of ceramic art.

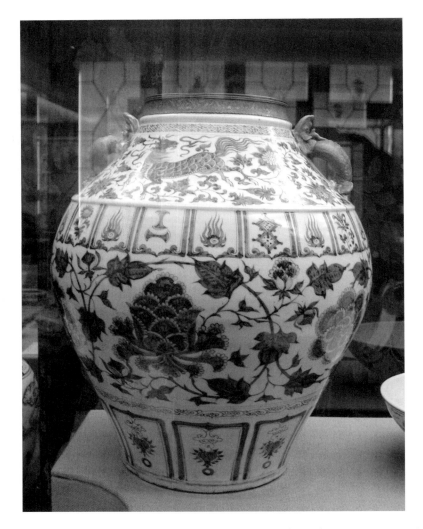

Figure 13.3 A project participant associated this wine jar with the form of a pregnant woman; blue and white wine jar, Yuan dynasty, about 1350, 56cm high (photograph by Wing Yan Vivian Ting, by kind permission of the Bristol City Museum and Art Gallery).

Music is considered to be the most abstract form of art, connecting one tone after another in different paces into a pleasant melody capturing the essence of diverse human experiences (Stravinsky 1947: 24; Kaminsky 1962: 125; Storr 1992: 172; Frith 1996: 109). Within the context of Chinese and Western classical music, a piece of musical work could be composed to depict a natural scene, narrate a historic event or convey emotional expression related to daily life experiences, and yet its intrinsic qualities, such as compositional structure or instrumental timbre, would bear very little resemblance to the sounds produced from the related phenomena (Scruton 1999: 125–129). Thus, it can be considered as an intangible form of metaphor connecting a series of tones with sensations, emotions or intellectual thoughts related to a specific dimension of human experiences as articulated by the artist.

Also, cognitive scientists suggest that in making sense of a piece of musical work, we have to memorize each of the separate tones and link them together into a continuous melody (Zuckerkandl 1956: 15). The audio experience is analogous to riding on a horse at free rein, so that the music would feed into our perceptions at its own pace and endow the listener with intrinsic meaning. This implies that the temporal character of the music experience engages us into a special, secluded realm in which external stimuli are blocked and we are allowed to explore the aesthetic imaginations articulated by the musicians (Sloboda 2000: 227; Scruton 1999: 221).

In view of the transcendental and engaging qualities of music, I hold that integrating music into ceramic display would invite visitors to explore the inner value of ceramic wares through different forms of aesthetic imagination. Such a multi-sensory experience would act as a perceptual synthesis, another form of metaphor, mapping visitors' sensory experiences with ceramic appreciation and enabling them to explore the infinite possibilities of playing harmonically with functions and materials.

During one of the Creative Space project trips to BCM, the idea of uniting music with ceramic appreciation was further explored. First, while a soft and easy-listening piece of music was played, participants were urged to write down ideas, feelings or images in relation to the rhythm and melody of the music, and to describe the character of the music as if it were a person. Next, this metaphorical mapping urged them to materialize the music clip by considering it with visual qualities such as colours, lines and patterns in mind, and then to extend their imaginations to tactile data, namely texture and form. The visitors were familiar with metaphorical association and felt sufficiently confident to make creative links between music, personality and some of the visual qualities, such as colour and decoration. In terms of tactile data, they associated ceramic form with personality and music, but were less likely to consider form and shape in an abstract sense. Some mentioned texture and identified it with different clay materials, but their creative ideas were less likely to be inspired by these qualities.

Integrating music and metaphors into ceramic appreciation, I provided participants with music according to their personal preferences and mental perceptions of the object. A template of how to look at ceramics was used, to help gather their creative ideas. Highlighting four formal qualities, namely texture, colour, form/shape and decoration, the template was a basic guideline for integrating metaphorical association and personal feelings and experiences into materiality. This was an unprecedented approach as there is relatively little literature showing how music evokes the aesthetic imagination (Storr 1992; Scruton 1999; Sloboda 2000), and no extant, objective criteria for how music pieces could represent the formal qualities of ceramics. Although some participants were more explicit than others, all were positive that listening to music was inspiring and expanded their personal feelings about ceramic work into creative ideas embracing poetic images, vivid metaphors and storytelling. From the former exercise, most participants did not respond to the guided questions regarding how an object would feel if it were alive. However, all who attended this session were able to ascribe personality to the ceramic works, and the majority even explored inner feelings of the objects as evoked by the music clips.

For instance, a celadon bowl with peony decoration was selected by Lyna, one of the ESOL participants, whose initial reasons included her favourite colour being celadon, the size of the bowl being big enough for her appetite, and the fact that she liked the carved floral pattern (Figure 13.4). She researched the object, considering the symbolism of the peony, and imagined the two flower buds as a young couple well protected by the leaves. As she related the bowl to happiness, gracefulness and romance, I selected two pieces of music: the third movement of Bach's Harpsichord Concerto in D major (BWV 1054), and 'Transformation

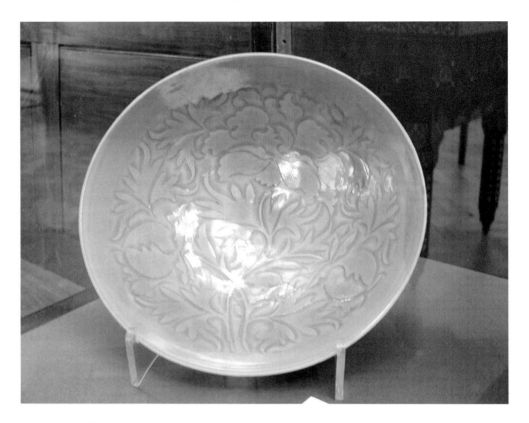

Figure 13.4 Celadon bowl with peony spray, Song dynasty (960–1207), 22 cm deep (photograph by Wing Yan Vivian Ting, by kind permission of the Bristol City Museum and Art Gallery)

in Butterflies' from the Butterfly Lovers' Violin Concerto, a modern Chinese piece, in the hope of inspiring her to play with her imagination. These music clips were kept anonymous so that creativity would not be influenced by the titles. Lyna considered both pieces of music 'light' and 'elegant', representing the celadon bowl in different ways. Eventually, she chose the Chinese piece because the more she looked at the bowl with that music, the more it appealed to her and the peony spray decoration seemed to her to be in the process of blooming. Working later on her creative label, she toyed with the idea of blooming, and associated this lively movement with the process of creation transforming 'a mute, thick lump of clay into an exquisite, living body … akin to a graceful woman', an enigma for her creator (quoted from Lyna's creative label). She portrayed the process of creation as follows: 'the hands of a master are cutting softly and carefully a peony pattern on a clay bowl' because 'he is full of love for his work'. Taking the artist's perspective, she described this 'ordinary' bowl as a 'beautiful stranger firing his imagination' – his muse. She explained her idea was partly inspired by the music, conveying a sense of transformation from nothingness to life. Interestingly, her feeling also corresponded to the section of the original score that portrays the butterfly lovers elevated from death to eternal life. On the other hand, the curves of the floral motif enabled her to feel how the artist had infused each cut with excitement in rendering its slim and supple decoration. It was clear that the music led her to another level of creative writing, bringing

her former idea of peony and love to a sensuous, even erotic imagination of how the artist's hands gave life to the celadon bowl.

Not every participant achieved as much involvement as did Lyna in tuning into a sensuous object–human communication. In fact, the idea of uniting music and metaphorical association into ceramic appreciation has not yet been sufficiently developed to reach any conclusion at this stage. I am convinced that combining these forms of art could enhance aesthetic imagination by suggesting various means of grasping the essence of materiality embodied by each form of art. However, it is difficult to identify by what means the facilitator might further encourage visitors to explore the possibilities of such aesthetic encounters. This community project justified itself in providing enjoyable activities for non-regular visitors, yet more research must be done to consider how to maximize the engaging capacity of music in the nexus of tactile looking.

Writing creative labels

One of the important outcomes of this community-led project was putting the interpretive labels written by participants into the exhibition, starting to transform the Schiller gallery into a 'creative space' for object–human communication. In the labels they produced, almost half of the participants expressed a strong link between their favourite objects and personal experiences in relation to their memories, cultural background and life experiences. The rest were inclined to be more aesthetic in exploring creative metaphors and personal feelings that were not necessarily related to their life experiences or cultural background. Either way, the labels they produced made clear that the visitors may have had limited prior knowledge or interest in the objects but were able to develop a fulfilling object-human relationship through metaphors, sensuously or creatively. This demonstrated that the interpretive principle of metaphorical association was effective in serving as: a perceptual synthesis that brings together various dimensions of experiences – including sensations, emotions and personal history; a means of inspiration to give a free rein to aesthetic imaginations; and/or a poetic embellishment to share thoughts with a wider audience.

From the museum's point of view, the real accomplishment of the project lies in the creative labels produced. These labels have provided unique connections between Chinese ceramic wares and the participants' own personal experiences – connections that broaden our scope of understanding Chinese decorative art. The label written by Emilia is one of the examples that justifies my conviction that every individual meaning is valid in its own right. Emilia found a black tea bowl with a skeleton leaf design more than a functional thing for a tea ceremony; the bowl became an aesthetic means to co-create different meanings with its viewer. Taking an object's perspective, her label reads:

> I am a black-glazed tea bowl. In the past, I felt terribly lonely when nobody drank tea from me for ages. But since I have been here everything has changed. I have found my place. I am here for you.
>
> Many people look at me and see different things depending on their personality and mood. My yellow decoration reminds them of fire, a gigantic explosion. Then it's only disease, death, nothing – Apocalypse. But…the yellow imprint is in a leaf shape. So, there is still hope for new life. What about you? What do you feel when you look at me?

In the museum context, this black tea bowl is usually a sample showing one of the technical variations of a genre developed in twelfth century China, or is used as material evidence

demonstrating the practice of whipped tea at the time. Instead of locating the object in its own historical context, Emilia suggests people examine the mundane world in a new light, while enabling the object to explain the reasons for its survival over time, and its entering into another form of social life in a museum context. She offers vivid images concerning the formal qualities of the bowl: new life begins after some kind of mysterious explosion that causes disease, death or emptiness. Though other visitors may not agree with her interpretation, it is likely that they may start looking at the bowl and pondering what its formal qualities, such as a shiny imprint contrasting with a black speckled glaze, mean creatively. This label suggests that there are myriad ways of approaching ceramics, if viewers could unleash their imaginations to look at the object *per se*. Throughout the workshops, one of the most frequently asked questions from the participants was why the BCM invited them, rather than experts of the field, to write the labels for the Schiller gallery. Emilia's interpretation shows that the answer is in the robust aesthetic inspirations that I sought from them in the hope of fostering more intimate and provoking dialogues between museum visitors and the ceramics.

Once the labels were installed in the display case, I noticed that visitors who casually wandered around the Schiller gallery were more likely to read the creative texts. Presumably, visual elements of the new labels, including clear layout, large font size and colourful photo portraits, appealed to these visitors instantly. I interviewed on various occasions sixteen visitors who had read the labels, and learned that most visitors had found the labels interesting and easy to read. A few visitors even made up their own stories as inspired by the texts. Some creative labels thus engaged others in a free play of imagination to look at the objects afresh.

Personal meanings vs. public interest

It should be evident that the notion of metaphors can inspire cultural understanding, sensuous pleasure and/or aesthetic imagination; yet free-flowing association without rein could also confirm established perceptions and deepen misunderstandings – there is a fine line between freely sharing personal thoughts and ideas, and presenting information that could be considered mistaken and irrelevant. By encouraging community groups to share their personal thoughts and aesthetic imaginations with other visitors, the museum tries to enhance visitors' dialogues with objects to be more personal, relevant and vigorous. A problem arises when the museum considers personal interpretation to be trivial or even inappropriate. The institution then feels obliged to take over interpretive authority so the presentation retains its integrity. Yet in safeguarding the public's interest, the museum's denial of certain personal narratives risks betraying the trust of the involved group. Maintaining a strong partnership with communities thus necessitates delicate communication and negotiation. For instance, working with Maria, a participant from the literacy group, was a good learning experience in considering how the museum can work with communities.

Maria's example indicates the complicated question of to what extent creative association is valid for the public as well as for the writer. A black tea bowl decorated with a swirl pattern was not Maria's favourite object, but she said she wanted to work on challenging her own aesthetic perception (Figure 13.5). In her notes, she jotted downs words like 'gritty', 'mouldy', 'squiggly patterns' and 'earthy' and imagined 'two different personalities' embodied by the exterior and interior of the bowl. Maria saw the object as a Native American artefact and created a story about how a tribal witch had used this bowl for making medicine and saved a child from a mysterious disease. To her, 'this bowl symbolizes a way of walking with the earth as opposed to walking upon it … it is the way that being a Native American is mainly from within'. I was reluctant to make

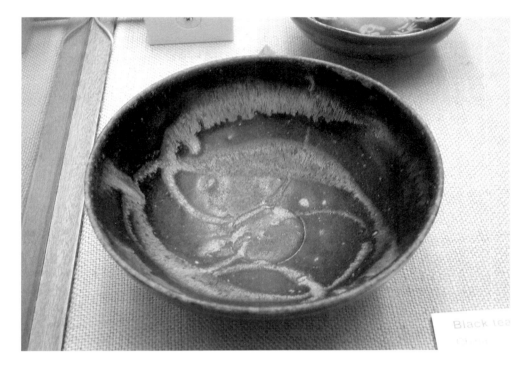

Figure 13.5 Black tea ware with swirl decoration, Southern Song dynasty (1127–1279), 15cm deep (photograph by Wing Yan Vivian Ting, by kind permission of the Bristol City Museum and Art Gallery)

such a liberal connection between Chinese tea ware and a Native American notion. Indeed, Maria had done research into how the bowl would have been used in twelfth century China and knew that it was related to making whipped tea along with the intellectual enjoyment of tea drinking. However, I failed to convince her not to go with her creative writing, as she thought it was what the museum was asking for. After many negotiations, and as other participants in the group discussed Maria's writing, I persuaded her to stress that it is a Chinese object and add an extra section explaining why she saw links between the two cultures. I was uncertain about this decision, though it seemed appropriate in the context of helping other visitors associate with the object and in showing the community that the museum truly appreciates their involvement.

Applying the notion of metaphorical association to ceramic appreciation, the 'Creative Space' project sought to democratize authoritative interpretation and to make collections more relevant to different sectors of society. Partnering with visitors, the museum learned about personal stories or creative associations to enrich its own interpretations of its collections. However, I realize that this interpretive approach may risk ignoring the formal qualities of objects and denying the sensuous pleasures they can elicit. The challenge for museums is to find ways to explore multiple layered meanings through interaction between the museum team, the collections and various community groups.

Conclusion: working with communities

I found the project a very satisfying experience in enabling me to work with communities and the collections. The process also inspired me to see Chinese ceramics from diverse perspectives beyond the academic framework of art history. I am convinced that the museum experience should be open to feeling, listening and imagining, in honour of visitors as co-creators of an artwork exploring its multiple interpretations. In this sense, the notion of metaphors is meant to be an empowerment, which enables an object to unfold its sensuous beauty whilst encouraging visitors to make sense of its formal qualities based on personal contexts. To illuminate the dynamism and beauty of sensory experiences, this BCM project explored three different dimensions of metaphors in the form of perceptual synthesis, aesthetics imaginations and literal expressions, that explore objects not as 'Chinese ceramics' but as object–human manifolds that connect materiality, cultural values of the object and the personal interpretations of visitors to unfold diverse meanings. Although I am aware that metaphorical association may cause confusion and misunderstandings, I argue that these personal interpretations are as relevant and truthful as the museum's official histories because they allow and encourage direct, meaningful connections to the objects. When misunderstandings arise, museums should suggest visitors to go back to the object and 'listen' carefully to what story it would like to tell.

Acknowledgements

I would like to express my gratitude to Kate Newnham, curator of Eastern Art at the Bristol City Museum, who has supported the 'Creative Space' project. My gratitude is extended to Reethah Desai, outreach officer at the museum, who co-developed this project and offered invaluable inspirations to the interpretive experiments I conducted at the museums. I am grateful to Graham Carter, and Anne Neugebauer, tutors from the adult colleges, who helped organize the experiments in numerous ways. My thanks also go to the ESOL and literacy students, whose participation in the workshops and honest opinions on the project are most appreciated.

Note

1 The Creative Space project was part of my PhD research, designed to be an interpretive trial investigating practical implications of the proposed interpretive principles. The doctoral research considered how object–human communication mechanisms (including museum interpretation and visitors' responses) operate in the exhibition context, and proposed a sensory model to engage visitors in a reflective exploration of what museum collections could mean to them.

References

Frith, S. (1996) 'Music and identity', in S. Hall and P. du Gay (eds) *Questions of Cultural Identity,* London: Sage Publications, pp. 108–27.

Golding, V. (2005) 'The museum clearing: a metaphor for new museum practice', in D. Atkinson and P. Dash (eds) *Social and Critical Practice in Art Education,* Stoke-on-Trent: Trentham Books, pp. 51–66.

Kaminsky, J. (1962) *Hegel on Art: an interpretation of Hegel's aesthetics,* Albany, NY: State University of New York.

Pearce, S. (1992) *Museums, Objects and Collections,* London: Leicester University Press.

Scruton, R. (1999) *The Aesthetics of Music,* Oxford: Oxford University Press.

Sloboda, J. A. (2000) 'Musical performance and emotion: issues and developments', in S. W. Yi (ed.) *Music, Mind and Science,* Seoul: Western Music Research Institute, pp. 220–238.

Storr, A. (1992) *Music and the Mind,* London: HarpersCollins Publishers.

Stravinsky, I. (1947) *Poetics of Music,* New York: Vintage Books.

Tilley, C. (1999) *Metaphor and Material Culture,* Oxford: Basil Blackwell.

Ting, W. Y. (2008) 'Communicating Chinese ceramics: a study of material culture theory in selected museums in Britain', unpublished PhD thesis, University of Leicester.

Xu Zhiheng (1994) *Yinliuzhai shuoci* [*Remarks on Porcelain from the Studio of a Wine Lover*], Chengdu: Bashu shushe.

Zhao Ruzhen. (1973) *Guwan zhinan* [*Guidebook for Collecting Antiques*], Taipei: Wenhai chubanshe.

Zuckerkandl, V. (1956) *Music and the External World, Sound and Symbol,* vol. 1, London: Routledge and Kegan Paul.

14

MYTH, MEMORY AND THE SENSES IN THE CHURCHILL MUSEUM

Sheila Watson

At the beginning of the twenty-first century a popular vote orchestrated by the BBC placed Winston Churchill as the greatest Briton of all time. Even today, it seems, he embodies key aspects of Britishness (Mowlam 2002: 126). In 2005, a Churchill Museum opened in London. The story it tells begins in May 1940 when Churchill became prime minister, examines his war leadership, and later considers other aspects of his life. By using objects, sound, light, photography, film and interactives, the museum interprets Churchill through the use of the senses, in particular those of hearing, touch and sight. Its use of sound and images in the first section of the museum and their relationship to the discipline of history, and its role in national memory, are examined here.

Gregory and Witcomb, drawing on the work of Chakrabarty (2002), have argued that it is the use of the senses rather than the analytical processes of the visitor that need to be considered when seeking to understand the museum experience (Gregory and Witcomb 2007: 263). This chapter examines the production of memory through affect and emotion and considers the nature of 'historical consciousness' (Seixas 2006). Here historical consciousness is understood as 'the study of broad popular understandings of the past, bringing to the forefront...the problematic relationships between the distinctly modern, disciplinary practices of historiography and the memory practices of ... populations...' (Seixas 2006: 9–10). Thus the historian's construction (and deconstruction) of the Churchill story in 1940 is compared with the museum's treatment of the same theme and, in particular, the way in which the museum elicits responses from visitors through its displays, and how these experiences relate to the nature of history. The chapter examines how feeling, imagination and memory are evoked by sound, light, photography and the visitor's movement through space. The use of affect in the museum and the way in which embodied forms of knowledge support historical understanding are also explored, in relation to the production of British identity. What follows is a phenomenological analysis of the *sensation* of remembering, as evoked (Cubitt 2007: 7) within part of the Churchill museum space, contrasted with the discipline of history's act of remembering through the dispassionate critique of the written word.

History, memory and affect in museums

History in museums is often presented as both authoritative and dispassionate, relying on disengagement by the visitor who is expected to engage intellectually with the content of an exhibition. In this it follows the tradition of academic history (Carr 2008: 133).

However, thinking about history has, for some academics working in this field, moved away from the former ideal of disengaged contemplation and reflection of written texts towards an attempt to understand cultural practices and phenomena that contribute to 'making historical sense' (Rüsen 2006: x, Watson 2008). If we apply this idea to history in the museum, where there is a different method of exploring the past from that of the university scholar, one that has its own rules and conventions, we can begin to understand the nature of history within the museum context. It is produced by the museum and experienced by visitors to become something else – their own understanding of the past, a type of 'historical sense' independent of the professional historian's ideal. While this history is not unlike that experienced by readers of books or viewers of documentaries, the museum presents history in a variety of methods that promote self-selection and independent learning in very diverse ways linked to a wide range of senses. Stuart Hall describes culture as not so much a set of things such as a painting or an object but a set of processes and practices through which individuals and groups come to make sense of things and produce similar meanings (Hall 2003: 2). Museums are part of the practice of making history. Thus museums are places where 'making historical sense' is embedded in the structures of the display techniques and the responses of the visitors. At the same time, history exhibitions require visitors to not only to engage with conventions such as the label, but also to possess a shared knowledge of historical events and characters. However, visitors may not have a precise sense of historical narrative or plot but may possess a few images or ideas around which meanings can be organised (Cubitt 2007: 203).

Cultural productions such as historical understanding in the museum, appear, as Cubitt points out, to evoke rather than represent a sense of the past, because what is represented is a detail of an action or event or person that 'alludes to something larger, but not necessarily precisely defined, of which the detail is taken to be a part' (Cubitt 2007: 203–4). Museums have to rely on this type of evocation – they possess fragments of material culture, they select photographs, excerpts from oral history, and they rely on the visitor to make meanings from these based on their existing understanding of the past. Such meanings are dependent on personal and community memory and imagination, and often involve emotion and sensory experiences. Indeed, Chakrabarty (2002: 10) goes so far as to say that memory always has embodied elements. For some these emotions, evoked through historical representation, are processed through thought and are distant and reliant on perspective (Bennett 2003: 27–8, drawing on Claparède 1911 and Janet 1919–25, 1928 cited in Van der Kolk and Van der Hart 1995: 160). However, Bennett, writing about trauma and art argues that this response is not necessarily merely cognitive and that it can be felt through the body: 'This kind of affect is … a crucial part of the process by which the sign unfolds to the viewer as corporeal, sensing, emotional subject …' (Bennett 2003: 37). Bagnall (2003: 89) has demonstrated that visitors to sites embody the past through a whole range of physical sensations, during which visitors emotionally and imaginatively map their experiences. She draws on the work of Colin Campbell (1989) in the *Romantic Ethic and the Spirit of Modern Capitalism,* in which Campbell argues that a key characteristic of modern consumption is the way in which emotion acts as the link between mental images and physical stimuli. Campbell suggests that it is the power of imagination that enables individuals to achieve this emotional engagement and control. Campbell points out that

'symbolic resources of a culture can be employed to re-define the situations in which groups find themselves and thus bring about changes in mood,' and this brings about the substitution of one emotion with another (Campbell 2005: 71–2). In the same way, objects, speeches and images in museums can evoke emotions connected to events in the past, and the original emotions once generated may be substituted for others or imitated. These multimedia products act as releases of memory – and they achieve this through affect, their ability to move us (Witcomb 2007: 37).

Past emotions cannot be conjured up in the museum setting, only imagined, and thus re-experienced, in a different time and a different context. The difficulty of evoking emotion, particularly trauma, has been explored by those who write about events such as the Holocaust, the bombing of Nagasaki and Hiroshima, and similar devastating events with long-term consequences not just for the victims but for post-event politics and cultural practices. Jill Bennett, citing the work of Delbo (1990, 1995), postulates that there exists a form of 'sense memory' that registers the physical imprint of an event (Bennett 2003: 29). She looks at the way this sense memory produces a kind of 'seeing truth' rather than a 'thinking truth', that complements history and memory but is different from the cognitive methods of understanding and is rooted in the affective and bodily experiences of those engaging with the past, particularly their own past.

National memory and the Second World War: 1940 – myth and history

Collective memory in twentieth-century Europe has been dominated by the Second World War. This was what Cavelli would call the 'crucial event' that changed all that came before (Cavelli 2008: 170). For many nations this remembering encompasses the foregrounding of resistance and heroism and the forgetting of collaboration (Berger 2007). For the British, the war was a validation of certain characteristics they saw as their particular strengths: resilience in the face of setbacks, endurance and humour in the face of terror, and dogged determination to champion the cause of right against wrong, whatever the cost. Rutherford argues that the war supported the imagining of the nation as a natural entity, a given, like the landscape, secure in its moral virtue (Rutherford 2005: 83). Churchill, as wartime prime minister 1940–1945, is inextricably linked in popular imagination to this set of national characteristics. His national and international status as a charismatic and successful wartime leader in Britain remains extraordinarily high today. It fits comfortably into the story the British like to tell about themselves: that they went to war in 1939 to save the world from fascism and dictatorship, stood alone against the tyranny of Hitler, survived defeat (Dunkirk) and disaster (Singapore), endured bombing (the Blitz), rationing and the blackout and defeated Germany and Japan (with a few allies) (Corrigan 2007: 11–2). It allowed them to consider that they were good at muddling through (Calder 2004b: 66–7), and ultimately winning, not because of innate aggressiveness, but because of dogged, good-humoured determination, guile, resourcefulness and pluck. Cull has demonstrated how British and American journalists worked together to present a picture of a mainly English nation, improvising its way through a disastrous conflict with humour, courage and honour (Cull 1995). This version of 1940 – Britain alone – overlooks the role played by the Empire, and also tends to resist acknowledgement of the contribution made later by the allies such as Russia and America. At the time of Churchill's funeral in 1965, 'the British remained entranced by the image of themselves as defenders of world democracy in their finest hour' (Calder 2004b: 63), a vision which still endures.

During the war the role of the 'little man,' as depicted in the interwar years as '… if anything a rather shy and timid sort' (Mandler 2006: 164), was re-worked to become someone who took on the mantle of history and, while still enjoying his native and harmless lifestyle (gardening and

going to the pub), rolled up his sleeves and got the job done with self-deprecating humour and little fuss. 1940 saw the end of the old regime with the fall of Chamberlain, and a new beginning with a sense that the ordinary people were going to save the country. There was to be no more appeasement, no more *Guilty Men*.[1]

The idea of the British national character was redefined during this time. In the 1930s and during the war, the words 'character' or 'race' were used in a way we might use 'identity' today. As Mandler points out, national character was a key component in the way the British saw themselves during the war. It was seen as a 'weapon' and as a means of 'setting the aims of the war' because it was a 'people's war' (Mandler 2006: 187). The Second World War was a time of exceptional unity and common purpose and 'it was a moment so sublime as to take it out of the realm of normal historical enquiry entirely' (Smith 2000: 111), at least until the 1970s.

Over the last forty years, critiques of the home front and its impact on British character claimed that the British had created a myth about themselves which stressed nostalgia, complacency and self-satisfaction, shoring up traditions, deference and the ruling elites.

The jacket cover to Calder's *The Myth of the Blitz* (originally published in 1991) summed up this approach:-

> The Myth of the Blitz was nurtured at every level of society. It rested upon the assumed invincibility of an island race distinguished by good humour, understatement and the ability to pluck victory from the jaws of defeat by team work, improvisation and muddling through.
>
> In fact, in many ways, the Blitz was not like that. Sixty thousand people were conscientious objectors; a quarter of London's population fled to the country; Churchill and the royal family were booed while touring the aftermath of air-raids. Britain was not bombed into classless democracy
>
> (Calder 2004a)

While Calder's arguments are not always convincing, he does remind us that the mood of the British during the summer of 1940 was a complex one. Similar research has foregrounded a lack of consensus about what it meant to be British in the war years (for example, Rose 2003). Here the focus is on the myriad identities that the term British obscured. However, the myth has remained strongly embedded in public memory that forms one aspect of current British national identity.

Calder has pointed out the image of British toleration and decency can only be maintained through a kind of 'collective suppression of memory' (Calder 2004b: 69). Anti-semitism, black market trading, looting, cowardice, greed, fear, selfishness, and other unwelcome characteristics all existed but have been forgotten within the national memory. Moreover, some versions of events omit how confusing and distressing 1940 was for many: 'Perhaps we simply cannot comprehend that fear and confusion imaginatively. Myth stands in our way, asserting itself, abiding no questions' (Calder 2004a: 18). Smith agrees that 1940 and the British experience during this time have become mythologised. This does not, he argues, mean that what is collectively remembered is not what happened but that:

> these myths are implicitly believed and that they help people to make sense of their lives, that they offer a popular memory that explains the past and the present and moulds expectations of the future. A social group or nation becomes a social group or a nation only when it has

a common mythology, and a common sense of the past is a very significant element in the collective identity of any interpretive community.

(Smith 2000: 2)

The events of 1940 were mythologised *at the time*, by the people who lived through them. In contemporary film, literature, the press and radio references were made to the British people's innate love of freedom, their ability to stand firm in times of trial while others gave in, and above all to Britain's role in history as the bulwark and guardian of liberty and decency against the evil tyrant. In this, the media followed the lead given by Churchill who regularly reminded people that Britain was centre stage in a war for civilisation. According to Weight '[t]he Second World War had more influence on British national identity than any other event in history' (Weight 2003: 116). Motivated by a deep love of their country, the British were patriotic as never before. 1940 was a year of intense emotion in Britain. By the end of the year, Britain's allies in Europe had been defeated or had surrendered, invasion had been expected. The evacuation of the British Expeditionary Force at Dunkirk and the Battle of Britain in the skies, and the bombing of Britain's cities, led to a resurgence of national confidence and pride.

British national identity and Churchill

Nationalism can take many forms, but it is always associated with emotion. Academic historians recognise this but some prefer to downplay such reactions in their analyses, for emotion is the antithesis of dispassionate deconstruction of evidence. There are notable exceptions, usually historians who write for a public audience, not their peers. Churchill himself wrote history with verve, style and enthusiasm that relied on the emotional reaction of his readers. As a journalist and great orator, he understood the way a mood could be engendered for political and popular ends. Above all he understood the historical framework in which current events could be placed, with emotional effect. His speeches, quoted at length in his history of the war, and by many others subsequently, have become symbolic of British attitudes to the war. They have been reproduced and broadcast so many times, that they are immediately recognisable to most people. His oratory in 1940 is perhaps the most memorable. Phrases such as 'blood, toil, tears and sweat', 'we will fight on the beaches', 'never in the field of human conflict has so much been owed by so many to so few', are quoted out of context on a regular basis. They drew on cultural references that were familiar to many people and subliminally reinforced their sense of common identity (Ramsden 2003: 65). Their words not only conjure up a time and a place that represents a certain type of Britishness, but they also tell the British what they wanted to hear about themselves at the time and some still wish to hear today. Churchill told the British it was their war and they would win it, and they believed him.

Churchill's image

In 'How Winston Churchill became "The Greatest Living Englishman"' Ramsden (1998) pointed out that during 1940, and indeed throughout the war, Churchill did not have the national and international status he subsequently acquired between 1955 (when he retired from the premiership) and 1965 (when he died). Churchill's personal popularity with the public and their gratitude for his leadership did not prevent a Labour landslide in 1945. However, by the mid–1960s he had become a mythical figure, absolved of all blame for any questionable actions, admired (at least publicly) by nearly everyone internationally as well as in Britain.

It is not difficult to understand the adulation in which he was held. By 1965 Churchill was inextricably associated with the image of the nation in 1940. His strong leadership at that time, and throughout the rest of the war years, particularly at times of defeat, inspired the British people. He refused to countenance a treaty with Germany at a time when several of his Cabinet colleagues were potential appeasers. He adopted a robust and uncompromising attitude to war, expressed in speeches in the House of Commons and on the radio, that resonated with his British audience. Indeed, it has been claimed that he personified Britishness itself for the British people during the war (Weight 2003: 35), though it was a particularly English form of Britishness. His image, reproduced in posters, in photographs and cartoons and newsreels, showing him touring bomb sites, reviewing troops, doffing his hat and giving his V for victory sign, became the symbol of the nation. His gentleman's clothing, cigar and bowler hat stood for middle-class respectability and upper-class insouciance. His siren suits and wit symbolised a certain British irreverence for officialdom and regulations. His military uniforms indicated a certain pugnaciousness that was not a result of aggression but the product of duty and conscientiousness. His round cherubic face and rotund figure could appear resolute, defiant and also confident and cheerful. His voice was difficult to place but was unmistakable. There can be no doubt that the British people regarded Churchill as the best leader they could hope to have in such terrible times. The British Institute of Public Opinion surveys of Churchill's premiership recorded that in July 1940, 88 per cent of those questioned approved of his leadership, only 7 per cent disapproved. His lowest percentage approval rating was 72 per cent in July 1942 (Cantril 1951: 106). Of course, in wartime, people may be reluctant to criticise a leader in case they appear to be unpatriotic. However, the Ministry of Information's *Home Intelligence Reports*, ever alert for negative morale, repeatedly commented on the special affection and admiration felt by the British public for the prime minister (Watson 1984). After 1945, his reputation was enhanced and supported by his own histories of the war which were serialised in fifteen different countries and eleven languages (Reynolds 2005: xxi). Despite some attempts to deconstruct and challenge elements of Churchill's reputation and uncover the complexity of his career and opinions, this 'three-dimensional Churchill…has still to make his way into the popular perception or political consciousness' (Cannadine 2004: 6).

Churchill's speeches

It is Churchill's words, spoken by him or repeated by others, read by the public in newspapers or on posters, that have become the enduring memory of his leadership and the war itself. Most historians agree on this, if on nothing else. Churchill himself said 14 years after he became Prime Minister that '[i]t was…the nation and the race dwelling all round the globe that had the lion's heart. I had the luck to be called upon to give the roar' (Gilbert 1983: 318). Anecdotes abound about the impact his words had not just on Britain but on the rest of the world, including even German listeners (Ramsden 2003: 62). The British literally stopped to listen and telephones were silent (ibid.: 65).

Isaiah Berlin, writing ten years after 1940, argued that he was predominantly responsible for creating Britain's mood in 1940 and that was what had given him the right to voice it.

> After he had spoken…as no one else has ever before or since, [the British people] conceived a new idea of themselves which their own prowess and the admiration of the world has since established as a heroic image in the history of mankind, like Thermopylae or the defeat of the Spanish Armada. They went forward into battle transformed by his words. The spirit

which they found within them he created within himself from his inner resources, and poured it into his nation, and took their vivid reaction for an original impulse…

(Berlin 1950: 26–7 quoted Ramsden 1998: 10)

Berlin went so far as to write that Churchill created an 'unsurrendering quality on the part of his people' (Berlin 1950: 26).

The notion of Britishness and Englishness that Churchill employed so successfully in his speeches has, since the war, been challenged repeatedly by a range of economic, social and political events. The Empire, the wisdom of old men, the sense of absolute certainty in right and wrong, unity in purpose all have passed and become ghosts (Rutherford 2005: 83), being replaced with new identities. However, while aspects of the war, its meaning and British identity have been deconstructed by professional historians so that Churchill's leadership is no longer immune from criticism, the media and the public default to Churchill and his leadership in times of crisis, particularly if British freedom appears to be under external threat.

Schama in his three-volume history of Britain argued that the speeches to the Commons and on the radio in May 1940 'irreversibly changed the way the country thought about him' (Schama 2002: 509). It is worth quoting Schama at length here as he sums up a virtual consensus of views about Churchill's speeches: -

Many years later Clement Attlee wrote that, if someone asked him, 'What, exactly, Winston did to win the war, I would say, "talk about it".' Ed Murrow, the American news correspondent, said much the same when he wrote of Churchill's mobilisation of words. The effect of his speeches on British morale is incalculable – meaning literally, that despite most of those early opinion-soundings it can never be precisely measured. But anyone of my generation (born as the war ended) who talks to anyone of my parents' generation knows, at least anecdotally, that those speeches can be described, without hyperbole, as transforming. Some 70 per cent of the country listened when the prime minister spoke. … his words…made Britain – not just England – a whole nation again.

(Schama 2002: 509–10)

The implication here is that people *heard* Churchill's unmistakable voice. This national memory of Churchill broadcasting to the people talking to the nation is integral to his role in the war. However, Churchill was more concerned with fighting the war in 1940 than in talking to the nation. Nor was he very interested in using his oratory to influence public opinion through formal propaganda channels. He delivered his speeches in various locations without consulting the Ministry of Information, (the department in charge of propaganda on the Home Front). Officers in that Ministry had to wait for their content, in common with other departments. Nor would he give speeches to order. When the Planning Committee of the Ministry wanted him to prepare a broadcast in advance to be in readiness for the expected German invasion, he refused.[2] Once he had delivered a speech it was up to the Ministry to promote his words, or not, as its officers saw fit. For example, it spent £17,600 on newspaper adverts to promote the last sentence of Churchill's Commons' speech of 18 June 1940: 'Let us therefore brace ourselves to our duties, and so bear ourselves that, if the British Empire and its Commonwealth last for a thousand years, men will still say: "This was their finest hour."'[3] Briggs points out that, in the six volumes of his history of the war, Churchill never referred to his own wartime broadcasts and was far more interested in the military conduct of the war than in propaganda (Briggs 1970: 4). He

only broadcast to the nation five times between May 13 and September 11 1940 (Calder 1971: 112). He only broadcast five times in three years between 1942 and 1944 (Ramsden 2003: 65).

After the war, largely thanks to the recordings of the speeches issued on gramophone records and subsequently rebroadcast on radio and television, to Churchill's extraordinary gift for self-publicity, and to the cult of his personality, based on genuine wartime achievements, the memory of what Churchill was thought to have said to the British people during the conflict itself became confused, and gave us a different canon of great speeches. As Ramsden comments, 'the myth that Churchill was a natural and regular performer on the radio is deeply entrenched in the popular memory' (Ramsden 2003: 64–5). This is not to question the role of the words themselves – repeated by newsreaders, read in newspapers, cited on posters, in cartoons, quoted by people throughout the country. There is no doubt that they were, as Schama asserts, 'transforming' in their emotional impact on a population desperate for strong leadership and a purpose for which to fight. It was just that people rarely heard them spoken by Churchill himself, until after the war.

The Churchill Museum

In the Churchill Museum, sensory engagement with the sound of Churchill's voice is used to enhance and support national memory. The museum itself is situated within one of the underground bunkers of the Cabinet War Rooms. On entering the Cabinet War Rooms visitors see, through large windows, the Cabinet War Room set out as it would have looked on Tuesday 15 October 1940. They then walk through a corridor with sound effects of walking feet and doors shutting, with material evidence from 1940 such as the board informing those working underground what the weather was above ground. Visitors then turn left, past the transatlantic telephone room, into a corridor where temporary exhibitions are held. They then enter into the Churchill Museum by approaching a large grey wall, upon which is written in white text on grey:

'We are all worms. But I do believe I am a glow-worm.' Winston Churchill

On turning the corner, visitors continue straight ahead into a grey space where there are eight relatively small, back-lit black and white photographs, set in a metal frame within a grey metal wall. They are positioned in a row so the visitors walk slowly, seeing them in sequence. The space where the visitor should stand in order to look at the photograph is marked on the floor. However, lighting is generally subdued so the eye is drawn to the photographs. It is not entirely clear what visitors have to do. When visitors step into the space immediately in front of the photograph they hear a woman's voice introducing excerpts from Churchill's speeches, explaining the historical context in which they were made and the audience to which they were first delivered. The visitor then stands and listens to Churchill while looking at the photograph. This is a relatively solitary experience although I observed couples standing close to each other in order to hear the sounds together. However, when the visitor steps away from a particular spot on the floor in front of the photograph, the sound ceases. It starts again from the beginning when the visitor moves back into that particular place. The sound is directed so that individuals standing on either side of the particular space in front of the photograph cannot hear what is being said. However, noise from the rest of the museum can be heard in the background and the visitor can turn with their backs to the photographs and look at other exhibits, but all those

I observed for approximately 20 minutes on three separate visits in 2007 and 2008, faced the photographs.

Visitors can listen to brief extracts from eight of Churchill's speeches. They begin on 13 May 1940 with 'Blood, toil, tears and sweat' and continue chronologically until 11 September 1940 and the beginning of the bombing of London. The extracts from the speeches and the text next to the photograph they accompany, are experienced in this order: 19 May 1940, 'Arm yourselves', with a picture of men with broomsticks, military drilling in shirts; 4 June, 'We shall fight on the beaches', with a photograph of tired men having been evacuated from Dunkirk; 17 June, 'The news from France is very bad', with a picture of Hitler in front of the Eiffel Tower; 18 June, 'This was their finest hour', with a picture of a war veteran polishing his gun in his home with the tea things in front of him and his wife knitting beside him; 14 July, 'War of the unknown warriors', with an image of men in uniform and a woman in an ARP arm band; 'The Few', 20 August 1940, with an image of airmen smiling as they walked away from their planes; 11 September 1940, 'A fire in British Hearts', with a picture of St Paul's surrounded by smoke during the Blitz.

Thus the four months of the war which include the German invasion and defeat of France, the evacuation of the BEF, preparations for invasion, the Battle of Britain and the beginning of the Blitz, are all experienced through Churchill's voice and black and white images.

Listening

The sound of Churchill's voice is unmistakable and is immediately recognised by the visitor. It is authentic, in that the listener hears what Churchill himself said at the time he spoke into the microphone, albeit this may have been in most cases after the end of the war. The *sound* of his unmistakable voice and the emphasis it places on words is more important here than the speech as written text for, as Sturken and Cartwright point out, 'the medium of your voice encodes messages through conventions such as accent, loudness, pitch, tone, inflection, and modulation, encodes messages with meanings that are not inherent in the content of the message' (Sturken and Cartwright 2005: 155). As human beings we instinctively listen to human voices and we are experts in detecting emotions within them. A remembered voice heard once more conjures up not only a sensation of familiarity but the words, and the way they are spoken, will evoke an emotional as well as cognitive response. Research into the emotional impact of music indicates that the brain groups sounds into patterns and responds emotionally to them (Cohen 1998). Thus it is likely that the sound of a familiar voice will engender emotion while the brain decodes what is being said.

Cameron has argued that material objects, though removed from their original contexts, are deemed by some ways of thinking to have values that derive from 'a series of assumptions as evidence of deep history where temporality is reified, and variously by a process of authentication based on their materiality and method of manufacture as "original" and "authentic"'(Cameron 2007: 53). In a similar way, recordings of Churchill's speeches assume values based on this authenticity. Although they are intangible in their spoken form we presume we hear the words as others at the time heard them. They affect us both as powerful words that can be heard outside of the time in which they were originally spoken and as words that we can imagine hearing at the time of their origin. We can still experience the sound, and through our senses, engage with the emotions of the speaker and imagine the responses of the original listeners. What we cannot do, however, is hear the speeches exactly as they were heard at the time. Those sounds only exist in memory. The recorded words imprint the sensation of hearing on what we have heard before

and create a new memory which reinforces older memories of hearing Churchill speaking, whether this was during the war or afterwards in one of the many television documentaries or radio programmes about his life, or in recordings sold commercially. Such hearing is embodied: research by Tacchi on radio sound (mainly music), for example, suggests that sounds heard in the home through the medium of the radio are bodily felt through affect, when radio sound has connecting power with (real or imagined) pasts (Tacchi 2006: 294).

The impact of the speeches upon the emotions is engendered not only by the sound of Churchill's familiar voice but by the content. Churchill never underplayed the threats the country faced. He told the people they would suffer but, at the same time, he gave them a reason to do so. He imagined the present in the context of the past and placed the role of the British people in the context of the future. His words were about more than just winning the war. He provided a purpose, a role for the British in the history of the world. Had Britain suffered invasion, lost the war and become an outpost of the German empire, Churchill's words would subsequently sound bombastic, lacking in foresight and pathetically impracticable. Now, they sound visionary, prophetic and inspiring.

Phil Reed, Director of the Churchill Museum, chose extracts from these speeches because they were emotional.[4] He recognised that Churchill used emotion deliberately to elicit strong responses from people and achieve his aim of uniting the Commons and the country behind him. Reed also sees the speeches as ways of allowing the visitor to engage with Churchill at a human level, to get a sense of his mindset, rather than seeing him as the distant hero. His words, in his own voice, humanise him. Only those who lived through 1940 in Britain can know how the words sounded then, and how they as listeners felt. But even their memories will be altered by all that came after. The effect of the words on the public, written or spoken, can never be retrieved from the past, but only imagined. However, within the museum the visitor is invited to participate in this emotional engagement with the national story as conceptualised by the leader. In so doing the visitor experiences not an *object* of memory passed down in an oral tradition, but participates in a *practice of remembering* (Ingold 2000: 148), through paying attention to the voice and words of the original speaker, engaging with him through an emotional response.

The first speech one hears in the Museum contains the phrase 'blood, toil, tears and sweat'. The woman narrator makes it clear that this speech was made to the House of Commons three days after Churchill became prime minister, on the day the Germans invaded the Low Countries. The speech contains some of Churchill's most memorable phrases:[5]

> I would say to the House, as I said to those who have joined the government: 'I have nothing to offer but blood, toil, tears and sweat.'
>
> … You ask what is our policy? I will say: It is to wage war, by sea, land and air, with all our might and with all the strength that God can give us: to wage war against a monstrous tyranny, never surpassed in the dark lamentable catalogue of human crime. That is our policy. You ask, what is our aim? I can answer in one word: victory – victory at all costs, victory in spite of all terror, victory however long and hard the road may be; for without victory there is no survival…
>
> Come, then, let us go forward together with our united strength.

It is generally assumed that Churchill spoke these words to the British public to rally them. In fact, he used this speech (altered) twice, once to his ministers in Admiralty House, then in the Commons. Newspapers published extracts and BBC newsreaders summarised the speech in evening news bulletins though, interestingly, they added in three extra 'ands', so what the

public heard was 'I have nothing to offer but blood and toil and tears and sweat' (Lukacs 2008: 46). Thus the visitor who hears the words today cannot experience the original impact of these words, what has been called 'the nature and significance of the oral communicative moment' or, in layman's terms, 'the magic of the moment' (Furniss 2004: 1), for that was ephemeral and belonged to those listeners in the Admiralty and the Commons experiencing the moment in the company of others, watching Churchill deliver his speech.

In the museum, however, Churchill's voice speaks to the individual visitor. His words are so well known that they elicit both a cognitive response (remembrance) and an emotional one. They were designed for this latter purpose and Churchill was master of his craft. They evoke an emotional response that varies from visitor to visitor but which results in an empathetic reaction, influenced by the image that accompanies the speech.

Image

The first image visitors see, is that of Churchill in civilian dress meeting infantrymen manning a coast defence position near Hartlepool. He is dressed in a suit with his bowler hat, cigar and stick. He stands looking away from the camera, looking out presumably to sea, while the men in the trench below him look towards him. This photograph was taken by an official war photographer and is carefully composed.

Churchill is not reviewing large numbers of well-armed troops. He is in civilian uniform looking relaxed. The few soldiers have some guns and sand bags. That is all. They no doubt represented the sorts of defences that were present all over the country in 1940, small scale and local. Here Churchill, in an ordinary suit, symbolises the civilian nature of the war. The soldiers are quite literally look up to him as the leader of the nation.

The extracts from Churchill's speech include not only the 'blood, toil, tears and sweat' but the following:

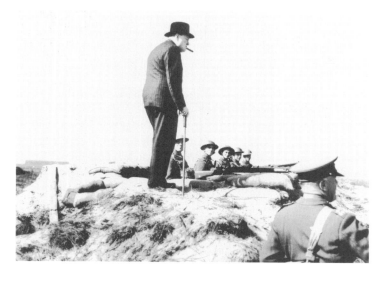

Figure 14.1 Churchill near Hartlepool (War Office official photographer, copyright Imperial War Museum, negative number H 2628, by kind permission of The Trustees of the Imperial War Museum)

And it must be remembered that we are in the preliminary stages of one of the greatest battles in history, that we are in action at many points in Norway and in Holland, that we have to be prepared in the Mediterranean, that the air battle is continuous and that many preparations have to be made here at home.

It is, however, the situation 'at home' that is emphasised by this picture. These are men defending their own shores. How does this image affect the viewer?

There is plenty of theory relating to the role of the image in eliciting a cognitively based response from the viewer based on an understanding that what is seen is what actually existed. Classen (1993) has argued that Western historical constructions of the senses prioritise sight as objective and rational. Photography has been seen in the twentieth century as the 'unvarnished truth' (Walsh 2007: 22). Walter Benjamin notes that 'photographs become standard evidence for historical occurrences' (Benjamin 1969: 226, cited Walsh 2007: 22). As such, photographs became tools for remembrance – people, events, places and objects were photographed and the image, positioned within a written or spoken narrative, became a way something gained credence and acted as a prompt to personal memory. Edwards has argued that 'photography, with its reproductive and repetitive qualities, is a form of externalised memory *par excellence*, fulfilling the inscriptional and performative qualities of memory and cultural habit' (Edwards 2006: 70, italics in the original). Moreover she argues that '[t]he performative habit of photography, especially its dynamic potential for repeated engagement, mirrors the performativity of memory, which in a neo-Lamarckian mode, becomes inherited identity' (ibid.). The question thus arises – what sorts of memories do photographs support through this performativity and to what extent are they embodied?

According to Barthes, photographs have denotative and connotative meaning. Denotative meaning can show certain apparent truths, providing documentary evidence of objective circumstances. Connotative meanings rely on the culturally specific meanings (Barthes 1977; Sturken and Cartwright 2005: 19). Barthes used the term myth to refer to the cultural values and beliefs that are expressed at the level of connotation. For him myth is the hidden set of rules and conventions through which meanings, which are in reality specific to certain groups, are made to seem universal and given for a whole society. Myth allows the connotative meaning of an image to *appear* denotative or literal and natural. According to Barthes photographs do radiate an aura, a distance, reference to a past and memory, particularly when they relate to personal reminiscence (Barthes 2000, Hazan 2001, cited in Cameron 2007: 70).

However, while this analysis of the photograph recognises its importance for memory, and understands it to be encoded within the framework of cultural meanings, it does not take account of its ability to engage the senses, nor how emotions impact upon the act of remembrance. As Sontag observes, one of the key qualities possessed by a photograph is the idea that it is not just an image, '(as a painting is an image), but an interpretation of the real' (Sontag 1979: 154). It thus has a special quality that stirs emotions that are less to do with aesthetic distancing than with the immediacy of confronting the past. Barthes recognises this when he writes that the photograph 'possesses an evidential force,' and that 'from a Phenomenological viewpoint, in the Photograph, the power of authentication exceeds the power of representation' (Barthes 2000: 88–9). Photographs thus reach through time to the present and we engage with them now, as others before us engaged with them in their own time. We also believe that what we see is what others saw too. We think we see through their eyes. Photographs can thus stir emotions, evoke wonder, horror or excitement. As Morris-Suzuki argues:

In an age of retreat from the written word, photographic images may become an increasingly important starting point for engaging with the past...They may be seen in other words, less as pieces of evidence to be labelled true or fake, than as question marks which set in motion a procession of speculations: that persistent reflection which forms the core of the process of historical truthfulness.

(Morris-Suzuki 2005: 118–9)

Morris-Suzuki argues that this sense of reality results in an imaginative and emotional response to the events and people we see in photographs. However, we have to recognise that our emotional reactions are not the same as those who made or saw the photograph in the past.

Most of the images used in the introductory section to the Churchill Museum, like the one taken at Hartlepool above, were taken by official war photographers. They were originally used by the media and the government to present versions of events and to stress certain types of cultural values. These were offered to the public in 1940 just as they are presented today, as images of 'facts' – but they were carefully chosen by both the original photographer and the censor. Althusser states that we are 'hailed' or summoned by ideologies that recruit us as their 'authors' (1971, cited in Sturken and Cartwright 2005: 52) and subject – we become/are the subject which we are addressed as. Thus the people of Britain in 1940 were encouraged to become the people of the image, just as visitors to the museum are encouraged to accept that this is the sort of people they were or the British were, and by implication still are.

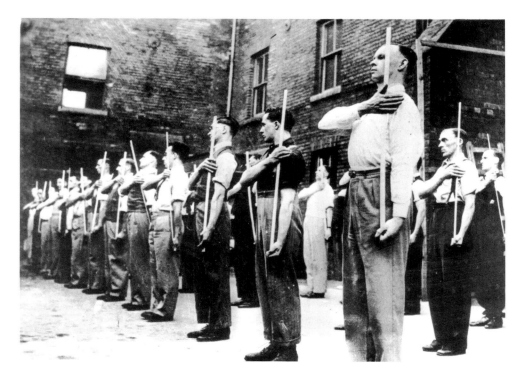

Figure 14.2 The Home Guard in Britain during the Second World War (copyright Imperial War Museum, negative number MISC 60739, by kind permission of The Trustees of the Imperial War Museum)

Of course, the reaction of the visitor to the image in the twenty-first century is mediated not only by knowledge unknown in 1940 (Britain was not invaded, civilians did not have to fight, Britain did win) but also all that happened afterwards, including the development of the Welfare State, the division of Germany and its later re-unification, and its peaceful co-existence and co-operation with Britain over 60 years. Thus the image in the museum evokes different emotions from those evoked in 1940, but it acts as a way in which the past appeals through the senses to the public.

The next picture shows civilians drilling with broomsticks while they wait for guns. These are the men of the Home Guard – no match for the German army. In the museum, this image is linked Churchill's voice explaining that, after the Battle in France will come:

> the battle for our islands – for all that Britain is, and all that Britain means.
> Centuries ago words were written to be a call and a spur to the faithful servants of truth and justice 'Arm yourselves, and be ye men of valour, and be in readiness for the conflict; for it is better for us to perish in battle than to look upon the outrage of our nation and our altars. As the Will of God is in Heaven, even so let it be.'

The female narrator explained that this speech was broadcast to the nation on 19 May 1940, his first broadcast to the nation as Prime Minister.

Such a juxtaposition of words and image evokes a strong emotional response. The word 'perish' takes on a special meaning – these men would not survive a German attack. Those listening to the words in the twenty-first century are thus encouraged to feel the desperation and determination of that era through an emotional reaction to the sounds and image and, at the same time, experience pride that the British were 'muddling through' with courage and resolution. A similar emotion response is elicited by the fifth image (Figure 14.3), also an official photograph of a Home Guard member (now with a gun). Here the domestic trappings of afternoon tea, the everyday details of life going on as normal, contrast with the image of this older man preparing his gun for a battle to defend his home.

The impact of this image is magnified by what were, perhaps, the most powerful words Churchill ever broadcast to the British people, on 18 June 1940, after he had made the speech first to the House of Commons. Even though Harold Nicolson, who heard both speeches, thought the second one inferior in delivery (Ponting 1990: 159) it was, nevertheless, extraordinarily powerful in its emotional impact.

> What General Weygand has called the Battle of France is over. The Battle of Britain is about to begin. Upon this battle depends the survival of Christian civilization. Upon it depends our own British life, and the long continuity of our institutions and our Empire. The whole fury and might of the enemy must very soon be turned on us. Hitler knows that he will have to break us in this island or lose the war. If we can stand up to him, all Europe may be free and the life of the world may move forward into broad, sunlit uplands. But if we fail, then the whole world, including the United States, including all that we have known and cared for, will sink into the abyss of a new dark age made more sinister, and perhaps more protracted, by the lights of perverted science. Let us therefore brace ourselves to our duties, and so bear ourselves that, if the British Empire and its Commonwealth last for a thousand years, men will still say, 'This was their finest hour.'

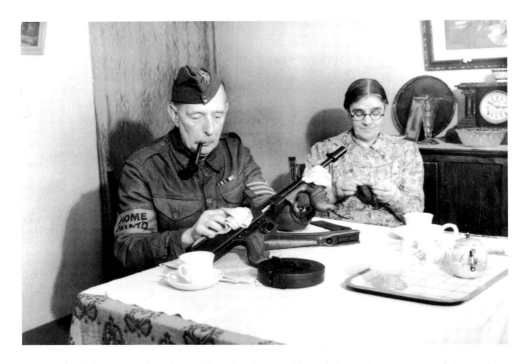

Figure 14.3 The Home Guard: seated at the dining table with his wife, a sergeant of the Dorking Home Guard in Surrey, England, gives his tommy gun a final polish before leaving home to go on parade (War Office official photographer, copyright Imperial War Museum, negative number H 5850, by kind permission of The Trustees of the Imperial War Museum)

The last speech of the sequence is that of 11 September 1940 and accompanies a picture of St Paul's Cathedral in London, with flames all around it. The narrator states that Churchill made this broadcast to the British people from the Cabinet War Rooms, four days after the Germans had begun their Blitz on London.

The image was actually taken much later, on 29 December. Visitors hear an extract which includes the following:

> These cruel, wanton, indiscriminate bombings of London are, of course, a part of Hitler's invasion plans. He hopes, by killing large numbers of civilians, and women and children, that he will terrorize and cow the people of this mighty imperial city, and make them a burden and an anxiety to the government and thus distract our attention unduly from the ferocious onslaught he is preparing. Little does he know the spirit of the British nation, or the tough fibre of the Londoners, whose forebears played a leading part in the establishment of Parliamentary institutions, and who have been bred to value freedom far above their lives. This wicked man, the repository and embodiment of many forms of soul-destroying hatred, this monstrous product of former wrongs and shame, has now resolved to try to break our famous island race by a process of indiscriminate slaughter and destruction. What he has done is to kindle a fire in British hearts, here and all over the world, which will glow long after all traces of the conflagration he has caused in London have been removed.

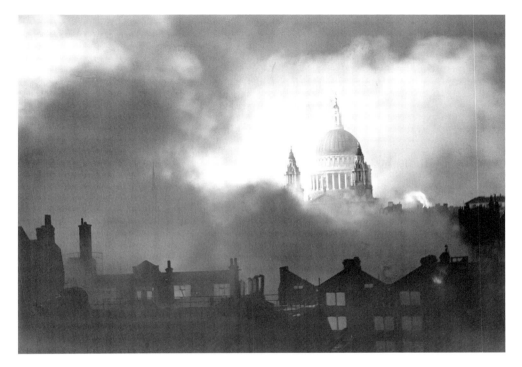

Figure 14.4 'Standing proud', St Paul's Cathedral surrounded by fires in the Blitz (2716767 (RM), copyright Hulton Archive/Getty Images)

Once again the speech is designed to elicit an emotional response, and it draws on the idea of the British as freedom-lovers who will resist anything Hitler can throw at them.

Throughout the Blitz, the symbol of British resistance was the survival of St Paul's Cathedral. Churchill knew how important the 'parish church of the Empire' was for morale and sent a message to the Lord Mayor of London on the night of 29 December, ordering it to be saved at all costs (Weight 2003: 29). This image appeared on the front page of the *Daily Mail* on Tuesday 31 December 1940 with the headline 'War's Greatest Picture: St Paul's Stands Unharmed in the Midst of the Burning City.' Thus this image, reproduced since, many times, was immediately disseminated to the general population. The dome of St Paul's standing in the midst of smoke and ruin, came to be associated with the idea of British strength and survival in adversity. Yet why should this be? Three days later the same image was reproduced in a German paper to denote London destroyed – a city in its death throes.

This image of a place, a cathedral as symbolic of a kind of identity, would have appealed to many. The idea of architecture and places representing a sense of national identity was deep rooted in England (Edwards 2006: 64). The National Photographic Record Association (active 1897–1910), according to Edwards (ibid.), prioritised sites 'saturated in the power of tradition, places bestowed and secured English identity and memory'. Churches were photographed often as the oldest building in a locality and thus they stood for 'the continuity of cultural experience and the power of the local' (Edwards 2006: 65). In 1940, churches, in particular St Paul's, came to stand for the righteousness of the British or English struggle against Nazism which was equated with unadulterated evil (Mee 1941: 26).

In the twenty-first century, a more secular age, the emotional response to this image is less likely to be triggered by associations of religion such as those felt by the British in 1940. Yet, the image of St Paul's surrounded by flames can elicit an emotional response even if one is secular or of a different religion, particularly when accompanied by Churchill's defiant words.

Conclusion

As culture is a process, so each visit to the Churchill museum will produce a different cultural experience just as every individual will have a slightly different reaction to the displays. Some may ignore the first section of the museum all together. If visitors do choose to experience this introduction their responses will be dependent on a range of different individual interpretive practices, past experiences, historical knowledge and backgrounds and their feelings and situation on the day. Initial reactions may be modified by interaction between individuals with one person's views influencing another's (Sturken and Cartwright 2005: 4). Some may choose to view only one or two photographs and listen to snatches of the speeches. Others may work their way methodically through the whole section, listening and focusing on the images as they incline their heads to hear the words. This analysis accepts this as a given. However, just as any reader of a text will take from it what they wish to take but the text remains and can be analysed, so the first section of the museum and the experience it engenders can be deconstructed within the frame of historical understanding.

The images and the voice of Churchill provide visitors with a chronological but incomplete and, for those not entirely sure of the events of 1940, a somewhat disjointed and confusing impression of what happened and why. The visitor stands alone and hears the cadences of Churchill's speech, the tenor of his voice rising and falling. The colour of the space is grey, the photographs are black and white, the sounds of his voice are not very loud so the visitor has to concentrate on each phrase. Within this part of the Churchill Museum time is presented linearly – the visitor physically moves through it. Each event is disconnected from the other. Each event is unexpected and shocking. The visitor thus moves through space and has control over how he or she encounters the experiences offered by the sound and image. However, the visitor experiences the sounds and sees the image in a strict sequence. The visitor does not control events, any more than anyone living through them in 1940 did.

It is an intensely immersive experience. I would suggest that this method of interpretation, using sound and images, provides the visitor with something akin to a sense of the experience of 1940 that has been forgotten in the myth-making: confusion, uncertainty, a rush of events without meaning at the time, and an emotional impression of the leadership of one man who provided a kind of certainty in the midst of chaos – a certainty that whatever happened he would carry on fighting and he believed the British people would do so too. At the same time, the experience provides a sensed and embodied understanding of the myth of 1940 – Churchill and the British people united amidst confusion and fear.

The experience in the museum cannot imitate the everyday confusion of the time, the anxiety and distress, but it allows individuals to experience something akin to the unfolding of extraordinary events and the charisma and leadership of an individual that made sense of them for the nation. It presents the world through his eyes – as he was leading the nation through one of the worst challenges it has ever faced. It reflects and reinforces the established reading of Churchill as the man who moulded the nation's sense of itself and gave it pride in what would otherwise have been seen as a terrible sequence of defeats and humiliations.

The museum thus encourages participation through the senses in a way a more conventional display which relied on text would find it difficult to do. It enables those who are not familiar with museum conventions or with the details of events in 1940 to engage with the events of that year. Once visitors leave this area they are immersed in more interactive and engaging displays, including one with changing digital comments on Churchill to indicate he was not admired by all. This is unlikely, however, to challenge the sense of Churchill as the great leader which the words and images already presented have conjured up. Within the context of the Cabinet War Rooms to which the visitor returns, having visited the rest of the highly interactive and emotive museum, this display technique offers opportunities for sensory participation in a time that is now long ago. In so doing, it provides visitors with something different from a dispassionate deconstruction of the events of 1940 and Churchill's leadership, allowing them instead to engage emotionally with these events and to sense something that people who lived through those times did – confusion, pride, and Churchill's conviction that the British people were making history. It evokes historical understanding, encouraging the visitors to make historical sense from their emotional engagement with the subject, and thus re-enforces a type of British national identity.

Acknowledgements

I am grateful to the following, who helped me with my research, Sarah Clarke, Exhibitions Manager, Churchill Museum and Cabinet War Rooms, Jocelyn Hunt, formerly in the education department in the Churchill Museum and Cabinet War Rooms, and John Pickford, Lead Project Designer, Casson Mann Designers. I am particularly grateful to Phil Reed, Director of the Churchill Museum and James Taylor, curator and member of the museum display team who talked to me about their involvement in the museum and kindly read and commented on a draft of the paper. I would also like to thank Professor Simon Knell for his perceptive comments on the draft of this paper and the Department of Museum Studies in the University of Leicester for allowing me a semester of study leave in 2006 during which time the groundwork for the ideas for this paper was laid.

Notes

1 In 1940 an immensely popular book, *Guilty Men*, blamed the defeat of France on Britain's political leaders in the 1930s. Published under the pseudonym Cato, the authors were Michael Foot, Frank Owen and Peter Howard. Churchill's premiership marked the end of the 'guilty men' era and a new beginning for Britain.
2 Planning Committee Minutes, 16 September 1940, INF1/249.
3 Planning Committee, Note on Action Taken, 26 June, INF1/250.
4 Interview with Phil Reed at the Churchill Museum on 22 November 2006.
5 All quotations from Churchill's speeches were transcribed by the author from the recordings in the museum.

References

Althusser, L. (1971) 'Ideology and ideological state apparatuses', in L. Althusser *Lenin and Philosophy and Other Essays*, trans. B. Brewster, New York and London: Monthly Review Press, 127–86.
Bagnall, G. (2003) 'Performance and performativity at heritage sites', *Museum and Society*, 1 (2): 87–103.
Barthes, R. (1977) 'The photographic message', in R. Barthes *Image, Music, Text*, trans. S. Heath, London: Fontana Press, pp. 15–31.
Barthes, R. (2000 [1980]) *Camera Lucida: reflections on photography*, trans. R. Howard, London: Vintage.

Benjamin, W. (1969) 'The work of art in the age of mechanical reproduction', in H. Arendt (ed.) *Illuminations*, New York: Schocken Books.

Bennett, J. (2003) 'The aesthetics of sense-memory: theorising trauma through the visual arts, in S. Radstone and K. Hodgkin (eds) (2007) *Memory Cultures: memory, subjectivity and recognition*, New Brunswick, NJ: Transaction Publishers, pp. 27–39.

Berger, S. (2007) 'National myths in Europe', *European History Quarterly*, 37 (2): 291–300.

Berlin, I. (1950) *Mr Churchill in 1940*, London: John Murray.

Briggs, A. (1970) *The History of Broadcasting in the United Kingdom, Volume III, The war of words*, London: Oxford University Press.

Calder. A. (1971) *The People's War, Britain 1939–45*, London: Panther Books

Calder, A. (2004a [1991]) *The Myth of the Blitz*, London: Pimlico.

Calder, A (2004b) 'Britain's good war', in A. Calder *Disasters and Heroes: on war, memory and representation*, Cardiff: University of Wales Press, pp. 61–9.

Cameron, F. (2007) 'Beyond the cult of the replicant: museums and historical digital objects – traditional concerns, new discourses', in F. Cameron and S. Kenderdine (eds) *Theorizing Digital Cultural Heritage*, Cambridge, MA and London: The MIT Press, pp. 49–75.

Campbell, C. (2005 [1989]) *The Romantic Ethic and the Spirit of Modern Consumerism*, London: Alcuin Academics.

Cannadine, D. (2004) 'Prologue: Churchill from memory to history', in D. Cannadine and R. Quinault (eds) *Winston Churchill in the Twenty First Century*, Cambridge: Cambridge University Press, pp. 1–7.

Cantril, A. H. 1951 (ed.) *Public Opinion 1935 – 1946*, Princeton, NJ: Princeton University Press.

Carr, D. (2008) 'The reality of history', in J. Rüsen (ed.) *Meaning and Representation in History*, Oxford: Berghahn Books, pp. 123–36.

Cato [M. Foot, F. Owen and P. Howard] (1940) *Guilty Men*, London: Gollancz.

Cavelli, A. (2008) 'Memory and identity: how memory is reconstructed after catastrophic events', in J. Rüsen (ed.) *Meaning and Representation in History*, Oxford: Berghahn Books, pp. 169–82.

Chakrabarty D. (2002) 'Museums in late democracies', *Humanities Research*, IX (1): 5–12.

Claparède, E. (1911) 'La Question del la "mémoire" affective', *Archives de Psychologie* 10: 361–77, 367–9.

Classen, C. (1993) *Worlds of Sense: exploring the senses in history and across cultures*, London: Routledge.

Cohen, A. (1998) 'The functions of music in multimedia: a cognitive approach', in *Proceedings of the Fifth International Conference on Music Perception and Cognition*, 26–28 August, Seoul University, Korea, 13–20. Online, <http://www.upei.ca/~musicog/research/docs/funcmusicmultimedia.pdf> (accessed 11 December 2008).

Corrigan, G. (2007) *Blood, Sweat and Arrogance, and the Myths of Churchill's War*, London: Orion Books Ltd.

Cubitt, G. (2007) *History and Memory*, Manchester: Manchester University Press.

Cull, N (1995) *Selling War: the British propaganda campaign against American 'neutrality' in World War II*, New York: Oxford University Press.

Delbo, C. (1990) *Days and Memory*, trans. R Lamont, Marlboro,VT: Marlboro Press.

Delbo, C. (1995) *Auschwitz and After*, trans. R. Lamont with an introduction by L. Langer, New Haven, CT: Yale University Press.

Edwards, E. (2006) 'Photography, "Englishness" and collective memory: the National Photographic Record Association, 1897–1910', in A. Kuhn and K. E McAllister (eds) *Locating Memory: photographic acts,* Oxford: Berghahn Books, pp. 53–79.

Furniss, G. (2004) *Orality: the power of the spoken word*, Basingstoke: Macmillan Palgrave.

Gilbert, M. (1983) *Finest Hour: Winston S. Churchill 1939–41*, London: William Heinemann Ltd.

Gregory, K. and A. Witcomb (2007) 'Beyond nostalgia: the role of affect in generating historical understanding at heritage sites', in S. Knell, S. MacLeod and S. Watson (eds) *Museum Revolutions: how museums change and are changed*, London: Routledge, pp. 263–75.

Hall, S. (2003) 'Introduction', in S. Hall (ed.) *Representation: cultural representations and signifying practices*, Milton Keynes: Open University Press, pp. 1–11.

Hazan, S. (2001), 'The virtual aura – is there space for enchantment in a technological world?', online, <http://www.archimuse.com/mw2001/papers/hazan/hazan.htm> (accessed 26 June 2008).

Ingold, T. (2000) *The Perception of the Environment: essays in livelihood, dwelling and skill*, London: Routledge.

Janet, P. (1919–25 [1984]) *Les Médications psychologiques,* 3 vols, Paris: Société Pierre Janet.

Janet, P (1928) *L'Évolution de la mémoire et la notion du temps,* Paris: Cahine.

Lukacs, J. (2008) *Blood, Toil, Tears and Sweat: the dire warning, Churchill's first speech as prime minister*, New York: Basic Books.

Mandler, P. (2006) *The English National Character: the history of an idea from Edmund Burke to Tony Blair*, New Haven, CT: Yale University Press.

Mee, A. (1941) *Nineteen Forty: our finest hour*, London: Hodder and Stoughton

Morris-Suzuki, T. (2005) *The Past Within Us: media, memory, history*, London: Verso.

Mowlam, M. (2002) 'Winston Churchill', in J. Cooper (ed.) *Great Britons, the Great Debate,* London: National Portrait Gallery Publications, pp. 124–137.

Ponting, C (1990) *1940: Myth and Reality*, London: Sphere Books Ltd.

Ramsden, J (1998) 'How Winston Churchill became: "The Greatest Living Englishman"', *Contemporary British History*, 12 (3): 1–40.

Ramsden, J. (2003) *Man of the Century: Winston Churchill and his legend since 1945*, London: HarperCollins Publishers.

Reynolds, D. (2005) *In Command of History: Churchill fighting and writing the Second World War*, London: Penguin Books Ltd.

Rose, S. O. (2003) *Which People's War? National identity and citizenship in wartime Britain 1939–1945*, Oxford: Oxford University Press.

Rüsen, J. (2006) 'Preface to the series', in J. Rüsen (ed.) *Meaning and Representation in History*, Oxford: Berghahn Books, pp. ix-xiv.

Rutherford, J. (2005) 'Ghosts: heritage and the shape of things to come', in J. Littler and R. Naidoo (eds) *The Politics of Heritage: the legacies of 'race',* London: Routledge, pp. 82–93.

Schama, S. (2002) *A History of Britain, volume three: the fate of empire, 1776–2000*, London: BBC Worldwide Limited.

Seixas, P. (2006) *Theorizing Historical Consciousness*, Toronto: University of Toronto Press.

Smith, M. (2000) *Britain and 1940: history, myth and popular memory,* London: Routledge.

Sontag, S. (1979) *On Photography*, London: Penguin Books.

Sturken, M. and L. Cartwright (2005) *Practices of Looking: an introduction to visual culture*, Oxford: Oxford University Press.

Tacchi, J (2006) 'Nostalgia and radio sound', in M. Bull and L. Back (eds) *The Auditory Culture Reader*, Oxford: Berg, pp. 281–95.

Van der Kolk, B. and O. Van der Hart (1995) 'The intrusive past: the flexibility of memory and the engraving of "trauma"', in C. Caruth (ed.) *Trauma: explorations in memory*, Baltimore, MD and London: Johns Hopkins University Press, pp. 158–82.

Walsh, P. (2007) 'Rise and fall of the post-photographic museum: technology and the transformation of art', in F. Cameron and S. Kenderdine (eds) *Theorizing Digital Cultural Heritage: a critical discourse*, Cambridge, MA: The MIT Press, pp. 19–34.

Watson, S. (1984) 'The Ministry of Information and the Home Front in Britain', unpublished PhD thesis, University of London.

Watson, S. (2008) 'Communities and history in twenty first museums in the United Kingdom: museums as a means of social change', paper delivered to the Second International Colloquium of Museums of Mexico and the World, National Museum of Colombia, October 2008.

Weight P. (2003) *Patriots: national identity in Britain 1940–2000*, London: Pan Macmillan.

Witcomb, A. (2007) 'The materiality of virtual technologies: a new approach to thinking about the impact of multimedia in museums', in F. Cameron and S Kenderdine (eds) *Theorizing Digital Cultural Heritage*, Cambridge, MA: The MIT Press, pp. 35–48È

DREAMS AND WISHES

The multi-sensory museum space

Viv Golding

I have a dream that one day this nation will rise up and live out the true meaning of its creed: "*We hold these truths to be self-evident*: that all men are created equal." ... on the red hills of Georgia the sons of former slaves and the sons of former slave owners will be able *to sit down together* at the table of brotherhood. ... my four little children will one day live in a nation where they will not be judged by the color of their skin but by the content of their character. ... down in Alabama, with its vicious racists, with its governor having his *lips dripping with the words of interposition and nullification*; one day right there in Alabama, little black boys and black girls will be able *to join hands* with little white boys and white girls as sisters and brothers.

(King 1963 [my emphasis])

YOU! YOU UGLY SHIT! DOG SHIT! YOU! YOU! YOU LOVE THAT DOG SHIT! YOU'RE UGLY DOG SHITS!

(Anon. 1968)

Introduction

This chapter explores the multi-sensory experiences and embodied knowledge(s) that can be gained with a range of material culture housed in an anthropology museum. The chapter focuses on embodied engagement with objects that are regarded as 'art' (a contested zone) originating from sub-Saharan Africa peoples, in both traditional and contemporary communities, which are displayed in the internationally curated permanent exhibition entitled *African Worlds*, at Horniman Museum, south London. Attention is directed to young children's creativity flowing from innovative affective experiences related to touch, sound, balance and dance, time and space, healing and wellbeing, which are all made possible in *African Worlds*.

Specifically sensory engagement with objects on display such as a small Shona headrest (c.1900 by an anonymous maker) that could fit the human hands, is shown to be enhanced through direct physical engagement with objects in the handling collection. Feeling links between the materiality or thingness of museum objects, and the mindful creative work they can inspire is developed throughout the chapter, by considering playful active learning experiences in both the museum but also at school. In addition to emphasizing the tangible material culture

exhibited in the museum and in the handling collection the value of employing contextual material, such as traditional stories and songs, to further the children's embodied experiences is explored. The importance of prompting communication, through non-verbal body language, oral exchange in dialogue, creative writing and artwork are key to the projects discussed. Furthermore such prompts are beneficial to all young children, and particularly those suffering emotional difficulties on the autistic spectrum, as will be considered below.

In sum, the communicative potential of material culture facilitated by a non-hierarchical teamwork approach that establishes twenty-first century emotional and intellectual connections, with peoples and cultures, teachers and pupils, past and present, in a spirit of openness and sharing is explored. Theoretically the collaborative ethos underpinning the chapter outlines a critical pedagogy informed by Paulo Freire, to challenge the stubborn persistence of dualism inherent at the basis of Western thought but without resorting to a relativist 'anything goes' approach of Paulo Freire (Freire 1985, 1998). Rather 'both and' holistic ways of being and knowing to promote greater intercultural understanding and self-understanding are emphasized.

The chapter is structured to address the key points of sensory engagement and promotion of embodied knowledge in the museum, the wider context of which I have covered elsewhere (Golding 2007a, 2007b, 2007c; 2006; 2005). First the key terms (the senses, emotions, intellectual and socio-political engagement across time and space), are more tightly defined and problematized, with language(s), for example, considered from an embodied perspective. Next I will sketch the Horniman Museum context and outline the aims and object of the *African Worlds* exhibition, and routes to engaging with visitors notably children. From this I will observe one case study group of disabled school pupils, their special learning needs and the value of the multi-sensory museum/school programming. Finally some conclusions are drawn and recommendations made for developing embodied knowledge(s) with anthropology collections at other museums around the globe.

Making sense

Constance Classen observes how the senses are ordered by and underpin all cultures with sensory models shaping lives. For example in the twenty-first century Western world within which I am writing, it is the 'eye minded' philosophy that came to dominance in the eighteenth century that continues to dominate thought. It was in the Age of Enlightenment that the earlier importance of smell positioned alongside sight was displaced. Perfume, once a metaphor for truth now has only cosmetic value while vision reveals truth and is privileged in the museum. Classen points out that the opposition between sight and smell is relatively recent, referring to Shakespeare's words: 'A rose by any other name would smell as sweet' – not 'look as beautiful' (Classen 1993: 25).

My enterprise in this chapter involves stepping outside the contemporary European ordering of just five senses, with the sense of sight positioned at the apex of 'civilization' followed by the aural, while smell, taste and touch are regarded as 'lower senses' associated with 'lower races' (Classen and Howes 2006: 199–206). Specifically in the context of the twenty-first-century anthropology museum, what seems to be required from a personal positioning of ten years' experience within museum/school education, is a fundamental acknowledgment that different cultures have unique ways of valuing, combining and ordering the senses commonly noted in the West, as well as recognizing a wider range of senses such as balance and proprioception (Guerts 2005: 166). A further contention is that material culture may be employed to 'dignify and engage' the senses across cultures, to permit a richer appreciation of the inextricable

interrelationship between the 'imagination and reason' based upon 'experience' in the world (Edwards, Gosden and Philips 2006: 25; Stoller 1989: 145).

In other words I shall explore ways of opening the museum to diverse 'worlds of sense' (Classen 1993). I argue that the human body and the senses, although they are counted and ordered differently around the globe – are fundamental to our common humanity – to personhood, and to the socio-cultural construction of embodied knowledge the world over (Stoller 1989: 95; Classen 1993; Howes 2005). Thus while the chapter highlights the senses and emotions it does not denounce reason; rather, it operates at a 'frontier' space of learning, which is politico-philosophically motivated (Golding 2005; 2006; 2007a, 2007b, 2007c). Language is key to understanding this frontier region of embodied knowledge and to 'safeguard against purely emotional outbursts that militate against debate' (Younge 2008: 29).

Language and emotion

In delineating a particular notion of embodiment and intention, I cite language as a prime feature of humankind. Language can be said to involve all the senses; writing is a tactile act and speech is not only auditory but also kinesthetic and olfactory, being 'carried on the breath' (Classen 1993: 50). Language arises out of the body, whether from '*lips dripping*' with hatred and division or from the desire for unity and love as the Dr Martin Luther King, Jr 'Dream' speech foregrounding the chapter highlights; it marks out our humanity in a world we share, a human relation or 'being with' the social world of objects and other humans (Gadamer 1981: 232–4; Freire 1998: 72). The human ability to manipulate ideas and communicate in language is a universal feature we may take pride in, and the voice of King, underscores the human capacity to use speech with intention, consciously or carelessly to celebrate or wound.[1]

Listening to King's 'Dream' speech in 2008, 45 years after it was delivered, points to the importance of the oral delivery of ideas to engage feeling and intellect, to add weight to the emotional power of words and their use as tools in the struggle for human rights, social justice and equality. There is a special cadence to King's delivery that can be heard online and a lyrical repetition of the key sentiments: the emotional desire inherent in the 'dream' to end segregation and 'let freedom ring', which is most importantly rooted within the wider 'American dream' that sadly eludes too many African Americans who remain disadvantaged by economic poverty (Younge 2007: 5–6). The 'grain of the voice', which is 'the materiality of the body speaking … the body in the voice as it sings, the hand as it writes, the limb as it performs' is vital to the impact of King's message (Barthes 1977: 182, 188).

King's speech shows how language can profitably connect affective impulses to the world. The words and delivery strike a pertinent balance between the emotional and the intellectual, the mind and the body, the individual and society that enables us to move beyond the 'either-or' of binary thought that traditionally separates emotion and reason. Similarly both emotion and critical thinking are central to the consideration of the embodied museum/school learning experience. A holistic position is taken, which regards socially constructed beliefs and value systems as central to the generation of individual emotions, and additionally perceives socio-cultural and mental linguistic factors as crucially impacting on emotional states (Svašek 2007: 229–30). This is a cross-cultural standpoint, emphasizing the emotions in a socio-cultural context and observing emotions as key to the rational making of meaning, as well as a sense of social wellbeing that closes the 'heart versus mind debate' and proves productive to learning (Wulff 2007: 1).

Now I feel my own emotions – predominantly fear and anger – rising, when I recall the words '… UGLY DOG SHITS …' cited above. In contrast with King delivery, the second abusive speech was vehemently hurled at me – who usually 'passes for white' – and at my black woman friend from St Kitts by an unknown drunken 'man on the Clapham omnibus' as we travelled to see *A Midsummer Night's Dream*. This speech was not my first personal experience of racism, but the extreme vehemence with which it was delivered – the words spluttering like wet bullets searing right into flesh, eyes, lips – as well as the particular time in my teenage life at which it came, was a particularly shocking instance of racial hatred intruding into our lives of economic poverty, which indelibly marked my thought – an epiphany, a sudden intuitive leap of understanding – pointing to a personal dream of solidarity and the necessity of standing firm in opposition to injustice (Freire 1985; 1998).

Objects and the dream theme

A 'dream', an ideal in King's speech, resonates in the liberatory museum praxis I have been developing and is the theme of a museum/school project I discuss presently. Just as King's dream text is inclusive – making positive connections between peoples today while acknowledging histories of oppression, rousing the intellect and the emotions towards the dream of a brighter future – so his passionate oral delivery has an electrifying effect on the audience who are included in a preaching tradition that recalls African 'call and response' modes of communication and musical forms; forms that I shall demonstrate being effectively employed to promote stronger connections between pupils in London and African collections displayed in their local museum.

As King draws connections between people and the land – the 'red hills of Georgia' – I explore connections between people and space, past and present times, through the sensory threshold of objects housed in the museum. Additionally, as King spatially connects his stance with earlier freedom fighters, noting the historical site where he stands and delivers his words – the steps of the Lincoln Memorial in Washington DC – to highlight the importance of black and white people marching ahead together to dismantle the barriers of racial inequality, to break the 'manacles of segregation and the chains of discrimination',[2] so the collaborative programming discussed here is crucially delivered by a multiracial team who endeavour to shatter the barriers to access for a group of disabled pupils.

Objects are located at the heart of liberatory educational programming and provide sensual routes to knowledge construction at the museum and the school. Objects like language move with people across time and space, and the meanings humans attach to things shift all the while, which leads to objects being 'imagined and experienced as emotional agents' by the pupils able to 'challenge, anger and please' (Svašek 2007: 230). In the next section I examine how thoughtful programming with museum objects can prompt dialogical exchange and communication that is problematic for autistic pupils, as well as progress 'community cohesion' by illuminating a common vision, a mutual sense of belonging and equality of life opportunities.[3] First I offer an outline of the museum/school fieldsite where the multi-sensory programmes took place.

African Worlds and 'Inspiration Africa!' at the Horniman Museum, London

The Horniman Museum's internationally curated *African Worlds* exhibition opened in 1999. Intellectually, it highlights the value of intense collaboration with originating communities and the African oral tradition of disseminating knowledge in raising a wide range of new voices

from around 25 members of the local UK communities and African experts in the text panels (Shelton 2001).

African Worlds is distinctive in employing a variety of innovative techniques to enhance the communicative power of the wonderful objects, historical and modern, which comprise it. The objects are treated as art and displayed according to aesthetic principles, but together with layers of contextual information to engage different levels of interest as well as portraits of the 25 voices quoted to personalize the text. This humanizing exhibitionary ethos was seen as important to positively revalue the cultural traditions of Africa and present a counter view to the widespread notions of famine and 'primitive otherness' that continue to be perpetuated in the media and which has such a detrimental affect on children of African-Caribbean heritage (Gilborn 1995). Archive and contemporary video, music and photographs impart rich thematic 'glimpses' of

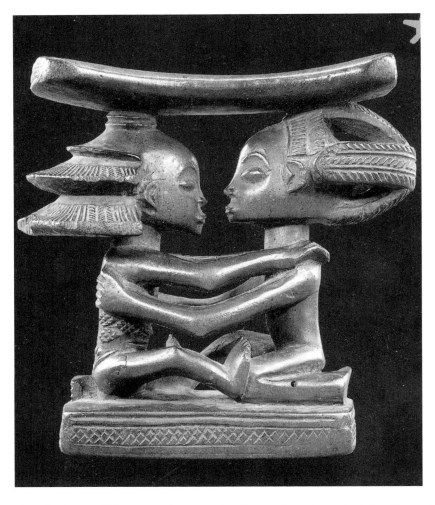

Figure 15.1 Headrest, c.19th century, Luba peoples, Congo; from the author's handling collection (photograph by Viv Golding)

African unity in diversity, contrasting strongly with the geographically homogenizing effect of earlier, more simplistic displays (Shelton 2001).

The exhibition's designer, Michael Cameron, used theatrical techniques to engage the viewer: for example key objects – characterized as 'heroes' by the exhibition team – are spot lit and set as if against a stage of warm earthy red colours, to excellent dramatic effect (Shelton 2001). A group of Shona headrests (such as the one shown in Figure 15.1) is presented together with Ashanti stools, some displayed on their sides, which prompts attention to the sculptural forms behind the fronts of the glass and steel cases. However, while drama in the theatre invites emotional responses by drawing on costume and the live voice, in the aesthetic display space it is predominantly 'eyes and minds' that are made most 'welcome, [while] space-occupying bodies' are usually less so (O'Doherty 1976: 15). It is to more holistic mind and body experiences during 'Inspiration Africa!' programming that I turn next.[4]

'Inspiration Africa!' – a £72,000 DfEE (Department for Education and Employment) funded collaborative programme jointly managed by Horniman Museum and the Cloth of Gold Arts Company – engaged twelve schools in twelve object-based projects over a two-year period of intensive research and creative activity.[5] A major aim of 'Inspiration Africa!' was to draw connections between the museum objects displayed in Horniman's *African Worlds* exhibition and the everyday lives of the individual pupils and the wider community, histories and futures. Similarly, while each school approached the 'Inspiration Africa!' project via intensive engagement with one particular key object and one specific key theme, all twelve schools also had the opportunity to engage with other objects in the museum and with the wider 'Inspiration Africa!' community through the dedicated website and the construction of the collaborative virtual banner.

An open, non-hierarchical ethos was a feature underpinning team-work, which directed work in a borderland space between the museum and the school where the children's voices expressing their feelings, wishes and dreams could be heard alongside the African objects. We viewed the contact with African art in the museum not as a homogenizing force but as specifically generative and illuminating, where actual differences, the particular cultural knowledge that inspired the making and use of the objects, might be perceived alongside similarity to progress understanding beyond limited stereotypes. Such practices demand that museum programmes proceed in multiple ways that are relevant to the present day context of the young people, making full use of their developing intellect, feelings and senses as I will demonstrate with reference to one school field-site.

Dream cushions: at the museum/school frontiers

Brent Knoll School is located in the London Borough of Lewisham, a ten-minute walk from the Horniman Museum. The teachers visited the museum regularly, at least once a month, with their pupils. They prepared their classes carefully for the new ideas and objects that were encountered on consecutive visits and attempted to build up a sense of familiarity with certain exhibitions, notably the Aquarium, which was most popular.

During 'Inspiration Africa!' the pupils engaged in considerable emotional engagement at the museum and eventually produced the highly creative outputs shown in Figure 15.2, the dream cushions, which were based on a Shona headrest (c. 1900). The 'Inspiration Africa!' project team leaders who facilitated these outcomes at Brent Knoll School included the core group: Tony Minnion as artist/project coordinator, Jacqui Callis as website developer/artist and myself as outreach worker from the Horniman Museum. This core team welcomed the Horniman

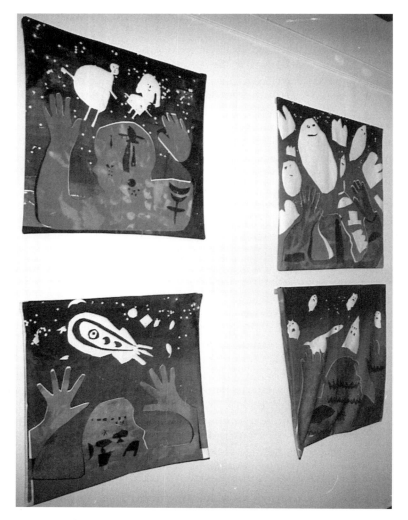

Figure 15.2 Brent Knoll's dream cushions in the 'Inspiration Africa!' display at Horniman Museum 2001 (photograph by Viv Golding)

Museum's education officer, Sheila Humbert, and Amoafi Kwapong, a regular Horniman Museum story-teller/musician originally from Ghana, West Africa, to work with sixteen pupils aged nine to eleven in two Year 5 and 6 classes who were all on the autistic spectrum and had mild learning difficulties.[6]

In the UK more than half a million people from all racial, ethnic and socio-economic backgrounds have an autism spectrum disorder, with varying degrees of severity and impact, which ranges from no speech and limited cognitive ability to high IQ and highly-focused interests and abilities. The emotional impact of autism on individuals and their families can be difficult since the autistic individual can perceive the world as a confusing and frightening place and around 30 per cent of children with autism have a clinically recognizable emotional or anxiety disorder.[7]

Group activities and team building are valuable tools to aiding such youngsters, and museums have scope to contribute much. In this instance, the Brent Knoll School teachers were keen to offer advice on their pupils' specific social impairments and to work alongside the 'Inspiration Africa!' team leaders. The teachers highlighted problems including inattention, lack of spontaneous response to the emotions of others, poor ability to communicate nonverbally and to take turns in groups as listeners and speakers, which are essential to success at Key Stages 1 and 2 of the National Curriculum for English.[8] They pointed out that autistic children do not prefer to be alone but highly value a limited number of quality friendships once they are forged, although they suffer difficulties in the initial stages of making and maintaining friendship bonds.

Reflecting on effective programming for their pupils, the 'Inspiration Africa!' team leaders noted the need to focus on developing communication, social, and cognitive skills. Music therapy and aromatherapy had proved to be particularly positive interventions at Brent Knoll and the importance of employing senses other than the visual was emphasized, since people with autism experience difficulty reading what are widely regarded as 'normal' visual traits of social communication, such as the safety and pleasure widely felt from seeing a mother's smiling face or returning her gentle touch. It was this lack of intuition about other people and the apparent gaps in understanding the processes of social communication, which the Horniman Museum/ school programming set out to address, by providing a number of stimulating pathways to social engagement and to the potential development of friendships or at least enhanced familiarity with fellow pupils.

In the first museum visit pupils were engaged in tactile experiences with a restricted range of original objects from the West African handling collection including: gourd cups, a headrest and an Ashanti stool. This selection took account of the teachers' experience that the pupils' attention span was limited and that they would tire easily, and so the textile wraps, hats, musical instruments and the toys were reserved for subsequent sessions. 'Inspiration Africa!' project team leaders were thus concerned to enable pupils not just for collecting 'facts' such as the information in the museum text panels and booklets, which could be dry and difficult. For example:

Shona headrest, c. 1900, maker anonymous, wood.
 Shona chief, Chief Nyoka, explained how, after having problems judging legal cases brought before him, he had commissioned a headrest for himself. By sleeping on it, he received dreams which he found useful in helping him make decisions about his cases.
 (Horniman label and booklet 2001)

As team leaders we considered this interesting and important historical information to impart, but our concern was also to facilitate pupil's learning about how to interrogate data for a range of underlying 'meanings', both historical and personal. This required us to translate key messages from the text panels into child friendly language that might promote pupils' personal meaning making and connections. Additionally Brent Knoll pupils with their particular learning needs found the theatrical museum displays rather forbidding and difficult to access – hence a 'safe' space where the pupils would feel a sense of belonging and homeliness was constructed to enhance this group's experience and achievement. Bringing the Education Department's 'magic carpet' – used for storytelling sessions – into the exhibition space where the key object was on display, helped to promote a cosy atmosphere conducive to dialogical exchange around objects.

The pupils were greeted warmly and gathered around for a range of multi-sensory experiences to develop what Howard Gardner terms their 'multiple intelligences', specifically their 'bodily kinaesthetic, musical, linguistic, intrapersonal and interpersonal intelligences' (Gardner

1993). In addition to these, Gardner holds that there are 'logical-mathematical, spatial, and naturalistic intelligences' (currently counting eight in total). Individuals are said to hold different combinations of these intelligences but, taken separately, each draws on different cognitive strengths and contrasting cognitive styles (Gardner 1993: 12). The importance of this pluralistic view of mind lies in revaluing the western concept of intelligence as primarily concerned with the rather abstract mathematical-linguistics to the exclusion of other ways of knowing and experiencing the world through more sensory means. However, while the concept vitally challenges the notion of value attached to the limited Western view of intelligence, which has disadvantaged black and working-class children in intelligence testing systems, we must admit that it is culture-bound in excluding taste and smell, for example, as ways of knowing (Howes 2006: 6).

Nevertheless, our educational experience with museum objects reinforces Gardner's point that the intelligences and we would add the senses, are vitally interconnected. To take one example here at the outset of the museum visit, we supported diverse pupils' involvement in handling an object – such as a gourd drinking vessel – employing bodily kinaesthetic, linguistic, intrapersonal and interpersonal intelligences since they were encouraged express their feelings and opinions all the while. To help connect the pupils with this object Amoafi asked the pupils 'what do you like to drink when you wake up in the summer mornings when it is hot?' This prompted comments about healthy drinks, juice and milk for everyday with cola and fanta at parties. Then as some pupils were thirsty we all partook of an imaginary cool drink – whatever we liked – from the gourd. Amoafi wanted to highlight both the universal feature and the local distinctiveness associated with human act of taking liquid into the body through handling one piece of material culture and engaging in dialogue. She noted human beings all over the earth and across the centuries require drink to sustain life, employing diverse materials and making different vessels to fulfill this need. Most importantly she took care throughout her sessions to use language appropriate to the pupils. She told them how some Ghanaians like her are fond of using gourds or calabash when drinking water since 'a special coolness or peace' can be derived from this method in hot weather, which other writers have noted (Guerts and Gershon 2006: 35).

Handling this object the pupils noted it was lighter than it looked and they imagined it getting lighter still as the imaginary drink was consumed. 'It's light, cool, cold, light, not heavy, lighter now' they commented. They all seemed to appreciate balancing the gourd form in their hands and exploring the smooth surface texture. Two non-verbal pupils especially enjoyed smelling the gourd while touching and endlessly tapping it all over, small section by small section, without spilling a drop of the imaginary liquid! Temple Grandin, writing from the perspective of an adult autistic person, has observed how such tapping seems to aid understanding of the object boundaries and the relation to the body in space for some autistic people (Grandin 2005: 321). In the museum context bodily contact with the object seems to be able to help promote a feeling of security in the social space that is derived from perceiving the stability of the external world and the human relation to it, which allows the child some relaxation and hence is felt as a pleasurable emotion of 'coolness and peace'.

Tactile handling activities such as this first gourd case were intended to bring objects in static displays to life in the eyes, ears, hands, noses, mouths, hearts and minds of the pupils. All the activities and objects I shall highlight next were chosen from previous experience by the team leaders to facilitate the making of sensual, emotional and intellectual connections between distant cultures on display and the children's everyday lives. This was crucial. As team leaders we agreed human sense-making is embodied in material culture rendered 'touchless, speechless,

and smell-less', through the glass cases of the traditional anthropology museum, in a symbolic disciplining of the 'other' to the dominant western gaze of the educated, wealthy visitor (Classen and Howes 2006: 210–211). For Brent Knoll pupils to access the meanings of the objects, multi-sensory routes to knowledge construction, imaginative and affective engagement was vital.

David Perkins, one of Gardner's Project Zero Harvard researchers observes how close observation of art can engender questioning or 'thinking dispositions', which 'connect to social, personal and other dimensions of life with strong affective overtones' (Perkins 1994: 3–4). At the Horniman Museum we also noted objects help to pose 'good questions' to the viewer and provide a powerful affective springboard for dialogue, drawing on intellect, emotion and imagination. It was important for children to employ creativity and imagination to mediate the external world of feelings, ideas and desires, which the object-centred talk generated. Handling objects offered a pertinent means of anchoring emotions, thought and motivated pupils to engage in talk over an extended period of time. We understand this sensual thinking activity as a 'passionate enterprise' stimulating strong feelings 'concern and commitment, spirit and persistence' over time (ibid.: 13).

Taking time to look, interact and discuss the objects in a spirit of mutual exploration with the team leader artists, museum-educators and schoolteachers, gradually raised the Brent Knoll pupils' confidence, which enabled them to build-up expressive skills and communicate increasingly complex ideas. For example, looking at the headrest in the handling collection and trying it out for comfort through touch prompted the engagement of pupils in discussing common experiences – the needs for sleep and dream across cultures. Posing questions when handling the headrest: 'do you sleep with a headrest at home, how do you rest your head when you sleep?', helped to connect the pupils with the object and also highlighted the differences between squashy feather pillows at home in London and firm wooden headrests in South Africa, which in turn prompted pupils' imaginations to explore the reasons for structural differences in materials and technologies. Pupils remembered we often wake up on our pillows with messy hair in the morning, while the headrest would protect a more elaborate hairstyle, which prompted the deduction that the headrest would be cooler to sleep with on a hot summer night when we often wake up sticking with sweat to our pillows.

The museum handling session importantly involved pupils listening to each other and to the museum's ideas on the displayed headrests: how some very old headrests were once covered with gold, how they can support our necks while we sleep and help to protect our fancy hairstyles, how we think only men owned headrests in old Zimbabwe and perhaps used them as a status symbol, what different ideas people have about the meaning of the symbols on the headrests and perhaps most importantly for this project, how some old headrests were thought to 'catch' the dreams of the sleeping person. These points inspired questions such as: if you had a headrest what would you like it to be made from? should women have a headrest too? do you have any status symbols, such as Nike trademark ticks on your trainers, for example? what do you think the headrest symbols might mean? Again, schoolteachers noted how enjoyable it was for the children to interrogate the museum object in conversation, by drawing connections with daily life. The enjoyment of the museum objects was enhanced by being linked to pleasurable activities outside the walls of the museum and school, for example reflecting on favourite TV programmes, comics, holidays, eating food and drinking while wearing trainers.

Following oral engagement, when these bodily kinaesthetic and talking activities had sufficiently relaxed the pupils, we asked them to look again closely at the Horniman headrests on display and write down on their worksheets what they thought about them and how they made them feel, with the help of a scribe if needed. They had mixed feelings: 'hard and uncomfortable

because they are made of wood … peaceful … happy … sleepy … confused and tired … horrible …-' After sharing their ideas the pupils went on to find and draw other objects in the exhibition, which featured shapes and patterns similar to those included on the Shona headrests. Finally, because we had spoken at the start of the session about the Shona headrests 'catching dreams', Amoafi ended the session by telling two short stories about dreams which aimed to engage the pupils in emotional dialogue – actively listening and making critical comments, rather than passively absorbing the words of the storyteller.

In one story, a dream spirit granted a poor man with a blind mother and wife who wanted a baby, one wish. Amoafi asked the pupils what *they* might wish for: wealth, sight for his mother or a baby for his wife? Different pupils responded with reasons for each of the three wishes: wealth would benefit the whole family, but it would not give sight to the blind nor could it buy a baby. We should not be selfish and wish for ourselves, but whose wish is more important in the story – the mother's or the wife's? One girl sadly recalled a blind grandpa crying, a boy mentioned his mum wanted a baby and another pupil said she might cry now. Amoafi had the sensitivity and storytelling skills to acknowledge and 'hold' the sad emotions of the group without an overwhelming negativity pervading the space and without abandoning everyone to a distraught state. Eventually she told the pupils 'the man wished his mother could see his wife rocking their baby in a golden cradle full of gold coins', which was considered to be a most satisfactory solution.

African storytelling, in posing questions, provided a powerful means for the museum to engage in a dynamic dialogue with the Brent Knoll pupils since they were asked to actively contribute their own ideas and feelings. This two-way dialogical process and the embodied experiences with objects equipped the listeners with inspiring tools for making their own meanings out of the handling and exhibited objects by helping them to draw connections with their daily lives as we have seen. For our final activity at the museum, Amoafi and I asked the pupils to reflect on their own dreams, which are like wishes, and share them in conversation with the group. Our intention was for pupils to begin to employ their dream images in the imaginative retelling of their own stories. The pupils offered some personal dream fragments, which included: 'computerized mini-scooters going into space; a cloud with an alien spaceship inside landing in the garden; toys; Kung Fu; ghosts eating jelly; a brother in hospital with water; watching a comet from earth; vampires and trees; animals; houses; racing cars having accidents and putting out fires.' Brent Knoll teachers considered these important fragments of personal communication for the pupils, and rich notions to build upon and expand in storytelling and art work back at school.

Thinking of dreams away from the museum: school reflections

At school the following day the pupils developed their dream ideas through literacy work. The autistic child, who can be fearful of human touch, was seen to welcome haptic interaction with objects in the museum and so handling was once more encouraged. Pupils were presented with a range of African textiles from the museum handling collection, including hats with sparkly threads, softly woven kente silks and brightly printed cottons, which prompted much joyful recall of the museum visit. We were especially pleased to observe the two non-verbal pupils again finding pleasure in touch with the textiles that they rather than another initiated (Grandin 2005: 318). Initiating touch was pleasurable for the pupils in offering physical interaction and a sense of connection with the material world, which brought the world into a more sharply defined focus and vividness leading to 'safer and happier' feelings (Classen 2005: 76).

Then literacy work began with Amoafi retelling the dream story to further remind pupils of the museum. There is dynamism to the oral event that escapes notions of a single rigid meaning, which might always be imparted in a linear fashion laid out before the eyes for reading (Classen 1993: 107). The ideal story space is rather likened to a 'forum', where all participants have an active role in negotiating meanings (Golding 2007c). For Brent Knoll pupils offering 'frame' sentences – 'Sometimes I dream about …' and 'But my best dream of all is …' – for the pupils to complete, provided a helpful structure for organizing their feelings and ideas in greater detail. For example:

> Sometimes I dream about: vampires taking over the world, making a rocket, attacking a robot, but my best dream of all is getting a new bike.
>
> Sometimes I dream about: dragons eating me, my brother is shooting in the night, about sleeping in my mum's bed, but my best dream of all is when I get a hamster for my birthday.

The 'safe' space that the 'Inspiration Africa!' team had constructed at the museum with the handling objects on the 'magic carpet' was mirrored at school and extended. Wrapped in their chosen dream cloths and wearing wish hats, pupils seemed to experience an embodied feeling of ease that furthered the pedagogical task of possibly sharing a nightmare alongside a 'best' dream. In some sense the touch of the textiles permitted the children's anxieties and fears to emerge orally and most importantly to be contained in the space. As in the museum providing a secure setting with objects was vital for the unfolding of narratives on frightening events such as 'accidents and fires'; terrifying meetings with 'ghosts, vampires and aliens' in scary places like 'hospitals and spaceships' that were disturbing in the wider world but not crippling when brought to voice and written word or expressed visually in art.

Raising negative feelings in, and in association with, the museum, demands that team leaders act therapeutically, helping to contain or 'hold' the emotion and minimizing its destructive effect. To a large extent it was Amoafi's skill that permitted uncomfortable feelings to be explored and held in the safe framework of the imaginative story space, which was enhanced by the selection of handling artefacts. It may be objected here that it is rare to have such a skilled educator like Amoafi and that the museum educator is not 'a therapist or social worker', but this 'does not excuse' her 'for ignoring the suffering or disquiet' of a student and furthermore the 'capacity for empathy and solidarity, that very humanity is in itself therapeutic' (Freire 1998: 128). We argue from our 'Inspiration Africa!' experience that giving voice to emotions, through reflexive dialogical exchange sparked by close encounters with objects made significant to children's lives, is of therapeutic value that can be enhanced through active play with language and narrative story structure.

Sigmund Freud, the great father of psychoanalysis, notes that certain objects are endowed with special significance by human beings from their earliest years. In 'Beyond the pleasure principle', Freud muses the special nature attached by a small boy, one and a half years old, to a wooden reel on a string in his game 'fort … da' [gone … here], where the child rolls the reel away expressively calling out 'gone' and reels it back again calling out 'here' with equal passion (Freud 1984). Freud notes the child in imaginative play with an object and with language. In his view, the child is employing the reel and the language game as a substitute for the absent mother and it is with these uniquely human means that the child can take some sense of control over the uncertainties of life as a vulnerable infant who is subject to separation from the first love object, the mother.

It can be argued that Freud's paper provides us with an analysis of the emotional power certain objects hold for human beings. If we accept that the reel can serve as an object in a language game permitting the small child to cope with difficult emotions, the feelings of loss, separation and the threat of abandonment, then perhaps this thesis may cast light on the power of the museum object to inspire 'resonance and wonder' in the viewer, and the power of human action and connectedness through objects (Greenblatt 1991). For example, through touch pupils were able to modify objects in the world, causing musical instruments to emit sound or the textiles they wrapped around themselves to change shape in line with increasing feelings of bodily comfort (Tuan 2005: 75–78). The sound of seed pod shakers, bells, xylophone and drums were relatively easily made with Amoafi's expert direction and carried a tremendous tonal quality that was quite literally 'felt' in the body, which made the music experience akin to experiencing an African language intimately connected to emotion (Stoller 1989: 163). In other words, the museum, with its objects and its wealth of contextual material surrounding them, was seen to offer a prime site for a deeply engaging experience or 'minds on' activity, which is distinct from simple 'hands on' (Hein 1998: 31). These ideas can be further illuminated, and demonstrate elements of fun learning or 'edutainment' with reference to artwork. The successful gaining of embodied knowledge through multi-sensory work with objects prompted similar approaches to the 'dream cushion' artwork, which highlighted the embodied mind as a vehicle for creative effort. The exceptional quality of Brent Knoll's art, which expresses complex ideas, visually arose out of the sensory work of communication with storytelling, for example, prompting listening attentively and speaking with respect – primary work of language and social engagement that the pupils had found so difficult.

Discussion and art activities were designed to bring the pupils together, in mutually supportive tasks. To make their dream cushion art work, pupils worked in pairs, one lying on a large piece of paper imagining themselves asleep on their pillow at home, whilst another child carefully drew around them to produce a silhouette of the sleeping child with space above to add dream shapes. The subsequent dream shapes activity employed images from the museum visit taken from observations of patterns sketched on worksheets and personal dreams. These were later screen-printed by the pupils onto individual dream cushions for the storytelling corner. In the process, pupils considered the emotional effect of different cold and warm colours, employing warm or cold colour blends. They were also able to make their blends visually effective, using light colours at the bottom growing darker at the top, just like a night sky.

While considering the emotions and colour, pale blue was widely seen as a cold unfriendly and unfeeling colour, which reinforces Classen, who also notes blue being associated with depression in the sixteenth century and indecency in the nineteenth (Classen 1993: 61–3). No pupil mentioned blue in the sense of obscene but blue was regarded as a sad colour by many pupils and linked to the expressions of feeling blue, although the brighter blues reminded one pupil of the Caribbean sea and were associated with warm waters. Pupils were reminded of the warm welcome at the museum when using and talking about the warm and hot red and yellow tints and hues, but they did not associate hot figuratively to mean excited, nor with scent to mean strong, or to describe lively music (Classen 1993: 67). The hot colours were associated with the sun, warm sunny days and lovely long warm baths, with sweet-smelling soft-textured bath foams by some pupils. This inspired some more touch activity and two bowls one with warm and one with cool water were provided for children to dip and wash their hands in. Here the tactile sense was activated by contrast, alternations of heat and cool, and this embodied experience was intimately bound to sunnier mood and emotion, by recalling the thermal delights of shade and coolness in the heat of the sun (Tuan 2005: 77–8).

Finally, before drawing some conclusions from this case study, it is worth emphasizing once again the pleasure derived from haptics, the pleasurable sense of touch during the making of their art work, which was achieved when hand painting directly onto squares of fabric for the back of the cushions, squeegeeing off the excess ink and then mono-printing designs on top. Grandin notes that while the sensual pleasure in touch may be compromised in autistic children whose skin can be excessively sensitive it can also be highly valued as providing reliable information about the external world and permit autistic individuals a degree of learning and understanding of the environment through their fingers (Grandin 2005: 320). Bearing in mind this point, sand was added to some of the smooth thick printing inks and the feeling of these contrasting textures enhanced the pupil's bodily pleasure just as the experience of contrasting temperatures had earlier.

Conclusion

In this chapter I have explored a vital unity between reason and the senses. I began from a personal position in the twentieth century, offering a disclosure of one traumatically emotional experience of racism during my youth together with the healing optimistic 'dream' speech of an anti-racist future, which served as a productive theme for a museum/school project entitled 'Inspiration Africa!' at the beginning of the twenty-first century. The chapter outlined how notions of the dream and the wish gave rise to a whole cluster of individual emotions such as happiness and fear for two classes of pupils on the autistic spectrum who were facilitated in sharing feelings, which they found difficult but manageable at a 'frontier' fieldsite between the Horniman Museum and their school Brent Knoll.

At the museum/school frontier the pupils focused on material culture: one key object, a Shona headrest on display, that was said to prompt dreams, and a handling collection of sub-Saharan objects including textiles, musical instruments, gourd vessels, headrests and stools. In active learning sessions including storytelling, music and art making attention was drawn to the museum objects as well as to the wider intangible oral traditions from which they emerge, which prompted dynamic emotional and intellectual connections between and within the displayed cultures and the contemporary lives of the pupils. Most importantly, activities did not set up binary oppositions between one sort of visual 'Western' and one sort of aural 'African' culture but attempted to work with a sensory mingling that Classen observes as the natural state of the baby the world over, who reaches out and looks to the light (Classen 1993: 56)

While all the activities were largely enjoyed, it was the pleasure derived from the sensual embodied experience of handling objects that was 'self-affirming and self-transcending', which was especially important for the autistic pupils for whom handling seemed to provide a variety of sensory keys to unlock their virtual imprisonment in private worlds (Classen 1993: 69). It was in giving individual expression within the school group through touch, smell, taste, voice, art and music, to the 'nightmare touch' of 'unutterable monsters and abortions' of dreams (De Quincey 2005: 342) that fears preventing communication seemed to be eased. Touch proved a key sense to gain embodied knowledge, just as handling offered an essential means of acquiring knowledge for the wealthy visitor to the Ashmolean Museum as long ago as 1702 (Classen and Howes 2006: 201). For example, pupils were able to feel the lightness of objects such as the big gourd water pots, which appeared so heavy to the eyes alone, and this startling correction to the illusion of the single sense of sight, provoked wonder and the desire to repeat the pleasurable experience.

Perhaps touch was a joyful experience because of its immediacy and direct relation to the body, the feel of silky textiles next to skin for instance, produced intense emotional reactions

and startling sensations in the mind that pupils were able to express through words, images or gestures. Touching objects seemed to provide a straightforward physical connection with the makers and users from past times and distant places, somehow prompting a feeling of what the other may have felt through the material reality of things. For example through embodied engagement with unfamiliar museum objects and discussing their tactile qualities in comparison with familiar objects from home, such as a Shona headrest and a feather pillow, pupils came closer to indigenous feelings and meanings and closer to communicating their own trapped feelings and meanings, which was seen to be immensely satisfying and agreeable. Working with a professional artist Tony Minion and the storyteller/musician Amoafi Kwappong, who shared the African heritage of the museum objects, proved an added impetus to inspire pupil's creativity and greatly motivated communication in general, which was difficult for the pupils. Collaboration not only raised the quality of the pupils' own art, the fantastic dream cushions and their musical skills and understanding, but also developed their multiple intelligences, which reinforces recent research (Perkins 1994; Gilborn 1995).

Overall, intercultural understanding was progressed by illuminating commonalities across cultural differences, and cross-cultural empathies were facilitated through the multi-sensory features of projects that enabled pupils to make 'sense' of their shared world (Classen 1993). This took time and the development of 'safe' social spaces in the museum and the school, such as the welcoming museum space with the 'magic storytelling carpet', which proved crucial to relaxing pupils. In short, in taking time to discuss ideas with the teachers throughout the project work; pedagogically slowing down and 'listening' to the pupils' expressing their dreams, wishes, doubts and fears; constructing as many sensual bridges as possible between the world of the autistic pupil and the world of the object, arming them with information, imagination and empathy – humanity was seen to communicate with humanity (Freire 1998; Csikszentmihalyi and Robinson 1990: 132).

Notes

1 http://www.usconstitution.net/dream.html, accessed 30 November 2008.
2 King's speech locates the importance of his dream of racial equality within the wider American dream: 'its creed', of 'self-evident truths' and values based on 'inalienable' human rights – first set out in the USA on 4 July 1776 in the Declaration of Independence (http://www.usconstitution.net/declar.html accessed at 15 May 2008). Nonetheless in the eighteenth century these human rights excluded certain humans – explicitly 'the merciless Indian Savages', and tacitly the enslaved African American people, whose humanity, liberty and equality was not recognized until the Emancipation Proclamation (1862, 1863) of the nineteenth century, which King cites. The Emancipation Proclamation of 22 September 1862 declared the emancipation of the enslaved, and the executive order of 1 January 1863 named the actual states to which emancipation referred. Then on 18 December 1865, the thirteenth Amendment ratified the prohibition of slavery in the Constitution http://www.usconstitution.net/eman.html; http://www.usconstitution.net/const.html#Am13; accessed 8 August 2008).
3 Cf. http://publications.teachernet.gov.uk/eOrderingDownload/DCSF–00598–2007.pdf accessed 30 November 2008.
4 I consider these issues further in Golding 2009.
5 http://www.clothofgold.org.uk/inafrica accessed, 30 November 2008.
6 http://www.brentknoll.lewisham.sch.uk, accessed 30 November 2008.
7 http://www.autismspeaks.org.uk/autism_spectrum_disorders.html, accessed 30 November 2008.
8 http://curriculumonline.gov.uk, accessed 30 November 2008.

References

Barthes, R. (1977) 'The grain of the voice', in S. Heath (ed.) *Image Music Text*, London: Fontana Press, pp. 179–89.

Classen, C. (1993) *Worlds of Sense: exploring the senses in history and across cultures*, London: Routledge.

Classen, C. and D. Howes (2006) 'The museum as sensescape: Western sensibilities and indigenous artifacts', in E. Edwards, C. Gosden and R. Philips (eds) *Sensible Objects: colonialism, museums and material culture*, Oxford: Berg, pp. 199–222.

Csikszentmihalyi, M. and R. Robinson (1990) *The Art of Seeing: an interpretation of the aesthetic encounter*, Malibu, CA: J. Paul Getty Museum and the Getty Center for Education in the Arts.

De Quincey, T. (2005) 'The nightmare touch', in C. Classen (ed.) *The Book of Touch*, Oxford: Berg, pp. 342–3.

Edwards, E., C. Gosden and R. Phillips (eds) (2006) 'Introduction', in E. Edwards, C. Gosden and R. Phillips (eds) *Sensible Objects: colonialism, museums and material culture*, Oxford: Berg, pp. 1–31.

Freire, P. (1985) *The Politics of Education*, New York: Bergin and Garvey Publishers Inc.

Freire, P. (1998) *Pedagogy of Freedom, Ethics, Democracy and Civic Courage*, New York: Rowman and Littlefield Publishers Inc.

Freud, S. (1984 [1920]) 'Beyond the pleasure principle', in S. Freud *On Metapsychology: the theory of psychoanalysis*, London: Pelican.

Gadamer, H. G. (1981) *Truth and Method*, London: Sheed and Ward.

Gardner, H. (1993) *Multiple Intelligences: the theory in practice*, New York: Basic Books.

Gilborn, D. (1995) *Racism and Antiracism in Real Schools: theory, policy, practice*, Buckingham: Open University Press.

Golding, V. (2005) 'The museum clearing: a metaphor for new museum practice', in D. Atkinson and P. Dash (eds) *Social and Critical Practice in Art Education*, Stoke-on-Trent: Trentham Books, pp. 51–66.

Golding, V. (2006) 'Carnival connections: challenging racism as the unsaid at the museum/school frontiers with feminist-hermeneutics', in M. Inglilleri (ed.) *Swinging her Breasts at History*, London: Mango Publishing, pp. 290–309.

Golding, V. (2007a) 'Challenging racism and sexism at the museum forum', in J. Anim-Addo and S. Scafe (eds) *I am Black, White and Yellow: an introduction to the black body in Europe*, London: Mango Publishing, pp. 148–66.

Golding, V. (2007b) 'Learning at the museum frontiers: democracy, identity and difference', in S. Knell, S. MacLeod and S. Watson (eds) *Museum Revolutions: how museums change and are changed*, London: Routledge, pp. 315–329.

Golding, V. (2007c) 'Using tangible and intangible heritage to promote social inclusion for students with disabilities: "Inspiration Africa!"', in S. Watson (ed.) *Museums and their Communities*, London: Routledge, pp. 358–78.

Golding, V. (2009) *Learning at the Museum Frontiers: identity, race and power*, Basingstoke: Ashgate.

Grandin, T. (2005) 'Autism and "the squeeze machine"', in C. Classen (ed.) *The Book of Touch*, Oxford: Berg, pp. 318–21.

Greenblatt, S. (1991) 'Resonance and wonder', in I. Karp and S. Lavine (eds) *Exhibiting Cultures: the poetics and politics of museum display*, Washington, DC: Smithsonian Institution Press, pp. 42–56.

Guerts, K. L. (2005) 'Consciousness as "feeling in the body": a West African theory of embodiment, emotion and the making of mind', in D. Howes (ed.) *Empire of the Senses: the sensual culture reader*, Oxford: Berg, pp. 164–78.

Guerts K. L. and A. E. Gershon (2006) 'Enduring and endearing feelings and the transformation of material culture in West Africa', in E. Edwards, C. Gosden and R. Philips (eds), *Sensible Objects: colonialism, museums and material culture*, Oxford: Berg, pp. 35–60.

Hein, G. (1998) *Learning in the Museum*, London: Routledge.

Howes, D. (ed.) (2005) *Empire of the Senses: the sensual culture reader*, Oxford: Berg.

King, M. L., Jnr (1963) 'I have a dream', online, <http://www.usconstitution.net/dream.html> (accessed 30 June 2008).

O'Doherty, B. (1976) *Inside the White Cube: the ideology of the gallery space,* Berkeley, CA: University of California Press.

Perkins, D. (1994) *The Intelligent Eye: learning to think by looking at art*, Cambridge, MA: Harvard Graduate School of Education.

Shelton, A. (2001) 'Curating African Worlds', *Journal of Museum Ethnography*, 12: 5–20.

Stoller, P. (1989) *The Taste of Ethnographic Things: the senses in anthropology*, Philadelphia, PA: University of Pennsylvania Press.

Svašek, M. (2007) 'Moving corpse: emotions and subject-object ambiguity' in H. Wulff (ed.), *The Emotions: a cultural reader*, Oxford: Berg, pp. 229–48.

Tuan, Y.-F. (2005) 'The pleasures of touch', in C. Classen (ed.) *The Book of Touch*, Oxford: Berg, pp. 74–9.

Wulff, H. (2007) 'Introduction: the cultural study of mood and meaning', in H. Wulff (ed.), *The Emotions: a cultural reader*, Oxford: Berg, pp. 1–30.

Younge, G., (2007) 'As the sun set on the last century Britain reached for a predictable comfort blanket', in *Uncomfortable Truths: the shadow of slave trading on contemporary design*, London: V&A Publications, pp. 5–6.

Younge, G. (2008) 'America lauds Martin Luther King, but undermines his legacy every day', *The Guardian*, 31 March 2008, p. 29.

16

MAKING MEANING BEYOND DISPLAY

Chris Dorsett

Agents of change

In the early weeks of January 1999 I started planning an exhibition to mark, later that same year, the centenary celebrations of Cheltenham Art Gallery and Museum. Paul McKee, the museum's exhibitions officer, had invited me to consider the contents of the reserve collection as my theme. There was, McKee let me know, a great quantity of things in the storerooms and archives that remain year after year unknown to the public and, on the occasion of the museum's anniversary, the idea was to ask an artist to respond imaginatively to this hundred-year-old residue of collecting. The commission followed a trend. Throughout the 1990s there had been growing interest in artists as 'agents of change in the museum environment'. This phrase, which I first encountered at a conference entitled 'Engaging Practices: the forum for artists and museums',[1]

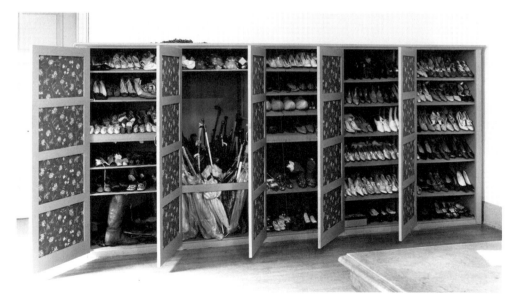

Figure 16.1 Storage cabinet with shoes and parasols, *Raid the Icebox 1 with Andy Warhol*: an exhibition selected from the storage vaults of the Museum of Art, Rhode Island School of Design, (photograph courtesy of the Museum of Art, Rhode Island School of Design)

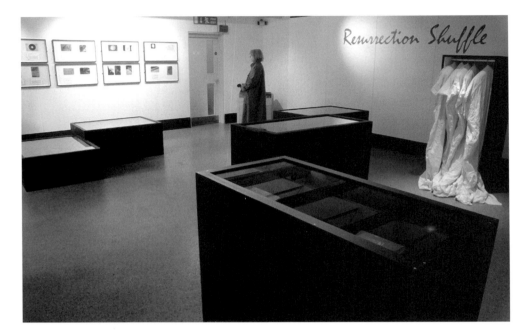

Figure 16.2 Display cases and framed journal entries from the author's installation at Cheltenham Art Gallery and Museum (photograph by Chris Dorsett)

introduces the topic of this chapter. I wish to review what happened when an idea about placing contemporary artworks amongst historical or scientific exhibits (my *modus operandi* at the time)[2] was refocused 'beyond display' to address collections held out of sight and in reserve.[3] I had been invited to speak at 'Engaging Practices' and so someone somewhere must have described me in appropriately transformational terms, even though the agent of change idea seemed, on first hearing, rather too instrumental to capture my own understanding of artistic endeavour. However, the phrase has rhetorical value in this chapter because it allows me to place curatorial meaning-making in a face-to-face relationship with my activities as an artist and thus form an interestingly asymmetrical image that renders contrasting ideas about experiencing materiality in the museum. We will follow this motif even though more complex affiliations between artists and museums are actually the case.

Despite a degree of artificiality, an asymmetrical relationship between curatorial and artistic processes allows me to build a discussion around that vague awareness of a hidden world, an inaccessible space behind the door marked 'private', which often accompanies our visits to museums. In bringing this elusive feeling to the fore I am able to discuss the process of moving objects from storeroom to gallery as a matter of conflicting ontology in which curators and artists take contrasting views on material presence. As the chapter continues I extend this discussion to the range of interpretative and semiotic registers that shaped the project I undertook at Cheltenham. My engagement with this reserve collection generated a span of apparently incompatible ways of making meaning and the concluding section returns to the rather managerial concept of artistic agency with which I have begun to consider, not the asymmetry of the curator and the artist, but the complementariness that these two forms of practice can together contribute to the museum-goer's understanding of collected objects.

Artists and curators

With rising levels of interest in the years before the millennium, the museum became the location for a distinct kind of artistic experiment: a mix of organizational challenge (everything relied on negotiation and collaboration) and challenging intentions (museum audiences would not necessarily behave as if they were looking at contemporary art). It was possible to claim, as James Putnam does in *Art and Artifact: the museum as medium* (2001), that even the most traditional museums (those 'criticized for having a rigid structure and for being out of touch with the real world') could be 'an ultimate arena for artistic discourse' (Putnam 2001: 33). Certainly, Putnam demonstrates that the 1990s saw an unprecedented outburst of museum-oriented activity (145 art projects are illustrated compared with 48 from the previous twenty years). This was a rather unexpected interest to have taken hold during a period dominated by 'white cube' exhibition spaces (Putnam 2001: 8). In order to understand why, out of the blue, artists began to emulate over-freighted museum displays or exhibit in the upstaging presence of historic or scientific objects, Putnam identifies two trends.[4] First, an aesthetic sea-change in which artists suddenly saw the museum as a location for site-specific practices as they rejected the clinically sparse spaces of mainstream art institutions. Second, a political disaffection generated by writers such as Roland Barthes and Michel Foucault who impelled artists to treat the traditional museum environment as a site of socio-cultural debate (Putnam 2001: 26–7, 31). Both may be seen as critiques of institutional authority instigated by the art world and projected onto our museum culture. But I wonder, as I reflect on my own engagement with museums at the time, if I was actually driven by a rather more straightforward urge to work with objects in the manner of a curator. It seems just as possible that the artistic desire to construct meanings through juxtaposition and context, a technique elaborated at an environmental scale within installation art, was an opportunity to project a museological experiment onto the art world: that is, a chance for museum radicals wanting to test and challenge their own profession to invent the agent of change idea.

One project amply demonstrates this proposition. Putnam tells us that in 1969 the museum attached to Rhode Island School of Design invited Andy Warhol to undertake a project called *Raid the Icebox 1*. Quoting David Bourdon's[5] essay in the exhibition catalogue, Putnam reports that the project aimed to 'bring out into the open some of the unfamiliar and often unsuspected treasures moldering in museum basements, inaccessible to the general public' (Putnam 2001: 18; Bourdon 1970: 17). This catalogue also contains an essay by the director of the museum, Daniel Robbins, who explains how the celebrated art collector John de Menil initiated the project. Whilst deliberating on the museum's role as a teaching collection, de Menil wondered why the entire stock of artworks and historic objects did not attract the attention of the school's students. His answer was to suggest that an artist curate an exhibition based on what could be found in the storage vaults. 'If he were famous enough,' de Menil reasoned, 'would it not oblige the curious to look?' (Robbins 1970: 14). This suggestion, the thought that launched *Raid the Icebox 1*, seems to anticipate the realm of the contemporary artist-curator by accepting that artistic expertise can be extended beyond the production of artworks to embrace the curatorial process of organizing exhibitions.[6]

Being an influential patron of the arts de Menil already knew Warhol, and this suitably famous artist was quickly secured to realize the plan. The only organizing principle would be artistic choice but Robbins makes it clear that, as Warhol made selections, the artist's disregard for curatorial procedure became increasingly uncomfortable. Indeed, the interest of Robbins' essay is its articulation of museum conventions under pressure. For example, Warhol decided to

display the entire reserve collection of shoes (see Figure 16.1). Robbins describes how, from his perspective, this meant placing before the public unnecessary duplications and inferior examples. Warhol seemed to be violating the purpose of a museum reserve: that is, the demonstration of expertise and connoisseurship (Robbins 1970: 15). To make things worse the artist also asked that the catalogue entry for each pair of shoes be as complete as possible. In response, Robbins protests about this laborious task but quickly moves on to describe his awakening appreciation:

> After the headaches of data assembly, we now understand why: each object is obliged to carry its full set of associations, and a weird poetry results; the combination of pedantry and sentiment that can be read in the entities is the serial image of history. There are personal overtones of almost unbelievable poignancy in the now anonymous rubbed kid heels of some fine lady's shoes.
>
> (Robbins 1970: 14)

Everything about this quotation, from Warhol's demanding request to the unexpected pleasures of the resulting exhibit, looks forward to the agent of change idea. The point to be noted is that the shift in Robbins' perspective seems to occur independently of the artist's intentions. Thinking back to Putnam's two trends, Warhol is neither rejecting the white cube (on the evidence of his career) nor openly promoting a critique of museum authority (Bourdon's essay is particularly good on the artist's casual, almost absent-minded, encounter with the museum)[7]. Although Warhol took pleasure in ironic dissimulation we have no reason to think his engagement with the museum was anything other than at one with his general disposition as a creative practitioner. In contrast, Robbins was alert to, and openly interested in, the provocative aspects of working with Warhol. His reflections on the experience anticipate those of many future museum professionals who, in the years ahead, will come to negotiate agent of change experiments. The asymmetry of the *Raid the Icebox* 'shoe' moment is surely the formative condition in which the museological function of artists arises. If we cannot yet observe the aesthetic or political ambitions that became prevalent twenty years later, we can identify an automatic fall into confrontation and an immediate application of self-reflection as curatorial authority is turned back upon itself. Robbins reacted openly to Warhol's disruptiveness and quickly made it the point of the project. To all intents and purposes Warhol had become, in the museum director's eyes, an agent of change.

Storage stuff

If Warhol could not help but trespass on Robbins' expertise with collected objects (the reserve existed for the exercise of curatorial knowledge), then Robbins certainly had no way of prevailing over Warhol's choices (being 'famous enough', the artist's interests were, in their own right, interesting) and this tension reveals not just unequal models of curatorial procedure but also irreconcilable ideas about the material make-up of the reserve collection. For example, the Museum staff saw the footwear collection as a quantity of discrete items. 'We had never before looked at those shoes except as isolated pairs' says Robbins as Warhol orders the whole storage cabinet for inclusion in the exhibition (Robbins 1970: 14). The thought-provoking plurality of the resulting exhibit was brought into being at the cost of the countable and distinguishable properties valued by the museum staff. Here, with my background in sculpture and installation art, I detect an artist's enthusiasm for 'stuff'. This kind of 'non-count' plurality, when experienced in a studio, is not so much about aggregation and quantity as presence. Stuff is the density of

raw material out of which, when the moment is right, art is formed. In the artworks illustrated in *Art and Artifact*, the stuff in question is often a mass of 'found objects' and it makes art-world sense to describe these museum-like installations, as Putnam does, using references to *wunderkammers*, an allusion that highlights the contemporary artist's rejection of the 'sheer calculated order' of modern museums (Putnam 2001: 12). Back in 1969, before installation art had become a mainstream practice and *wunderkammers* a topic of serious museological enquiry, Robbins was clearly worried by both the untidiness and the density of the shoe exhibit: indeed, Warhol's piece must have seemed no different to the unselected mass of the reserve collection which the Director ridicules in his essay as 'stuffed storage' (Robbins 1970: 8).

For Warhol, even catalogue entries were 'stuff'. The information about the shoes may have concerned separate and historically distinct lives but the 'weird poetry' arose within a creative non-individuation that Robbins celebrated as the 'serial image of history'. Here talk of stuff could seem pejorative but the philosopher Henry Laycock seems to support the way I want to use the term. His book *Words without Objects: semantics, ontology, and logic for non-singularity* (2006) unravels our tangled thinking about the plural entities that come into being, not as particular amounts, but as concrete units of accumulation (we speak of 'silver' while referring to a pocket full of fifty-pence pieces). Warhol seems to think of the shoes in this way and *Words without Objects* allows us to picture this artistic idea alongside our current feelings for entities such as air and water. Here the notion of a singular plurality is embedded in a deeply subjective anxiety about the preservation and sustainability of natural resources and this often manifests itself as an environmental aesthetic which, in turn, demands an active appreciation of the world at large.[8] This brings me back to the commission at Cheltenham Art Gallery and Museum and my engagement with the evolving ecology of a hundred-year-old collection, a museological 'world at large' that has been sustained by both its visible and hidden parts and whose collective state is well expressed, and properly appreciated, in non-count terms.

At the time of McKee's invitation, familiarity with Robbins' essay would have alerted me to the fact that reserve collections, as the shoe story makes clear, generate conflicting views on materiality in the museum. Indeed, it is museum storerooms, perhaps more so than public displays, that trigger searching reflections on the relationship between curatorial and artistic practices. The Cheltenham project (see Figure 16.2), in requiring me to respond to the museum's reserves, placed me within a rather exaggerated agent of change position by expecting me to adopt the selective processes of a curator when all my instincts as an artist led me to think of storage as a collective state that would evaporate as soon as I made any choices. And so, by default, I fell into a non-curatorial relationship with the reserve collection in which I valued the patient perseverance of this unselected mass, a body of storage stuff that, from the perspective of a museum visitor standing amidst the hand-picked public displays, formed a hidden, almost unfathomable, 'reservoir' of things.

As I began to plan my project I considered public viewings of these secluded 'depths', visits that would reveal traces of my own creative actions and thus fulfil the conditions of the commission. I wondered if I could somehow 'drain-off' parts of the reserve and replenish them with contemporary artworks but decided instead to use a series of outreach projects to organize a mass donation based on what the people of Cheltenham thought should be stored in their museum. I worked with various community groups imagining not only likely donations but also the entire process of accession.[9] At no point were actual objects involved but when the exhibition opened, alongside my installation, visitors could view a collection of calico storage covers and identification labels specially prepared to keep each immaterial gift unsoiled by the passage of time (see Figure 16.3). Here everything was about the kind of sensitized receptivity I

associate with environmental aesthetics. In treating the reserve collection as a reservoir that could be imaginatively 'topped up', the subjective and non-externalized reactions of the workshop participants, as one would expect in any form of aesthetic engagement, were given preference to communicable meanings and historical facts. Amongst artists and art theorists there is a well-established tradition of celebrating these kinds of self-guided responses. Indeed, many would say that such experiences are the purpose of art but, as we shall see, this conflicts with the interpretative mission of contemporary museums and exacerbates the asymmetry of the agent of change idea.

Openness to re-meaning

Rosalind Krauss' 'Sculpture in the expanded field' (1978) and Susan Sontag's 'Against interpretation' (1987) are two well-circulated essays that acknowledge the artist's flight from restrictive explanations. Both writers were worried that textual commentary made the viewing of art safe. Krauss thought the freshness of vanguard aesthetics was diminished, and the contingency of the future denied, by placing creative risk taking within a trans-historical continuity. When the 1960s avant-garde cut trenches across deserts or raised earthworks in fields, commentators gave these experiments prehistoric roots. For Krauss such responses made distinct historical moments

Figure 16.3 Victorian dresses in protective calico covers and examples of the mass donation to Cheltenham Art Gallery and Museum; the museum's method of labelling and storing costumes was used to register and record one hundred imagined objects donated by local community groups (photograph by Chris Dorsett)

Figure 16. 4 Clearing the house of the Cheltenham antiques dealer Ron Summerfield and deletions on a musical score from the archive of the composer Gustav Holst (photograph by Chris Dorsett)

appear ludicrously similar. 'Against interpretation' identified a complementary problem. 'Once upon a time (a time when art was scarce),' Sontag argued, 'it must have been a revolutionary and creative move to interpret works of art', but, in a post-Freudian age, a preference for 'latent content' would only stifle and impoverish our engagement with material presence. 'In place of a hermeneutics,' Sontag continued, 'we need an erotics of art' (Sontag 1987: 14).

Thus art theory often celebrates the deliberate accommodation of multiple understandings within the interpretative processes that are occasioned by the material properties of artworks. This idea can be seen as a critical elaboration of an important incentive in creative production: the desire to transfer the singularity of art experiences to others (an 'erotics' of creative action). The Cheltenham workshops emphasized our diversely subjective responses to the processes of collecting and preserving objects. Given that the invisibility of the reserve collection was a central component of this experience, it was not surprising that the resulting exhibition, when it was finally installed in September 1999, caused the museum's staff to worry about 'the emperor's new clothes'. It was not easy for them to treat my installation, particularly the display cases I had made (effectively my main statement about the nature of storage), as an adequate representation of the collection they knew and loved behind the scenes at the museum. Some agreed that the overall effect hovered uncomfortably between storage and display and I like to think this response recognized, in the palpability of the installation experience, the curious relationship between what is, and what is not, seen in a museum. However the result was not judged to be equal to an exhibition of selected objects placed in conventional vitrines.

Of course, my display cases were not actually empty; storage stuff had been placed at the bottom of the deep-sided boxes. For example, exhibition-goers could see a watercolour from the *Terra Nova* expedition to Antarctica that was too delicate to display in direct light or a painting by the French artist Maurice Loutreuil that an art historian had declared a waste of space. These objects, hardly visible in the shadowy recesses of each box, were brought before the public not as a pretext for authoritative interpretation but as an opportunity to convey in narrative form the extraordinary ambition of museum storage. Indeed, the journal I had kept during the preparatory stages of the commission had provided my installation with a sequence of stories

about the rigours of the conservation process and the commitment that had been made to the preservation of objects that, outside the museum, would almost certainly have been thrown away. My labels, based on these day-to-day notes, recorded arbitrary encounters with this world: everything from a ghost story I was told about an eccentric antiques dealer who bequeathed objects to the museum to an account of how I came to sit at Gustav Holst's family piano and play all the deletions I could find on a musical score from his archive (see Figure 16.4).[10]

If this was an agent of change experiment, at least in the terms described in this chapter, then the museum's curators were bound to feel perplexed by techniques of display and uses of objects or texts that were too closely aligned with artistic practices. Certainly McKee, presumably reflecting on conversations with his colleagues, wrote that my 'quiet, thoughtful and poetic' approach to their centenary had 'made us look again at collecting and the role of the museum' (McKee 2000: 14).[11] Robbins had responded similarly following Warhol's project[12] and this sense of re-evaluation associated by curators with artistic agency suggests a tentative recognition that, elsewhere, exhibition techniques openly embrace the subjectivity and physical immediacy of our material experiences in a way that is difficult to support in museums. Artists accept the limitations of attaching interpretations to artworks but for curators the difficulty of conveying anything other than abstracted information in textual commentaries remains a museological problem. Eilean Hooper-Greenhill's *Museums and the Interpretation of Visual Culture* (2000) considers the gut feelings and emotions that are impossible to capture on labels and she is critical of the impact of visual culture on museums. Her concern is that this ever-expanding field of study, in privileging what might be thought of as a disembodied spectatorial eye and brain, threatens to banish our sense of 'handling knowledge' from the appreciation of material culture (Hooper-Greenhill 2000: 115). The fear is that those understandings each of us has acquired through our physical immersion in the world of things are eclipsed by the notion of the 'museum as a scopic site' (Hooper-Greenhill 2000: 108). The result is an inhibition of the 'bundle of interests' that shape diverse encounters with objects (Hooper-Greenhill 2000: 122). Indeed, *Museums and the Interpretation of Visual Culture* proposes that the polysemous nature of the physical world is a valuable resource that allows museums to mirror the complex make-up of their audiences and Hooper-Greenhill recommends that curators develop a sympathetic 'openness to re-meaning' when planning their displays (Hooper-Greenhill 2000: 122).

Given these concerns, the special material presence of storage stuff could be seen as a contribution to curatorial openness. Unfortunately, the sensory experiences that activate stuff-like responses in museums, in being tied to a property generated by that environment, arise through our tacit rapport with the working stock of a collection, not, as Hooper-Greenhill would have it, within the socio-cultural origins of individual objects. Thus storage stuff is not itself part of the world at large because collections are not meant to be experienced in their own right: they must point dutifully beyond their compound selves to non-museum experiences of handling, smelling, hearing and seeing things. And so Hooper-Greenhill's idea cannot include the bulk presence of objects in museums even though it is concerned with the way that collected artefacts, once grouped and displayed, cause multiple acts of recognition which, as cognition proceeds, shape an awareness of one thing within a matrix of juxtaposed things. This is a very accurate representation of how exhibition display works although installation artists and their audiences would wonder why such matrices do not themselves achieve tactile, odorous, sonorous, and visual values like any other part of the material universe.

Inter-artefactuality

Hooper-Greenhill's point about handling knowledge, whether it turns out to be a response to accumulated stuff or to discrete objects, is that it involves sensory reactions that are 'especially powerful precisely because they remain unexamined' (Hooper-Greenhill 2000: 116). These are feelings that are so embedded in the personal lives of museum-goers that they cannot be invoked without using conceptual frameworks that tolerate those tacit understandings we associate with aesthetic or poetic intuitions.[13] To understand why such responses are powerful, Hooper-Greenhill journeys into literary theory to explore the celebrated ambiguity of poetic language. Here the matrix-like play of object with object quickly turns into a theoretical proposition resembling Julia Kristeva's concept of intertextuality (1980). For Kristeva, reading literature is only meaningful because its texts are provocatively set within an overlapping series of textual models which create subtle, often un-stated, but always highly resonant, backgrounds to each writing project. Hooper-Greenhill proposes that we could usefully think of curatorial practice in this way: if literary writing is intertextual, then curating objects is 'inter-artefactual'.

At a risk of expounding the over-familiar, let us recall the literary theory at the root of this idea. Whilst studying the birth of the novel, Kristeva saw that the weaving of narrative textures by the first novelists could be broken down into separate strands which reveal borrowings from a wide range of late medieval communication practices (from hawkers' cries to scholarly treatises). Thus it was possible to see the early novel as an emergent textual system that transposed and transgressed its surrounding linguistic environment. This idea owes a great deal to the Russian literary theorist Mikhail Bakhtin, for whom the act of writing was always a reply to other texts and the subversive positions that such dialogues entail: an opportunity to study the history of social and political resistance (Kristeva 1980: 64–91). However, Kristeva's interests were semiotic and psychoanalytical, not historical. Following the theories of the psychoanalyst Jacques Lacan, it was possible to explore the scope that novelists and poets have to signify one thing whilst meaning something quite 'other'. The ability to call up thoughts in a reader's mind without referring to them in writing is located in the 'otherness' of vocal expression and reading. For example, the sounds and rhythms of read words and the visual impact of a page of text can sit in a powerfully ambiguous relationship with the apparent meaning of the written words and, as a result, transgress the dominant act of interpretation in a continual and unresolved opposition to the transparency of communication (Roudiez 1980: 5).

If we turn to contemporary poetry to briefly consider where Kristeva's notion of intertextual otherness leads us, these subversive qualities can be pictured as a clash between contrasting textual and material experiences. There is a fascinating exploration of the tension between illegible print and linguistic meaning in Julian Moyle's semiotic analysis of Peter Reading's poem *Erosive* (Moyle 2003: 129–51; Reading 1994). Because the poet uses compositional techniques that make his published work look like degraded printed matter, the reader is forced to interpret his writing as if it were a visual artwork.[14] 'This alternative form of semiosis threatens to de-stabilize the notion of a generic core of verbal semiosis […] through an uncovering of the 'other' lying within' (Moyle 2003: 141). Moyle's point is that the visual power of *Erosive* '*must* plot its revolution' (my emphasis) against the book of conventionally printed poems in which it has been published (Moyle 2003: 141). This is a very Kristevian idea and, recalling Robbins' response to Warhol, we can note that an inevitable breech in interpretative coherence, just like an automatic fall into curator/artist conflict, is as much a feature of the juxtaposition of semiotic domains as it is of the agent of change idea.

Interpretative communities

Thus literary theory underwrites Hooper-Greenhill's description of materiality in the museum and produces a fuller understanding of how, in situations where semiotic processes conflict, material otherness can violate the authority of textual commentary. Certainly, an artist who treats the accumulated mass of a reserve collection as storage stuff would provoke an effect very like the cross-semiotic tension described by Moyle (the plurality of the storeroom *must* plot its revolution against the singularity of the selected displays); and a curator who embraced inter-artefactuality, in opening themselves to the process of re-meaning, would become aware of unexpected levels of Kristevian subversion in each attempt at authoritative textual explanation. Unlike the artist, who will absorb this conflict into their creative practice, the curator has to make sure that re-meaning, however innovative and transgressive, is 'forged and tested in relation to communities of meaning-making' (Hooper-Greenhill 2000: 119). Once again, Hooper-Greenhill utilizes literary theory to describe the social and cultural frames against which these curatorial experiments must be validated. In *Museums and the Interpretation of Visual Culture* the diversity of museum audiences is modelled on the concept of 'interpretative communities', an idea borrowed from the literary theorist Stanley Fish.

Fish's idea, a variety of reader-response criticism, was developed in a celebrated critique of the *Variorum Commentary on the Poems of John Milton* (Woodhouse and Bush 1972) and it is worth pausing to make sure we understand that, despite Hooper-Greenhill's emphasis on the unexamined power of meaning-making, this theorist is particularly interested in the conscious non-compliance of 'meaning' with 'making'. For Fish the interpretative process comes into being through moments of 'hesitation or syntactic slide, when the reader is invited to make a certain kind of sense only to discover (at the beginning of the next line) that the sense he has made is either incomplete or simply wrong' (Fish 1988: 311). As readers hazard conclusions, these frustrations harden into strategic habits. Fish thinks the resulting strategies *are* the content of a poem. There is no hidden meaning awaiting recovery and three hundred years of interpreting Milton is a history, not of an enduring poetic message, but of a hazarding process that has created, in succession, measures of collective unity. To state Fish's idea baldly: interpretation exists, individually or communally, because we continually fail to achieve interpretative closure and we find this situation stimulating.

To fully explore Hooper-Greenhill's application of this controversial theory is a task beyond the scope of this chapter; however if the core concern of *Museums and the Interpretation of Visual Culture* is what happens when curators and museum-goers do not share the same responses, Fish does have some outstandingly germane thoughts on offer. For example, his theory claims to address the contrasting aspirations of very different types of reader: from religious interpreters who apply one narrow strategy across countless textual experiences (seeing God in everything) to literary critics who strategize widely around a single poem and expect their interpretation to sit competitively within multiple and diverse readings (Fish 1988: 326–327). On Fish's account, everyone seems to be an informed interpreter as long as they are at ease with, even excited by, their particular form of uneasy guesswork. As a result, all kinds of strategies are available for communal success. For example, if the full range of museum responses that interest Hooper-Greenhill were to be arrayed across a span of interpretative ambitions, then the hazarding of unexamined handling knowledge would have equal (though not similar) communality to the application of curatorial expertise. Indeed, theoretically speaking, with Fish in mind we could map *whatever* happens regularly in a museum and call it an interpretative strategy.

Figure 16.5 Cheltenham's last tram (photograph by Chris Dorsett)

Figure 16.6 Photograph of the tram's interior from the author's journal and the conductor's mirror on display at Cheltenham Art Gallery and Museum (photograph by Chris Dorsett)

The last tram

At this point I want to return to the project at Cheltenham Art Gallery and Museum. During my tour of the storage and archival facilities, just before leaving the Large Object Store, McKee remembered the tram. Of all the historical vehicles collected by the museum this particular 'large object' so exceeded the resources of the designated storeroom that it had to be placed in a barn-sized industrial unit belonging to the town's Parks Department. Here Cheltenham's last tram was kept amidst the paraphernalia of lawn management without a hope of being displayed unless the museum's public galleries grew in size (see Figure 16.5). In being set aside on a more-or-less permanent basis, this extraordinary piece of museum storage was unavailable for selection and therefore, for the foreseeable future at least, beyond the demonstration of curatorial expertise. As a result, this object could not help but plot a revolution against the objects in the museum's public galleries. Moreover, as McKee began to fill in some of the background details he had discovered about the tram, it was possible to imagine textual commentaries that, in avoiding the forms of interpretation favoured by curators, employed those interpretative strategies that achieve communal success at the unexamined end of our span of interpretative ambitions: that is, through the narrative modes of rumour and anecdote.

1999 saw the thirtieth anniversary of the death of Brian Jones of the Rolling Stones and there was local interest in recognizing Cheltenham's unlikely place in the history of the celebrated rock band. McKee would have liked to mark the occasion with an exhibition but there were no relevant objects in the Museum's collection or, at that time, suitable material available from collectors. However McKee was aware of a link to the tram. Jones was a bus enthusiast in his early teens and some believed he was a member of the team of volunteers that had renovated the vehicle and presented it to the Museum. There was a photograph (which McKee had never seen) that showed the fledgling musician, about thirteen years of age, standing on the footplate with a wire brush in his hand. The story was probably apocryphal. Certainly all efforts at finding the photograph came to nothing. Nevertheless the link was *some kind* of opportunity to mark the anniversary: the otherness of the tram (a historic object kept permanently in reserve) seemed to reflect the unachievable nature of the Jones celebration (an inassimilable piece of Cheltenham's history). Several days in the mower shed filled my journal with accounts of polythene awnings suddenly flapping in the draughty building and the conductor's mirror lying forgotten, covered with dust, beneath the footplate.[15] All these experiences, now infected with the mythology of the Rolling Stones, were an opportunity to explore the relationship between the closed world of the reserve collection and the open forms of meaning-making that are usually trivialized as mere gossip or telling tales. At the time, under the influence of Fish, I was deeply interested in what happens when you shift allegiance from one interpretative community to another and I saw the tram story as a way of promoting these types of narrative as an alternative form of museum communality.

Thus, once the tram story was realized as the central component of my installation (see Figure 16.6), a museum visitor was almost certain to experience a lack of hard evidence and the hazarding process this engendered would become an issue, not just of significance (does aging polythene and a dusty mirror add up to an anniversary display?), but also of signification (do you believe what you are told?). Whilst viewing my installation, museum-goers discovered a rumour about a tram in a context where authenticated facts about Brian Jones should have prevailed. In the extended space of the public galleries, the physical separation of my textual commentaries from the deep-sided display cases reinforced the hesitancy created by this uneasy match. Perhaps we should consider how an embodied sense of uncertainty, here

engendered by walking back-and-forth in my exhibition, strikes us as being as subversive to curatorial authority as unexamined handling knowledge. Hooper-Greenhill would certainly have found the process a long way from those museum experiences that are supported (put beyond question) by layers of considered curatorial conceptualization. In *Museums and the Interpretation of Visual Culture* gut feelings and emotions are seen as helpless unless they are rescued by a top-down cognitive framework put in place by the curator's openness to re-meaning. In my project I tried to co-opt the social power of anecdotes and rumours as an interpretative strategy and hoped to avoid curatorial calculation by utilizing forms of interpretation that achieve communal success without institutional authority. If top-down interpretation were the only way of valuing unexamined feelings in a museum there would be no need to generate museological versions of Kristeva's intertextuality or Fish's interpretative communities.

Mutual understanding

I now want to sketch out a resolution to this discussion using the notion of cross-semiotic interpretation, that state of subversive incompatibility introduced with Moyle's analysis of Peter Reading's poem *Erosive*. Here the materiality of the poet's text automatically rivalled the meaning of his poetic words because it was not easy to decide if the activities involved were based in the literary or the visual arts. As a result, the reader's expectations were challenged, and (as Fish would have it) their interpretative strategies enhanced, as *Erosive* fell into semiotic uncertainty in relation to the application of an interpretative framework. Clearly you cannot participate in, or communally exploit, this kind of indecision unless you are comfortable with hazardous meaning-making. In addition, an emergent group of cross-semiotic enthusiasts, a community that is at ease in this uneasy way, will only look like an audience if, as the group expands under its own steam, a sense of belonging is built through a shared transposition and transmutation of surrounding conventions.

The challenge of not knowing if *Erosive* is a text or an object (a poem or an image) is remarkably similar to the difficulty of recognizing if an agent of change project has its basis in museological or art practices. On this account, selecting and exhibiting objects from a reserve collection, a task that could look alike in the hands of both curators and artists, generates, when everything starts to appear dissimilar, just the right amount of hesitancy to sustain an agent of change community and, as this group becomes aware of its own continuity, just enough coherence to make the results distinguishable from other activities that take place in either museums or art venues. In this sense, the agent of change idea, in order to be fully appreciated, requires a degree of independence from both contexts.[16] From the beginning of this chapter I have treated this emergent practice, particularly in relation to its zenith in the 1990s, as the product of a symmetrical transaction that 'must' distort into asymmetry. Clearly, in the cross-semiotic frame provided by Moyle, the word 'must' is important. When artists repeat curatorial tasks there need be no compulsion to rebel against curatorial procedures. For example, de Menil's intention was that Warhol should make interesting selections in the same manner as Robbins and, methodologically speaking, that was what he did. But at a semiotic level it would be impossible for the artist to mirror the interpretative processes of the curator (Warhol saw storage stuff, Robbins separate items). From this perspective, the agent of change idea is not so much a matter of asymmetrical process but of incompatible signification. As Moyle suggests, one semiotic frame can only subvert its 'other' and it seems reasonable to now place a semiotic structure at the heart of the interpretative strategy that, once it has generated an agent of change

community, thrives on ontological differences such as the apparently irreconcilable conflict between pluralized stuff and itemized things.

This concluding discussion requires just one more theoretical tool to reach a point of resolution. This is the triad of sign categories known as 'icon', 'index' and 'symbol' developed by the American philosopher Charles Sanders Peirce to exhaust the entire process of signification (Peirce 1931–58, Vol. 3: 359–62). Peirce recognized that signs operate differently: some strike you immediately with a sense of similarity and likeness (e.g. a cloud that resembles a human face), whereas others alert you to physical connections (e.g. a footprint in the sand) and others still, activate prior knowledge of conventional associations (e.g. words written on a page). Likeness signs (icons) provide us with the most direct representations possible. As the literature on iconicity makes clear our physical environment is full of things that remind us of other things. In contrast, semioticians tell us that we require both experience and an ability to calculate in order to identify footprint-type signs (indices). In relation to this category the interpretative skills of forensic science and medical diagnosis have evolved. Finally, semiotic theory also recognizes that an acquired knowledge of codes is the only way to engage with word-type signs (symbols). In this last category, we build signs on signs, notate abstract relations and disseminate ideas across communities of readers who share an understanding of the same language.

It follows that indexical and symbolic signs lead us toward increasingly generalized states of understanding whereas iconic signs remain embedded in the singularity of personal experience. Of course, icons can be shared. I can draw your attention to a cloud that looks like a face but the correspondence of our interpretations will always be approximate (there would never be an issue about decoding a likeness). In 'The Semiotic foundations of iconicity in language and literature' (2001) Winfried Nöth points out that all cognition relies on iconic processes. Mental images are integral to our ability to think and any reciprocity of thought must, in some sense, include a procedure by which the production, transmission and reception of ideas resemble each other:

> the speaker can only suppose or perhaps hope that the hearer evokes the same images, but actually there are always differences which remain and give rise to a dialogic 'sequence of successive interpretations in the process of unlimited semiosis, which is the necessary prerequisite of the growth of signs.
>
> (Nöth, 2001: 27)

Here iconicity is both a form of mutual understanding and a vehicle for the expansion of signification. Once again, we are considering the creative transferral of experiences, not as a body of explanatory knowledge, but as an overlapping consensus of response. We might recall Krauss and Sontag and recognize that, whilst artists are often 'against interpretation', they are always in favour of iconicity because creative practices are sympathetic to meaning-making at its most personal level. This would include a propensity for deeply idiosyncratic intuitions in which meaning-making is, whilst not actually in progress, somehow sensed to be possible. Peirce called this primary iconicity. To be at ease with uneasiness at this fundamental level is surely a speciality of the artist, the fruit of much creative hazarding in the studio. What is important here is the understanding that singular and personal responses can be simultaneously diverse and shared. As far as artists are concerned, and this seems to contrast with a curator's top-down promotion of sensory and embodied reactions, iconicity does not require indexical or symbolic development to turn itself into a satisfactory form of communal sharing; it already is one. In this sense, to value icons in the museum environment is to extend the range of semiotic possibilities out beyond the curator's commitment to indexical and symbolic meaning.[17] As a result, when

an artist joins a curatorial team as an agent of change it is the span of overlapping interpretative activities that automatically provoke subversive tensions not the asymmetric pairing of practices.

As we saw with Cheltenham's last tram, when indexical connections were not forthcoming, the entire curatorial project was inhibited. If a photograph had established a historical link to Brian Jones (and I say this knowing that such 'evidence' would require its own form of semiotic scrutiny) then McKee would have been able to move quickly towards an exhibition theme to mark the anniversary. Furthermore, as soon as his information labels were written, any rumour-based acts of recognition would have, in being likenesses formed within the transmission of a story from one person to another, started to fall outside the conventions of curatorial meaning-making. By the time this happened the semiotic process would have long ceased to be mutual in the sense described by Nöth. A semiotic reading of the agent of change idea recognizes that artists restore the disjunctive nature of iconic mutuality to the indexical and symbolic generalizations of curatorial interpretation. For semiotic theorists these disjunctions are a necessary prerequisite to the growth of signs and it is possible to see the iconicity of the artist, once introduced into the museum environment, as a driver of openness to re-meaning, albeit in a very individualistic form.

Iceboxes

Of course, symbolic signs (for example, a curatorial text confirming indexical links between Brian Jones and the tram) also have iconic dimensions. As a short coda to this chapter I want to remind the reader that words, those abstract vehicles of explanation on which the transparency of communication seems to depend, can be treated as 'stuff' too. As we saw with *Raid the Icebox 1*, a 'weird poetry' was generated when an accumulated mass of catalogue entries was viewed as a single entity. Robbins notes that '[t]here were exasperating moments when we felt that Andy Warhol was exhibiting "storage" rather than works of art, that a series of labels could mean as much to him as the paintings to which they refer' (Robbins 1970: 15). This subversive reaction to linguistic signs was a powerfully iconic contribution to the indexical and symbolic culture of the Museum of Art, Rhode Island School of Design. I like to picture this kind of cross-semiotic transaction, so much at the heart of the agent of change idea, using a tall tale told by Joseph Addison that returns us to the Robbins/Warhol correlation of storerooms with iceboxes. Addison's story *Frozen Voices* concerns a group of sailors forced to winter on the arctic island of Nova Zembla (1710). The weather becomes so cold that their speech freezes in the air around them and, accordingly, with the arrival of spring and the thawing of the lost conversations, their words are restored, not as they were spoken, but in disorderly fragments. The result is a no-man's-land of missing context and intention.

> Upon a turn of wind, the air about us began to thaw. Our cabin was immediately filled with a dry clattering sound, which I afterwards found to be the crackling of consonants that broke above our heads … These were soon followed by syllables and short words, and at length by entire sentences, that melted sooner or later, as they were more or less congealed.
>
> (Addison 1925: 223)

Symbolic meanings in a museum are, like an accumulation of frozen voices, a mass of 'more or less congealed' material. Within this density all information has been confused and curators work hard to ensure that their interpretations form entire sentences rather than let loose a sequence of incomprehensible crackling sounds. Nevertheless, the quickening effect of uncertain

rumours and anecdotes at the centenary of Cheltenham Art Gallery and Museum celebrated the iconic value of the countless displaced narratives that surround all museum collections; these flourish within a creative context that is, figuratively speaking, the equivalent of the disordering thaw that returned Addison's lost conversations to their owners. As Paul McKee and I eventually agreed, the important thing about my exhibition was that, whilst the reserve collection remained out of sight and inaccessible, its meaning had been well and truly shuffled by artistic agency in the museum environment.[18]

Acknowledgements

I would like to thank Ysanne Holt and Paul McKee for the thoughtful and useful comments they made on the early drafts of this chapter. I also feel indebted to my visual arts master's and doctoral seminar groups at Northumbria University for the discussions we had on the concept of making meaning beyond display. In particular, I am grateful to Michelle Hobby for her help with the images.

Notes

1 Organized by the Museum Directors' Federation of Aotearoa New Zealand and held at the Maritime Museum, Auckland, New Zealand in 1997.
2 By the mid–1980s my activities as an artist had shifted from installation art to experimental curatorial projects as I explored different ways of merging contemporary art practices – particularly those developing around me in my work as an art school tutor – with permanent displays such as those at the Pitt Rivers Museum in Oxford. These 'interventions', conceived as large-scale collaborative exhibitions (initially organized in Oxford with Hélène La Rue and later, after I moved to Northumbria University, extended to other museums under the generic title 'Divers Memories') aimed at an exploratory broadening of meaning within established collections, particularly those with an apparently stable frame of reference. Whilst many of the contributing artists, performers and writers had political agendas, the term 'agent of change' remains, without the kinds of modifications I attempt in this chapter, of limited value when it comes to describing the poetic and ontological ambiguities these projects produced.
3 For an exploration of the visual arts dimension of 'beyond display', see Dorsett 2007.
4 This simplification, aimed at elucidating Putnam's view of the 1990s, ignores his broader discussion of curator-like activities developing within the practices of artists throughout the twentieth century. *Art and Artifact* builds a picture of 'the museum as medium' using examples as diverse as Marcel Duchamp's *Boîte-en-valise* (a miniature collection of scaled-down models and reproductions of the artist's past works) and Joseph Cornell's basement (a store of carefully grouped and graded 'found objects' used to produce assemblages).
5 Bourden was a well-known art critic. In the late 1960s he was writing for *LIFE* magazine.
6 For more commentary on this pioneering exhibition, see Wollen's discussion (1993), an expansion of his earlier essay (1989: 14–27). In contrast to the museum-oriented ideas I develop in this chapter, Wollen interprets the project at Rhode Island School of Design using the habits and practices of Warhol's highly idiosyncratic way of life. In this sense, Wollen's treatment, like that of Putnam, projects the values of the art world onto those of the museum. As a result, it is difficult not to see the latter as a quiescent recipient of the former's progressive buoyancy – a one-sided approach that my exploration of the agent of change idea tries to nuance. However, a great deal of elucidatory material is made available within Wollen's biographical frame. Of particular interest is Warhol's use of 'time capsules', boxes containing everyday clutter deposited in rented storage space throughout the artist's adult life. Another of Wollen's themes, the pleasure Warhol took in rejects and leftovers, has been subsequently developed as a queer aesthetic in Michael Lobel's essay 'Warhol's closet' (1996) and in Deborah Bright's 'Shopping the Leftovers: Warhol's collecting strategies in *Raid the Icebox 1*' (2001). I find it reassuring to read in Bright that the exhibition has been 'overlooked in the Warhol corpus until very recently'. Despite my close association with the expansion of artist's projects in museums during the

1980s and 1990s, *Raid the Icebox 1* only came to my attention with the publication of Putnam's book in 2001. Wider recognition is clearly long overdue. Bright rightly believes the exhibition anticipated our postmodern view of the museum by twenty years and she cites Lisa Graziose Corrin's view that Warhol played an important part in 'developing a genealogy for the 1990s museum interventions by conceptual artists such as Fred Wilson, Joseph Kosuth, Andrea Fraser, Louise Lawlor, Christian Boltanski and James Luna' (1996: 54–61).

7 Bright also tells us that 'Corrin found Warhol's approach "charming in its remarkable lack of self-consciousness" and "attitude" when compared to the "rhetoric of critique and populism" that had characterized more recent postmodern museum projects' (2001: 280).

8 I have in mind here the kind of receptiveness to environmental conditions, based on our perceptual and interpretative experiences of viewing art, which has been promoted by writers such as Arnold Berleant and Allen Carlson. A key text in this field is Carlson 2002. Laycock (2006) has linked the contemporary relevance of philosophical debates on the ontology of mass nouns to our widespread sympathy for environmentalist values.

9 Participants included the Cheltenham Older and Bolder Group, the Painting and Decorating Group from the Whaddon, Lynworth and Priors Neighbourhood Project, Year 8 art class at Pate's Grammar School and the Friends of Cheltenham Art Gallery and Museum. Each workshop began with a slide presentation in which I described my exploration of the museum's storerooms. Blank cards and drawing materials were provided and each participant was invited to sketch a donation. I commissioned the artist Chris Yeats, a colleague in the printmaking department at Northumbria University, to make each image as diagrammatically simple as the labels used in the museum's costume store. The results can be seen in Figure 16.3.

10 The relevant journal entry runs as follows: Thursday, 5 August 1999. I am invited by Paul McKee to meet Simon Chorley, the auctioneer who remembers clearing out the house of the Cheltenham antiques dealer Ron Summerfield after his death in 1989. He talks about 'getting spooked in the cellar' and so I make a tape-recording of our conversation. Chorley's story goes like this: one evening, whilst sorting the furniture stored in the basement, he decides to carry on cataloguing after his colleagues have finished for the day. About ten minutes after finding an Edwardian display table he comes across its pair and re-runs his dictaphone to correct the earlier entry. In the background he hears somebody laughing. It couldn't have been his colleagues because they had left half-an-hour earlier. 'I just flung it all in the air and tore out of the building'. After the interview I visited the archives in the Gustav Holst birthplace (the composer was born in Cheltenham 125 years ago). The scores are full of crossings-out that both solicit and resist my interest. Here it is not a matter of treasure hidden away with a long-term intention of recovery, Holst did not want these notes to be played. It's irresistible. For those who visit museum storerooms even that which was deliberately put aside awaits resurrection. I decide to record Holst's deletions and mix them with the Simon Chorley interview. My exhibition now includes a sound piece.

11 McKee's sympathetic engagement with my work reflects his interests as both a curator and a practising artist. As I said above, the asymmetrical opposition of curators and artists is a rather contrived device since it is not uncommon for museum staff to have trained in an art school before moving onto museum studies.

12 'Our conception of our own jobs as curators is rather sweetly altered' (Robbins 1970: 14).

13 It seems likely that these aspects of Hooper-Greenhill's thinking owe their character, like McKee's above, to her background experiences as an artist (in this case, a period studying and practising sculpture).

14 Reading's technique involved the repeated photocopying and cutting up of his verse, a process in which the texts were progressively abraded and blurred.

15 The relevant journal entry runs as follows: Friday, 11 June 1999. Are there ghosts in the storeroom? My imagination is working overtime. Today, whilst exploring the tram, a glimpse of a loose sheet of polythene completely destroyed my concentration. I am reminded of the story by M. R. James in which a character is startled by a ghastly face in a crumpled linen sheet. This tale, 'Oh, whistle, and I'll come to you, my lad', provides another gloss on storage and recovery. An archaic whistle is found in a burial mound by an amateur archaeologist who is foolish enough to blow it. From that moment his world is full of twisted ghostly shapes in curtains and unmade beds. Later I had another go at locating the photograph of Brian Jones. My enquiries are leading nowhere and I begin to sense a piece of museum apocrypha. This afternoon, I found the tram's mirror lying unattached beneath the footplate

covered by a layer of thick dust. It was once thought that mirrors could store reflections. Medieval pilgrims visiting the cathedral at Aachen returned home with souvenir looking glasses that they had used to 'photograph' the sacred relics. The surface had to be covered immediately after exposure in order to prevent contamination by further reflections. Elizabeth Edwards tells me that some historians think this story is part of the prehistory of photography. Looking into the small reflective hole my finger has made in the dust, I wonder if the tram's mirror could stand in for the missing photograph of Brian Jones.

16 This point about the evolving identity of agent of change experiments has its origins in my experiences of 1990s museum-oriented art projects. For example, reviewing a version of 'Divers Memories' at Manchester Museum in 1996 (organized with John Hyatt and Manchester Metropolitan University), Michael Bracewell noted that our interventionist process was most subversive when the audience was not obliged to treat the results as art (Bracewell 1996).

17 Anyone familiar with museological debates over the past two decades will recognize that, in particular, the symbolic sign has often been elevated to a first principle and, as a result, the interpretative process treated as a matter of convention. Nöth thinks that iconicity has been disqualified, and with it the heuristic value of Peircian thought, by semiotic theories derived from the teaching of Ferdinand Saussure (Nöth 2001: 17). Here the entire process of signification is seen as the manipulation of arbitrary relationships between signs and their referents. Peirce's view of semiotics was very different: he saw interpretation as a three-way system involving the continual interaction of iconic, indexical and symbolic properties. To concentrate only on the mediatory functions of symbolic signs, however well this promotes the analysis of ideological agendas hidden within our linguistic conventions, denies the fullness of the semiotic experience. In deriving ideas from the extensive discussion of Peircian semiotics in journals such as *Iconicity in Language and Literature* (e.g. Nöth 2001 and Moyle 2003) and Umberto Eco's stimulating account in *Kant and the Platypus: essays on language and cognition* (2000), my chapter makes a case for the heterogeneity of semiotic processes in museums.

18 The commission described in this chapter resulted in *Resurrection Shuffle: a story of storage*, an exhibition held to mark the centenary of Cheltenham Art Gallery and Museum, September–November 1999.

References

Addison, J. (1710) 'Frozen voices', *The Tatler*, November 23. Reprinted in H. A. Treble and G. H. Vallins (eds) (1925) *Narrative Essays and Sketches*, London: George G. Harrap & Co. Ltd., pp. 221–5.

Bourdon, D. (1970) 'Andy's dish', in *Raid the Icebox 1 with Andy Warhol: an exhibition selected from the storage vaults of the Museum of Art, Rhode Island School of Design*, Providence, RI: Rhode Island School of Design, pp. 17–24.

Bracewell, M. (1996) 'Past, but not gone', *The Independent*, 2 April

Bright, D. (2001) 'Shopping the leftovers: Warhol's collecting strategies in Raid the Icebox 1', *Art History*, 24 (2): 278–91.

Carlson, A. (2002) *Aesthetics and the Environment: the appreciation of nature, art and architecture*, London: Routledge.

Corrin, L. G. (1996) 'The legacy of Daniel Robbins's *Raid the Icebox 1*', in *Rhode Island School of Design Museum Notes*, June, Providence, RI: Rhode Island School of Design, pp 54–61.

Dorsett, C. (2007) 'Exhibitions and their prerequisites', in J. Rugg and M. Sedgwick (eds) (2007) *Issues in Curating, Contemporary Art and Performance*, Bristol and Chicago, IL: Intellect, pp. 77–87.

Eco, U. (2000) *Kant and the Platypus: essays on language and cognition*, London: Vintage.

Fish, S. (1988) 'Interpreting the *Variorum*', in D. Lodge (ed.) *Modern Criticism and Theory: a reader,* New York: Longman Inc., pp. 310–29.

Hooper-Greenhill, E. (2000) *Museums and the Interpretation of Visual Culture*, London: Routledge.

Krauss, R. E. (1978) 'Sculpture in the expanded field', in R. E. Krauss (1986) *The Originality of the Avant-Garde and other Modernist Myths*, Cambridge, MA: MIT Press, pp. 277–90.

Kristeva, J. (1980) *Desire in Language: a semiotic approach to literature and art*, edited by L. S. Roudiez, Oxford: Basil Blackwell.

Laycock, H. (2006) *Words without Objects: semantics, ontology, and logic for non-singularity*, Oxford: Clarendon Press.

Lobel, M. (1996) 'Warhol's closet', *Art Journal*, Winter: 42–50.

McKee, P. (2000) 'A story of storage', *Museums Journal*, 100 (1): 14.

Moyle, J. (2003) 'Where reading peters out: iconic images in the entropic text', in O. Fischer and W. G. Müller (eds) *Sign to Signing: iconicity in language and literature 3*, Amsterdam/Philadelphia,PA: John Benjamins Publishing Company, pp. 129–51.

Nöth, W. (2001) 'Semiotic foundations of iconicity in language and literature', in O. Fischer and M. Nänny (eds) *The Motivated Sign: iconicity in language and literature 2*, Amsterdam/Philadelphia, PA: John Benjamins Publishing Company, pp. 17–28.

Peirce, C. S. (1931–58) *Collected Papers*, vols. 1–6, edited by C. Hartshorne and P. Weiss; vols. 7–8, edited by A. W. Burks, Cambridge, MA: Harvard University Press.

Putnam, J. (2001) *Art and Artifact: the museum as medium,* London: Thames & Hudson Ltd.

Reading, P. (1994) *Last Poems*, London: Chatto and Windus.

Robbins, D. (1970) 'Confessions of a museum director', in *Raid the Icebox 1 with Andy Warhol: an exhibition selected from the storage vaults of the Museum of Art, Rhode Island School of Design*, Providence, RI: Rhode Island School of Design, pp. 8–15.

Roudiez, L. S. (1980) 'Introduction', in J. Kristeva (1980) *Desire in Language: a semiotic approach to literature and art*, Oxford: Basil Blackwell, pp. 1–20.

Sontag, S. (1987) *Against Interpretation and Other Essays,* London: André Deutsch Ltd.

Wollen, P. (1989) 'Raiding the Icebox', in M. O'Pray (ed.) *Andy Warhol: film factory*, London: BFI Publishing, pp 14–27.

—— (1993) *Raiding the Icebox: reflections on twentieth century culture*, London: Verso.

Woodhouse, A. S. P. and D. Bush (eds) (1972) *Variorum Commentary on the Poems of John Milton*, vol. 2, pt. 2, New York: Columbia University Press.

17

AUTHENTICITY AND OBJECT RELATIONS IN CONTEMPORARY PERFORMANCE ART

Klare Scarborough

The recent exhibition *Evidence of Movement* at the Getty Center in California (10 July to 7 October 2007), presented visitors with a survey of contemporary performance objects from the second half of the twentieth century. Featuring artists such as Günter Brus, Tehching Hsieh, Linda Montano, Yves Klein, Alison Knowles and others, the exhibition displayed a range of documentary and supplementary objects produced in relation to performances, including preparatory sketches, scores, photographs, posters, artifacts, video and audio recordings. Objects were grouped under thematic headings to highlight the different kinds of approaches used by artists to document, preserve and promote their performances for public dissemination as well as for commercial sale. The overlapping presentation of stories in the exhibition – from the immediacy of live events within specific historical contexts, to mediated and often manipulated performance documents created for later audiences, to remnants of artistic actions packaged as marketable relics – offered visitors a complex setting in which to understand the history of an ephemeral art form defined by process, temporality, and live audience interaction. The exhibition also posed questions regarding the authenticity of various kinds of performance objects, presenting a creative gallery environment combining fact and fiction which immersed viewers in a game-like situation of playing detective, putting the pieces of evidence together, and forming their own interpretations.

Evidence of Movement provides an excellent springboard for examining critical issues involved with the exhibition and interpretation of contemporary performance objects. Through its thematic displays and overlapping categories of objects, the exhibition presented visitors with culturally valuable souvenirs, relics and traces of the past, suggesting stories about past actions, artists' lives and socio-historical contexts. In the absence of original live events, the exhibition highlighted the fact that performances as well as artists can achieve a sort of immortality through material traces that are both documentary and theatrical. Ultimately, the manipulated nature of many performance photographs and other surviving objects raises important questions about the place of authenticity in relationships between objects and their audiences, and in the socially-constructed, relational nature of viewer interpretation. In this chapter, I will explore how the display of objects in *Evidence of Movement*, as in other exhibitions about contemporary performance art, challenged viewers to reconstruct the 'truth' of artistic actions, while reinforcing the sheer impossibility of such a task. As a means of interpretive access to the past, performance objects in the end represent only fragments of

historical events, residues of artists' lives and actions that resonate in authentic ways with different viewers over time.

As an exhibition about contemporary performance art, *Evidence of Movement* employed organizational techniques and interpretive strategies based in contemporary art exhibition practices, marked by experimentation with shifting frames of presentation and interpretation, particularly since the postmodern artistic turn of the 1970s. Howard Fox, a curator at the Los Angeles County Museum of Art (LACMA), explained that '[r]eflective viewers and curators perpetually contextualize, and then re-contextualize, the art they see' (2005: 21–22). In the absence of the original live events and, often, without the physical presence of the artists represented, curators of contemporary performance art must sort through disparate collections of archival documents, performance objects, and traces of artists' lives, to produce cohesive and engaging public educational experiences. In one of the earliest exhibitions about performance art, *Outside the Frame: performance and the object. A history of performance art in the USA from 1950 to the present*, co-curator Olivia Georgia noted the importance of the original performance context or 'frame', and the elusive quality of the 'many interlacing subframes', describing performance as 'open to interpretations that can take on a life of their own and can, for better or worse, go far beyond the original intent and impact of the work itself' (1994: 85). Exhibitions displaying contemporary performance objects underscore what scholars have described as an ironic and sometimes 'slippery' relationship between performances and their documentation or, as the case may be, between the display of performance objects and their presumed ontological relationship with some kind of originary artistic actions (Jones 1997; Auslander 2006: 84).

In the last decade or so, it has become important for exhibitions about contemporary performance art to frame the display of documentation within a discourse highlighting the diversity of surviving objects and posing questions relating to the truth or falsehood of performance documentation. Kristine Stiles' debunking of the infamous tale about Viennese Actionist Rudolf Schwarzkogler, whose photo documentation of his alleged genital mutilation action in 1969 (actually faked in 1965–66) was erroneously cited as fact in Henry Sayre's *The Object of Performance* (1989: 2), had a notable impact on scholarly literature and on exhibitions about contemporary performance history (Stiles 1990). Questions regarding the truth and falsehood of performance documentation and the theatrical nature of some performance images were explicitly explored, for example, in an exhibition at the UK's Tate Liverpool entitled *Art, Lies and Videotape: exposing performance* (14 November 2003 to 25 January 2004). Of particular note was the thematic section dealing with 'fact or fiction?', which addressed the uncertainty of performance records, noting inconsistencies in eyewitness accounts and in archival documents. Catalogue contributor John-Paul Martinon commented that 'as in the many group exhibitions, truth and fiction are shown indiscriminately side by side, with the result of confusing the viewer'. However, he pointed out that, in *Art, Lies and Videotape*, curator Adrian George deliberately displayed known fictitious photographs alongside factual documents. This kind of juxtaposition ultimately asked the question 'what is an event?' (e.g. what qualifies as performance?), and presented the idea of artists creating images which 'refuse the certainty of knowledge', leading viewers to waiver between certainty and doubt in comprehending an event that, in the end, remains a mystery (2003: 43–46).

While performance documentation provides evidence, however fragmentary, for reconstructing artistic actions, scholars have noted that the surviving records are not always objective or even accurate. It is clear that artists documented their performances for a variety of reasons, beyond just recording events as proof that they actually happened. Artists also created performance documentation to validate and promote their professional careers as artists; to

reach additional audiences beyond the scope of their performances and, thus, disseminate their ideas further; and to create artifacts and relics which could be sold to both individual and institutional collectors for financial gain. Thus, the surviving documentation encompasses a range of materials produced prior to, during and after artistic actions, with performance images replicated in several artistic formats, including limited-edition prints as well as off-print spreads in popular journals. Some artists also created objects in relation to plans for performances that never actually happened, or as performative of their artistic theories or conceptual ideas. Other artists incorporated visual and textual documentation of and references to their performances within later manifestations of their art work, such as two- or three-dimensional collages. Thus, performance provided a medium for live expression as well as raw material for manipulation in other media, including performed photography and videography, fostering both immediate and ongoing layers of public engagement and interpretation.

Several scholars have pointed out the performative nature of the documentation itself in transforming events, enacted both privately and publicly, into the cultural category of performance art. Philip Auslander argued that events are framed as performances through their presentation in galleries as well as through their documentation for later audiences, concluding that 'it is not the initial presence of an audience that makes an event a work of performance art; it is its framing as performance through the performative act of documenting it as such' (2006: 6–7) The documentation not only framed events as performances, but also framed performers as artists. Through manipulating and replicating images of their performances in various media for later public audiences, artists promoted the legendary qualities of their live actions and their artistic personas. Since many artists also engaged in the performance of everyday activities as art, particularly since the 1960s, the documentation provided an authoritative means of substantiating the transformation of their lives into art. Through documenting their autobiographical acts, artists could market their artworks as well as their personal myths to become, themselves, both living artworks and icons of popular culture. Performance scholar Jon Erickson argued that live art 'becomes myth' through documentation, adding that 'from the moment that the artist recognizes that his or her survival or fame depends upon documentation, much memorable contemporary art has been made *with* the view to adequate documentation, if not playing to documentation primarily' (1999: 99, italics in original). Art historian Amelia Jones has written about Yves Klein, Chris Burden and other male artists of the 1960s and 1970s who 'mastered the art of self-fashioning' through performing choreographed actions which 'played' with masculine tropes, then manipulated and distributed the documentation to public audiences (Jones 1997: 546–55). Scholars have also remarked on the performative nature of the documentation with regard to Joseph Beuys, Gina Pane, and other artists who created carefully-planned documents to market their professional personas and careers (Maude-Roxby 2003: 70–1).

The staged quality of much of the surviving documentation has also raised questions about how broadly or narrowly to define the field of contemporary performance art; about the interconnections between the artistic categories of performance documentation and performed photography; and about the relationship between performance objects and some kind of authentic artistic action (Jones 1997; Auslander 2006). With contemporary performance art, the concept of authenticity is often discussed in terms of the 'liveness' of the original event, and the immediacy, intersubjectivity, and genuine quality of direct interactions between artists and their audiences (Phelan 1993; Auslander 1999). The growing interest in 'live' art and in the presumed authenticity of 'live' artistic expression before live audiences, reflected in the *Live Culture* symposium at the Tate Modern in 2003, highlights the contemporary social valuation of direct live experience above the mediated experience of viewing performance documentation.

Countering this, Alan Read has argued that 'performance is just as acquainted with lies as all other spectacle' and that, despite claims of autobiographical authenticity, artists are not compelled to tell the truth but, in fact, can intentionally mislead viewers through creative invention (2004: 245). Though live art is not always truthful or honest, by Read's account, the idea persists that performance documentation is more authentic than performed photography by virtue of the presumed accuracy of its representation, fostering the illusion of credibility and trust when viewers attempt to access and reconstruct artistic events. If one considers performance documentation not as a record of performance, however, but an object connected with an artist's life, and thus an authentic carrier of life stories, the object may then be viewed as a kind self-portrait, tied in autobiographical construction and expression which, as noted by Paul-John Eakin (1999), is both processual and relational.

In light of this, where does the concept of authenticity fit into our interpretation of performance objects? Does it matter to viewers if an object displayed in an exhibition is an accurate record of an artistic event? Martha Burkirk has argued that 'it is not important whether these photographs are fact or fiction, actual documents or staged, because this is how each artist has decided to represent the work' (2003: 223). Thus, we may ask, alongside the authenticity of relics that carry residues of history, do we value performance objects for the truths they convey about artistic events, or for the stories they carry and elicit, both true and fabricated, about artists' lives? And, as Auslander proposed, does our knowledge of whether an image is truly documentary or theatrical make any difference in our appreciation of the artwork or in our viewing pleasure? Citing Lee Brown's work on phonography (2005: 214–16), Auslander offered the possibility that 'the crucial relationship is not the one between the document and the performance but the one between the document and its audience. Perhaps the authenticity of the performance document resides in its relationship to its beholder rather than to an ostensibly originary event'. He suggested that the pleasures of experiencing performance documentation do not depend on whether a person was present at the original event or whether the event actually happened, concluding, '[i]t may well be that our sense of the presence, power, and authenticity of these pieces derives not from treating the document as an indexical access point to a past event but from perceiving the document itself *as a performance* that directly reflects an artist's aesthetic project or sensibility and for which we are the present audience' (2006: 9, italics in original). It would seem that a more experiential approach to authenticity would enhance our understanding of the relational nature of both artistic expression and viewer interpretation.

Entering the public interpretive setting of an exhibition, we see these critical issues played out in *Evidence of Movement*, which brought together different kinds of performance objects in the Exhibition Gallery of the Getty Research Institute, drawing primarily from the collections of the Research Institute Library, to highlight the diversity of traces of artistic actions that are collected, studied, and exhibited as art. As curator Glenn Phillips noted in the exhibition brochure, '[r]arely, however, have artists accepted the straightforward archival documentation of performance events as sufficient permanent record. Many artists have always assembled documentation and other remnants from their projects into thoughtfully designed and commercially viable art works' (2007). Framing the presentation of objects within a broad and inclusive view of the history of performance art, the exhibition emphasized the important role of artistic manipulation in the preservation and promotion of performances for later audiences. The exhibition's presentation of different kinds of objects, both documentary and theatrical, including photographs taken from different visual angles, film footage creatively altered for later audiences, and images of events which never actually happened as depicted, encouraged viewers to interpret the objects as evidence of some kind of artistic movement, without restriction of any narrow definitions of

performance actions or performance documents. The exhibition was intellectually provocative in its questioning presentation within an authoritative setting, situated near the J. Paul Getty Museum and its various Exhibitions Pavilions (all part of a destination experience for visitors), and in its efforts to engage visitors in critical thinking about the objects on display.

The title of exhibition, promising the presentation of 'evidence' of artistic activity, provided a neutral primary framework within which viewers could formulate their interpretations. The title evoked associations between the objects on display with evidence presented in a courtroom, found at a crime scene, or brought to a police station. While evidence is usually defined as proof of a truth, as indicative of the verity of a past action, evidence may also serve to either prove or disprove that an action took place, providing testimony upon which to form a judgment. Within the setting of an exhibition gallery, with objects displayed in shallow display cases, set off by white and grey walls, crisp lines and neutral tones, the exhibition's presentation of objects within thematic groupings guided the visitors' experiences and invited thoughtful comparisons and interpretations. The exhibition did not present any kind of grand narrative about performance history and, in fact, did not even include any narrative descriptions of the performance actions. Text panels for each section contained summary information about the themes connecting the featured artists and objects, and identification labels provided basic information about the actual objects on display. Thus, in the absence of the original events, and without a defined sequence of the performance activities, viewers were left to question what really took place in the past, how to interpret the mediated and often manipulated traces of performance actions, how to distinguish authentic remnants from fabricated traces and, in the end, if it was even possible or worthwhile to make that attempt.

Stepping off the Getty tram, visitors were welcomed with a large promotional banner for the exhibition featuring a dramatic self-portrait of Vienna Actionist Günter Brus (Figure 17.1). Making their way through the complex of buildings, gardens, and open spaces of the Getty Center, they reached the Research Institute Exhibition Gallery where they met with signage and a wall of performance videos introducing the exhibition. Following the arrow, visitors then walked past a large floor-to-ceiling reproduction of Yves Klein's *Leap into the Void (Saut dans le vide)* (1960). The display of this photograph, enlarged to fill two floor-to-ceiling panels, offered viewers a reflective black and white surface in which to peer into a window of appearances, as Yves Klein performed what appeared to be a suicidal leap from a second floor ledge onto the street pavement below (Figure 17.2). As evidence of movement, the photograph proclaimed a theatricality that belied the presumed reality of the performance, effectively framing the opening of the viewers' experience of the exhibition with a question mark rather than a statement. The image, in its theatricality, was appropriate for its placement at the entrance to the exhibition, where it accentuated the idea of playfulness and suspension of belief (as well as gravity) which might be involved in interpreting *Evidence of Movement*. The image also reinforced the exhibition's broad definition of performance and its welcoming engagement of viewer interpretations.

This photograph, which is actually a photo collage of two separate scenes, has become one of the most reproduced and iconic mages in the history of contemporary performance, achieving mythical status in representing a performance which was, in fact, a carefully staged illusion. Produced by Harry Shunk in October 1960, the photograph did not document an actual live performance before an audience, or even one enacted in private; rather, it referenced an artistic action staged solely for the purpose of producing part of the desired image. The photograph was intended to re-create Yves Klein's jump from a second floor window which purportedly took place earlier that year (1960), and to create the illusion of a real leap of a man in space. Amelia Jones noted that Klein in fact performed his leap several times, 'attempting to get the desired

Figure 17.1 Banner with reproduction of image from *Selbstbemalung II* (*Painting Self II*), 1964, Günter Brus (© Günter Brus. courtesy Galerie Heike Curtze, photograph by John Kiffe, Research Library, The Getty Research Institute, Los Angeles, California (94.R.34))

transcendent expression on his face', witnessed only by photographers and close friends holding the safety tarpaulin (Jones 1994: 553–4). Certain aspects of Klein's leap still remain unclear, such as the actual date that the photographs were taken: 16, 19 or 25 October 1960 (Martinon 2003: 41). After the initial staged performances by Yves Klein, a later performance took place in the darkroom, where the two photos were unified into a seamless image to create the illusion of a documentary photograph.

While the theatrical qualities of Yves Klein's *Leap into the Void* contributed to its interpretation by scholars, and by visitors upon entering the exhibition, as an independent art object and a kind of performed photography, comparable to photographs by Cindy Sherman, for example, the original context of the image was in fact quite different. The photograph was first introduced to Parisian audiences in a four-page artist's newspaper that Yves Klein created, entitled *Dimanche: le journal d'un seul jour* (*Sunday: The Newspaper of a Single Day*), distributed on 27 November 1960,

Figure 17.2 Reproduction of image from Yves Klein, *Leap into the Void*, in *Dimanche: Le journal d'un seul jour*. November 27, 1960 (relief halftone 850022. © 2007 Artists Rights Society (ARS), New York / ADAGP, Paris; photograph by John Kiffe, © The J. Paul Getty Trust, Los Angeles, California)

presented in the format of the Sunday edition of a Paris daily newspaper. Giving the impression of documentary coverage as part of the 'Festival of Avant-Garde Art' in Paris, the front page of the newspaper ran the headline, 'Theater of the Void', announcing 'A Man in Space! The Painter of Space throws himself into the void!'. Klein's text proclaimed his Sunday performance as a 'veritable spectacle of the void, at the culminating point' of his theories. 'However', he noted, 'any other day of the week could have been used. The theater of operations for this conception of theater that I propose is not only the city, Paris, but also the country, the desert, the mountains, the very sky, and even the entire universe, why not?' Thus, Klein produced his *Leap into the Void* as a theatrical and ironic expression of his metaphysical theories, within a simulated newspaper that was itself performative of those same theories, for the purpose of promoting his artwork as well as his reputation as a living legend until his early death in 1962.

Walking past the enlarged banner reproduction of this photograph at the entrance to *Evidence of Movement*, visitors were prompted to locate an original version of Klein's simulated newspaper within a thematic grouping of objects near the back of the exhibition, under the heading 'Published Performances', with each document illustrating the independent aesthetic and conceptual function of performance photographs within artistic publications (Figure 17.3). Performances staged for the purpose of publication often played to the camera, producing dramatic and iconic images which emphasized the artistry of the activities depicted. Alongside Klein's *Dimanche*, this section included photos published during the 1970s in artistic journals such as *High Performance* and *Avalanche*, including a two-page spread of photo stills from eight

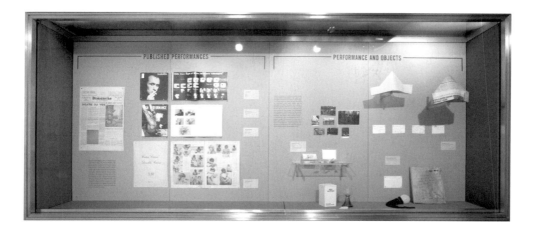

Figure 17.3 Display case presenting 'Published Performances' and 'Performance and Objects'. Yves Klein's *Dimanche* is included in the far left of the case (photograph by John Kiffe, © The J. Paul Getty Trust, Los Angeles, California)

of Bruce Nauman's videotapes. Also included was Paul McCarthy's *Criss Cross Double Cross* (1976), an exhibition which took the form of a single-issue magazine publication, in which each featured artist received space in the magazine instead of a gallery.

These documents were exhibited in the left side of a double case, with the right side dedicated to a section labelled 'Performance and Objects'. This latter section featured objects commemorating or celebrating performances, remnants of artistic actions which were transformed into sculptures, relics packaged and sold as artistic products. Included in this section were silver gelatin prints, paper hats and instructions from a performance entitled *Hran na vijáky* (*At play as soldiers*) (1965) by Milan Knížák; and a light bulb and a padded envelope from a performance by Nam June Paik entitled *My Toe is My Best TV* (ca. 1979). The exhibition brochure noted that while the objects in the first instance 'lend immediacy' to the documentation, the objects in the second instance tell us little about Paik's otherwise unrecorded performance (Phillips 2007). These and other material remnants displayed provided proof that artistic events actually happened, challenging the viewers to reconstruct performances but, in the end, providing only glimpses of past events, serving as relics of actions and ideas but proving inadequate in any attempts to reconstruct the past. The exhibition's presentation of the two interrelated themes within a double case naturally encouraged viewers to make creative comparisons and interpretations regarding the objects on display.

The exhibition displayed the diversity of surviving performance objects, representing different moments in the artistic conception and execution of artwork, with many sections juxtaposing preparatory scripts or scores for performances alongside photographs taken during the same performances (Figure 17.4). One of the initial exhibition sections, 'Scores and Documentation', presented objects related to a famous year-long performance by Tehching Hsieh and Linda Montano, entitled 'Art/Life One Year Performance 1983–1984'. The display featured three offset prints, with dates stamped in red to represent different moments of the performance. Below these prints were photographs taken at various times during that year, and an offset print of the artists' statement taken from the records of *High Performance*. These objects were at once documentary and promotional, reminding viewers of the performative role of the

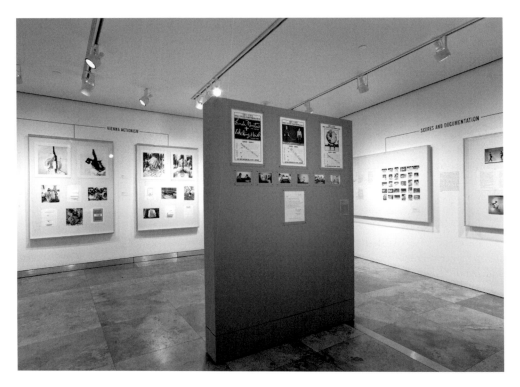

Figure 17.4　Displays in the front area of the exhibition gallery, with images and documents from Art/Life One Year Performance 1983–1984 by Tehching Hsieh and Linda Montano on the free-standing grey wall; 'Vienna Actionism' to the left; and 'Scores and Documentation' on the right (photograph by John Kiffe, © The J. Paul Getty Trust, Los Angeles, California)

documentation in framing Hsieh and Montano's everyday life together, tied by a rope at the waist but never touching, as performance art.

This section also included objects related to Carolee Schneemann's performance of *Meat Joy* (1964), featuring typed instructions outlining the planned sequence of activities alongside an arrangement of 36 photographic snapshots taken during the performance. The placement of these snapshots within a six-by-six image grid, as part of a random non-sequential arrangement of images, encouraged viewers to interpret the images as fragments of the photographer's experience. Additionally, the display of typed instructions edited with the artist's handwritten notes, combined with several casual images of performers in resting positions who smiled for the photographer, heightened the personal and social aspects involved in producing and viewing the documentation. While the display of performance objects provided a means of interpretative access to the original event (actually one of several performances of *Meat Joy*), the mode of display did not encourage viewers to try to reconstruct the performance, but rather to view the remnants of history in terms of multiple viewpoints and stories.

Several sections of the exhibition addressed the diversity of photographic records as well as the relationship between performance documentation and performed photography. As suggested by the Getty's promotional poster featuring Günter Brus' *Selbstbemalung II* (*Self-Painting II*) (1964), the exhibition included a section about 'Vienna Actionism', highlighting an influential

group of artists who produced striking photographs, often representing violent imagery or activities. Each of the three wall cases of this section displayed silver gelatin prints of Günter Brus on the top level, with photos and drawings documenting two of Hermann Nitsch's Actions from *Das Orgien Mysterien (O.M.) Theater (The Orgies Mysteries Theater): the 31st Action* which took place in Munich (1969), and the *59th Action* which took place in Los Angeles (1978) as depicted in the pages of *High Performance*. The exhibition also presented an adjacent section on 'Performance and Photography', featuring casual snapshots of performances by Paul McCarthy, Mike Kelley and Claes Oldenberg, as well as more formal images from *Pelican* (1963) and *Elgin Tie* (1964) by Robert Rauschenberg. The exhibition's inclusion of artists known for working in other artistic formats demonstrated the pervasiveness of the performance medium during the 1960s and beyond, as well as the effectiveness of performance documentation in publicly promoting both artists and their artworks. The merging of these two sections in the exhibition brochure further underlined the frequent intermingling of the documentary and theatrical functions of performances objects.

The exhibition highlighted the fact, both here and in other displays, that many artists created and manipulated performance records in different media, for different audiences, and for different purposes – producing silver gelatin prints or limited-edition portfolios that could be sold to collectors, and photo spreads for artistic journals such as *High Performance*, that could be used to promote their works and disseminate their artistic ideas to a wider public. The fact that many observers also photographed performances provided yet another level of documentation that broadened the artistic impact among public audiences. RoseLee Goldberg wrote that 'more people "see" performances through reproduction than can ever actually attend them' (1998: 33). A case in point is Yves Klein's *Leap into the Void*, which was published in *Dimanche* for distribution to Parisian audiences, and was also sold to collectors as silver gelatin prints. Different versions of the image have appeared in other contemporary art exhibitions, aside from *Evidence of Movement*, notably in *Art, Lies and Videotape* cited above (as a silver gelatin print and on the cover of the catalogue); and in *Out of Actions: between performance and the object 1949–1979* (Schimmel *et al.* 1998: 17–120). With the replication of performance documentation in different formats, and the repetition of particular images which attained iconic status within contemporary culture, artists were able to promote information about their actions, their ideas, and their lives as part of an ongoing series of mediated reconstructions.

Evidence of Movement also featured a range of different kinds of video and audio recordings of performances, which replicated both the immediacy and theatricality of the original artistic presentations, providing visitors with dynamic components in addition to static objects within an experiential gallery setting. As previously stated, the exhibition displayed several different videos near the entrance, including two videos of performances made specifically for the camera, with no audiences present; a video adaptation of a live performance; a documentary video of a performance before a live audience; and a performance video involving creative image processing and artful editing. Towards the back of the exhibition was a section entitled 'Close Radio', which featured sound and art projects broadcast from radio station KPFK in Los Angeles from 1976–79 as part of a Close Radio programme, demonstrating the variety of different types of artistic performances produced using only sound (Figure 17.5). The instruction sheet listed 111 recordings by artists such as Allan Kaprow, Eleanor Antin, Paul McCarthy, Allison Knowles, Herman Nitsch, Carolee Schneemann, and Chris Burden, with directions about how to access the recordings from a phone in the exhibition gallery, from the Getty website through streaming audio, and from visitors' cell phones or home phones (Phillips 2007). The inclusion of video

Figure 17.5 Displays in the back area of the exhibition gallery, with 'Close Radio' to the left and 'Scores and Documentation' on the right (photograph by John Kiffe, © The J. Paul Getty Trust, Los Angeles, California)

and audio components, the latter which could be accessed at different times and places, in many respects functioned to expand the interpretive experiences of museum visitors.

While *Evidence of Movement* did not include a public programme of associated live performances before live audiences, the other exhibitions cited above offered museum visitors a combination of live and mediated experiences, raising questions about differences in the public reception and interpretation of performances and their documentation. The idea of viewing live performances as presumably more authentic and communal, as compared with the mediated and individual experience of viewing performance documentation, has also been explored by numerous scholars in terms of subjectivity, temporality and variability. Amelia Jones, for example, has questioned whether the on-site viewer has a 'privileged relationship to the historical "truth" of the performance', concluding that the issue of 'privileged' access is complicated by 'personal feelings', leaving 'no possibility of an unmediated relationship to any kind of cultural product, including body art' (1997: 11–12; 1998). RoseLee Goldberg has written about the individualised and temporal aspects of viewing documentation, stating that '[r]eaders may view the image of a one-time only performance as frequently as they like, resuscitating the live performance repeatedly in their imagination, while quotations from the artist and descriptions of the event, indicating sequences and duration, may provide a fuller explanation of a performance than was evident during the actual presentation' (1998: 33–4). Kathy O'Dell has explored the haptic experience of viewing performance journals and publications intended for private appreciation, presenting an intimate relationship whereby viewers could see and touch performance images at their leisure in their own homes (1997: 74–5). Tracey Warr has noted that the original experience of the viewer, fixed in time and space, can become multiplied through viewing documentary

images from different angles, contributing to layers of interpretation by later audiences (2003: 31). While differing in their contributions, these scholars agree that multiple forms of knowledge play into viewers' interpretations of live performances as well as performance documentation, and that the context of reception is an extremely important factor in the interpretation of both performances and objects.

With regard to public exhibitions about contemporary performance art, I would then argue that each viewing, each interpretation, of performance objects is contextualized by its spatial, temporal and social dimensions, as viewers perceive evidence differently within different contexts at different times. Interpretations are both personal and relational, as visitors view exhibitions within interactive public settings where the context of reception combines both individual and communal elements. Viewers not only interpret isolated objects but they also make associations between different kinds of objects. Furthermore, they frequently base their judgements in the light of their conversations with others, as they visit the Getty Center and other cultural institutions with family, friends, colleagues, and strangers. Following Auslander's suggestion that '[p]erhaps the authenticity of performance documentation resides in its relationship to its beholder rather than to an ostensibly originary event' (2006: 8), my discussion of the presentation and interpretation of performance objects in *Evidence of Movement* illustrates the ways in which visitors were invited to glimpse fragments of original artistic actions or, as in the case of Klein's photograph, perhaps a series of fabrications, hinting at the liveness of artistic actions in the absence of lost originals, and conveying stories, both true and false, about artists and their artworks. Though faced with mediated and often manipulated performance objects, viewers interpret records and remnants of the past within dynamic, authentic and live social contexts.

Just as artworks perform, so too do viewers perform within a relational game of social communication. The performativity of the performance documentation transforms life into art and performers into artists through keying into artistic conventions of representation. Following the sociological theories of Erving Goffman (1974), I would argue that the documentation frames an event as a performance in a variety of ways: through formal or theatrical means; through the choice of artistic media that ambiguously combine documentary and theatrical modes; and through the presentation of performance objects within contexts such as artistic journals and fine art galleries. However, the performative accomplishment depends not only on the form and vehicle of presentation, but also on the context of public interpretation, for artistic conventions must be recognized by viewers for the keying process to work. Notably, J.L. Austin's linguistic definition of performative verbs, which 'should be doing something as opposed to just saying something', acknowledged that the communication of meaning is to a large degree determined by the speech context and by the listener's recognition of the speaker's intentions (1965: 33–52,133). Other scholars who study performativity have noted the presence of complex citational processes which function within the changing social contexts, involving both participants and witnesses in the creation of meaning (Parker and Sedgwick 1995: 2–3). From this, I conclude that the performativity of performance documentation transforms events into art and individuals into artists through a process that is rooted in social communication, with layers of meaning that shift with different contexts of presentation and reception.

On another level of interpretation, as I study the *Evidence of Movement* exhibition through the Getty's website, the exhibition brochure, and the formal 'installation' photographs kindly provided by the curator, I recognize that the exhibition itself, while occupying a specific space and duration of time (like contemporary performance), has a life outside of its original physical presence which reaches different audiences in different times and places. In the absence now of

the original physical exhibition, these records provide me with documentary access to the shape of the exhibition space, the conceptual layout of the design, and the flow of interpretive displays – access which is met at each turn by my subjective responses and interpretations. Looking at the objects in the double display case combining 'Published Performances' and' Performance and Objects', for example, I am repeatedly struck by the faded edges and crease fold of Yves Klein's simulated newspaper, and I imagine people holding and reading the manifesto on the day it was produced and many times afterwards. I think about the artistic construction of performance objects such as *Dimanche* or the play soldiers' paper hats – relics and reminders of past actions which carry different meanings for different viewers at different times. As I sort through the various types of evidence exhibited, I return again and again to Klein's photograph, not in the original newspaper context, but as a dramatic blown up image guiding my entry through the twisting maze of facts and fictions. My experience is visual, intellectual, subjective, authentic, as well as temporal, as I return repeatedly to the exhibition documents and their stories, to traces of an exhibition from a year past, which continue to resonate into the future.

Acknowledgements

I want to extend a special thanks to Glenn Phillips, curator of *Evidence of Movement*, for contributing information and photographs for this chapter, and to the Getty Center for allowing me to reproduce installation photographs of the exhibition.

References

Auslander, P. (1999) *Liveness: performance in a mediated culture*, London: Routledge.
Auslander, P. (2006) 'The performativity of performance documentation', *PAJ: A Journal of Performance and Art*, 28 (3): 1–10.
Austin, J.L. (1965) *How To Do Things With Words. The James Wilson Lectures delivered at Harvard University in 1955*, edited by J.O. Urmson and M. Sbisà, Cambridge, MA: Harvard University Press.
Brown, L.B. (2005) 'Phonography', in R. Goldblatt and L.B. Brown (eds), *Aesthetics: a reader in philosophy of the arts*, Upper Saddle River, NJ: Pearson-Prentice Hall.
Buskirk, M. (2003) *The Contingent Object of Contemporary Art*, Cambridge, MA: MIT Press.
Eakin, P.J. (1999) *How Our Lives Become Stories: making selves*, Ithaca, NY: Cornell University Press.
Erickson, J. (1999) 'Performing distinctions', *PAJ: A Journal of Performance and Art*, 21 (3): 98–104.
Fox, H.N. (2005) 'The right to be wrong', in B. Altshuler (ed.) *Collecting the New: museums and contemporary art*, Princeton, NJ: Princeton University Press, pp. 15–27.
Georgia, O. (1994) 'Framing Out', in R. Brentano and O. Georgia (eds) *Outside the Frame: performance and the object. A history of performance art in the USA from 1950 to the present* (exhibition catalogue, 1 Feb.–1 May), Cleveland, OH: Cleveland Center for Contemporary Art, pp. 85–107.
Goffman, E. (1974) *Frame Analysis: an essay on the organization of experience*, Boston, MA: Northeastern University Press.
Goldberg, R. (1998) *Performance: live art since the 1960s*, London: Thames and Hudson.
Jones, A. (1994a) 'Dis/playing the phallus: male artists perform their masculinities', *Art History*, 17 (4): 546–84.
Jones, A. (1994b) '"Presence" in absentia: experiencing performance as documentation', *Art Journal*, 56 (4): 564–55.
Martinon, J.-P. (2003) 'Fact or fiction', in A. George (ed.) *Art, Lies and Videotape: exposing performance* (exhibition catalogue, 14 Nov. 2003 – 25 Jan. 2004), Liverpool: Tate Liverpool, pp. 40–9.
Maude-Roxby, A. (2003) 'The delicate art of documenting performance', in A. George (ed.) *Art, Lies and Videotape: exposing performance* (Exhibition Catalogue, 14 Nov. 2003 – 25 Jan. 2004), Liverpool: Tate Liverpool, pp. 66–79.

O'Dell, K. (1997) 'Displacing the haptic: performance art, the photographic document, and the 1970s', *Performance Research*, 2 (1): 73–81.

Parker, A. and E.K. Sedgwick (eds) (1995) *Performativity and Performance*, New York: Routledge.

Phelan, P. (1993) *Unmarked: the politics of performance*, London: Routledge.

Phillips, G. (2007) *Evidence of Movement* (Exhibition brochure, close radio instruction sheets, and phone interview with curator on 8 Sept. 2008, exhibition summary, Getty Research Institute Exhibition Gallery, 10 July–7 Oct), online <http://www.getty.edu/art/exhibitions/evidence_movement> (accessed 1 April 2008).

Read, A. (2004) 'Say performance: some suggestions regarding live art, in A. Heathfield (ed.) *Live: art and performance*, New York: Routledge, pp. 242–7.

Sayre, H. (1989) *The Object of Performance*, Chicago, IL: University of Chicago Press.

Schimmmel, P., K. Stiles, G. Brett, H. Klocker and S. Osaki (1998) *Out of Actions: between performance and the object 1949–1979* (exhibition catalogue, The Museum of Contemporary Art, Los Angeles, 8 Feb.–10 May), New York: Thames and Hudson.

Stiles, K. (1990) 'Performance and its objects', *Arts Magazine*, 63 (3): 35–47.

Warr, T. (2003) 'Image as icon: recognizing the enigma', in A. George (ed.) *Art, Lies and Videotape: exposing performance* (exhibition catalogue, 14 Nov. 2003 – 25 Jan. 2004), Liverpool: Tate Liverpool, pp. 30–7.

AFTERWORD

Howard Morphy

Before writing or when the strands of an argument I am developing become so entangled that I cannot see a way out, I go for a walk up Mount Painter, the impressively named but rather low hill behind my house in the suburb of Cook in Canberra, Australia. Today I began my walk in the early evening. As I left the streets and suburban gardens behind I sensed smoke in the air – the faint smell of burning eucalyptus. It is an evocative smell and carries me to Arnhem Land in Northern Australia in the early dry season. Yolngu people begin to burn off the land as soon as the wet season is over to make the country more accessible and in their terms to make it clean. I love walking through the blackened forest as the green shoots emerge. Many generations of controlled burning by Indigenous Australians is what made the Australian landscape as we see it today. Burning off is also used as a means of hazard reduction in the more densely settled region of southern Australia. But uncontrolled fire is rightly feared. The devastating bush fires in Victoria had just resulted in the loss of over 200 lives. I had heard no news of local bush fires so I assumed burning off was taking place and that when I reached the top of the hill I might see a distant plume of smoke. However as I continued up the hill the smell of smoke became stronger and more acrid, less pleasant to me. Then I realised that the smoke was emanating from barbecues lit to prepare the evening meal – the initial smell of the wood smoke from the lighting of the fire was overpowered by that of sizzling fat as the sausages and lamb chops began to cook. As I continued my walk I left the smell behind and became conscious of the crunching sound of my footsteps as they broke through the dry soil of the crusty path and as the path got steeper and stonier my feet began to slip. I became aware of the stress that was being placed on my muscles and on the way down I became increasingly conscious of the pain developing in my knees.

It can't be a coincidence that these thoughts occurred as I took my evening walk while preparing to write this afterword. In reading the chapters and the editor's introduction my mind was spinning with thoughts about the material nature of the world and its apprehension by the full range of our senses. I was also aware of a theme emerging of a slight unease I have with the too easy slippage from the complex world in which millions of people carry out their lives and one's own bodily experience – my phenomenal world is so different from many others yet I wish to understand how they experience it and indeed feel their sense of being in the world.

Writing an afterword for an edited book can be thought of as a privileged task for which there is no formula and perhaps no rules. An introduction has to set the scene and survey the chapters. The editor has to be relatively neutral in encompassing the diversity that inevitably exists within a multi-authored book. Indeed a good book will have chapters that take up different positions not all of which coincide with that of the editor. The editor needs to ensure quality and coherence and show how all the contributors add something to the main theme of the book. There is no point in writing an afterword that duplicates the task of the introduction, especially not in a

book that is so well thought out and introduced as this one. An afterword is dangerous for the editor since it comes when the book has been completed. The writer has been asked to respond, to reflect on the chapters as a whole and relate them to his or her own work and interests. The writer of an afterword is almost inevitably a positioned reader, passionate about the subject but with strong views.

The core focus of the book is on the materiality of objects – in particular objects housed within museums. Museums are storehouses of material culture. Objects are their resource and releasing their potential should be among the core objectives of the institution. Their potential exists in the understanding that they can bring of the cultures of origin of the people who made the objects and in conveying information and affect across space and time. There is a need to give equal weight to the accumulation of knowledge and the use of the imagination. Collections reflect the different purposes of those who engage with them. Museum collections can be an investment in the artefact market, a source of inspiration to the artist or craftsperson, a source of information about techniques and the properties of raw material, and a source of delight for the senses. Museums are used for all these purposes and many more. But the focus of the essays in this book has been mainly on objects as sources of information and objects as the means of communicating information to different publics. I will not be referring to most of the chapters though reading them has given me access to an enormous resource on the topic. The very diversity of the authors ranging from museum curators to anthropologists and archaeologists, to historians, to practising artists ensures that the book is likely to expand any reader's perspective on the material world and its potential to delight and inform.

The great era for the founding of the museums was during the nineteenth and early twentieth centuries. Building on the heritage of the cabinets of curiosity and global engagement of the Enlightenment, museums were a focal point for the human and natural sciences. However for much of the twentieth century they became a somewhat neglected resource – they remained important as sites of public education and aesthetic inspiration but in many areas they became set apart from the mainstream of disciplinary research. For much of the twenieth century until the 1960s material culture, as a source of evidence for the study of human societies, had been largely neglected by anthropologists and historians alike. Material culture was the subject of art history but only that segment of material culture that had been incorporated within the framework of art with its bias towards the aesthetic evaluation of form. Material culture had also been among the primary data of archaeologists but again the perspective was often too narrow. The methods centred on the typological analysis of artefacts as traits that marked temporal sequences and cultural boundaries or provided a source of information about technology and function linked to human action.

I think that until the latter half of the twentieth century one major factor in the neglect of material culture was the essentially utilitarian attitude of Western capitalism to the production and consumption of material objects. There was a sense in society that material objects were the passive subjects of human action, a view expressed perhaps in its most extreme form by Anthony Wedgwood Benn, at the time minister of technology in the Wilson Labour government. Written in the introduction to an Open University book on Technology, when he was the Minister of Science and Technology in the first Wilson Labour Government it is almost unrecognisable as a statement of the radical of later years:

'Do machines control us? I do not believe it at all. I have a washing machine, and a motorcar and an electric shower and a fountain pen and a wristwatch, and none of them has ever made the slightest attempt to tyrannise me. They are entirely inanimate objects' (1971: 16). He goes on to consider what technology is doing for the individual person – it is in practice, he argues,

devolving power – this is perhaps best reflected in the motor car – 'instead of using national public transport systems like the old railways which limit movement to existing lines, transport decisions are decentralised for the man who has the motor car, he can go anywhere he likes' (1971: 19). It is the ideology that underlies the motor car rather than the potentialities of the machine itself that has determined the trajectory of transport policies over decades – the investment in road rather than railway track and the creation of facilities that favour the rapid passage of the car to the detriment of other aspects of the environment. The affective aspects of material culture were in the domains of fashion and design and their arena was in advertising.

Material culture objects were treated in almost too material a way. In order to become part of the data of human societies they had to be made more abstract and reconnected to the societies that produced them. Material culture objects had to rejoin to the world of ideas that they were part of and be joined to the people who used them and valued them. Far from being passive objects of human action and subject to their control they are integral components of the world in which people live, influencing people's conception of themselves, the world and the possibilities of human action. Moreover it became recognised that the material world was not divided up into discrete functional types that neatly circumscribed the use and significance of objects, a knife for cutting, a vessel for containing and so on. Objects had multiple attributes and dimensions that connected them deeply to social life, so that a knife could indicate status, seasonality or gender, and reflect personal preferences, conditions of trade, the scarcity of raw materials and so on. Indeed one of the difficulties in studying material culture is that once one begins to trace the network of connections that are linked to a single object it is difficult to know where to stop. Material objects, technologies and the associated ideational complexes could radically transform society outside their immediate domain of application. Technological change is not simply substitution but often results in social transformation precisely because of the ways in which it is interconnected with other areas of life. Schivelbusch's study of the impact of the railway on nineteenth-century Europe and America is an exemplary study of the ways in which material culture can have a transformative impact on society (1986). The railways necessitated the creation of a single time zone across Britain, facilitated the development of telegraphy for signalling, opened up regions that had previously been distant from the metropolis, altered perspectives on landscape and affected peoples sense of time and space. However such studies of material culture remained relatively rare.

Towards a new paradigm for material culture

The emergence of a new paradigm for studying material culture was the result of two factors that at first may seem contradictory. On the one hand material objects began to be conceived of in more abstract and conceptual terms and on the other hand people became more attuned to the material nature of things (see essays in Tilley *et al.* 2006). Making objects more abstract and making them integral to human society was an important first step. Once material culture objects began to be seen from an ideational perspective it became less easy to separate out the different components of material objects from each other – objects literally became more complex. Objects were understood to simultaneously mark status or gender, perform a number of utilitarian functions, and create an atmosphere, present core aspects of the value structure of society. Often the meanings and significances of objects were implicit, variable and even idiosyncratic.

As well as requiring a more abstract and ideational model or conception of the object it was necessary to re-engage with its material form. It was recognised that different attributes

of the objects could connected in very different ways to the place the object had in the world. Attributes that connected to the utilitarian function of the object – its capacity to cut, or protect, or convey information – might be relatively autonomous from those that signalled the status of its users or contributed to the contexts of its use. The embellishments required for a ceremonial item may even contradict its utilitarian referent. The elaborately carved ceremonial spears of the Yolngu or the Tiwi of Northern Australia make them ineffectual as weapons except in the most controlled of circumstances. However in analysing the ceremonial spears it is necessary to adopt a broad perspective in which the utilitarian role of spears in the life of a hunter-gatherer society contributes to them being viewed as objects of power subject to transformation into objects of ritual power.

This engagement with material form also coincided in anthropology with the coming together of three other trends that had in part emerged out of the discourse over symbolic anthropology: a turn towards a more phenomenological approach, an emphasis on the body and theories of embodiment and steps towards an anthropology of the senses. These themes developed on an interdisciplinary basis and connected anthropology, history, archaeology, and cultural studies, to research undertaken more generally on museum collections.

At the end of the twentieth century the study of material culture was at the beginning of a paradigm change. The paradigm change has involved, among other things, reconnecting objects to society, developing an awareness of the affective dimension of material objects, a growing sense that material culture is closely connected to issues of identity and that indeed material objects are integral to processes of world making. People are socialised into a world in which it was becoming harder to separate the material from the immaterial. Times of paradigm change are the moments when new tropes replace old and stimulate the direction of discourse. There was a vital need to recognise that material culture objects were integral to society and to explore their social dimensions. It was necessary to move away from a view that saw material culture as facilitating rather than world making and to recognise that objects had properties that human beings responded to as well as utilised, properties that had an affect on people, that stirred emotions and evoked a bodily response.

There is no question that the human body is a rich source for the metaphorical extension of language to the object world. In describing objects and landforms body parts abound in all language crosscutting categories and connecting the animate to the inanimate. Nails have heads, rocks have veins, apples have skins and colours can run or bleed. Sensuous and emotional vocabulary can readily be applied to material culture objects so that a pattern can be aggressive, vibrant or gentle, and can have attributes of strength and weakness or connotations of gender. Certainly it is possible to argue over the focal meaning in such cases and the extent to which the bodily analogy is in mind – in hammering a nail do we really think of a human body? But it is undeniable that in certain contexts we can use the same vocabulary to talk about people and material culture objects. Moreover there are certain types of material culture objects with which people can develop affective relationships – a security blanket, a favourite jacket, a walking stick, a pair of shoes and so on. Objects can be the subject of desire and the focus of competition. Objects can be so much part of the way one presents oneself to the world that they become not only part of self-conception but of other people's perception of a person. Part of the art of portraiture and descriptive writing is to signify personality and history through associated objects.

In many societies there are categories of objects that seem to have more of the attributes of people than others, where the use of vocabulary across categories appears to imply more than metaphorical extension. In the case of the Yolngu of eastern Arnhem Land the land as a whole is

viewed as a body breathing water in and out: the water moving inland through tidal flows and wet season rains and pouring out through the river mouths in great plumes of freshwater that stretch out into the sea (Morphy and Morphy 2006). In the Massim area of Papua New Guinea, *kula* valuables are the centre of the regional system of trade – necklaces of coral-red beads and armbands of conus shell circulate among a chain of islands in opposite directions. The rich vocabulary associated with the valuables and people's dispositions towards them all reinforce the idea that these are objects with a personal history: that they travel on paths or 'roads', acquire a set of names, they age, gain in fame, and they can affect the livelihood and health of people (Munn 1986).

It is possible to see why the analogies drawn and resemblances seen between people and things proved to be an attractive source of tropes for the study of material culture. However a number of tropes have almost reached the point of becoming clichés in writing about the nature of material culture objects. Objects have become too like persons, they have wants or agency, they have social lives and they go on journeys. The danger of treating objects as if they were people is that the analyst can leave behind the very methodologies that are required to understand how the form of objects has its effect in context. It is essential both to analyse closely the phenomenological distinctions that people make in the world and then to understand how those phenomena appear to people. It is necessary for the analyst who wants to understand the impact that objects have, to place them in the abstract framework of their social-cultural context and the phenomenal world of the individuals who interact with them. It is then that we will be able to apprehend how in Sandra H. Dudley's words 'affective objects evoke feelings'. It is by placing the materiality of the objects as it impacts upon people in the broader context of the world of which they are a part that we will be able to understand how people endow them with the attributes of persons or see in them the presence of the spirit world, and how they reinforce hierarchy or become integral to value creation processes. Material culture objects in lived worlds are on the whole encountered and used by people who know the kinds of things they are – it is important to build knowledge as well as affect into our interpretative models.

Reading these essays the role of the museum as the fulcrum between the present and past comes to the fore. Material objects can play a mediating role, yet the museum must also be a place of separation not false union across time. No one can deny the powerful feeling when holding a Palaeolithic hand axe that someone has held it 30,000 years before. Or deny Andrew Motion's (2007) response to the original manuscript of a poem when he feels 'an extraordinary electrical charge is coming through me, and that can't be replicated by things that are replicas' (cited by Saunderson *et al.* this volume), or the feeling of empathy for the subjects of a photograph and almost sharing their experience as they place one next to another in the family album. The magic of the museum is partly the magic of personal discovery and exploration of the magic of the place. But in engaging with objects in a museum we are entering a constructed environment at the same time as we carry our dispositions and knowledge with us.

As someone who has spent among the happiest days of my life in museum store rooms among the reserve collections, that characteristic smell of well-worn objects from different cultures in an arrested state of decay no doubt added to by the cocktail of chemicals employed by past conservation practices, is at least as evocative and satisfying as the smell of the Arnhem Land bush after a fire. And I too feel a sense of excitement – electricity? – when I decode the labels written in the hand of Baldwin Spencer as he documented the original object collected from the Arrernte of Central Australia in 1901. And I know that at least the latter sense is widely shared and reinforced since the digital age has resulted in a proliferation of manuscripts reproduced together with parallel edited and transcribed texts, so that we can enter the past via the internet

if only through the medium of facsimiles. However we need to be cautious in generalising these feelings cross-culturally and be aware that the sense of excitement over the original may not be shared in the same way in China, and the Arrernte of today may not share my empathy with Baldwin Spencer. In order to see the objects as other see them we need to step back from ourselves.

The history of the creation in the west of the category of 'primitive' art provides a lesson of the dangers of incorporating to the material culture of non-Western societies according to Western preconceptions about the 'other'. The history is now too well known and the critiques sufficiently well made for me to go into any detail (Errington 1998). Indigenous art began to be broadly recognised in the West through its entanglement with the modernist movements and the associated art worlds. An element of modernism was an emphasis on the properties and potential of form and an escape from the illusion of representation that had arguably been a dominant paradigm of European art since the Renaissance. An exploration of material form and its properties had the potential to inform the study of material culture in general. However as far as indigenous art was concerned the creation of primitive art projected a series of assumptions onto the objects and the producing societies. Primitive art was logically prior to contemporary art, it shared features in common with the art of children and the insane, it was untutored and reflected primary expressive urges, and it was close to the roots of the human psyche and spiritually powerful. The art world was less concerned with its significance in its own cultural context or what its meaning was to the artists. Even the category 'artist' was problematic, as ironically the works were often positioned as tribal forms rather than as reflecting individual creativity. The consequence of this approach was to distance indigenous art from the present, to define its authenticity in terms of the past, and at the same time be unconcerned with art as a mode of action in the context of the societies from whence it came. This positioning of the art resulted in a neglect of studies of indigenous art practice, separated indigenous art from world art history without exploring its history in its own terms and made it harder for indigenous artists to engage with the global art world that was emerging.

The materiality of objects is both a resource for discovering more about them and the societies of origin and a means of communicating those understandings to others. It is important to realise that those two processes are fundamentally different and that they indeed require separate relationships to be established with the object. The object itself cannot communicate cross-culturally in an unmediated way except in the limited sense we have discussed already. Certainly the Western viewing audience can appreciate form aesthetically from their own standpoint without entering into its significance to the producers. People can use the form of objects to challenge and inform their own understandings of the material world to understand qualitative aspects of the material world and add to them. And in developing their appreciation of the qualities of artefacts that will feed in to analytic frameworks, making people aware of the potentiality of form to interrogate the object and to challenge preconceptions.

The object as a source of information requires precisely that interrogative approach that reveals the object in all its richness and connects it to all the contexts in which it is used and appreciated. The engagement of artists and others with the diversity of the form of material objects has opened up new ways of looking at things as too has attention to the affect of objects within the curator's own society. Chapter 2 by Elizabeth Edwards for example demonstrates the potential of a dialogical approach that connects the materiality of the photographic image to historical processes and the ways in which individuals relate to photographs – selecting, ordering, touching, crying over, sending, carrying and so on. As analysts we need to move between different frameworks of interpretation from seeing marks on photographs as evidence

of age, or processes of conservation, to the consideration of technological change and usewear – we need to be as sensitive to the impact of tears, touch, to neglect and fetishisation, as we are to properties of chemicals and type paper. Sensitivity to form opens out so many potentially interconnected and also relatively autonomous domains of enquiry that the researcher needs to be cautious of tropes that encourage too simplistic connections.

Disjunctive interpretation

I am attracted by the idea that arose through reading Chris Dorsett's chapter (Chapter 16) of a disjunctive space existing between different interpretative communities. His focus is on artists and curators as interpreters of museum collections. The focus of his artwork was the reserve collections which viewed from the perspective of the museum visitor he sees as 'a hidden, almost unfathomable, "reservoir" of things'. Dorsett acknowledges that different constraints exist on artists and curators because their respective motivations, and because they have different principles of professional practice and different obligations to the community. It is part of Dorsett's argument that artists and curators are not doing the same thing but are none the less involved in overlapping discourses over the meaning and interpretation of museum collections.

Disjunctive spaces equally exist between artist's curators and their audiences. Helen Rees Leahy's chapter (Chapter 11) on installations in the Turbine Hall of the Tate Modern refers to the disjunctive space between Doris Salcedo's artwork *Shibboleth* and the gallery goers' interpretation. Salcedo's work comprised a jagged fissure that ran across the gallery floor. To her it signalled racism as the underlying fracture in modernity. However in the context of the exhibition the potential performative aspects of the work in effect appropriated its meaning as people responded to it, pondered over its construction, dangled their legs over it and were photographed in action by their friends. But as Rees Leahy argues it was not simply the material form of the object but the nature of the gallery and its past exhibitions that influenced the response of the audience. I would argue that the curator/researcher and in this particular case the artist need to be aware of the disjunctive nature of the space between themselves and the public and anticipate the likely response to the exhibition by stepping back and taking up the position and presuppositions of the audience.

I find the concept of creative disjunction useful as means of conceptualising the transformational processes that link the communities of origin with the curators, researchers and others who work with the collections, and then in turn to the audiences with whom they communicate. My argument is that it is important for those engaged in mediating affect between the producing societies and the museum audiences to acknowledge the relative autonomy of those communities and engage in reflective process of stepping back – to acknowledge the disjunctive nature of the creative space and to exercise caution in eliding the distance between different communities through the material effect of artefacts alone. The key question in each case is one of how? How did the producing community, perceive, respond to and use the object(s)? How can the researcher of the museum collection interpret the object(s) in the ways they were apprehended in earlier times and in different cultural frames? And how can the information be conveyed to audiences in such a way that they can share an experience with original producers and respond to the object in analogous way? Clearly the answers to these questions are going to depend on the distance in time and the conceptual space between the original producers, the curatorial interpreters and the audience. And in the case of objects such as the Sultanganj Buddha, that have existed in very different contexts, these questions need to be asked in a number of different ways (see Chapter 4 by Wingfield). The process is a dialogical one since movement between the

different 'communities' is integral to the process – one can learn about the society of origin from the museum collections and learn about the museum collections from the society of origin. None of this of course denies the use of collections that can be undertaken for quite different purposes.

I will begin my argument with the community of origin even though, with museum collections, that may be the second stage of the process. Research into material culture ought where possible to begin outside the museum and will invariably include information from outside the collection – archival data, archaeological context and so on. By beginning with the societies of origin I am directing attention towards societies where it is possible either through observation or indirectly though the use of archival and historical sources to gain access to people's engagement with their material world. This research is what produces the rich ethnographies that enable us to see how value is created in *kula* objects, and how Haida portrait masks bring the dead back to life, or how photographs are believed to contain the spiritual essence of the person. Historical research will connect us to the lives of Virginia Woolf and Vanessa Bell illuminated by Virginia's writing and Vanessa's painting (see Chapter 8 by Hancock). However as interpreters we cannot be content with the ethnography and sources at our disposal; we need to analyse and interpret in order to understand their significance, and this is the first stepping back that is required. Even though we want to get close to the phenomenal world in which they existed we need to disengage and to enter the disjunctive space between us and them in order to understand how they perceived the world in the way they did and to communicate that understanding to audiences. The ethnography that enables us to understand the sense in which *kula* valuables can be thought to have agency has been the subject of the most intense debates in anthropology that have lasted for nearly a century. And as I will shortly argue the historical research that enables Nuala Hancock to understand the significance of Virginia Woolf's glasses that contributes to their impact on the viewer, cannot be reduced to the affect of the object itself. It cannot reside in the object or its life history except in a rhetorical sense; it is in fact created by context and by the detailed analysis of rich and complex data. Unless we show how and why an object has significance in the context of its times then we can never hope to communicate that significance to others.

In order to get this far we have already undertaken the second stepping back – the stepping back required by the curators and researchers of collections. Centred on the material objects housed in the museum they need to stand aside from their own immediate responses and interrogate the materiality of the objects in relation to the maximum of information that can be gained about their original context. This requires a stepping back from the curator's own society, dispositions and pre-suppositions. Yet the stepping back is only undertaken in order to reengage with the material form as an exercise of the imagination. The imagination needs to be stimulated by a broad sensitivity and knowledge of the material properties of things and the perception of those cross-culturally. Knowledge that the affective dimension of objects may be integral to their significance, that objects may move people and fill them with desire, are sometimes attributed with agency, have significant histories as well as instrumental functions and so on, are all valuable guides as to how the object may have been interpreted in context.

The final communities to engage with are the audiences of the present day – the exhibition visitors, the readers of books, the artist, and the broader public. And here the stepping back involves a double movement. The curator and the interpreter of the collections must be sensitive to both the affective power of objects in the culture of origin and the feelings they are likely to evoke in the contemporary audiences. It is important to involve affect in conveying ideas and interpretation of different cultural groups whether of the past or present to the museum public – so that people can experience meaning through the objects. But in many cases the curator must

accept that the materiality of the object may convey the wrong message. The Fijian club that is the most powerful because of its reputation that it almost has the attributes of a God may appear to be the least powerful either aesthetically or as a weapon. The most valuable *kula* object – a value so great within its own regime that it is unlikely ever to enter a museum collection – may be characterised by the marks of the many voyages it has journeyed rather than by its spectacular form. In many such cases spectacle will reside in the way it is presented in context and the awe that surrounds it as much as it does in the form of the object itself. The highest value may reside in the most ordinary of objects and the task of the interpreter is to show the audience how that is the case.

Similar considerations apply to the aesthetics of beauty and canons of realism in different artistic traditions. The *sowo-wui* masquerade of the Mende of Sierra Leone provides an illustration of both. The masks disembodied and displayed in museum cabinets may not resonate with Western conceptions of beauty yet Boone (1986) provides convincing evidence of how this is the case for the Mende and rapidly the viewer's conception of the masks change. Similar considerations apply to the iconography of objects that make it difficult for an audience unfamiliar with the cultural context to grasp the sense it has to the people concerned. Yolngu paintings and dances that focus on death share, in common with many other societies in similar contexts, attention to the processes of bodily decay. Western attitudes to death have tended to distance maggots and bodily decay from funeral rituals. In Yolngu rituals they are foregrounded but in contexts where the emphasis is joy and communitas and the maggots are irreverent and sensual as well as symbols of regeneration (Morphy 2008). The museum curator has to be sensitive to the likely reactions of contemporary audiences and persuade them to see feminine beauty in Mende masks and the joyous dimension of maggots in Yolngu iconography. Thus attention to the materiality of objects may require the use of techniques or the provision of supplementary information that enables people to see the objects concerned in very different ways – to be able to sense their presence and experience them as they were experienced in the societies that produced them.

The curators of collections and the historians and anthropologists who research them today have access to many techniques for guiding the interpretative experience of the viewer. Digital technology enables multiple media to be deployed in the exhibition space to add information or create an exciting or immersive environment. Dialogue with practising artists has added to understanding of the ways in which sensual experiences can transcend the limitations of particular media. This has added new dimensions to the ways in which the significance and phenomenal nature of material form in its cultural context can be communicated. Wing Yang Ting (Chapter 13) describes an interesting experiment in engaging students with the sensual dimension of Chinese porcelain by transferring ideas through musical association or the qualities of food. Although in this case her attention was directed more to getting the students to appreciate the materiality of the objects rather than communicate particular cultural significance, the approach is clearly one that can be used to alter people's received perceptions of objects. Indeed implicitly it is part of the practice of exhibition designers to create an environment that enhances the aesthetic appreciation of the work or references its historical background. Attention to the materiality of objects indeed requires making connections outside the object itself and using those connections to create an understanding of its significance.

Museums can themselves be the very houses in which historical figures lived or the buildings wherein important events occurred. Sheila Watson shows in Chapter 14 the ways in which the Churchill Museum situated in the wartime underground bunker of the Cabinet creates an immersive experience through the combination of sound and photographic imagery that carries the visitor back in time. Nuala Hancock's chapter takes us inside Virginia Woolf's Charleston and

Vanessa Bell's Monks House (Chapter 8). Her analysis of a few selected artefacts is particularly powerful and revealing. Hancock had a privileged position. She was not just a casual tourist visiting the house and briefly engaging with the objects. She had a placement in the houses and was able to experience the objects in their present context and relate them to the past lives of their owners and the more recent history of the objects themselves. And the paying customer would not even have seen the title object of her chapter, 'Virginia Woolf's glasses'. The glasses were part of the reserve collection, Chris Dorsett's space of the imagination. In writing about them and in her unwrapping of them she creates a mystique, which both enlightens and endows the object with power. And with subtlety she redirects the reader's thoughts from the materiality of the spectacles – 'weightless, exquisitely fragile, inordinately narrow; impossibly ephemeral' – to the physicality of the long dead wearer.

Performativity enters Hancock's writing and performativity is an important component in today's museum displays. It is one of the areas in which the agency of the artist can act in harmony with the curator in conveying the sense that objects had or have in particular cultural contexts. Increasingly in settler colonial societies performance has become an integral part of exhibitions of indigenous cultures and one of the ways in which indigenous communities have reclaimed agency over museum collections. Similar developments have taken place elsewhere in including local communities in the process of planning and curating exhibitions and at least for a moment including the objects within a framework of action. Objects in museums have in a sense been taken out of their contexts of action and in communicating their value it is important to include a dynamic element even if it is done only through the power of lighting. The materiality of the object is one important resource but it needs to be set in action by the researchers and curators. We can attempt in these subtle ways to communicate the affective meaning of material form from one cultural context to another to challenge the initial response of an audience and try to evoke feelings that are in harmony with the maker's culture.

Feelings across cultures

As an anthropologist, my perspective on material culture reflects a particular value system that includes at its centre a weak form of cultural relativism. My objective is to place material objects in the contexts of their cultures of origin and to communicate the sense that the objects have cross-culturally – to 'connect visitors to the richness of other's life worlds' as Wehner and Sears phrase it so succinctly in this Chapter 10. My relativism extends to the affective response that people have to material forms and to the influence culture, as well as experience, has on the senses. The capacity to discriminate material forms varies cross-culturally and will articulate with very different systems of meanings, and the same form can evoke very different feelings according to the interpreter and context. Working in coastal Arnhem Land I have always been struck by the ability of Yolngu to discriminate diversity in the textured form of the sea where I tend to see relative uniformity. And associated with this power to discriminate is a rich vocabulary that differentiates between different states and characteristics of the waters. And such discrimination as well as relating to the practical side of life to the safety of boats and the distribution of marine resources, connects directly to the ancestral dimension that underlies all forms of life (Morphy and Morphy 2006).

My own relativism is modified where translatability enters the discourse – the human capacity to enter other people's life worlds and hence to an extent step outside their own. Those very same capacities that enable human beings to see family resemblances between different behaviours, institutions and beliefs cross-culturally also apply to the world of the senses. However it often

requires work, a suspension of belief and an interpretative process. Material forms, smells, textures, sounds, weight, colours – things apprehended by the senses – require translation. While the level of discrimination and differentiation of material forms may vary it is possible to communicate those differences inter-culturally and cross-culturally to learn how fellow human beings respond in similar and different ways to the same material stimulus to the senses. The process is often going to be dialogic. We need to enter the value creation processes of Mende society in order to see the shining blackness of the *sowo-wui* as the expression of feminine beauty, even though we can respond in our own way to its form. There may strong overlaps but it is just as likely the feelings evoked may diverge. We need guidance to see the thin-framed spectacles that once belonged to Virginia Woolf as Nuala Hancock sees them. The structuring of aesthetic systems may in some contexts and times operate in such a way that we can direct the responses of people in a particular way to make them feel joy or sadness and attempt to guide people's interpretations and responses as Win Yang Ting suggests.

The chapters in this book represent an immense richness and a diversity of perspectives that it is important to maintain. The focus on the materiality of objects should be a primary one. But it must also be seen as a perspective. Not everything flows from the material form and indeed the very materiality of the object is itself better conceived of in abstract and dialogical terms. Materiality as it relates to the affective meaning of objects is not a given but rather a potential – it involves the connection of the object to its use, its history, the value creation processes and aesthetic systems of the societies of manufacture. Form in material culture is ultimately something produced by people and it is that connection that we need to explore. Human beings have a great capacity to respond to objects and the power of objects to create affect is considerable. The affect that is located in material form is as many of the chapters have shown the product of immensely complex socio-cultural processes. People are socialised into the significance of objects and learn about them through use, and gain a sense of their value through context. Indeed to an extent it is the materiality outside the object – the materiality in the mind that produces form and creates meaning – that is as important as the objects that are produced.

References

Boone, S. (1986) *The Radiance of the Waters*, New Haven, CT: Yale University Publications in Art History.
Errington, S. (1998) *The Death of Authentic Primitive Art and Other Signs of Progress*, Berkeley, CA: University of California Press.
Morphy, H. (2008) 'Joyous maggots: the symbolism of Yolngu mortuary rituals', in M. Hinkson and J. Beckett (eds) *Appreciation of Difference: W.E.H. Stanner and Aboriginal Australia*, Canberra: Aboriginal Studies Press.
Morphy, H. and F. Morphy (2006) 'Tasting the waters: discriminating identities in the waters of Blue Mud Bay', *Journal of Material Culture* 11(1–2): 67–87.
Munn, N. (1986) *The Fame of Gawa*, Cambridge: Cambridge University Press
Schivelbusch, W. (1986) *The Railway Journey*, New York: Berg.
Tilley, C., W. Keen, S. Küchler, M. Rowlands and P. Spyer (eds) (2006) *Handbook of Material Culture*, London: Sage.
Wedgwood Benn, A. (1971) 'Introduction', in *The Man-Made World*, Milton Keynes: The Open University Press.

INDEX